How to select & use

MINOLTA SLR CAMERAS

by Carl Shipman

THIS IS AN INDEPENDENT PUBLICATION
Cooperation of Minolta Camera Corporation is gratefully acknowledged, however this publication is not sponsored in any way by Minolta Camera Corporation. Information, data and procedures in this book are correct to the best of the author's and publisher's knowledge. Because use of this information is beyond author's and publisher's control, all liability is expressly disclaimed. Specifications, model numbers and operating procedures may be changed by the manufacturer at any time and may no longer agree with the content of this book.

Publisher & Editor: Bill Fisher; Art Director: Don Burton; Book Design: Lloyd P. O'Dell
Book Assembly: Lloyd P. O'Dell, Ken Hoidon
Typography: Cindy Coatsworth, Joanne Nociti, Patty Thompson
Photos: Carl Shipman or as credited.

Published by H.P. Books, P.O. Box 5367, Tucson, AZ 85703 602/888-2150
ISBN: 0-89586-044-9 Library of Congress Catalog Card No. 80-81594
©1980 Fisher Publishing, Inc. Printed in U.S.A.

1 PREVIEW

A photograph records more than an image. For the photographer, it records the experience—the day, the place, the feeling of the moment. Both artistic and technical considerations are involved in every photo. Technical factors such as cameras, lenses and film are the means by which we find satisfaction in our photos.

After more than 50 years as a leading manufacturer of quality cameras and lenses, the Minolta Camera Company today offers a very wide range of cameras, lenses, accessories and related products.

There are Minolta cameras of every popular type ranging from simple non-adjustable pocket cameras up to very sophisticated single-lens-reflex (SLR) models with a vast array of accessories. There is a Minolta camera to suit virtually every need and every purpose.

This book discusses Minolta SLR cameras of two types: Those using 35mm film and those using 110-size film. The 35mm SLR is commonly used by professional photographers, advanced amateurs and a large segment of the general public interested in high-quality photographs. Therefore, most of this book is devoted to Minolta 35mm SLR cameras, lenses and accessories.

Minolta 110 SLR cameras have the same basic concept as their larger 35mm "cousins" and some of the same advantages, although they are simpler and have fewer accessories. These cameras are discussed in Chapter 14.

This book serves three purposes: It explains how SLR cameras work and the functions of accessory items including interchangeable lenses. I begin with basic ideas that are easy to understand and build up to more complicated ideas that you will use to get the most from your SLR.

The general discussion is illustrated with photographs of Minolta SLR cameras. This helps you understand the information being presented and also helps acquaint you with currently available Minoltas—which is the second purpose of this book. You will see features of various camera models and learn how they work.

In Chapter 15, current and recent 35mm SLR camera models are discussed individually with complete specifications and operating instructions.

You can "go shopping" in this book, to select a new camera and accessories or to add equipment to your present system.

Another purpose is to tell and show you how to use Minolta equipment to make photographs. Of course, this is the payoff. After you have equipment and know how it works, you can learn to use it well and enjoy the satisfaction that comes with creating good photographs

As you will see, the range of Minolta 35mm cameras and accessories has been carefully and logically developed as a system of interchangeable parts centering around the basic camera body. Whatever you want to do in photography, you can accomplish it by choosing equipment from the Minolta system to meet your needs.

ELEMENTS OF THE SYSTEM

If you are not acquainted with 35mm SLR systems, the complete array of hardware items looks impossibly complicated when viewed all at once. When the basic elements are identified and the purpose of each is described, it becomes easy to find your way through the system and select the equipment you need.

Most photographic equipment falls into fairly definite categories, each with a specific purpose or purposes. The most important categories are listed in this section. Besides these, a variety of miscellaneous items is discussed at

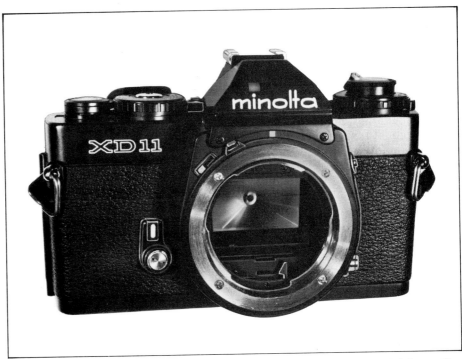

The camera body holds the film and has most of the controls. The bright metal ring on the body is the lens mount.

appropriate places throughout this book.

Camera Body—The camera body has a lens mount which accepts interchangeable lenses. The body contains the film and the mechanism which transports film from a cartridge at one end to a takeup spool at the other.

Also in the body is a shutter which opens to allow light from the lens to strike the film and record a photographic image. As the film moves through the camera, you can expose frames of film along its length. Other features will be described later.

Camera Body Accessories—Major accessories are automatic auto winders and motor drives. The auto winder advances film after each exposure so you can shoot faster, without the trouble of advancing film manually. Motor drives also advance film automatically but at a faster rate than auto winders.

Viewfinder—The viewfinder is in a housing on top of the camera body. The viewfinder has an eyepiece on the back which allows you to see the image that will be recorded on film when you operate the shutter button. This helps you compose the photo and verify good focus. An important feature of this type of camera is that you get the same view through the lens that will be used to take the picture. Therefore you see exactly what you are photographing.

Some cameras have removable viewfinders which can be interchanged with other finders of different types. Most have the viewfinder built in as a permanent part of the camera body.

Viewfinder Accessories—Some of these accessories fit on the viewfinder eyepiece to magnify the image you see, so you can focus more precisely, or to allow you to view from a different position in respect to the camera.

3

A simple but important viewfinder accessory is a rubber eyecup to exclude stray light and make viewing more comfortable.

Inside the viewing system is a focusing screen with a device to help you find best focus. On some cameras, the focusing screen is interchangeable so you can select and install the type that best suits your personal preference or best meets the requirements of the photography you are doing. Interchangeable focusing screens are discussed in Chapter 7.

Interchangeable Lenses—Minolta 35mm SLR cameras all have the same lens-mount design and all models can use interchangeable lenses. It's an advantage to switch lenses for different situations—using wide-angle lenses, telephoto, zoom lenses and special types to make pictures that are not possible using a camera with a single, fixed lens.

Lens Accessories—These include lens hoods which keep stray light off the front surface of the lens, filters to change the color or amount of light entering the lens and a variety of accessories to increase magnification or size of the image on film.

CAMERA MODELS

The following photos and brief descriptions of Minolta SLR cameras are an introduction to the cameras discussed in this book—just so you will recognize model numbers as they are mentioned in following chapters.

Minolta 35mm SLR cameras are manufactured in more than one series. Within each series there is usually more than one camera model. All cameras in each series are basically similar but some models have more features than others.

For example, in the XG series, three models have been manufactured: XG-1, XG-7 and XG-9. The XG-9 has more features than the lower-priced XG-1 but these models are basically the same camera.

Cameras from four different series are presently available: XD, XG, SR-T, and XK.

Each of the cameras discussed in this book is shown by a photograph in this section. Photo captions give you a general idea of the capabilities of each model. For more specific information, camera descriptions and a specifications table are in Chapter 15.

For Minolta 110 cameras, similar information is in Chapter 14.

Minolta sometimes uses different model designations for the same cameras, depending on where the cameras are sold. This book uses model designations for the USA. If you live in another part of the world, you can "translate" the model designations using this table:

| | EQUIVALENT MODELS | |
USA	Europe and Africa	Japan
XD-11	XD-7	XD
XD-5	XD-5	XD-5
XG-9	XG-9	XG-9
XG-7	XG-2	XG-2
XG-1	XG-1	XG-1
XK Motor	XM Motor	X-1 Motor
SR-T 201	SR-T 10 lb	SR 101 or SR 101s
SR-T 200	SR-T 100b or SR-T 100X	—

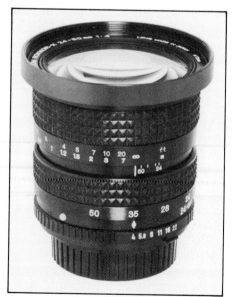

A large variety of interchangeable Minolta lenses is available for Minolta SLR cameras that use 35mm film. Attaching or removing a lens is very simple, as you'll see later. This lens has a rear cap installed to protect the mount.

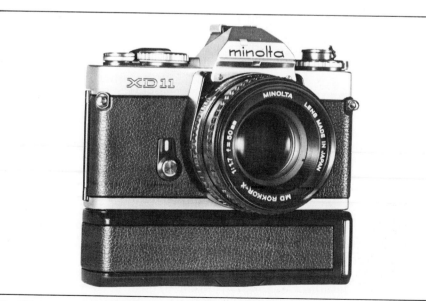

The XD-11 offers *manual* exposure control plus two kinds of automatic operation—called *aperture priority* and *shutter priority*. These automatic modes are explained later. The Auto Winder shown installed on the bottom of the camera is an important accessory that advances film automatically.

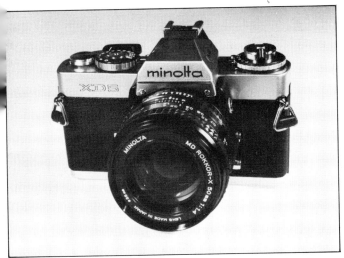

The XD-5 also has three modes of operation. It has fewer features but has basically the same capabilities as the XD-11.

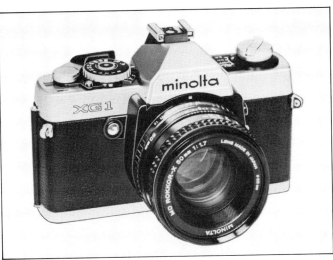

The XG-1 is simple and easy to use. It is the lowest-priced Minolta 35mm SLR with automatic exposure control—and it also offers the option of manual control.

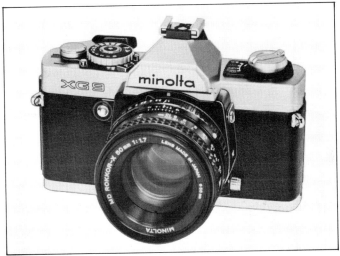

XG cameras have two modes of operation: aperture-priority automatic and manual exposure control. The XG-9 has more operating features than other XG cameras.

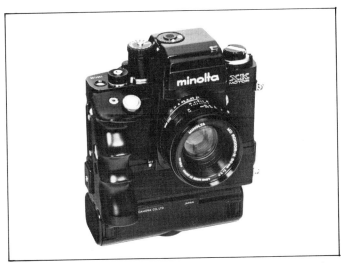

The XK Motor Drive camera has a wider range of accessories than other Minoltas, plus a built-in motor drive that will take photos as fast as 3.5 frames per second. It's a camera for professionals and advanced amateurs.

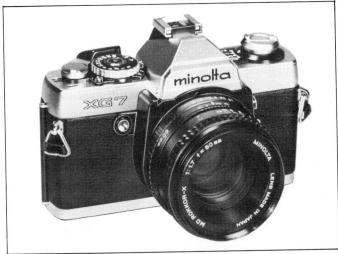

The XG-7 is no longer in production. It is basically similar to the XG-9 but with fewer operating features. It is included in this book because it is a recent model.

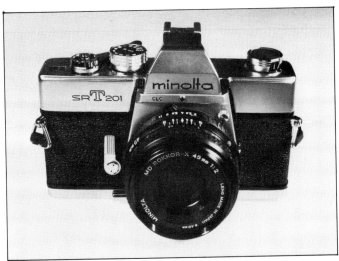

The SR-T 201 is a simple non-electronic camera with manual exposure control only. It's a good camera for beginners and those who prefer manual exposure control.

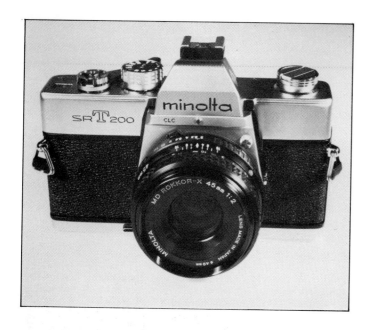

The SR-T 200 is similar to the SR-T 201 but with fewer features and a lower price. It has manual exposure control only.

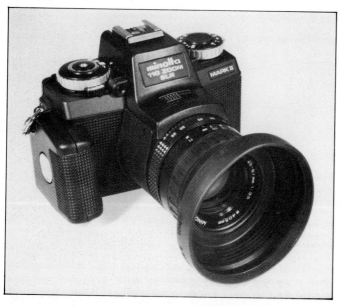

The Minolta 110 Zoom SLR Mark II looks like a 35mm SLR and works like one except that it uses 110 film in drop-in cartridges. Instead of interchangeable lenses, it has a permanently attached zoom lens.

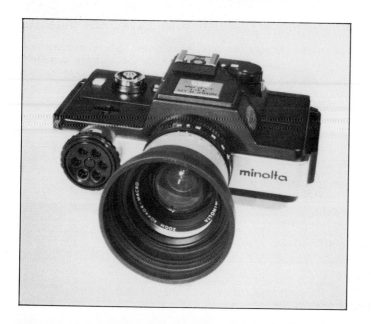

The Minolta 110 Zoom SLR was the first SLR using 110 film. It brought high-quality images to users of 110 film.

EXPOSURE— THE BASIC TECHNICAL PROBLEM 2

EXPOSURE—THE BASIC TECHNICAL PROBLEM

Everything about a camera serves in one way or another to get proper exposure of light onto the film. The camera body excludes stray light which can affect the film. The lens admits light from the subject being photographed.

Inside each lens is a *diaphragm* made of metal leaves which form an approximately circular hole which we call the lens *aperture*. By changing the position of the leaves, the hole in the center of the diaphragm can be made larger or smaller. This changes the amount of light that passes through the lens into the camera where it exposes the film.

Aperture size is controlled by a serrated ring on the outside of the lens body, called the *aperture ring*. Click stops, or *detents*, on the aperture ring provide definite steps as you rotate the control. Each major step is numbered, with each number representing a certain aperture size. These numbers are called *f-numbers*.

The aperture ring on each lens is marked in a series of *f*-numbers representing all steps between the

Photographs record light. To capture the range of brightnesses and colors, and their subtle variations, you must produce correct exposure of the film.

The amount of light that passes through the lens is determined by the size of the lens aperture. Aperture size is an exposure control.

largest possible setting and the smallest. This control can be set anywhere in its range of operation, whether exactly on an *f*-number or not.

f-numbers are important to photography with adjustable cameras and you will become very familiar with them. They are written in more than one way: *f*-2, *f*/2 and *f* :2. This book is part of the H.P. Books series on photography where the form *f*-2 has been standardized.

In the language of photography, when you set a lens to an *f*-number setting on the aperture ring, you have chosen a certain aperture size or *f*-stop. If you then change to another *f*-number setting on the aperture ring, you have selected a different *f*-stop.

THE *f*-NUMBER SERIES

It is useful and practically necessary to memorize the series of *f*-numbers engraved on the aperture ring. It helps you speak and think in the language of photography and it helps you make adjustments to your camera. It's easy to memorize.

All you have to do is remember two numbers: 1 and 1.4. Double them alternately as shown in the accompanying drawing. The *f*-

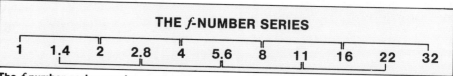

THE *f*-NUMBER SERIES

| 1 | 1.4 | 2 | 2.8 | 4 | 5.6 | 8 | 11 | 16 | 22 | 32 |

The *f*-number series can be created by doubling the numbers 1 and 1.4 as shown by the lines. Notice there are some approximations for convenience. The *f*-number series extends both above and below the range shown here but this list includes the common values.

number series continues both above and below the numbers shown but those are the common values. Notice there is an approximation between 5.6 and 11: *f*-11 is not exactly double *f*-5.6, but it is close enough and easier to remember.

This series of *f*-numbers is chosen so the area of the lens aperture is doubled with each full step toward larger aperture size. Going the other way, area is halved with each full step toward smaller aperture size. Because the amount of light that gets through a hole is determined by the area of the hole, each *f*-number step allows twice as much light, or half as much, as its immediate neighbors in the series.

Another thing you have to remember is that larger *f*-numbers mean smaller lens openings, and the reverse. If you have a lens set at *f*-8 and change it to *f*-11, the amount of light passing through

the aperture will be reduced to half. If you change the aperture from *f*-2 to *f*-1.4, the amount of light reaching the film will be doubled.

In the early days of photography, variable apertures had not been invented. Cameras used removable metal plates in the light path to the film. The plates were made with holes of different sizes and the thinking was that the plate would *stop* all the light except that which got through the hole. Changing these plates to allow more or less light on the film became known as changing *stops.*

The word remains with us; *f*-numbers are often called *f*-stops. Changing to smaller aperture is often called stopping down. Changing to larger aperture is usually called opening up although one might call it stopping up with equal logic. Changing aperture to one that is three sizes smaller is called stopping down three stops.

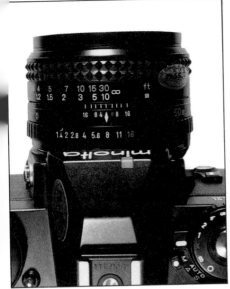

To control aperture size manually, turn the Aperture Ring on the lens. The Aperture Scale is is engraved on the Aperture Ring. It's the set of numbers nearest the camera body, ranging from 1.4 to 16 on this lens. Aperture size is read on the aperture scale, directly opposite the diamond-shaped white *index mark*. This lens is set to *f*-8. In one of the automatic modes of operation, XD cameras set aperture size automatically, using an internal mechanical linkage between camera and lens.

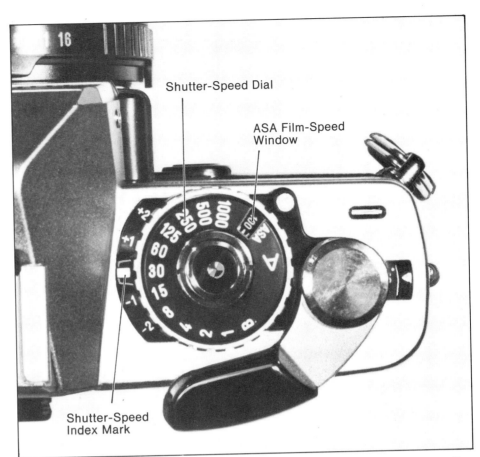

To set shutter speed manually, turn the Shutter-Speed Dial on top of the camera so the desired shutter-speed number aligns with the adjacent index mark. This XG-1 is set for a shutter speed of 1/30 second. The range of available speeds on this camera is from 1 second to 1/1000 second. Not all cameras have the same range. Settings A and B, along with the ASA Film-Speed Window are explained later.

I define doubling or halving the amount of light as a change of one *step*. You can conclude that the words *stop* and *step* mean the same thing in photography. I prefer to use the word *step* to mean doubling or halving exposure, which agrees with usage in the international standards for photography.

EFFECT OF LIGHT

The effect of light on negative film is to create a record of the light pattern in the light-sensitive layer, called *emulsion*, which is coated onto a clear base.

Exposure of film to cause an image after development is not just a matter of how bright the light on the film is. Exposure is determined both by how bright the light is and how long it is allowed to fall on the film.

The length of time light is allowed to fall on the emulsion is measured in seconds or fractions of a second. It is controlled by a shutter inside the camera body, in front of the film.

THE SHUTTER-SPEED SERIES

Shutter speeds also change in steps so each longer time is double the preceding step. The standard series of shutter-open times in seconds is: 1 1/2 1/4 1/8 1/15 1/30 1/60 1/125 1/250 1/500 1/1000 1/2000.

Notice the approximation between 1/8 and 1/15; also between 1/60 and 1/125. The longer time is not exactly double the shorter time. The approximations are close enough and they make the shutter-speed series of numbers easier to remember and work with. You should learn the series.

For simplicity and ease of reading, the shutter-speed dial on a camera does not show the numerator of these fractions. Instead of 1/125, the shutter dial just shows **125**. **500** means 1/500 second, and so forth.

RECIPROCITY LAW

The amount of exposure on film can be expressed by a simple formula which is a basic fact of photography. It is called the *reciprocity law*.

Exposure =
Illumination X Time

Illumination means the brightness of the light which falls on the film. You can change brightness of light reaching the film by adjusting the aperture ring on the lens.

Time is the length of time the shutter remains open so light can reach the film. Exposure time is controlled by a shutter-speed dial on the camera, unless the camera sets exposure time automatically—in which case it is controlled by an electronic system inside the camera body.

9

The reciprocity-law formula is often written in abbreviated form as:

$$E = I \times T$$

where the letters stand for the words given in the preceding paragraph.

The important thing about the reciprocity law is: To get a certain amount of exposure on the film, no particular amount of light is required and no particular length of time is required. The requirement is simply that the amount of light multiplied by the length of time must be equal to the desired exposure.

This means you can use less light and more time, or the reverse. When there is not much light, you expose for a longer time. When the light is very bright, you expose for a shorter time.

In practice, this is made very simple by the use of exposure steps on both aperture and shutter controls, as discussed earlier. If you double the intensity of light reaching the film, you can compensate by reducing the exposure time to half. If you double exposure time, cut the amount of light in half. In other words, one step on the aperture ring in the direction of increased light is exactly balanced by one step on the shutter-speed dial in the direction of shorter time.

FAST AND SLOW LENSES

Most Minolta lenses have a control to adjust aperture size. To admit maximum light into the camera, the lens should be set to maximum aperture. For example, if the range of aperture sizes on a lens is from *f*-1.4 to *f*-16, the largest or *maximum* aperture is *f*-1.4. Minimum aperture is *f*-16.

In dim light, photographers often use maximum aperture and are sometimes concerned with how large it is. Lenses with relatively large maximum aperture, such as *f*-1.2 or *f*-1.4 are called *fast* lenses because they make exposures faster—meaning in less time. Lenses with relatively

small maximum aperture, such as *f*-5.6 or *f*-8, are called *slow* lenses because they require longer exposure times.

HOW FILM REACTS TO DIFFERENT AMOUNTS OF EXPOSURE

This discussion of how film responds to exposure applies to any kind of film; color or black and white (b&w). It is simpler to describe and understand when applied to b&w film, but the same basic ideas apply also to color film. If negative film is not exposed at all, but put through development anyway, it will be clear. Not perfectly clear, but practically clear.

Increasing exposure causes b&w film to become increasingly dark when it is developed. It will change from light gray to medium gray to black. There is a limit to how black it can get, just as there is a limit to how clear it can be.

For testing, it is convenient to change exposure in a series of definite steps and then observe the amount of darkening which results at each step. The technical word for darkening of the film is density. More density means it is blacker or more opaque and transmits less light when you look through it.

All human senses, including vision, operate in a way that's surprising when you first learn of it. Suppose you are looking at a source of light such as a light bulb. It is making a certain amount of light and it gives you a certain sensation or mental awareness of brightness.

Assume the amount of light coming from the source is doubled. It will look brighter to you. Not twice as bright, but you will notice a definite change.

The simplest film structure is a light-sensitive layer of emulsion supported by a film base. Most films are more complex than this. Color film, for example, has three layers of emulsion—each sensitive to a different color.

To make another increase in brightness which you will interpret as the same amount of change, the amount of light must be doubled again. Successive increases in brightness which all appear to be equal changes must be obtained by doubling the actual amount of light to get the next higher step. This tells us what must be done on film to make steps of brightness which appear equal to an observer.

This is the reason standard step-increases in exposure are multiples of two.

Figure 2-1 is a test made by exposing each frame on a roll of film at a different exposure, doubling the exposure each time. The subject is a white piece of paper.

The result shows how film behaves over a wide range of different exposures made in orderly steps for convenience. You can see that the negative reaches a point where it doesn't get any blacker even with more exposure. It also reaches a point where it doesn't get more clear with less exposure.

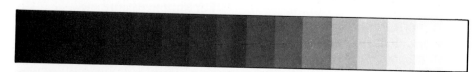

Figure 2-1/Different amounts of exposure result in different densities. For convenience, film testing is done by changing exposure in definite steps, making a *gray scale* as shown here.

These two limits of the film—maximum black and maximum clear—are practical limitations in photography. Normally you try to fit the different brightnesses or tones of a real-world scene into the range of densities the film can produce.

This is done by adjusting the camera controls with a rather simple idea in mind. In the range of densities the film can produce, one density is the middle one. The scene you are photographing also has a range of brightnesses or tones to be transformed into densities on the film. One tone in the scene is the middle one.

If you arrange exposure so the middle tone of an average scene is transformed into the middle density on the film, exposure is just right. When the negative is made into a print, lighter tones of the scene use lighter densities on the print—above the middle value. Darker tones of the scene use the darker densities of the print.

The only technical problem which can result from exposing film this way is if the brightness range of the scene exceeds the film's density range. In that case, the film doesn't have enough different densities to match the different brightnesses of the scene. That can happen when part of the scene is in bright light or sunlight and another part is in shadow.

In the real world, scenes usually have all shades or tones from white to very dark. These must be recorded realistically on the film. Photo by Theodore DiSante.

EXPOSURE CONTROL

Getting a desired exposure on the film depends basically on three things:

The amount of exposure the film needs—it varies from one type of film to another.

The amount of light reflected toward the camera by the scene or subject.

The setting of the camera exposure controls.

ASA Film Speed—Film manufacturers publish numbers called ASA Film Speed, a way of stating the amount of exposure needed by the film.

Film speed is a number such as 25 or 400. Higher speed numbers mean the film is more sensitive to light and requires less exposure. Doubling the film-speed number means it requires half as much exposure, and so forth.

Please notice that the idea of steps is built into the film speed numbering system. ASA 100 film is one step "slower" than ASA 200 film because the lower film speed is one-half of the higher number. The slower film requires one step more exposure. Similarly, ASA 400 film is one step "faster" than ASA 200 film and will require one step less exposure.

The standard series of ASA Film-Speed numbers is 12, 25, 50, 100, 200, 400, and so on. It can be extended in either direction by doubling or halving the numbers.

Minolta cameras have a film-speed dial which you use to set the ASA speed number of the film you are using. This sets the camera to give correct exposure to that film.

Not all films have ASA speed ratings which fall in the series of numbers given earlier. For example, Kodak Panatomic-X has an ASA speed of 32. Kodachrome 64 has a speed of 64.

ASA 12 . . 25 . . 50 . . 100 . . 200 . . 400 . . 800 . . . 1600 . . . 3200 . . . 6400
 16 20 32 40 64 80 125 160 250 320 500 640 1000 1250 2000 2500 4000 5000

If the film-speed scale doesn't show all film-speed numbers, use this table to find the film speeds represented by dots on the scale. Better still, memorize the film-speed numbers from ASA 25 to ASA 400.

Film manufacturers and camera makers have agreed to divide the ASA scale in thirds, so there are two additional numbers between each pair of the standard series. That is, two possible film speeds between ASA 25 and ASA 50, two between 50 and 100, and so forth. Films which don't have a speed number on the standard series are assigned one of the intermediate numbers, such as 32 or 80.

Cameras have an ASA film-speed scale to show each standard speed number and each of the intermediate numbers, but there isn't room to engrave all the numbers. Some are shown and some are just represented by a dot. The accompanying table shows ASA numbers for every setting on the film-speed dial.

Here's a little memory trick that can save you the problem of trying to remember what all the unlabeled dots mean. Just remember 8, 10 and 12. Repeatedly doubling any one of these three numbers gives one-third of all possible film-speed numbers. Do the same to the other two numbers and you generate all possible film speeds.

ASA or DIN—The ASA method of stating film speed was developed in the United States. The DIN system was developed in Germany. They are two different ways of giving the same information about film. In the ASA system, each step is double the next lower value. In the DIN system, the steps mean the same thing, but are obtained by adding 3 to get the next higher number.

ISO—The International Standards Organization has announced a world standard method of stating film speed. It incorporates both of the common methods already given. If a film has an ASA speed of 100, it has a DIN speed of 21. For this film, the ISO speed is stated as 100/21°, where the degree symbol identifies the DIN rating.

The ISO and DIN speed-numbering systems agree at 12 and then follow their individual patterns for higher and lower speeds.

With either system, higher speed numbers mean the film is less sensitive and therefore requires less exposure. We say film with higher speed numbers is faster.

Film manufacturers label film boxes to show film speed. Film speed is also marked on the film cartridge inside the box.

FILM SPEED RATING		
ASA	**DIN**	**ISO**
12	12	12/12°
25	15	25/15°
50	18	50/18°
100	21	100/21°
125	22	125/22°
160	23	160/23°
200	24	200/24°
400	27	400/27°
800	30	800/30°
1600	33	1600/33°
3200	36	3200/36°

With each of these film-speed numbering systems, higher speed numbers mean the film is more sensitive and therefore requires less exposure. We say film with higher speed numbers is *faster*.

Amount of Light From the Scene—After film speed is set into the camera, the next essential is to measure the amount of light reflected by the scene. This can be done by a separate accessory exposure meter or by a meter built into the camera.

Through-the-Lens Metering—Light measurement in the camera is done by an electronic sensor in the viewfinder housing—commonly called a photoelectric cell or PEC, sometimes photo diode. I will refer to it as a sensor, because it senses light. The sensor "sees" the image that will be used to make the picture, just as you do. It measures the brightness of the scene to be photographed. This type of light measurement is sometimes called *through-the-lens* metering, or *behind-the-lens* metering because it measures the amount of light after it passes through the lens.

Through-the-lens metering is a great convenience. You don't have to carry along a separate light meter although some photographers do it anyway, out of habit or personal preference, or for the "insurance" of having two light meters in case one fails. If you use lens accessories, such as a color filter, the camera's built-in light meter automatically measures the change in light so you don't have to worry about it or do calculations to set exposure properly.

Exposure-Control Settings—With film speed dialed into the camera metering system, and the amount of light coming through the lens measured inside the camera, the camera itself can figure the correct settings for the exposure controls. As you adjust the camera exposure controls, a display in the viewfinder helps you find correct exposure for an average scene. Or, automatic cameras such as the XD-11 and XG-9 will set exposure for you.

The two exposure controls—aperture size and shutter speed—are used together to arrive at a pair of settings which produces the desired exposure as indicated by the viewfinder display. Several different pairs of settings can produce the same amount of exposure. You can change shutter-speed and make a balancing or compensating change in aperture size so you end up with the same amount of exposure—but you got it with a different pair of exposure-control settings. This is a practical application of the Reciprocity Law.

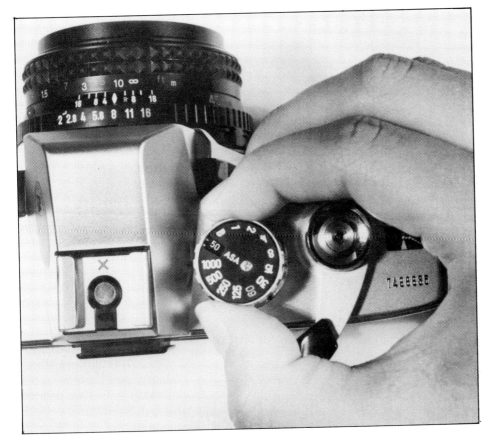

The ASA Film-Speed Window is at different places on different models. To set film speed, *lift up* the outer rim of the control and turn it so the desired film-speed number is visible in the window. This camera is set for ASA 50. The control will have another function if you rotate it without lifting up the outer rim. On this camera, the other function is to set shutter speed.

3 HOW A SINGLE-LENS-REFLEX CAMERA WORKS

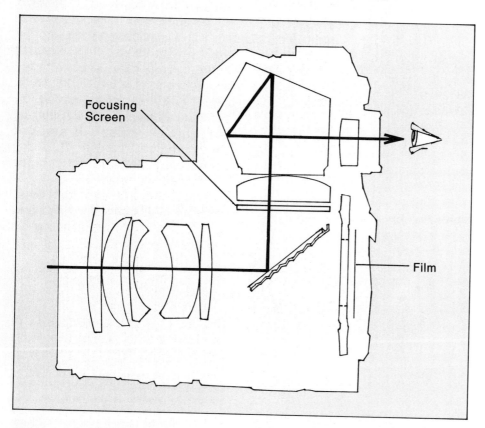

Focusing Screen

Film

Figure 3-1/To view the scene through the lens of an SLR camera, you look into the viewfinder eyepiece on the back of the camera body. What you see is light from the scene which passes through the lens and is reflected upward by the angled mirror. An image of the scene is formed on the focusing screen which is just above the mirror. Light rays from the image on the focusing screen continue upward through the pentaprism and out through the viewfinder eyepiece. To make an exposure, the mirror moves up out of the way so light from the lens can expose the film.

HOW A SINGLE-LENS-REFLEX CAMERA WORKS

The main feature which distinguishes a single-lens-reflex (SLR) camera from other types is: You view and focus through the same lens used to make the image on the film. This has several advantages and some relatively minor disadvantages. One of the advantages is that the SLR design allows you to look through the lens as you focus and compose so you see the same image that will be recorded on film.

The word *reflex* is a form of the word *reflection* and indicates that the image you see in the viewfinder is bounced off a mirror in the optical path between the lens and your eye.

Single-lens-reflex cameras are designed as shown in Figure 3-1. The lens receives light from the subject being photographed. A focusing control moves the lens closer to or farther away from the film and is used to bring the image into sharp focus.

To view, a mirror is moved to the "down" position to intercept the image-forming light beam that travels from the lens toward the film in the back of the camera. This intercepted image is reflected upward by the mirror to a viewing screen, also called a focusing screen. The camera is built so there is the same distance between lens and focusing screen, by way of the mirror, as there is from lens to film when the mirror is out of the way.

Therefore, when the image is brought to focus on the focusing screen, it will also be in focus on the film when the mirror is moved out of the way to make the exposure on film.

The focusing screen is a *substitute* viewing surface, capturing the image that will later fall on the film. It is used to judge focus and to compose the image.

A special prism in the viewfinder housing, called a *pentaprism*, allows you to examine the image on the focusing screen. Light rays from the screen travel upward into the pentaprism and emerge at the viewfinder eyepiece where you see an upright image with correct left-to-right orientation.

When you have focused the image, arranged the composition as you want it to be on film, and set the camera to produce a good exposure, depress the shutter button. Several things happen very quickly.

The mirror moves up out of the way. As it swings up to its parking place, it covers the bottom of the focusing screen which blacks out the view so you can no longer see the image. When the mirror is up out of the way, the lens aperture closes down to the correct size to make the exposure and the shutter opens to let the image fall on the film.

After the desired length of time has passed, the shutter closes again and exposure is completed. In Minolta 35mm SLR cameras, the shutter is in the back of the camera, just in front of the film and very near the plane where the image is focused. It is called a *focal-plane shutter* and I'll show you how it works in just a minute.

After the focal-plane shutter has closed to end the exposure, the mirror moves down again so you can resume viewing through the lens. Except for unusually long exposures, the mirror moves up and down so quickly you hardly notice it—it's as though the camera blinked.

In addition to synchronized mirror and shutter movements, the lens aperture is also controlled automatically by the camera.

When viewing and focusing, it is an advantage to have the lens aperture wide open so the maximum amount of light enters the camera body and you see the brightest image in the viewfinder. However, a smaller aperture size may be necessary to give correct exposure of the film.

The camera keeps the lens aperture wide open while you are viewing. Just before the focal-plane shutter opens, the camera quickly closes lens aperture to the desired smaller size to make the exposure.

After the shutter closes and the exposure is completed, the lens

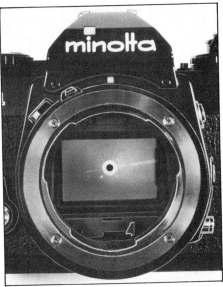

With the lens removed, you can see into the camera body. The mirror is down and you are seeing the bottom of the focusing screen, reflected in the mirror. The circular spot in the center of the focusing screen is a focusing aid, discussed in Chapter 7.

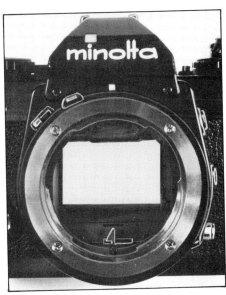

To make an exposure, the mirror swings up out of the way. Then the focal-plane shutter opens in the back of the camera so light from the lens can expose the film. In this photo, the mirror is up and the focal-plane shutter is open. You are looking at the film.

aperture returns to wide open again so you can resume viewing at maximum focusing-screen brightness. This feature is called *automatic diaphragm*, sometimes abbreviated to *auto-diaphragm*.

Automatic diaphragm operation requires a mechanical connection between camera body and lens—a lever on the body and a pin on the lens. All Minolta 35mm SLR cameras have the necessary lever. Nearly all lenses have the pin and therefore have automatic diaphragm operation, as you can see in the lens table in Chapter 4.

Meter Coupling—Current Minolta cameras allow viewing and focusing at full aperture and then automatically stop down lens aperture to the size needed for correct exposure of the film, as just described. In addition, these cameras measure the light and calculate correct exposure while the lens is wide open even though the actual exposure will be made later with the lens stopped down to a smaller aperture.

Here's how it works: When setting the exposure controls, one of the adjustments is made by turning the aperture ring on the lens. When you have set the controls correctly for an average scene, the viewfinder exposure display indicates correct exposure. However, while you are turning the aperture ring on the lens, the aperture actually remains wide open and the maximum amount of light comes through the lens and into the camera's built-in light-measuring system.

A separate mechanical linkage between lens and camera "tells" the camera the *f*-number you have selected on the lens aperture ring even though aperture does not actually stop down until the moment of exposure.

The camera light meter measures light coming through the lens at wide-open aperture. It calculates exposure based on the aperture size that will actually be used later to make the exposure, when the auto-diaphragm feature

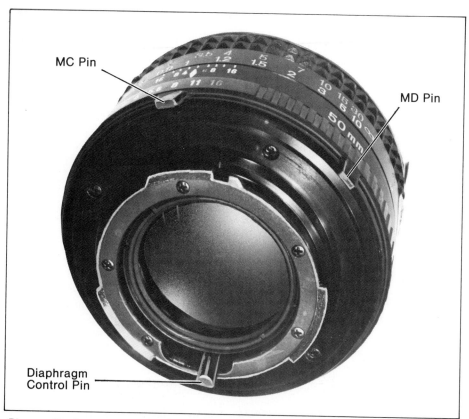

MC Pin

MD Pin

Diaphragm
Control Pin

Pins on the lens work with levers on the camera body to provide automatic features. Automatic diaphragm control is done using the Diaphragm Control Pin on the lens. Full-aperture metering is possible because the MC Pin on the lens "tells" the camera what aperture setting has been made. A third pin, on MD lenses, is called the MD Pin. It makes shutter-priority automatic exposure possible with XD cameras. Mechanical couplings between lens and camera body are discussed in Chapter 8.

stops down the lens aperture to the selected value.

In other words, because of a mechanical coupling between lens and camera body, the camera meter anticipates the light reduction when the lens is stopped down to make the exposure.

This feature is called *full-aperture metering*, sometimes *open-aperture metering* or *maximum-aperture metering*. The main advantage is convenience: You can meter and set exposure controls while viewing the scene at maximum brightness.

Mechanical linkages are called *couplings*. One of the couplings between lens and camera is the one just described. It tells the camera meter what aperture size is being selected at the lens. This coupling

makes full-aperture metering possible. Lenses designed to do this are called *meter-coupled*.

When this feature was first added, Minolta lenses were engraved with the letters **MC** to indicate that they were Meter-Coupled. Since that time, other new features have been added, so MC lenses are not the latest design.

VIEWFINDER DISPLAYS

SLR camera viewfinders show you at least three things: the scene you are photographing, a focusing aid in the center of the frame, and an exposure display to help you set the controls.

The exposure display can be a moving needle or flashing indicator lights, depending on camera model. However it is done, when

the exposure display indicates correct exposure, we say it is balanced or satisfied. This means you have set the camera so the film will receive the amount of exposure required by the ASA speed number of the film.

A common error is to assume that a balanced exposure display means you will get correct exposure for anything you happen to have in view. This is not true. The entire exposure-measuring system is based on photographing average scenes. These are scenes most people like to shoot—typical travel photos are an example.

The exposure-measuring system and the exposure display in your camera will not give correct readings when you are photographing non-average or unusual scenes, which often make the best pictures. This is so important that a whole chapter is devoted to exposure metering—Chapter 8.

FOCAL-PLANE SHUTTER

Minolta SLR cameras have a back cover which swings open to load film. Inside the camera, a partition divides the camera body into two parts. The film is behind the partition. The lens and mirror box are in front. A window in the partition is normally closed by the focal-plane shutter.

To make an exposure, the focal-plane shutter moves to open the window. A beam of light from the lens passes through the window and exposes a rectangular area on the film which is directly behind the window. Therefore, the window determines the size and shape of the exposed area on the film. The window is usually called the *film gate*. The rectangular exposed area on the film is called the *film frame*. After each exposure, the film is advanced so an unexposed area is behind the gate and the next frame can then be exposed.

Focal-plane shutters use two curtains or blinds. One opens the frame to light; the other follows behind the first and closes the frame to light. This is shown in Figures 3-2 and 3-3.

HOW A FOCAL-PLANE SHUTTER WORKS

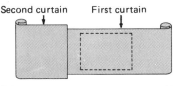
Second curtain First curtain

(1) Ready to make an exposure. Film frame is covered by first curtain.

Opening in camera body determines size of film frame.

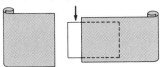

(2) First curtain begins to travel across frame, opening frame to image from lens.

(3) First curtain travel completed. Film frame is fully open to light.

(4) Second curtain begins to travel across frame, closing frame to image from lens.

(5) Second curtain travel completed. Film frame covered by second curtain. Exposure completed. Advancing film to next frame resets shutter to (1) ready to make another exposure.

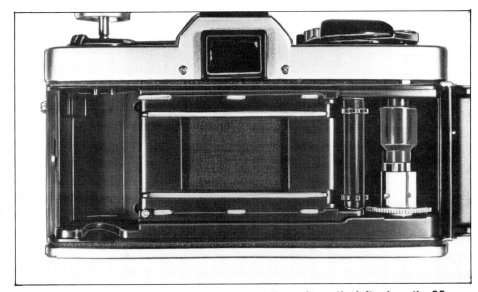

With the back of an XG camera open, you can see the cavity on the left, where the 35mm film cartridge fits. Film is drawn from the cartridge across the camera and wound up on the take-up spool at the right. The rectangular window is closed by the focal-plane shutter. When the shutter is open, the window determines the size and shape of the exposed area on the film—called the film frame. This is a cloth focal-plane shutter which moves horizontally.

Figure 3-2/This drawing shows operation of a focal-plane shutter which travels horizontally. The sequence of events shown here is for a slow shutter speed. When exposure time begins, the *first* curtain is released to start its travel. As it moves, it uncovers a window in the camera body which allows light from the lens to expose the film. When the first curtain has completed its travel, the window is fully open and all of the film frame is exposed to light.

When exposure time ends, the *second* curtain is released to begin its travel. It moves across the window and closes the film frame to light.

Exposure time is measured from *release* of the first curtain to *release* of the second curtain. In this drawing, shutter speed is slow enough that the second curtain does not begin to move until after the first curtain has completed its travel across the frame.

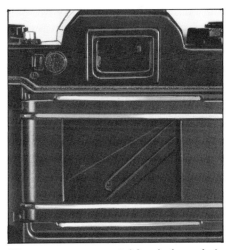

XD cameras use a metal focal-plane shutter with panels which move vertically to open and close.

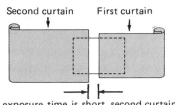
Second curtain First curtain

If exposure time is short, second curtain "chases" first curtain across frame and exposure is through a narrow traveling slit between the two curtains.

Figure 3-3/For short exposures such as 1/500 second, the second curtain follows so closely behind the first curtain that the entire film frame is never open to light all at the same time. The frame is exposed by a traveling slit of light formed by a gap between the two moving curtains.

There are two types of focal-plane shutters, both used by Minolta. In one type, the curtains travel horizontally across the long dimension of the film frame. This type is called *horizontal-travel*, sometimes *horizontal-traverse*, and in this type the curtains typically are fabric.

Vertical-travel focal-plane shutters use thin metal panels operated by levers to open and close the frame. The operating principle is the same for both types. In Chapter 15, you can see which cameras use which shutter type.

MANUAL EXPOSURE CONTROL

With manual exposure control, you set all controls yourself. First, you dial in the film speed of the film you are using. Then you choose a shutter speed and aperture size so the film will be correctly exposed.

Because there are two exposure controls, it is customary to set one first, then adjust the other to get correct exposure. It is possible to choose the first setting and then find it impossible to balance the camera exposure display. Suppose you decide to shoot at a very fast shutter speed such as 1/1000 second. Because exposure time is short, this will require a large lens opening. If the light is dim, the largest lens aperture may not be large enough. In that case, you will rotate the aperture ring on the lens to the largest available aperture setting and the exposure display still won't balance. That means you can't shoot at 1/1000 second in that light and you must use a slower shutter speed.

Setting aperture size first can get you into the same kind of situation, so it isn't a cure for the problem. For example, you may decide to use the largest aperture and then find that there's no shutter speed fast enough to work with the large lens opening. This can happen when the light is very bright. If so, change to a smaller lens opening and you will have a shutter speed that works.

AUTOMATIC EXPOSURE CONTROL

Some cameras will automatically set one exposure control for you, after you have set the other. This frees you from worrying about each individual exposure and lets you concentrate more on the scene or subject you are photographing to get the best artistic result.

Suppose you are using a camera that sets shutter speed automatically. To prepare the camera for use, dial in the film speed. Then set lens aperture to any setting you

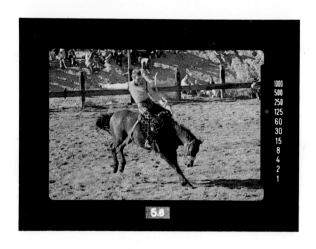

5.6

What you see in the viewfinder depends on the camera model. You always see the scene you are photographing. A focusing aid in the center helps you find best focus. This is an XD-11 camera set for aperture-priority automatic. At the bottom, below the image area, is the aperture size you selected. At right is the shutter speed selected by the camera for correct exposure of an average scene. Other viewfinder displays are shown in Chapters 8 and 15.

want to use. Point the camera at the scene. The light-measuring system inside the camera will calculate exposure for that scene and automatically set shutter speed to give correct exposure for an average scene. Depress the shutter button to make the exposure.

STEPLESS EXPOSURE ADJUSTMENTS

The click-stops or *detents* at the marked numbers on lens aperture rings and camera shutter-speed controls are steps—each giving twice as much exposure as the next smaller step.

When setting shutter speed manually, always set the control exactly on a numbered setting—which means you are using full steps.

When setting lens aperture manually, you can set the control anywhere and the camera will use that aperture setting.

As a practical matter, you can choose any lens aperture setting when doing it manually but you usually end up either on full-step or half-step settings.

When a camera is making an exposure-control setting for you, it does not use the shutter-speed dial on the camera or the aperture ring on the lens. It uses *internal* electronic and mechanical controls

for these purposes. The internal controls are *stepless*, meaning the camera doesn't have to use exact shutter speeds or *f*-numbers. It can use 1/543 second rather than 1/500, or it can use *f*-8.3 rather than *f*-8.

APERTURE PRIORITY AND SHUTTER PRIORITY

Automatic SLR cameras measure the amount of light and set one of the two exposure controls automatically, after you have set the other one manually. If you set aperture and the camera sets shutter speed, the camera is operating with aperture priority. If you set shutter speed and the camera then chooses a suitable aperture opening, the camera is operating with shutter priority.

There is sometimes a photographic reason to prefer aperture or shutter priority—and sometimes the photographer has a preference based on his own experience.

Minolta offers camera models with all of these exposure-control modes. There are manual-only cameras; cameras with aperture-priority automatic operation plus manual; and cameras with both aperture-priority and shutter-priority automatic in addition to manual exposure control.

MINOLTA LENSES 4

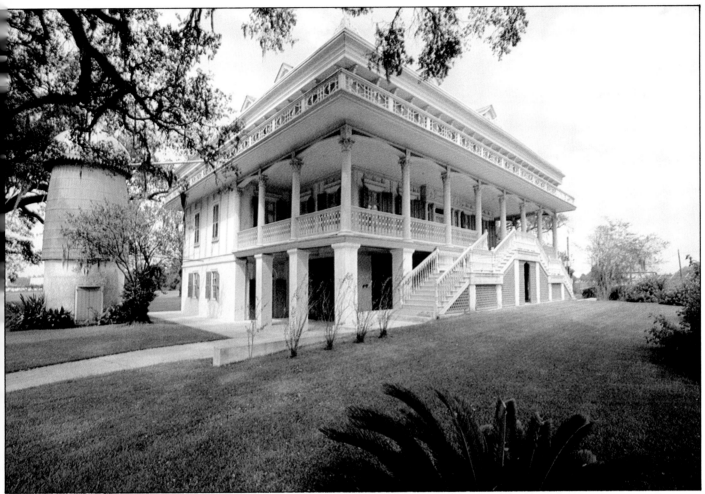

In New Orleans, Louisiana, I saw a photo similar to this on the cover of a travel folder about the old San Francisco Plantation. When there, I found only one way to make this photo. The Mississippi River has changed its course over the years, forcing the boundary fence very close to the house. To get this view, I backed up to the fence and used a lens with 17mm focal length. The other photographer and I solved the same problem the same way—by choosing a lens that could get the shot.

MINOLTA LENSES

Minolta is one of the few camera manufacturers in the world who also make their own lenses, starting with special formulations of optical glass that are precisely formed into individual glass lens *elements*. These individual elements are assembled into *groups*. One or more groups of elements are installed in a lens barrel to make the complete lens.

MINOLTA LENS SPECIFICATIONS

Lens	Angle of View (°)	Min. Focus Ft. (m)	Min. Aperture	Filter Dia. (mm)	Dimensions Dia. x Length in. (mm)	Weight oz. (kg)
7.5mm f-4 MD Fisheye Rokkor-X	180	1.6 (0.5) (Fixed)	f-22	Built-in	2.7x2.5 (6.9x6.4)	12.2 (0.36)
16mm f-2.8 MD Fisheye Rokkor-X	180	1 (0.3)	f-22	Built-in	2.8x2.5 (7.1x6.4)	15.5 (0.44)
17mm f-4 MD Rokkor-X	104	0.8 (0.25)	f-22	72mm	3x2.1 (7.6x5.3)	11.4 (0.32)
20mm f-2.8 MD Rokkor-X	94	0.8 (0.25)	f-22	55mm	2.5x1.7 (6.4x4.3)	8.3 (0.24)
24mm f-2.8 MD VFC Rokkor-X	84	1 (0.3)	f-22	55mm	2.6x2 (6.6x5.1)	12.0 (0.34)
24mm f-2.8 MD Rokkor-X	84	1 (0.3)	f-22	55mm	2.5x1.9 (6.4x4.8)	9.7 (0.28)
28mm f-2 MD Rokkor-X	75	1 (0.3)	f-22	55mm	2.6x2.4 (6.6x6.1)	12.2 (0.35)
28mm f-2.8 MD Rokkor-X	75	1 (0.3)	f-22	49mm	2.5x1.7 (6.4x4.3)	6.4 (0.18)
28mm f-2.8 MD Minolta Celtic	75	1 (0.3)	f-22	49mm	2.5x1.7 (6.4x4.3)	6.4 (0.18)
35mm f-1.8 MD Rokkor-X	63	1 (0.3)	f-22	49mm	2.5x1.9 (6.4x4.8)	8.3 (0.24)
35mm f-2.8 Shift CA Rokkor-X	63	1 (0.3)	f-22	55mm	3.3x2.8 (8.4x7.1)	19.8 (0.56)
35mm f-2.8 MD Rokkor-X	63	1 (0.3)	f-22	49mm	2.5x1.5 (6.4x3.8)	5.8 (0.16)
45mm f-2 MD Rokkor-X	51	2 (0.6)	f-16	49mm	2.5x1.2 (6.4x3.0)	4.4 (0.13)
50mm f-1.2 MD Rokkor-X	47	1.5 (0.45)	f-16	55mm	2.6x1.8 (6.6x4.6)	11.1 (0.32)
50mm f-1.4 MD Rokkor-X	47	1.5 (0.45)	f-16	49mm	2.5x1.6 (6.4x4.1)	7.8 (0.22)
50mm f-1.7 MD Rokkor-X	47	1.5 (0.45)	f-16	49mm	2.5x1.4 (6.4x3.6)	5.6 (0.16)
50mm f-3.5 MD Macro Rokkor-X	47	0.75 (0.25)	f-22	55mm	2.5x2.2 (6.4x5.6)	7.3 (0.21)
85mm f-1.7 MD Rokkor-X	29	3.3 (1.0)	f-22	55mm	2.8x2.4 (7.1x6.1)	16.0 (0.45)
85mm f-2 MD Rokkor-X	29	2.8 (0.85)	f-22	49mm	2.5x2.1 (6.4x5.3)	9.9 (0.28)
85mm f-2.8 Varisoft Rokkor-X	29	2.6 (0.8)	f-16	55mm	2.8x3.1 (7.1x7.9)	15.2 (0.43)
100mm f-2.5 MD Tele Rokkor-X	24	3.3 (1.0)	f-22	55mm	2.5x2.5 (6.4x6.4)	12.9 (0.37)
100mm f-4 MD Macro Rokkor-X	24	1.5 (0.45)	f-32	55mm	2.6x3.5 (6.6x8.9)	13.4 (0.38)
100mm f-4 Auto Bellows Rokkor-X	24	—	f-32	55mm	2.5x1.4 (6.4x3.6)	5.4 (0.15)
135mm f-2.8 MD Tele Rokkor-X	18	4.9 (1.5)	f-22	55mm	2.5x3.3 (6.4x8.4)	18.0 (0.51)
135mm f-3.5 MD Tele Rokkor-X	18	4.9 (1.5)	f-22	49mm	2.5x3.4 (6.4x8.6)	14.1 (0.40)
135mm f-3.5 MD Minolta Celtic	18	4.9 (1.5)	f-22	55mm	2.5x3.4 (6.4x8.6)	14.1 (0.40)
200mm f-2.8 MD Tele Rokkor-X	12.5	6 (1.8)	f-32	72mm	3.1x5.3 (7.9x13.5)	24.7 (0.70)
200mm f-4 MD Tele Rokkor-X	12.5	8.2 (2.5)	f-32	55mm	2.5x5.1 (6.4x13.0)	18.8 (0.53)
200mm f-4 MD Minolta Celtic	12.5	8.2 (2.5)	f-32	55mm	2.6x5.1 (6.6x13.0)	18.8 (0.53)
250mm f-5.6 RF Rokkor-X	10	8.2 (2.5)	f-16 ND Filter	Rear-Mounted	2.6x2.3 (6.6x5.8)	8.8 (0.25)
300mm f-4.5 MD Tele Rokkor-X	8.2	9.8 (3.0)	f-32	72mm	3.1x7.0 (7.9x17.8)	25.0 (0.71)
300mm f-5.6 MD Tele Rokkor-X	8.2	14.8 (14.5)	f-32	55mm	2.6x7.3 (6.6x18.5)	24.5 (0.69)
400mm f-5.6 MD Apo Tele Rokkor-X	6.2	16.4 (5.0)	f-32	72mm	3.3x10.1 (8.4x25.7)	50.8 (1.44)
500mm f-8 RF Rokkor-X	5	13.1 (4.0)	f-16 ND Filter	Rear-Mounted	3.3x3.9 (8.4x9.9)	21.1 (0.60)
600mm f-6.3 MD Apo Tele Rokkor-X	4.2	16.4 (5.0)	f-32	Rear-Mounted	4.3x14.7 (10.9x37.3)	84.6 (2.40)
800mm f-8 RF Rokkor-X	3.2	26.2 (8.0)	f-16 ND Filter	Rear-Mounted	4.9x6.6 (12.4x16.8)	67.0 (1.90)
1600mm f-11 RF Rokkor-X	1.5	65.6 (2.0)	f-22 ND Filter	Rear-Mounted	7.1x12.7 (18.0x32.3)	241.6 (6.85)
24-50mm f-4 MD Zoom	84-87	2.3 (0.7)	f-22	72mm	2.9x2.8 (7.4x7.1)	13.9 (0.40)
35-70mm f-3.5 MD Zoom	63-34	3.3 (1.0)	f-22	55mm	2.6x2.6 (6.6x6.6)	12.9 (0.37)
50-135mm f-3.5 MD Zoom	47-18	4.9 (1.5)	f-22	55mm	2.7x4.6 (6.9x11.7)	16.9 (0.48)
75-200mm f-4.5 MD Zoom	32-12.5	3.9 (1.2)	f-22	55mm	2.8x6.1 (7.1x15.5)	22.3 (0.63)
100-200mm f-5.6 MD Zoom	24-12.5	8.2 (2.5)	f-22	55mm	2.5x6.8 (6.4x17.3)	20.1 (0.57)
100-500mm f-8 MD Zoom	24-5	8.2 (2.5)	f-32	72mm	3.6x13 (9.1x33.0)	71.6 (2.03)

THE MINOLTA LENS MOUNT

All 35mm Minolta SLR cameras use the same basic bayonet type lens mount. When installing the lens, three metal projections on the lens pass through three similar openings in the mount on the camera. Then the entire lens body is rotated about 54° clockwise until the lens clicks into place and will turn no farther.

Springs inside the camera mount hold the lens tightly against the camera body and a catch prevents the lens from rotating after it has been mounted. Thus the lens is precisely and positively located, both optically and mechanically.

To remove the lens, depress a small Lens-Release Button on the camera body while turning the lens counterclockwise until it is free of the mount and can be lifted away from the camera.

LENS NAMES

Minolta manufactures lenses in two series: Minolta Rokkor-X identifies an extensive array of lens types of the highest quality including several innovative special lenses. These cover a wide range of focal lengths and are the preferred lenses for use on Minolta cameras.

For the budget-minded, there is a smaller group of Minolta Celtic lenses which are good quality and lower in price.

Both of these brands are manufactured by Minolta for use on Minolta 35mm SLR cameras. In this book, where it is necessary to distinguish which brand of lenses is being referred to, the brand name will be used. Where it is not necessary to make that distinction, lenses will be referred to as Minolta lenses—or just lenses.

HOW TO ATTACH A MINOLTA LENS

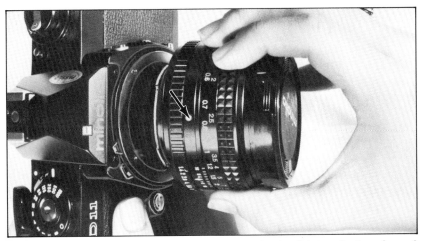

Place the lens carefully on the camera with the raised red dot on the lens (arrow) aligned with the red mark on the camera body at the top of the mount.

Then rotate the lens clockwise until it clicks in place. It's a good idea to have a front cap installed to protect the front glass surface when mounting or removing a lens.

To remove the lens, depress the Lens-Release Button on the camera body while turning the lens counterclockwise until it can be lifted off the mount. Install a rear cap as soon as you remove the lens to protect the mount and keep dirt off the rear element.

HOW A LENS
MAKES AN IMAGE

Later in this book, I'm going to discuss close-up and macro photography and for that you need some basic information about how a lens makes an image, types of lenses, and what focal length means in the technical sense. This requires some formulas and simple math but it has a practical payoff in several ways. The most important is in photography with attachments to the camera.

LIGHT RAYS

We assume that light travels in straight lines called *rays*, and light rays do not deviate from straight-line paths unless they are acted on by something with optical properties such as a lens.

Light rays which originate from a source such as the sun, or which reflect from an object such as a mountain, appear to be parallel rays after they have traveled a considerable distance. In explaining how lenses work, the simplest case is when the light rays reaching a lens have traveled far enough to appear parallel, as in Figure 4-1.

CONVERGING LENSES

If you photograph a distant mountain, each point on the surface of the mountain reflects light rays as though it is a tiny source of light. The rays which enter the lens of your camera are effectively parallel. Rays from each point of the scene are scattered all over the surface of your lens but all those which came from one point of the scene are brought to focus at one point on the film as shown in Figure 4-2.

This drawing shows a simple single-element lens which is convex on both sides. This is called a converging lens because when light rays pass through, they converge and meet at a point behind the lens.

Focal length is defined as the distance behind the lens at which parallel light rays will be brought to focus by the lens. This implies a

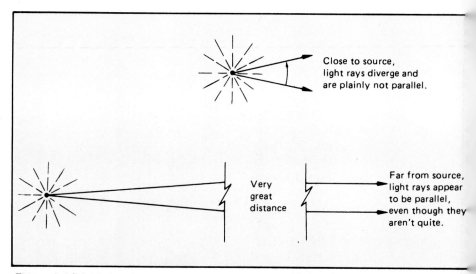

Figure 4-1/Light rays from a point source obviously diverge when you are close to the source. At a great distance, they still diverge, but *appear* to be parallel.

subject far enough away from the lens so the light rays appear to be parallel. We label that subject distance infinity—symbol ∞—on the distance scale of a lens but it actually doesn't have to be very far away. Any subject beyond about 100 feet appears so far away that the light rays from it are effectively parallel.

Figure 4-2 shows what happens to *parallel* rays when they are brought to focus by a converging lens. This lens will image subjects closer than infinity, but it takes a greater distance between lens and film to bring nearby subjects into focus.

Figure 4-3 shows why. Light rays from a nearby subject diverge as they enter the lens. The lens will still change their paths so they come to focus, but because they were diverging rather than parallel when they came into the lens, it takes a greater distance behind the lens to bring them all together at a point.

Focusing a camera moves the lens toward or away from the film so there is the needed amount of distance between lens and film to bring light rays from the subject into focus.

Please notice that the shortest distance ever required between lens and film occurs when the subject is at infinity and the light rays are parallel. All subjects nearer

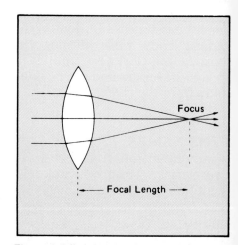

Figure 4-2/Lenses treat rays which appear parallel as though they are actually parallel. A converging lens brings parallel rays to focus at a certain distance behind the lens. This distance is called the focal length of the lens.

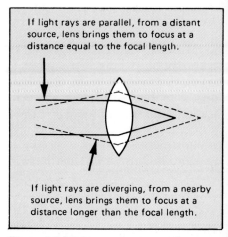

Figure 4-3/Light rays from a *nearby* source are not parallel, so more distance behind the lens is needed to bring the diverging rays into focus.

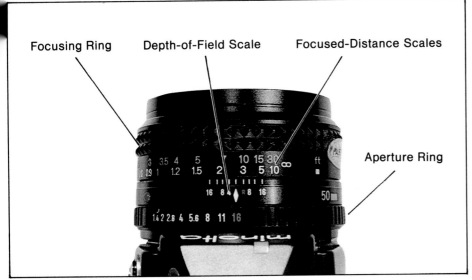

Focusing Ring Depth-of-Field Scale Focused-Distance Scales

Aperture Ring

Most Minolta lenses have these controls and scales.

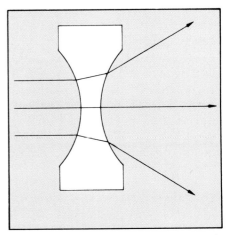

Figure 4-4/A diverging lens causes rays to diverge as they pass through.

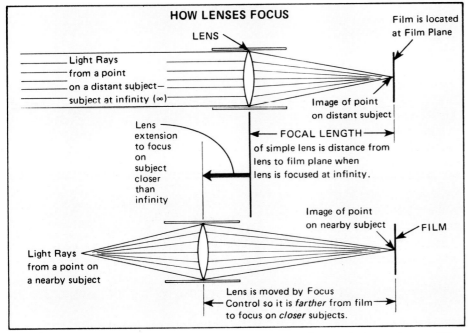

HOW LENSES FOCUS

Film is located at Film Plane

LENS

Light Rays from a point on a distant subject— subject at infinity (∞)

Image of point on distant subject

FOCAL LENGTH of simple lens is distance from lens to film plane when lens is focused at infinity.

Lens extension to focus on subject closer than infinity

Image of point on nearby subject

FILM

Light Rays from a point on a nearby subject

Lens is moved by Focus Control so it is *farther* from film to focus on *closer* subjects.

To make a focused image on film, the lens is moved so the distance between lens and film is correct—which depends on how far away the subject is.

than infinity require a longer distance between lens and film. Therefore, to change focus from a distant subject to something nearby, you move the lens *away from* the film.

DIVERGING LENSES

Diverging lenses are shaped the opposite way and do the opposite thing. Parallel rays entering a diverging lens emerge on the other side as divergent rays— angled away from each other as shown in Figure 4-4.

FOCUSING

Minolta lenses focus by rotating a ring on the lens body called the *focusing ring*. Mechanically, rotation of the focusing ring causes glass elements in the lens barrel to move toward or away from the film, bringing objects at various distances into focus at the film plane. In most lenses, the glass elements in the lens barrel move by traveling along a screw thread inside the lens, called a *helicoid*.

When focused at infinity, the glass lens elements are positioned

so the lens-to-film distance is equal to the lens focal length. To focus on nearer objects, the glass lens elements travel outward on the helicoid. When the end of the helicoid thread is reached, that's as close as the lens can focus without special accessories.

All Minolta lenses will focus to infinity. The closest focusing distance varies as you can see in the lens tables at the beginning of this chapter.

Lenses with short focal lengths typically have minimum focusing distances that are also short— usually around 12 inches. Long-focal-length lenses typically have correspondingly long minimum focusing distances—a few feet to over 60 feet.

A distance scale is engraved on the focusing ring so you can see where the lens is focused. The scale shows distance in both feet and meters and the scale is read by reference to an index mark on the lens body. The same index mark is also used to read *f*-numbers on the aperture ring.

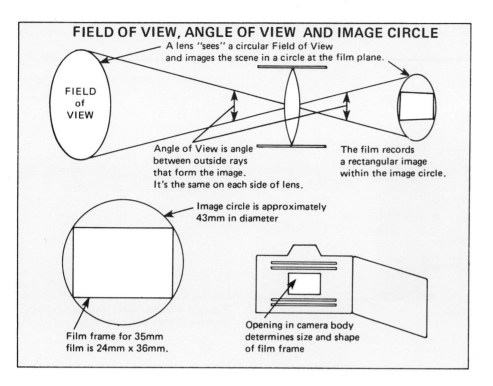

FIELD OF VIEW, ANGLE OF VIEW AND IMAGE CIRCLE

A lens "sees" a circular Field of View and images the scene in a circle at the film plane.

FIELD of VIEW

Angle of View is angle between outside rays that form the image. It's the same on each side of lens.

The film records a rectangular image within the image circle.

Image circle is approximately 43mm in diameter

Film frame for 35mm film is 24mm x 36mm.

Opening in camera body determines size and shape of film frame

This gives you two ways to determine where the plane of sharpest focus is. One way is to look through the camera viewfinder and observe which part of the scene is in sharpest focus. The other is to look at the *focused-distance scale* on the lens. If the lens is focused sharply on an object 10 feet away, the focused-distance scale should indicate 10 feet. Focused distance is measured from the film plane in the back of the camera.

Some camera models have a film-plane indicator mark engraved on the top of the camera. On models without the film-plane indicator, the film plane is about 4mm in front of the rear surface of the camera. For practical purposes you can usually assume that the focused distance indicated on the lens is measured from the camera's back cover.

FIELD OF VIEW

What the lens "sees" is called the field of view, which is circular at any point, but the circle has greater diameter at points farther from the camera. In other words, the lens sees everything in an expanding cone, with the tip of the

cone at the lens.

ANGLE OF VIEW

Angle of view is the angle between the two edges of the field of view. Because a lens sees a circular part of the scene and makes a circular image, its true angle of view is the same vertically, horizontally or at any angle in between.

However, the 35mm film format is a rectangle fitted closely into the image circle made by the lens. Therefore, everything seen by the lens is not recorded in the film frame.

This results in a slightly different definition: *the angle of view recorded on film.*

In that sense, a 35mm camera lens has three angles of view: horizontal, vertical and diagonal. Diagonal is the largest angle because it is corner-to-corner of the film frame. Horizontal is smaller; vertical is smallest because the film frame is not as tall as it is wide.

In photographic literature, when only one angle of view is given for a lens, it it the diagonal angle.

You can get a feel for angle of view by testing your own vision. With both eyes open, hold your

arms straight out to the sides and then move them forward until you can just see your hands while looking straight ahead. Your angle of view will be a little less than 180 degrees.

Do it again with one eye closed. The angle will be a lot less. Clear vision for a single eye covers a total angle of around 50 degrees, depending on where you decide you can't see clearly enough to call it vision.

IMAGE CIRCLE

A circular lens makes a circular image of a circular portion of the scene. In the camera a rectangular opening in front of the film allows only part of the circular image to fall on the film. This defines a rectangular *film frame.*

35mm film-frame dimensions are 24mm by 36mm, which is about 1" by 1-1/2". This rectangular frame fits snugly inside the *image circle* which is about 43mm in diameter with all ordinary lenses.

Even though the viewfinder shows a correctly oriented image, the image on film is upside down and reversed left-to-right.

FOCAL LENGTH

Focal length is expressed in *millimeters*, abbreviated *mm*. Technically, focal length is the distance from a certain location in the lens to the film, when the lens is focused at infinity as shown in Figure 4-2.

One practical value of focal length is a label or name for different types of lenses. The focal-length number tells you some important things about how the lens will "act" when installed on your camera.

Lenses are grouped by focal length into three classes: Short, Medium and Long, according to this table:

Short Focal Lengths—35mm and shorter

Medium Focal Lengths—45mm to 135mm

Long Focal Lengths—200mm and longer

EFFECT OF FOCAL LENGTH

200mm

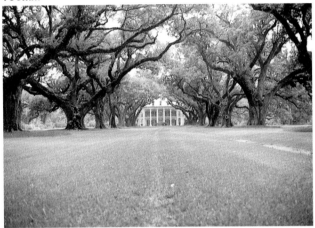

100mm

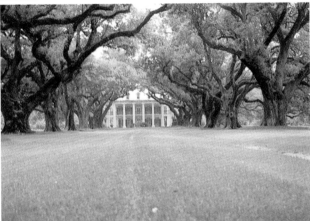

50mm

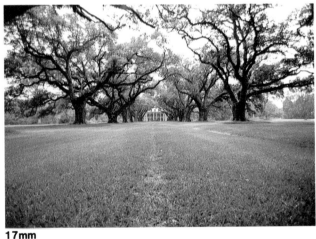

35mm

17mm

Focal length is an indication of the angle of view of a lens and the magnification or size of the image on film. Notice that short focal lengths, such as 17mm have a wide angle of view and capture a lot of the scene, but individual objects are very small in the photo—because magnification is small. Long focal lengths, such as 200mm, perform in the opposite way. Angle of view is narrow so less of the scene is included, but each object in the frame is larger—because magnification is greater. The standard focal length for 35mm cameras is about 50mm, which is a good compromise between long and short focal lengths.

The differences are angle of view and magnification of the image on film. Short-focal-length lenses such as 20mm or 28mm have wide angles of view and low magnification. Use wide-angle short-focal-length lenses when you want to show a lot of the scene being photographed. They are handy in taking interiors when you want to get a lot of the room but the walls prevent you from backing up very far.

Conversely lenses with long focal lengths such as 200mm or 300mm have relatively narrow angles of view and high magnification. A common type of lens with long focal length is called *telephoto*. Not all long lenses are of the telephoto design but most are and the word has come to mean the same thing in popular terminology.

We think of a long lens as one that can "reach" out and fill the frame with a distant subject such as a mountain climber high up on a rock face. It excludes most of the mountain because of its narrow

angle of view. What that really means is the lens has high magnification.

A 50mm lens has an angle of view of about 47 degrees. This is often called a *standard* lens for 35mm cameras and this reason given is that the angle of view is about the same as the human eye. Obviously this means one eye. Most people see with two eyes, so this definition doesn't make much sense.

Another way of defining a standard lens is to say it has a focal length approximately the same as the film-frame diagonal. There's no basic wisdom in this—it's merely another way of stating the angle of view. In the 35mm film format, the diagonal measurement of the frame is about 43mm, so a standard lens should have a focal length of approximately 43mm.

For 35mm cameras, focal lengths from about 45mm to 55mm are considered standard. A lens in this range is usually sold with a new camera. It is a good general-purpose lens and a compromise between wide and narrow angles of view. You can't do everything with a standard lens, but you can take a lot of fine pictures with it.

MAGNIFICATION

Magnification is illustrated with the outside rays that pass through a lens, Figure 4-5. In this drawing, the subject is an arrow and the image is an upside-down arrow. In each case, the arrow extends all the way across the field of view.

Magnification is a ratio or fraction: *Size of the image divided by the size of the subject.*

The image is the one formed inside the camera, at the film plane. When making prints or enlargements, the image is usually magnified a second time. This discussion concerns only magnification in the camera.

Because angle of view is the same on both sides of a lens, the sizes of image and subject are proportional to their *distances* from

the lens. If image and subject are the same distance from the lens, they will be the same size.

This leads to two ways to think about magnification. You can compare sizes, or you can compare distances. Either way, you get the same result. A simple formula to figure magnification is:

$$M = I \times S$$

where I is either image size or image distance from the lens, and S is either subject size or subject distance. Of course, you must work either with sizes or distances—you can't mix them

together in the same calculation.

Suppose the image on film in your camera is 1'' tall and the subject you are photographing is 50' tall. Figure magnification by comparing sizes:

$$M = \frac{\text{Image Size}}{\text{Subject Size}}$$
$$= 1/50$$
$$= 0.02$$

Which you can also write as 2%. The image is 2% as tall as the subject. Whenever magnification is a number less than one, the image is smaller than the subject.

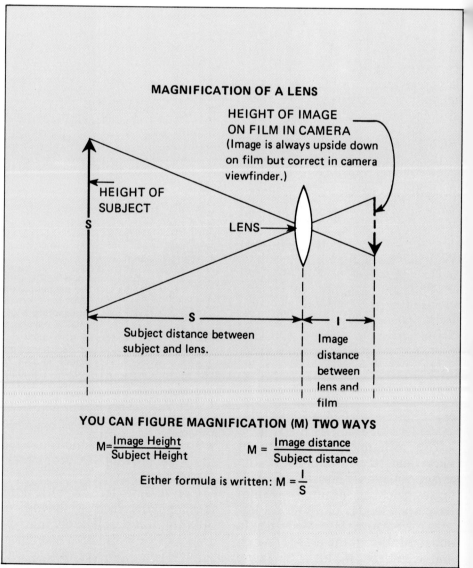

Figure 4-5/You can calculate magnification by comparing image and subject heights, or image and subject distances from the lens.

Suppose the distance from lens to film is 2'' and the distance from lens to subject is 100''. You can figure magnification by comparing distances:

$$M = \frac{\text{Image Distance}}{\text{Subject Distance}}$$
$$= 2/100$$
$$= 0.02$$

With lens accessories discussed in Chapter 9, you can make the image larger than the subject. Suppose the image is 1'' tall and the subject is only 0.25'' tall.

$$M = \frac{\text{Image Size}}{\text{Subject Size}}$$
$$= 1/0.25$$
$$= 4$$

The image is 4 times as large as the subject and magnification is 4. Whenever magnification is a number larger than 1.0, the image is larger than the subject. When magnification is exactly 1.0, image size and subject size are equal.

FLARE AND GHOST IMAGES

Light arriving at the front surface of a lens is partly transmitted through the glass in the direction we want it to travel, and partly reflected back toward the source. This happens at every air-glass boundary in a lens.

Light rays which have passed through the front surface of a lens element are again reflected at the back surface of the piece of glass. Some light rays leave the glass and continue traveling toward the film. Some are reflected *internally* at the glass-air boundary and then bounce around inside the lens element.

Modern camera lenses are *compound*, meaning they have more than one lens element, so there are multiple reflections both within a single lens element and between elements.

In general, any light which is deflected or scattered from its intended path of travel will land somewhere it doesn't belong. This tends to put light on the film where there would otherwise be less light. The stray light has been "robbed" from areas where it should have been. Therefore, light areas on the film are not as light as they should be and dark areas are not as dark. The result is a general reduction in contrast.

If the light which is scattered around by lens reflections forms no definite image on the film but is an overall fog and even a fog over a relatively large area of the picture, we call it *flare*.

Sometimes the reflections from

When a bright light source shines directly into a lens, flare and ghost images of the lens aperture usually appear.

lens surfaces happen in a way that causes a definite shape on the film—typically geometrical figures which are images of the lens aperture. Images of this sort are called *ghosts*.

The cure is to reduce light reflection at each glass-air surface. This is done by lens coating.

LENS COATING

The first lens-coating method was a single very thin layer of a transparent material such as magnesium fluoride. This made a great improvement in picture quality by reducing reflections from coated lens surfaces. However a single coating is not effective at all colors of light.

An improvement was obtained by using multiple coating layers of different thicknesses, so reflections are reduced at all colors of the spectrum.

About 20 years ago, Minolta began applying multiple coating to lens surfaces, starting with the application of two layers. This was

Shooting directly into the light produces flare, which reduces image contrast, even when ghost images of the aperture do not appear.

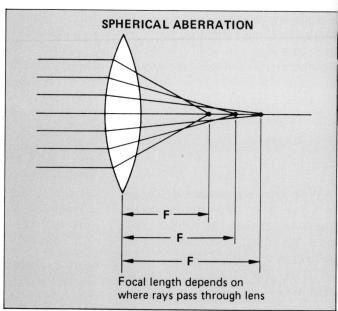

SPHERICAL ABERRATION

Focal length depends on where rays pass through lens

Figure 4-6/Spherical aberration causes rays to focus at different distances, depending on where the rays enter the lens. Light rays which pass through the lens near the edges are brought to focus closer than rays near the center of the lens. Reducing aperture size reduces the effect of spherical aberration because the smaller aperture blocks the outside rays and admits only those that entered the lens near the center.

MINOLTA ROKKOR LENSES WITH FLOATING ELEMENT OPTICAL SYSTEM

17mm *f*-4 MD
20mm *f*-2.8 MD
24mm *f*-2.8 MD VFC
28mm *f*-2 MD
35mm *f*-2.8 Shift CA

called Achromatic Coating. Since then, Minolta has paced the state of the art in advanced materials and techniques for multiple coatings. However they have not changed the name applied to the process. Today, Achromatic Coating means multiple-layer coatings scientifically applied to improve color quality of the image, reduce flare and improve contrast.

When a surface reflects less light, it transmits more light. Therefore multiple-layer coating has several beneficial effects. It reduces flare and ghosts which makes pictures sharper, with better contrast between adjacent light and dark areas. It also makes the viewfinder image brighter and puts more light on the film during exposure.

Achromatic coating also helps to color-match the light through Minolta lenses so you don't see a color difference when the same subject is photographed through different lenses.

Complicated modern lenses, such as zoom lenses, use a lot of glass elements. Good quality in these lenses is possible because of modern multiple-layer coating.

LENS ABERRATIONS

To photographers, lens aberrations are like the boogie-man: mysterious, threatening and always lurking around trying to do something bad. Aberrations of a lens cause defects in the image.

There is a long shopping list of aberrations, including spherical aberration, chromatic aberration, coma and astigmatism. All lenses have all of these defects to some degree. Total elimination is probably impossible but partial correction is part of the design of each lens. For more money, you get more correction.

Correction of lens aberrations is done in several ways. Basic is the design of the lens itself, using multiple pieces of carefully shaped glass elements. This has always involved laborious mathematics. The process has been both speeded and improved by use of modern electronic computers to do the arithmetic.

Because there are many different aberrations and correcting them is a series of compromises, the best guide to the lens user is simply the reputation of the lens maker.

Aside from purchasing lenses from a manufacturer with an established reputation for quality such as Minolta, there are only a few things the user can do to affect image quality:

Keep the lens clean and protected from mechanical damage. Use a lens hood to keep stray light off the front surface of the lens. Focus carefully and don't move the camera during exposure.

Most aberrations have less effect on the image if the lens is used at medium apertures. Using ordinary films, it's hard or impossible to see any difference, but theorctically it is better to shoot at an aperture smaller than wide open.

There are two aberrations that you should know by name and understand in a general way:

Spherical aberration results from the fact that conventional lens elements are manufactured so the surfaces are segments of a sphere—that is, they are spherical.

A perfect lens would bring all light rays that pass through the lens into focus at the same plane. Real-world spherical lenses aren't perfect. Rays that pass through the

exact center of the lens come to focus at a certain distance from the lens. Rays that pass through at a small distance from center are brought to focus closer to the lens, as you can see in Figure 4-6. Rays passing through the edges of the lens are affected most by spherical aberration and travel the shortest distance before they come to focus.

This means that some rays are in focus at the film plane and some are not. A point on the subject is brought into sharp focus by *some of* the light rays from that point. Other rays, which are not in focus at the film, create a sort of halo around the sharply focused image of the point.

Spherical aberration is reduced by closing down the lens aperture so the outside rays don't pass through the lens. Rays that remain to produce the image are in better agreement as to the point of best focus and the image is sharper.

Spherical aberration is also reduced in lens design by using concave, diverging elements to correct the aberration of the convex, converging elements. For this to work, the glass types in the various lens elements must be different—one of the reasons lens design is complicated.

Chromatic aberration has to do with colors of light and is usually described by observing what happens to the three primary colors: red, green and blue, discussed in Chapter 10. This defect causes light of different colors to come to focus at different distances from the lens.

Red light comes to focus farthest from the lens, green comes to focus nearer, and blue comes to focus nearest to the lens. Sharp focus of course depends on all light rays coming to focus at the same plane no matter what color they are.

With b&w film, chromatic aberration causes points to become small fuzzy discs and the image is not sharp. With color film, the same thing happens but we can see

the colors. Those that are out of focus form color fringes around the edges of objects in the photo. The color photo is not sharp and sometimes you can see the color fringing.

Chromatic aberration is reduced in the design of the lens by employing a variety of correction methods.

DIFFRACTION

When light rays make grazing contact with an opaque edge such as the edge of the lens aperture, they are diffracted. They are changed in direction slightly, bending toward the edge. If the region on the film where diffracted rays have landed is examined under a microscope, you can see alternating light and dark bands caused by diffraction.

Light rays from each point of the scene should be imaged at a point on the film. Due to diffraction, some rays are diverted and land at the wrong places. This reduces image contrast and image sharpness.

Only those rays which pass very close to the edge of the lens aperture are affected—those which go through the center of the opening are not diffracted.

Therefore the amount of image degradation due to diffraction depends on what proportion of the rays graze past the edge of the aperture and what proportion go through the center of the hole.

As an aperture is made smaller, there is more edge in proportion to the amount of hole, so the total percentage of rays which are diffracted is higher.

Theoretically, the image made by a lens at its smallest aperture will not be as good as one made at larger apertures, because of diffraction.

OPTIMUM APERTURE

If a lens is scientifically tested for image quality starting at maximum aperture, the image will improve at successive *f*-stops as the lens aperture is closed because

the effect of aberrations is reduced.

It varies among lenses, but typically at around *f*-8 the image is as sharp as it's going to get. Further reductions in aperture size cause diffraction effects to degrade the image.

Usually there are other compelling reasons which determine aperture size, but if you have none and you want the best image, set the lens at an *f*-stop near the center of its range.

FLOATING ELEMENTS

Even at optimum aperture—neither too large nor too small—image quality changes when the lens is focused at various distances and the effect is more pronounced with short-focal-length lenses. All conventional lenses focus to infinity and are designed for best image quality at far and middle distances.

As the lens is focused closer, image quality deteriorates because lens aberrations have more effect. At some close distance, image quality has been reduced as much as the lens designer wishes to allow, therefore that becomes the close-focusing limit of the lens.

As used here, *conventional* means lenses designed so all of the glass elements move in unison, toward or away from the film, as the focusing control is rotated.

A recent improvement in lens design, called the *floating focusing system* changes the spacing between lens elements as they move along the focusing helicoid. In other words, the lens elements do not move in unison and some appear to "float" in relation to the others. The advantage is reduced aberrations at close focusing distances with short-focal-length lenses.

Minolta uses the floating system in some lenses with focal lengths of 35mm or less, as you can see in the accompanying table. This improves image sharpness with close subjects and is especially beneficial at full aperture.

You can control depth of field by choosing aperture size. At left, small aperture gives pretty good focus on all three screws. At right, large aperture causes reduced depth of field, however center screw remains in focus. The other two are less sharp. You can see the zone of good focus along the ruler scales.

DEPTH OF FIELD

Most photos include objects in the foreground, in the middle distance and far away. Typically, not all objects in the picture are in sharp focus. Usually there is a zone of good focus. Objects on the near side of this zone are out of focus, and objects on the far side are also out of focus.

The point of best focus—where you have actually focused the lens—is somewhere within the zone of good focus.

If a subject stands at the point of best focus and then starts walking toward the camera, focus will gradually get worse as the subject moves nearer. At some point focus will be just barely acceptable. That point defines the near limit of the zone of good or acceptable focus. Subjects closer to the camera have unacceptable focus. Similarly, there is a far limit to the zone of good focus.

Depth of field is a measure of the zone of acceptable focus. It is the distance from the nearest object in good focus to the farthest object in good focus. For example, if the near limit is 10 feet from the camera and the far limit is 30 feet from the camera, depth of field is 20 feet.

RULES ABOUT DEPTH OF FIELD

Several things affect depth of field. Here are some practical rules or "ways to think" when taking a photo.

DEPTH OF FIELD IS
INCREASED BY:
 Shorter focal-length lens
 Smaller lens aperture
 Greater subject distance

DEPTH OF FIELD IS
DECREASED BY:
 Longer focal-length lens
 Larger lens aperture
 Shorter subject distance

These rules force you to this conclusion: If the image doesn't have enough depth of field, there are only two things you can do to improve it. You can use smaller aperture or make a smaller image in the camera. The smaller image comes from using a lens with shorter focal length or backing away from your subject, or both in combination.

VIEWING DEPTH OF FIELD

If you observe the scene through the viewfinder at wide-open aperture, and then the camera takes the picture at a smaller aperture, you did not see the same depth of field that was recorded on film because smaller apertures give more depth of field.

Viewing depth of field in the viewfinder is a thoroughly practical and simple way to see if there is enough depth to satisfy your objective in making the photo. But to see depth of field as recorded on film, you must close or stop down the lens to the aperture size that will be used to make the picture.

Most Minolta 35mm SLR cameras have a control to do this, but some don't as you can see in the Camera Specifications Table in Chapter 15.

The control used to view depth of field is a pushbutton on the camera body, near the lens mount. When depressed, it will stop down the lens to the *f*-number set on the aperture ring. If the aperture ring is set to *f*-8, the control will stop down the lens to *f*-8.

This control is sometimes called *depth-of-field preview button*, because it can be used for that purpose. It is also called *stop-down button* because that's what it actually does when you push it.

You can see depth of field change as the lens stops down. Sometimes the effect is very pronounced and has great impact on

Controlling depth of field is an important part of photography. The effect on your photos is sometimes dramatic, sometimes subtle, but it's always there. Having the background out of focus in this shot is better than having it sharp, in my opinion.

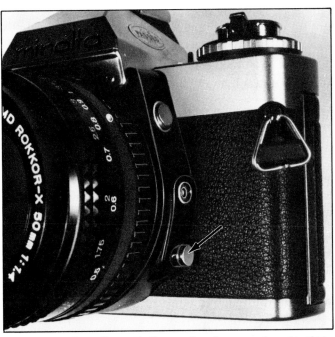

Pushing the Stop-Down Button causes lens aperture to stop down to the *f*-number set on the aperture ring. Not all Minoltas have this control.

the image.

If the depth of field you see is not what you want, you are probably not stuck with it. Usually you can choose a different aperture size and compensate by using a different shutter speed. With an adjustable camera, you have control over depth of field.

If you have selected a small aperture size, perhaps to get lots of depth of field, the viewing screen will become noticeably darker when you operate the stop-down button. It may take a moment for

your eye to adapt to the lower light level.

READING DEPTH OF FIELD OFF THE LENS SCALE

Sometimes there isn't enough light to judge depth of field accurately in the viewfinder, particularly if you are using small aperture and shooting in dim light. Sometimes you need to plan a shot in advance and you need to know how much depth of field there will be before you actually view the scene through the camera. And, some cameras don't have a stop-

down button.

In all of these cases, you can find depth of field another way.

Minolta lenses have a Depth-of-Field Scale engraved on the lens body. It works with the other scales on the lens—aperture size and focused distance—because depth of field is controlled by aperture size and focused distance.

To use the depth-of-field scale, the lens must first be focused on the subject. When the lens is focused, then select the aperture size you will use.

Now you are ready to read depth of field using scales on the lens. It helps to look at the scales while we discuss them. Please refer to the accompanying photo which shows a lens focused at 15 feet or 5 meters and set at *f*-8.

Between the Distance Scale and the Aperture Scale is the Depth-of-Field Scale, which is centered on the diamond-shaped index mark. The numbers on the depth-of-field scale are *f*-numbers and they are used in pairs.

Notice that the two outside lines on the scale are labeled 16, which means *f*-16. The next pair are for *f*-11 although not marked. The next pair toward the center is for *f*-4 although one is marked with a red R which I will explain later. Notice that all possible *f*-number settings for this lens do not appear on the scale because it would make the scale too crowded.

To find depth of field, use the pair of lines that agree with the aperture setting of the lens. That is, if the lens is set for *f*-8, use the two lines on the depth-of-field scale that are marked 8—one on the left and one on the right.

From the left line marked 8, read the distance scale directly opposite. In this example, the distance is about 3.5 meters or about 12 feet, depending on which distance scale you prefer to read. This is the *near limit* of depth of field.

Read opposite the other line marked 8 to find the *far limit*. It's about 10 meters or 30 feet.

Depth of field is the difference between the near limit and the far limit. In this case it is about 6.5 meters or 18 feet. You can't read these scales exactly but the results will normally be close enough.

At this setting, the lens scales give three important distances and we can calculate one more. The near limit of acceptable focus is 12 feet away. Best focus is where the lens is actually focused, which is about 15 feet. The far limit of acceptable focus is 30 feet. Depth of field is 18 feet. If you prefer these distances in meters, read

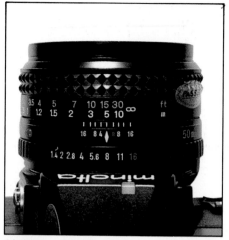

At these settings, depth of field for this lens extends from about 12 feet to 30 feet. If you change aperture to *f*-16, depth of field changes also and will extend from about 9 feet all the way to infinity.

them off the meter scale on the lens.

Please notice that from the point of best focus to the near limit there is only about three feet of distance. From the focused distance to the far limit is about 15 feet. Depth of field is not evenly divided on each side of best focus. There is less of it in front.

Suppose you are using this lens to photograph an automobile that is 18 feet long and you are standing in front of the car. You can get all of the car in acceptable focus because the depth of field is 18 feet at *f*-8 when the focused distance on the lens is 15 feet. We got that information from the scales on the lens.

To get the front bumper and the rear bumper equally sharp in the photo, you must focus the lens three feet into the depth of field. That means you stand 12 feet in front of the vehicle and focus three feet behind the front bumper.

How the depth of field is distributed around the plane of best focus depends on focused distance. When the camera is very close to the subject, the plane of best focus—the actual focused distance of the lens—is about halfway

into the depth of field. As distance to the subject increases, there is less depth of field on the near side of the focused distance and more depth of field behind the focused distance.

It will help your photography to think of focusing as a way of moving the *zone* of good focus closer to or farther away from the camera. As you focus at farther distances, the zone of good focus not only moves away but it becomes deeper.

For any lens and focused distance, changing to smaller aperture gives more depth of field; larger aperture gives less depth of field.

DEPTH OF FIELD IS ARBITRARY

If you dig into the math behind depth of field, you'll find many ifs, buts, and maybes. Depth of field is not an exact thing. It's an estimate. One problem is deciding where good focus stops. If your eyesight or desire for perfection differ from mine, we will not agree on acceptable focus.

To establish some standard for acceptable focus, lens designers reason as follows: Every tiny point on the subject should be a tiny point on the image. As focus gets worse, the tiny point on the image becomes a circle instead of a point. When the circle exceeds a certain diameter, focus is no longer acceptable.

The technical name for that blurred circle on the film is *circle of confusion*—a popular and sometimes apt name chosen for camera clubs.

The circle of confusion is defined in more than one way. Sometimes it's an absolute diameter such as 1/1000 inch. The reasoning is: A circle that small is indistinguishable from a point. Another way is to specify the circle of confusion as a certain fraction of the lens focal length, such as

1/1000. There is no solid agreement on any of these numbers.

For most lenses for 35mm SLR cameras, depth of field is calculated assuming the circle of confusion is 0.033mm which is very close to 1/1000 inch.

Please notice that changing the definition of depth of field will not change the actual image.

DEPTH-OF-FIELD TABLES

Viewing depth of field through the camera, or reading it off the lens scale, will satisfy nearly all ordinary requirements.

You Can Look It Up—Depth-of-Field Tables are included with individual lenses. Save the data for those few occasions when you can't satisfy a depth-of-field requirement by any other method.

Tables for 17mm, 50mm and 300mm lenses are reproduced here to show how depth of field changes with focal length, focused distance and aperture setting. The left column of each table is focused distance of the lens. The other columns are for various aperture settings as shown at the top of each column. The two numbers in each rectangle of the body of the table are near and far limits of depth of field, given in meters.

For example, please refer to the table for the 50mm f-1.4 lens. Find the shaded rectangle which represents a focused distance of 3 meters and an aperture setting of f-2. The near limit is 2.80 meters and the far limit is 3.23 meters. Notice that depth of field becomes larger if you reduce aperture size to f-8. Notice that depth of field for any aperture size increases at greater focused distances.

Compare the depth of field for the 50mm lens at 3 meters and f-8 with the depth of field for the 17mm lens at the same distance and f-number. Lenses with shorter focal lengths have greater intrinsic depth of field.

DEPTH OF FIELD IN METERS FOR 17mm f-4 LENS

Dist. (m)	f-4	f-5.6	f-8	f-11	f-16	f-22
∞	∞ / 2.33	∞ / 1.70	∞ / 1.22	∞ / 0.88	∞ / 0.64	∞ / 0.473
3	∞ / 1.35	∞ / 1.12	∞ / 0.90	∞ / 0.71	∞ / 0.55	∞ / 0.425
1	1.64 / 0.73	2.19 / 0.66	4.57 / 0.59	∞ / 0.50	∞ / 0.425	∞ / 0.352
0.6	0.76 / 0.50	0.85 / 0.470	1.04 / 0.434	1.52 / 0.392	5.2 / 0.346	∞ / 0.300
0.4	0.455 / 0.358	0.481 / 0.345	0.53 / 0.327	0.61 / 0.306	0.81 / 0.280	1.57 / 0.253
0.3	0.325 / 0.279	0.336 / 0.272	0.355 / 0.262	0.386 / 0.250	0.443 / 0.235	0.57 / 0.218
0.25	0.265 / 0.237	0.271 / 0.233	0.282 / 0.226	0.298 / 0.218	0.326 / 0.208	0.379 / 0.196

DEPTH OF FIELD IN METERS FOR 50mm f-1.4 LENS

Dist. (m)	f-1.4	f-2	f-2.8	f-4	f-5.6	f-8	f-11	f-16
∞	∞ / 55.5	∞ / 40.3	∞ / 28.5	∞ / 20.2	∞ / 14.3	∞ / 10.1	∞ / 7.2	∞ / 5.1
10	12.2 / 8.5	13.3 / 8.0	15.3 / 7.4	19.7 / 6.7	32.4 / 5.9	630.1 / 5.1	∞ / 4.2	∞ / 3.4
5	5.5 / 4.6	5.7 / 4.5	6.0 / 4.3	6.6 / 4.0	7.6 / 3.7	9.7 / 3.4	16.1 / 3.0	207.8 / 2.6
3	3.16 / 2.85	3.23 / 2.80	3.34 / 2.73	3.50 / 2.63	3.76 / 2.50	4.20 / 2.34	5.05 / 2.14	7.06 / 1.92
2	2.07 / 1.93	2.10 / 1.91	2.14 / 1.88	2.21 / 1.83	2.30 / 1.77	2.46 / 1.69	2.72 / 1.59	3.20 / 1.45
1.5	1.54 / 1.46	1.55 / 1.45	1.58 / 1.43	1.61 / 1.40	1.61 / 1.37	1.74 / 1.32	1.86 / 1.26	2.07 / 1.18
1.2	1.22 / 1.18	1.23 / 1.17	1.25 / 1.16	1.27 / 1.14	1.30 / 1.12	1.34 / 1.09	1.41 / 1.04	1.53 / 0.99
1.0	1.02 / 0.98	1.02 / 0.98	1.03 / 0.97	1.05 / 0.96	1.07 / 0.94	1.09 / 0.92	1.14 / 0.89	1.21 / 0.85
0.9	0.91 / 0.89	0.92 / 0.88	0.92 / 0.88	0.94 / 0.87	0.95 / 0.85	0.97 / 0.84	1.01 / 0.81	1.06 / 0.78
0.8	0.81 / 0.79	0.81 / 0.79	0.82 / 0.78	0.83 / 0.77	0.84 / 0.76	0.86 / 0.75	0.88 / 0.73	0.92 / 0.71
0.7	0.71 / 0.69	0.71 / 0.69	0.71 / 0.69	0.72 / 0.68	0.73 / 0.67	0.74 / 0.66	0.76 / 0.65	0.79 / 0.63
0.6	0.61 / 0.60	0.61 / 0.59	0.61 / 0.59	0.61 / 0.59	0.62 / 0.58	0.63 / 0.57	0.64 / 0.56	0.66 / 0.55
0.5	0.50 / 0.497	0.50 / 0.496	0.51 / 0.494	0.51 / 0.491	0.51 / 0.488	0.52 / 0.483	0.53 / 0.476	0.54 / 0.467
0.45	0.453 / 0.447	0.454 / 0.447	0.455 / 0.445	0.457 / 0.443	0.460 / 0.440	0.465 / 0.436	0.471 / 0.431	0.480 / 0.424

DEPTH OF FIELD IN METERS FOR 300mm f-4.5 LENS

Dist. (m)	f-4.5	f-5.6	f-8	f-11	f-16	f-22	f-32
∞	∞ / 607	∞ / 403	∞ / 341	∞ / 242	∞ / 171	∞ / 121	∞ / 83
50	54.4 / 46.3	55.6 / 45.4	58.4 / 43.8	62.7 / 41.6	70.1 / 38.9	84.2 / 35.6	123.7 / 31.5
30	31.5 / 28.6	31.9 / 28.3	32.8 / 27.7	34.1 / 26.8	36.1 / 25.7	39.4 / 24.2	46.3 / 22.3
20	20.6 / 19.4	20.8 / 19.3	21.2 / 19.0	21.7 / 18.6	22.5 / 18.0	23.7 / 17.3	26.0 / 16.3
15	15.3 / 14.7	15.4 / 14.6	15.6 / 14.4	15.9 / 14.2	16.3 / 13.9	16.9 / 13.5	18.0 / 12.9
10	10.1 / 9.86	10.2 / 9.82	10.3 / 9.75	10.4 / 9.65	10.5 / 9.51	10.8 / 9.32	11.2 / 9.03
7	7.07 / 6.93	7.08 / 6.92	7.12 / 6.88	7.17 / 6.84	7.25 / 6.77	7.35 / 6.68	7.54 / 6.54
5	5.03 / 4.97	5.04 / 4.96	5.06 / 4.95	5.08 / 4.92	5.11 / 4.89	5.16 / 4.85	5.25 / 4.78
4.5	4.52 / 4.48	4.53 / 4.47	4.54 / 4.46	4.56 / 4.44	4.59 / 4.41	4.63 / 4.38	4.69 / 4.32

VIEWING AN ENLARGEMENT

This depth-of-field discussion, so far, relates to the image in your camera. Normally this image is made larger for viewing, either by making a print or projecting a slide.

After enlargement, the depth of field perceived in a picture depends on two additional things: how much the image is enlarged and how far the viewer stands from the print or the projection screen.

Often the photographer doesn't have control over viewing conditions. If they are not optimum for depth of field, you can't do much about it. If the image is enlarged more, or the viewer stands closer, apparent depth of field is reduced. If the image is enlarged less, or viewed from farther away, apparent depth of field is increased. This can be deduced by thinking about circles of confusion on the enlargement and whether the viewer can see them or not.

The practical approach is to make a picture that will have satisfactory depth of field in the viewfinder or as determined by any of the methods given earlier.

DEPTH OF FOCUS

Depth of focus is sometimes confused with depth of field. It isn't the same thing.

Depth of field relates to how far a *subject* can move either way from the point of best focus and still be in satisfactory focus.

Depth of focus is the same idea, applied to the film plane. It's how far you could move *the film* and still get a satisfactory image, assuming the subject didn't move at all.

Depth of focus concerns lens and camera designers but does not concern the camera user. In a well-built camera, the film plane is fixed and immovable.

HYPERFOCAL DISTANCE

If you focus a lens at infinity, it has some depth of field in both

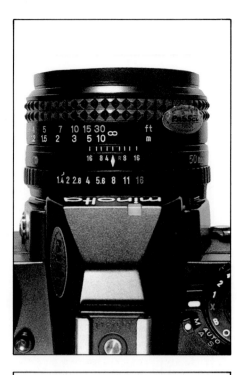

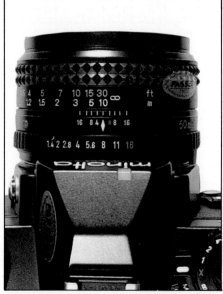

To find hyperfocal distance: First, focus the lens at infinity and notice the *near limit* of depth of field for the aperture you are using. In this example, the near limit is 10 meters. Second, refocus the lens to the near limit you just found. In this example, to 10 meters which is the hyperfocal distance for this lens at *f*-8. Notice that the far limit of depth of field is infinity and the near limit is equal to half the hyperfocal distance.

Now you can do it in one step: Set the lens focusing ring so the far limit of depth of field is at infinity and the lens is automatically focused at its hyperfocal distance. In this case, set the infinity symbol opposite the line representing *f*-8 on the depth of field scale.

However you do it, when a lens is focused at its hyperfocal distance at a certain aperture size, it has maximum possible depth of field for that aperture. Changing aperture size changes both hyperfocal distance and depth of field.

directions from the focused distance. However, that part which extends beyond infinity is wasted because nobody lives there.

A way to use all of the depth of field without wasting any on the far side of infinity makes use of the lens designer's term *hyperfocal distance.*

If you focus a lens at its hyperfocal distance, depth of field extends from 1/2 the hyperfocal distance all the way to infinity.

Suppose you know the hyperfocal distance is 10 meters. Set the focusing ring of the lens to 10 meters. Depth of field "automatically" starts at 5 meters and goes all the way to infinity.

When focused at the hyperfocal distance, the lens has more total depth of field than at any other setting of the focus control. Therefore it is a very good way to set the lens when you are carrying the camera around. Then, if something happens suddenly and you want to shoot as fast as possible, you have a very good chance of getting the picture without fooling around with focus.

How To Find the Hyperfocal Distance—Finding the hyperfocal distance is easy because it is just the *near limit* of depth of field when the lens is set at infinity. It will vary with *f*-number.

Set the lens to infinity and notice the near limit of depth of field, at the aperture you intend to use. Then refocus to that distance.

Do that a few times for practice and you will soon start using the hyperfocal distance as a standby setting of the focus control.

FLATNESS OF FIELD

In ordinary photography, the lens images a three-dimensional subject onto flat film and the photographer is concerned about depth of field.

There are some special cases where the subject is flat and has no depth at all—for example, photographing a printed page. These applications are a severe test of the

ens' ability to record details in sharp focus all the way to the edges of the frame.

Some lenses are specially designed to photograph flat subjects and have special correction for *flatness of field.* In the Minolta series, these are lenses intended for use at both normal and higher-than-normal magnifications—called *macro* or *bellows* lenses.

In general, good flatness of field and large maximum aperture are incompatible in the design of a lens. Lenses with special correction for flatness of field typically have smaller maximum aperture than other lenses of similar focal length.

For example, the 50mm macro lens has a maximum aperture of *f*-3.5 whereas the three standard 50mm lenses have maximum apertures of *f*-1.7, *f*-1.4 and *f*-1.2.

If you are copying or photographing flat subjects and corner to-corner detail is important, use one of the macro or bellows lenses. If you use one of the standard lenses, the 50mm *f*-1.7 will give slightly better flatness of field than either of the others.

Whatever kind of lens you use, it's a good idea to close down one or two steps from maximum aperture to be sure there is enough depth of field for "flat" subjects that are really not flat. Slides are usually curved rather than perfectly flat. Printed materials such as stamps usually have some curvature even though they look flat.

LENS NODES

As you remember, the technical definition of focal length is the distance from lens to film when the lens is focused at infinity.

All lenses mount on the camera the same way and at the same place, so you may wonder how a long-focal-length lens finds additional distance behind the lens to make the image.

Image distances are not tiny. As a rule of thumb, 25mm equals 1 inch. A 50mm lens requires about

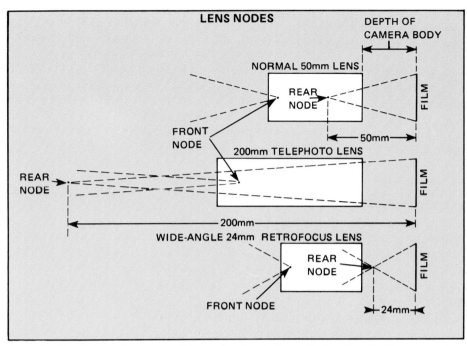

Lens-to-film distance is measured from a location in the optical path called the rear node. The lens designer places the rear node where it needs to be so lenses of various focal lengths can fit on the same camera body. Lens-to-subject distance is measured from another optical location called the front node. To get the correct lens-to-film distance, it is sometimes necessary to place the rear node in front of the lens, sometimes even in front of the front node.

2 inches between lens and film. A 200mm lens requires about 8 inches behind the lens to make a focused image.

Even though the *mechanical* distance between lens mount and film plane is fixed by the design of the camera body at about 2 inches, every lens has enough distance behind it to make a focused image, no matter what the focal length is. This is done optically, rather than mechanically.

Every lens has two points in the optical path from which distances are measured. These locations are called *nodes.*

The *front node* is used to determine lens-to-subject distance. The *rear node* is used to determine lens-to-film distance.

In lenses with focal lengths of 50mm the rear node is near the rear glass surface of the lens. It is *exactly* 50mm away from the film when the lens is focused at infinity.

Lenses with longer or shorter

focal lengths require more or less distance between the rear lens node and the film plane. This is done by scientific trickery rather than mechanical spacing. The lens nodes can be placed anywhere in the optical path by the lens designer.

To get a longer optical distance between rear node and film, the node is moved forward, away from the film. In some cases, the rear lens node is actually out in front of the lens.

Lenses of differing focal lengths, designed so they all fit on the same camera body and all have the correct optical distance from rear node to film plane are called *parafocalized.*

You can't see a lens node and you can't find it to measure from, but it's there. You can always assume that the *optical* distance between rear lens node and film plane is equal to the focal length of the lens, when the lens is focused at infinity.

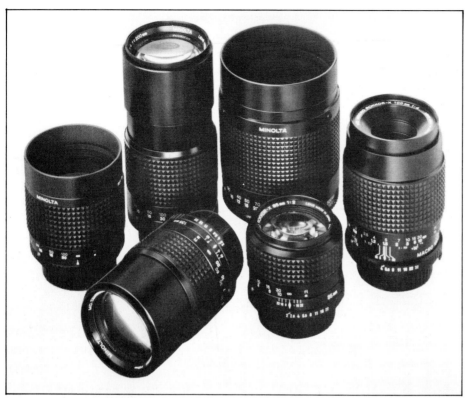

Minolta offers a large variety of lenses so you can set up your camera for virtually any photographic purpose.

CATEGORIES OF LENSES

Following is a discussion of the categories of Minolta lenses with comments on the design of the lens types when that information is useful to the lens user. Also included are suggestions about selection and use of lenses.

Nomenclature—Identification and basic specifications are engraved on the front of each Minolta lens. For example, one of the standard lenses is the 50mm shown in the accompanying photo. The engraving reads: MD ROKKOR-X 50mm 1:1.4 LENS MADE IN JAPAN ⌀ 55mm

MD indicates that the lens is the latest series and can be used on XD cameras with either aperture-priority or shutter-priority automatic exposure.

The earlier lens series was labeled **MC** to indicate *meter-coupled*. **MD** lenses are also meter-coupled, so MD "includes" MC.

ROKKOR-X is a "brand name" for lenses made by Minolta to fit Minolta SLR cameras. **CELTIC** is Minolta's lower-priced series of lenses for Minolta SLR cameras.

50mm is the lens focal length.

1:1.4 is a traditional but obscure way of stating the maximum aper-

Essential information is engraved on each lens. This is an *f*-l.4 MD Rokkor-X with 50mm focal length that uses filters with 55mm thread diameter.

ture size of the lens. Disregard the colon and the number 1 to the left of the colon. What's left is 1.4 and that is the lens *maximum* aperture.

By using the lens aperture control ring you can select smaller aperture sizes. *Minimum* aperture is not part of the lens nomenclature but is listed in the lens tables at the beginning of this chapter and also appears on the *f*-number scale on the lens aperture ring.

LENS MADE IN JAPAN simply gives the country of origin.

⌀ is a symbol meaning diameter. It's the diameter of the threaded ring on the front of the lens into which you can screw filters and other accessories. This ring is called a *filter ring*, sometimes an *accessory ring*.

⌀55mm means the filter ring on the lens has a diameter of 55mm. Some 50mm lenses have 49mm filter-ring diameter. Filtering-ring thread diameters are shown for each lens in the table at the beginning of this chapter.

MINOLTA is the manufacturer.

Some lenses show focal length as an equation such as $f = 24mm$, where the symbol f means focal length. In this book, the symbol f is used only to indicate aperture size such as f-2.8. F is used to indicate focal length.

Special Nomenclature—The nomenclature discussed in the preceding section is standard and appears on all lenses. In addition, special identifiers are used to provide additional information about special lens types. Special identifiers are discussed with the appropriate lenses.

All lens terminology is summarized later in this chapter.

STANDARD LENSES

Lenses of about 45mm to 55mm focal length are called *standard* lenses. The angle of view in the middle of this range, at a focal length of 50mm, is about 47°. These lenses don't use optical trickery to move the lens nodes

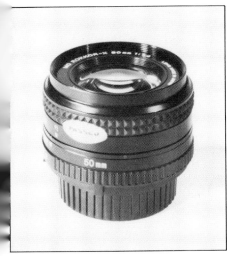

The 50mm *f*-I.4 is one of the standard lenses sold with Minolta 35mm SLR cameras. This lens and others shown in this book have the rear cover in place to protect the back of the lens.

This shot was made with a 50mm lens. Unless you have a photographic reason to use another focal length, use a standard lens.

Fisheye lenses curve straight lines that do not pass through the center of the image. The frame in this photo actually has straight sides.

around—at least not very much. These are the lenses usually sold with cameras and they are a good general-purpose focal length.

Standard lenses make photos which we accept as realistic views of the scene, such as we would expect to see if standing at the camera location and viewing the scene directly. With a standard lens, there is no indication of an unusually wide angle of view or the narrow angle of a telephoto lens.

If you are new at 35mm photography, start with the standard lens and let it teach you the basics of photo composition. Even if you own every lens in the Minolta catalog, take pictures with a standard lens unless you have some reason to use a different lens. Forcing a wide angle or a telephoto angle of view onto a scene will not automatically turn your pictures into creative masterpieces.

WIDE-ANGLE

Focal lengths from 35mm to 17mm give angles of view from 63° to 104°. All of these are called wide-angle, however a 35mm lens is not noticeably so and serves many photographers as the standard shooting lens. When you use 24mm and shorter focal lengths,

the picture often makes it obvious that a wide-angle lens was used.

The letter W is used in the lens nomenclature to signify Wide angle. These lenses are often used because the photographic situation requires it. If something prevents you from standing back far enough to get all of the desired view with a normal lens, put on a wide-angle. Shooting inside a room is a good example. Or, photographing a building from across the street, where other buildings limit how

far back you can stand to make the shot.

Besides these cases where the situation forces a wide-angle lens onto your camera, there are many opportunities to use a wide angle for artistic reasons. These lenses allow you to focus closer than lenses with longer focal length, so you can emphasize the subject of interest and still include a wide view of the background. You can capture that ''wide-world'' feeling in a picture—if the scene is right.

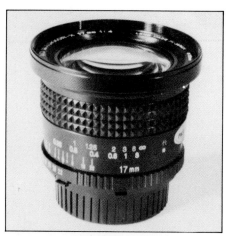

One of the short-focal-length, wide-angle lenses is this 17mm *f*-4.

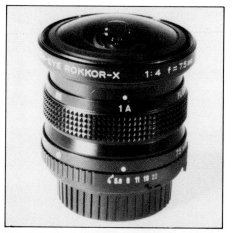

The 7.5mm *f*-4 fisheye makes a circular image within the film frame. Because the angle of view is 180° in all directions, a lens hood cannot be used.

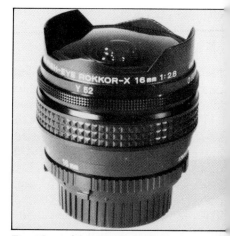

The 16mm *f*-2.8 fisheye makes a rectangular image that fills the frame. Angle of view is 180° only at the corners. A specially shaped hood is part of the lens. It is cut away at the corners of the frame.

FISHEYE LENSES

From the film's point of view, the lens projects an image onto the film. The light rays which form the image seem to originate at the rear node of the lens.

There are several ways to project the image. The one that "looks right" is called *rectilinear*. Straight lines appear straight in the picture and the viewer is not aware of any kind of distortion of the image. The relative sizes of objects appear natural and true-to-life except in unusual cases.

As focal length is made shorter, and angle of view becomes wider, it is more difficult to maintain rectilinear projection of the image and avoid obvious image distortion. Among Minolta rectilinear lens designs, the limit is an angle of view of 104°.

At wider angles, the lens designer switches to a different kind of image projection and a different lens design, called *fisheye*. Obvious image distortion with fisheye lenses is permitted and unavoidable in the present science of lens design.

If you go underwater and look upward, you will see an amazingly wide angle of view in the air above the water. For sure, this is an underwater people-eye view but we surmise that this is what the fish sees, even though no fish has

yet confirmed that speculation. Anyway, that's why lenses with unusually wide angles of view are called fisheyes.

Switching to the fisheye design and allowing fisheye distortion has a great effect on angle of view. The rectilinear 17mm Minolta has an angle of view of 104°. The *fisheye* 11mm lens has an angle of view of 180°, although we don't see all of it on film as I will explain in just a minute. The enormous increase in angle of view between two lenses of approximately the same focal length is due to the fisheye lens design.

Because fisheye lenses can record a hemisphere on the flat surface of film, the image they make resembles a global map. In the image, straight lines which pass through the center remain straight. Straight lines which do not pass through the center of the image are bowed away from center.

This fisheye distortion is obvious in photos of buildings and similar objects with straight lines or boundaries. It can be much less obvious in photos of nature and subjects without straight lines or edges.

When taking scenic views, a fisheye will curve the horizon line unless you compose the picture so the horizon passes through the center of the image.

Circular or Rectangular Image—
As do all other circular lenses, fisheyes project a circular image. To make full use of it's horizon-to-horizon viewing angle, the 7.5mm Minolta fisheye lens records a circular image on film. The image is 23mm in diameter and fits *inside* the frame. The rest of the frame is unexposed and black in a print.

A circular image calls attention to the fact that it was made with a fisheye—which is not always desirable in general photography.

Another category of fisheye lenses, called *full-frame* fisheye, makes a circular image that is *larger* than the film frame. Recorded on film is a rectangular frame that fits inside the circle.

The full angle of view of the lens is used only from corner to corner of the film frame because sides, top and bottom of the circular fisheye view are cut off by the edges of frame. The Minolta 16mm fisheye lens makes a full-frame rectangular image.

Fisheye Angle of View—Both of these fisheye lenses have an angle of view of 180° in the specifications, but the two specs mean different things.

For the circular fisheye image, the 180° angle of view applies in all directions.

For the rectangular fisheye image, the 180° angle of view is

visible only on the diagonals of the frame. The rest of the image is cut off to make the rectangle.

Focusing—As mentioned earlier, depth of field is increased by using lenses with shorter focal length.

The 7.5mm fisheye has the shortest focal length of all Minolta lenses and therefore has the most depth of field. In fact, depth of field is so large that this lens doesn't have a focusing control. The point of best focus is 1.2 meters from the film plane in the camera—about 4 feet.

At all aperture settings, depth of field extends to infinity as you can see in the accompanying table. The near limit of acceptable focus depends on aperture but even at the maximum aperture setting of *f*-4, depth of field is from, 0.4 meters (1.25 feet) to infinity.

The only other Minolta lens without a focusing control is a special *bellows* lens which mounts on the forward end of a bellows and is focused by changing the length of the bellows.

Except for these two special lenses, all other Minolta lenses have a focusing control, including the 16mm fisheye.

Filters and Hoods for Fisheyes—Because of their wide angles of view, fisheye lenses cannot use filters mounted in front of the lens. The forward extension would intrude into the field of view, darkening the picture around the edges—called *vignetting*.

Minolta fisheye lenses have filters built into the body of the lens, selectable by a control on the lens. Filter types and their uses are discussed in Chapter 10.

Circular fisheyes cannot use accessory lens hoods attached to the front of the lens because the hood would vignette the image. The 16mm rectangular fisheye lens has a permanently attached lens hood which is cut away at the four corners of the image so as not to intrude into the diagonal 180° angle of view.

The word *fisheye* is used in lens

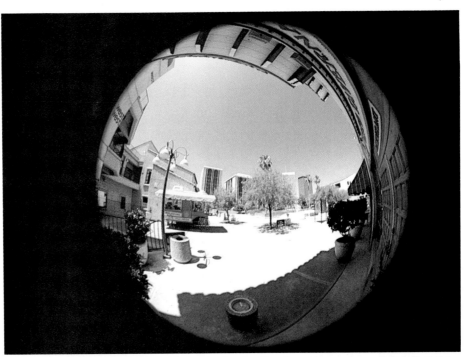

Because a circular fisheye image is visibly circular, the viewer knows immediately that the photo was taken with a fisheye lens.

I used the rectilinear Minolta 17mm *f*-4 lens to get the widest possible view of this interior without fisheye distortion.

Rectangular fisheye images are sometimes accepted as normal photography by the viewer. Depending on what you photograph, fisheye distortion may be obvious or subtle.

Lenses built this way are called *telephoto*. The telephoto principle has two advantages: A lens can be physically shorter than it would be without the diverging element. The rear node can be located where it needs to be so the focused image lands on the film plane in the camera body.

Even though the word *telephoto* has a specific meaning as just described, it is also widely used in a general way to mean any lens with a long focal length.

It is possible to design long-focal-length lenses to mount on an SLR body without using the telephoto principle. The lens barrel must be long enough to provide the correct distance between the rear lens node and the film. Such lenses are not as compact as they would be with a true telephoto design.

In some literature, Minolta uses the word *telephoto* to mean lenses with long focal length without regard to the actual optical design of the lens.

In lens nomenclature, the abbreviation *tele* is used to denote long-focal-length lenses—usually with true telephoto design.

Telephoto Ratio—A measure of the reduced length of a lens because of the telephoto design is called telephoto ratio. It is the distance from the front lens surface back to the film plane, divided by the lens focal length. Telephoto lenses which are more compact have smaller telephoto ratios. Most have telephoto ratios less than 1.

Telephoto Focal Lengths—Minolta lenses using the telephoto design include focal lengths from 85mm to 600mm. The angle of view at 85mm is 29°, narrowing to about 4° at 600mm as you can see in the lens table at the beginning of this chapter. There are Minolta lenses with even longer focal lengths but they are a different design that uses mirrors inside the lens.

nomenclature to identify fisheye lenses.

TELEPHOTO LENSES

The basic requirement of long-focal-length lenses is to have a relatively long optical distance between the rear node and the film. This can be done in a clever way by using a diverging lens element in the lens as shown in Figure 4-7.

The first lens element converges the rays so they would come in focus as shown by the dotted lines. Before reaching the film, the converging rays are intercepted by the diverging lens element, causing them to come into focus at a greater distance as shown by the solid lines.

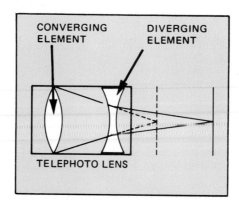

Figure 4-7/The telephoto lens design is shown in this simplified drawing. It uses a converging element and a diverging element. Dotted lines show where the converging element would normally make a focused image. Because the rays are intercepted and diverged by the diverging element, the image comes into focus *farther* from the lens. Therefore the focal length of the lens is increased by addition of the diverging element.

A telephoto lens with 200mm focal length is very useful for general photography, sports and some scenic views.

I used a 200mm lens for this shot so I could take the photo without attracting attention from the horse washers.

Tripod Mounts on the Lens—As a rule of thumb, anyone can hand-hold a 200mm lens if it is done carefully and if shutter speed is not too slow. Most people can hand-hold a 300mm lens if they are thoughtful about doing it and learn to hold it steady. Few people can hand-hold a 400mm lens except at the fastest shutter speeds. Nevertheless, you can use a 400mm lens without a tripod if you find some other steady support for the lens such as a fence railing or the limb of a tree.

Longer-focal-length lenses become physically longer and heavier even though of telephoto design. Recognizing that you will use a tripod at least part of the time with longer telephotos, Minolta telephoto lenses with focal lengths of 400mm or longer have a tripod socket in a rotatable collar on the lens itself. This allows mounting the combination of lens and camera approximately at the balance point, which gives much better stability.

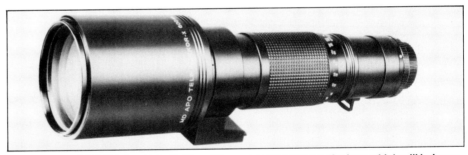

The 600mm f-6.3 MD Apo Tele Rokkor-X has a tripod mount on the lens which will balance lens and camera better than the tripod mount on the camera.

Because the lens can be rotated in its tripod mount, it is very easy to position the camera for either a horizontal or a vertical format—meaning the long dimension of the film frame can be horizontal or vertical.

Working Distance—Distance between the front of the lens and the subject being photographed is called *working distance*, sometimes *free working distance*. This distance is important in several kinds of photography one of which is portraiture.

With lenses of longer focal length, you can locate the camera farther from the subject and still make a portrait in which the subject's face fills most of the frame. When the camera is not close, the subject tends to be more relaxed and the resulting photos usually look better.

For this reason, and for improved perspective, lenses with focal lengths from 85mm to 135mm are recommended for portrait work. These focal lengths are sometimes referred to as short telephoto lenses because they are at the short end of the telephoto range.

41

LENS PUPILS

Telephoto lenses can be identified by looking into the front and back of the lens while holding it away from your eye and pointing it toward a window. At each end of the lens you will see a spot of light, called a *pupil*, which is actually the lens aperture seen through that end of the lens.

With a normal lens, the two pupils will be the same size or nearly so. With a telephoto lens, the pupil seen looking in the front will be plainly larger than the pupil seen looking in the back.

If you change aperture size while looking at a pupil, the size of the pupil will change because it's an image of the aperture.

TELE CONVERTERS

As shown in Figure 4-7, lenses of telephoto design use a built-in diverging element at the rear to extend the focal length. This can also be done by an accessory which fits between lens and camera. The accessory contains the diverging lens element or elements and is usually called a *tele extender* or *tele converter*. It has the same effect as it would if built-in. It increases the focal length of the lens.

Tele converters are labeled to show their effect. Minolta offers a 2X Converter which doubles the focal length of the lens it is used with. This converter is specifically designed to work with the 400mm f-5.6 MD Apo Tele Rokkor-X lens.

In addition, Minolta offers two general-purpose teleconverters, labeled **300S** and **300L**, which also *double* lens focal length. Tele Converter 300S is for use with lenses of 300mm focal length or shorter. Tele Converter 300L is for lenses with focal lengths longer than 300mm. Both of these preserve all features of MD lenses and can be used on an XD camera in the shutter-priority mode.

Tele converters have the same effect on lens aperture size as they do on focal length. A converter

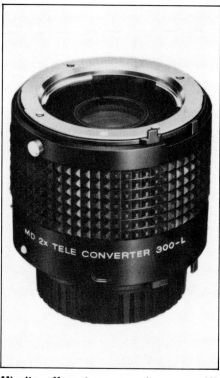

Minolta offers two general-purpose 2X Tele Converters: MD 2X TELE CONVERTER 300-S and MD 2X TELE CONVERTER 300-L. **They are similar in appearance. This is the 300-L.**

that doubles focal length also doubles the effective f-number setting of the lens. When used with the 400mm f-5.6 lens, for example, the lens behaves optically as an 800mm f-11 lens. The 200mm f-4 lens becomes a 400mm f-8 lens, and so forth.

Doubling the f-number may sound like more of a penalty than it actually is. It's only two exposure steps, which in many photographic situations is not a problem. If it is, it can sometimes be solved by switching to faster film with a higher film-speed rating. Considering the weight and cost of long-focal-length tele lenses, the 2X Converter offers a very handy way to have another focal length in your camera case at minimum cost, with minimum added weight.

RETROFOCUS LENSES

The telephoto design is used to move the rear node forward so there is enough distance between node and film plane to accommodate a long focal length.

The problem is reversed with wide-angle lenses because they have focal lengths *shorter than* the depth of the camera body.

It is always necessary that the distance between the rear lens node and the film be equal to lens focal length when focused at infinity. Therefore the rear lens node of some wide-angle lenses must be positioned in the air behind the lens, inside the camera body.

For example, a 24mm lens has a focal length of about one inch. The depth of the camera body between the lens mounting surface and the film plane is about 2 inches. Therefore a conventionally designed 24mm lens would make a focused image about 1 inch in front of the film in the camera.

To solve this problem, the telephoto design is reversed. This has the effect of locating the rear lens node in the airspace between lens and film, and the designer can use optical trickery to put the node exactly where it should be.

These lenses are called *reversed telephoto* or *retrofocus*. Minolta wide-angle lenses are retrofocus lenses.

With a retrofocus lens, the pupils are not the same size either. The rear pupil is larger than the front pupil.

REFLEX LENSES

The word *reflex* is a form of the word *reflect*. In cameras and lenses, it means the light rays are reflected by a mirror somewhere along the optical path. As you know, this happens in the viewing system of an SLR.

Reflex lenses use internal mirrors to reflect light back and forth. The mirror surfaces are curved to produce an expanding or converging beam, so the mirrors do the same things lens elements do.

Some lens aberrations are eliminated when image formation is done by a mirror. Mirrors don't have chromatic aberration, for example.

Practical mirror lens designs for cameras use doughnut-shaped mirrors combined with glass elements as shown in Figure 4-8. The two mirrors reflect the light rays twice, thereby "folding" the light path and producing a lens that is much shorter than its own focal length; shorter and lighter than conventional lenses of the same focal length.

This construction is usually called *catadioptric*, implying use of both mirrors and glass lens elements. In the Minolta lens series, it is called *reflex*, signifying the use of mirrors in the lens.

All Minolta reflex lenses use special filters mounted in a special threaded ring on the rear of the lens. These lenses have fixed apertures which are not variable in size to control the amount of light. Exposure is adjusted by changing shutter speed or by use of gray-colored neutral-density filters that reduce the amount of light without changing its color. Neutral-density filters are discussed in Chapter 10.

Because they don't have variable apertures, these lenses are non-automatic.

Four focal lengths are available: 250mm, 500mm, 800mm and 1600mm with angles of view from 10° at 250mm to 1.5° with the 1600mm lens. All of these lenses are smaller and lighter than non-reflex lenses of similar focal lengths.

The 250mm and 500mm Minolta reflex lenses are triumphs of compactness and light weight, which makes hand-holding these focal lengths easier.

In lens nomenclature, the letters **RF** are used to identify reflex lenses.

Reflex lenses have one characteristic that is visible in the picture and calls attention to the lens type. Out-of-focus points in the scene record as small "doughnuts" in the picture, because of the doughnut-shaped mirrors in the lens. This is more noticeable if the points are bright, such as reflections from dewdrops.

Figure 4-8/Minolta uses RF as an abbreviation for reflex lenses which are also called mirror lenses. Light rays enter the lens at left and are reflected twice by mirrors before they come out the back of the lens to make a focused image at the film plane.

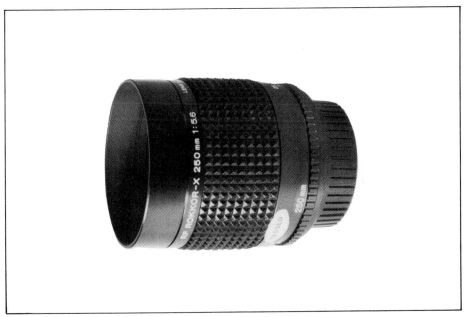

This is the RF Rokkor-X 250mm ƒ-8. Mirror lenses are surprisingly small compared to lenses of conventional design with the same focal lengths.

USING LONG-FOCAL-LENGTH LENSES

There are photographic situations where is is impossible or not practical to get the picture you want without using a long lens.

In addition to "reaching out" to capture a distant image, long lenses offer you selectivity. You can single out one face in a crowd or one building on a hillside.

Long focal lengths can fool the viewer of a photo by seeming to compress distance.

When shooting over very long distances, the air between you and the scene may degrade the image. "Heat waves" in the air path will blur the image. Light scattering by particles in the air also reduces image contrast and sharpness.

Long-focal-length lenses require very firm and steady supports because the least amount of vibration or lens movement blurs the picture.

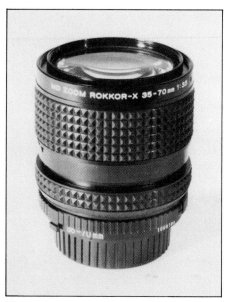

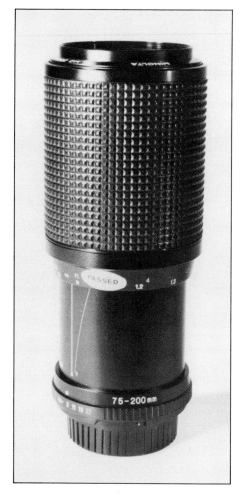

These two zoom lenses give you every focal length from 35mm to 200mm. At left, the *f*-3.5 35—70mm Zoom; at right the *f*-4.5 75—200mm Zoom.

ZOOM LENSES

A zoom lens can be focused on a subject and then, by a zoom control on the lens, the focal length can be changed to alter the size of the image on film.

If you will please refer back to Figure 4-7, which shows how a diverging lens changes the focal length of a converging lens, it will be apparent that the distance between the converging and diverging lens controls the focal length of the combination.

Zoom lenses are complex, using many glass elements in a mechanical assembly that requires high precision and extremely close manufacturing tolerances. They work by moving all of the lens elements to focus and *some* of the lens elements independently to change focal length.

In an ideal zoom lens, nothing changes except focal length when zooming the lens. The image on film should remain sharp while image size changes. The *f*-number should remain constant and aberrations should not increase.

In practice this is difficult to accomplish. A lens design can preserve good focus at one or more points along the zoom range, but it is difficult to keep sharpest focus at all focal lengths.

With high-quality zoom lenses of modern design, these reservations about image quality are more theoretical than actual. In normal viewing, including projection on a screen, it is difficult or impossible to see any quality difference between an image made with a zoom lens and one made with a conventional lens of similar focal length.

When using a zoom lens, focus with the lens set to its longest focal length. Depth of field will be smallest and therefore your focus adjustment will be more accurate. Then zoom to shorter focal lengths if picture composition benefits.

If you do it the other way, imprecise focusing can be masked by the greater depth of field at short focal-length settings. Then when you zoom the lens to a longer focal length, your subject may be outside the zone of good focus.

The main advantage is the obvious one—you can change focal length in a hurry, without interchanging lenses. This is essential in some kinds of photography such as sports. It is very convenient in nearly any kind of photography. Once you use a zoom lens, it's very easy to become addicted.

Zoom lenses typically have smaller maximum aperture sizes than fixed-focus lenses of similar focal lengths. This has two effects, one on viewing and the other on exposure.

When viewing through a smaller aperture, the viewfinder image will always be less bright. This is not a handicap in daylight or bright surroundings but it can be in dim light.

Obviously, smaller apertures put less light on the film and require longer shutter speeds. However, modern fast films in both b&w and color can often solve this problem.

The word **ZOOM** appears in the nomenclature of Minolta zoom lenses.

Zoom Ratio—A way to express the zoom capability of a lens is the *zoom ratio*—the longest focal length divided by the shortest. The Minolta 35—70 zoom lens has a zoom ratio of 2; the 100—500 lens has a zoom ratio of 5.

For optical reasons, it is not possible to manufacture a short-focal-length zoom lens with a zoom ratio as great as a long-focal-length zoom. The 35—70 lens is just as "good" as the 100—500 even though the zoom ratio of the shorter lens is a lot less. Both have zoom ratios about as high as the lens designer can accomplish with available lens materials.

As a practical matter, zoom ratio tells you how zooming the lens will affect the size of the overall scene that can be imaged on film, or the size of any object in the scene.

If the zoom ratio is 5, you can make an object in the scene appear five times larger by zooming from the shortest focal length to the longest. When that happens, the amount of scene you include in the film frame becomes five times smaller in both width and height.

The purpose of a zoom lens can be stated in two ways. You can consider that zooming changes the *amount of scene* imaged in the film frame. Or, you can consider that zooming changes the *size of an object* in the scene.

When using a zoom lens, you will nearly always think of the zoom capability in one of these two ways but not both.

When photographing a landscape, for example, you may decide that the view on film should center on a lake, and also include a grove of trees on the hillside. You can point the lens so the lake is centered in the viewfinder and then zoom until the grove of trees is also in the frame. The fact that zooming alters the size of each object in the scene is not an important consideration.

If you are photographing a specific item of importance or perhaps making a portrait, you may want to fill the frame with the subject of interest. In that case you zoom so the object becomes large enough. The field of view becomes narrower and extraneous objects are excluded from the frame but this is a byproduct of your main goal—to fill the frame with a certain subject.

SPECIAL LENSES

Minolta offers a variety of special lenses, some of which are unique.

85mm *f*-2.8 Varisoft—One of the portrait photographer's "tricks" is to make the image slightly soft rather than in sharpest focus. This

Zoom lenses are very useful. They allow you to change focal length so you get the composition you want. These photos show the zooming range of the *f*-4.5 75—200 Zoom lens.

The Varisoft lens was used to make these two photos. One is at the 0 setting of the softness control, the other is at 2.

causes facial wrinkles and minor skin blemishes to be less apparent and subjects usually like the photos.

With 35mm cameras, this is often done by a diffusion filter attachment which screws into the filter threads at the front of the lens. These filters are usually manufactured in three grades with three different amounts of diffusion to soften the image.

Minolta takes an unusual approach. The 85mm Varisoft lens has a built-in control to produce image softness when desired. VARISOFT is a contraction of the words *variable softness*.

The softness control is a ring on the lens which serves to reduce the lens correction for spherical aberration. In effect, it *adds* spherical aberration, which causes

some light rays to be in sharp focus at the film plane and other rays not to be in focus. The effect applies to all colors equally.

The result is that each point of the image has a sharply focused central core surrounded by a diffused halo of unfocused rays which produces the appearance of softness.

The advantage of this method is that some of the image is always sharp and therefore the picture doesn't look merely blurred or out of focus. With ordinary diffusion attachments at the front of a lens, all light rays are affected and points on the image do not have sharply focused cores.

As mentioned earlier, with any lens the effect of spherical aberration is reduced by using small aperture. When using the varisoft

lens with deliberately induced spherical aberration, reducing aperture size will reduce the visible effect of the aberration. At apertures of f-5.6 or smaller, the varisoft control has no effect.

The varisoft control ring on the lens has four positions: 0, 1, 2, and 3.

When set to 0, there is no added spherical aberration. The image is sharp and the lens can be used as a conventional short telephoto for any purpose. Softness increases as you turn the varisoft control ring to higher numbers.

Image softness is affected by the setting of the varisoft control and the setting of the lens aperture ring.

The softness effect at *any* varisoft control setting is maximum when lens aperture is fully open at *f*-2.8 and decreases with smaller aperture settings until it disappears entirely at *f*-5.6. Within this range, changing aperture by a half step has about the same effect on the image as changing the varisoft control a full step.

You can see the effect in the viewfinder. To see the effect at smaller-than-maximum aperture requires a Stop-Down Button on the camera body to close down the lens aperture to the value selected on the aperture ring.

Not all Minolta cameras have a Stop Down Button as you can see in the Camera Specifications table of Chapter 15. If your camera doesn't have this control, use the lens at maximum aperture and control image softness by turning the varisoft control.

Added softness makes focusing less precise. The best procedure is to focus with the varisoft control set at 0, then add softness as desired and make the exposure without changing the focus setting.

The focal length of 85mm is useful for general photography, travel and scenic views, and portraiture. In the Minolta series of lenses, you can choose from three with this focal length: the 85mm *f*-2.8 Varisoft, the 85mm *f*-

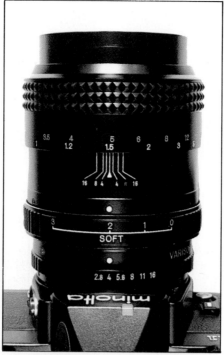

The 85mm *f*-2.8 Varisoft lens has all the usual lens controls, plus one more that adds softness to the image. At the 0 setting of the softness control, the image is sharp with no added softness. Softness increases from 1 to 3 on the control. This control is set at 2.

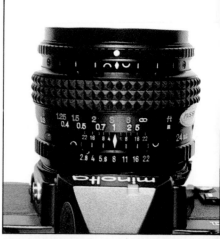

The VFC Control is near the front of the VFC lens. When set at the center, as shown here, the field is not curved. Move the white dot to one of the colored lines on either side, and the field will curve in the direction shown by the half-circles on the scale. To see how much the field is being curved, match the color at the setting of the VFC control to one of the colors on the the curvature scale adjacent to the depth-of-field scale. The amount of field curvature is read on the focused-distance scale. For example, this lens is focused at about 1 meter. If you set the VFC control on the yellow mark to the right of center, the field will curve away from the camera so best focus at the sides of the frame will be at 5 meters. In other words, this setting curved the field by 4 meters on each side of center.

1.7 MD and the 85mm *f*-2 MD.
24mm f-2.8 MD VFC—All ordinary lenses are corrected for flatness of field. Flatness of field means that the zone of best focus is flat. If you are photographing a brick wall for example, and any part of the wall is in focus on the film, all parts of the wall should be in focus—assuming that the film is parallel to the surface of the wall.

Usually we don't photograph flat surfaces such as a wall. Instead there are objects in the field of view at various distances from the camera and we want some of these objects to be in acceptable focus. With a conventional lens, we rely on depth of field to provide good focus for objects at different distances from the camera.

Sometimes it doesn't work. If a large lens aperture is necessary, there won't be much depth of field

and you may not be able to get everything in good focus.

Minolta has a unique solution to this problem also: The 24mm VFC wide-angle lens, which has a control to curve the zone of acceptable focus as shown in the accompanying sketch. You can curve it away from the camera, or toward the camera, or leave it flat—in which case the lens works the same as a conventional 24mm lens.

The letters VFC in the lens nomenclature stand for Variable Field Curvature. A special color-coded control ring on the lens shows the amount of field curvature on a special scale adjacent to the normal depth-of-field scale.

Using the VFC control and reading the curvature scale are shown in the accompanying photos and explained in the captions.

Using the VFC lens set for a flat field, I photographed this curved wall and, sure enough, the sides of the frame are out of focus. Then, without changing aperture size, I used the VFC control to "wrap" the depth-of-field around the wall. Focus at the sides improved.

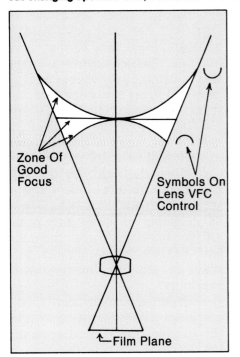

Zone Of Good Focus

Symbols On Lens VFC Control

↥—Film Plane

The curved zone of acceptable focus is made thicker by increased depth of field at smaller apertures just as it would be if it were flat. Therefore this lens gives you two ways to improve focus on objects at different distances from the camera: You can curve the field and also control depth of the curved field.

Minolta offers two 24mm wide-angle lenses: the VFC lens just described and a 24mm *f*-2.8 MD W Rokkor-X which is equivalent except that it lacks the VFC feature.

35mm *f*-2.8 Shift CA—This lens has a long name because it has a

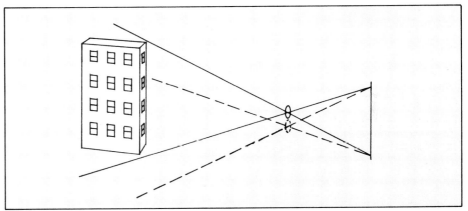

To get correct-looking photos of a building, you should hold the camera so the film plane is parallel to the face of the building. With an ordinary lens, sometimes you can't get the composition you want. With a shift lens, you can shift the lens to control what part of the scene is in the film frame. This drawing shows shifting the lens vertically so the entire building is in the frame.

The 24mm *f*-2.8 MD VFC lens has a control to curve the zone of good focus. You can curve the zone toward the camera, away from the camera, or leave it flat—the same as a conventional lens.

lot of unusual features. Its basic purpose is photographing buildings and interiors.

A common problem in this kind of photography is that buildings seem to be leaning over backwards. In interior shots, walls of rooms don't appear to be parallel with each other. This is caused by tilting the camera so the film plane is not vertical.

With ordinary lenses, it is often necessary to tilt the camera to get the view you want. When photographing a tall building, if you hold the camera so the film plane is vertical, the frame includes the lower part of the building and a lot of

parking lot. Tip the camera upward to get more building in the frame and you see the peculiar "leaning-backward" effect. The building looks narrower at the top than the bottom.

As you can see in the accompanying drawing, a shift lens solves the problem. The lens can be moved, or shifted, so a different part of the lens field of view falls within the film frame.

The shifting movement can be in any direction with the Minolta shift lens—up and down, side to side, or at any angle in between. The lens face always remains parallel to the film plane, which

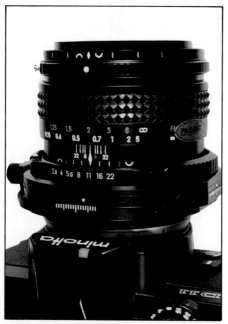

The Minolta 35mm shift lens has two unusual features. It has a VFC control ring and curvature scale, the same as the VFC lens.

In addition, the shift lens can be shifted vertically and horizontally by releasing clamp screws and moving the lens body in the direction you want to shift. One clamp screw is visible on the side of the lens in this photo, the other is on the bottom. The amount of shift is indicated by the scales nearest the camera—one on top, one on the side. This lens is shifted three millimeters to the right.

means the lens does not tilt—it only shifts.

As you know, a circular lens casts a circular image. Lenses of conventional design make a sharply focused image circle about 43mm in diameter. The rectangular film frame fits closely inside this circle.

The Minolta shift lens image circle is 58.8mm in diameter. Shifting the lens shifts the image circle in the camera so a different part of the image falls within the film frame.

To photograph the top of a building, shift the lens upward while holding the camera so the film plane is vertical. This avoids the "falling-over-backwards" effect.

You can also shift the lens horizontally or diagonally to improve the composition of a photo without actually moving the camera. Lateral shifts can be used to change the point of view to eliminate something undesirable, such as a telephone pole, that would otherwise be in the frame.

This lens is slightly wide-angle, with a 35mm focal length, because photographing buildings and interiors is often done where you can't back up enough to capture the view with a 50mm lens.

The shift mechanism is simple and straightforward using two sliding dovetail joints, one horizontal and the other vertical. Each slide has a scale to show the amount of shift on that axis, with a center mark and a lock screw to hold the setting.

When shifted in one direction only, the lens can be moved 11mm up or down, or 8mm to the left or right. When shifted diagonally, the lens uses some of the vertical travel and some of the horizontal movement. Even at maximum shift in any direction, the film frame always remains inside the image circle.

All conventional lenses put less light on the film at greater distances from the center of the lens. With conventional non-shifting lenses, the viewer of a photo is usually unaware that the corners of the frame are slightly darker than the center but you can usually see it if you look closely, particularly in photos of a uniformly lit surface or of the sky. This fall-off in illumination is called the cosine4 law by optical designers.

This law applies also to the 35mm shift lens and the effect is sometimes more pronounced because this lens can be shifted so the film frame is off-center. A corner or one side of the frame can be farther from the center of this lens than conventional non-shifting lenses, therefore that corner or side is darker than we normally see with other lenses. For this reason, Minolta suggests giving color-slide film an additional half-step of exposure when the lens is fully shifted.

In addition to the shift feature, this lens also has variable field curvature with a control and scale similar to the 24mm VFC lens described earlier.

The variable-field scale is exact only when the lens is not shifted and therefore field curvature is symmetrical around the center of the film frame. When the lens is shifted, there will be more field curvature on one side of the frame than the other, and the maximum amount of field curvature will be greater than indicated on the scale. The best way to judge this is by looking at the image on the focusing screen.

The VFC feature is used in generally the same way as already described. For example, if you are photographing the corner of a building, limited depth of field may cause the two visible walls to go out of focus at greater distances from the camera. The VFC control can help solve the problem by curving the depth of field so more of each wall be sharply focused.

Curving the field the opposite way will cause less of each wall to appear in good focus, which may be desirable in some photos for artistic reasons. Using the shift and VFC features together provides a unique image-control capability.

Shift lenses usually don't have any automatic features because of the complex mechanical design of the lens. Minolta is the first to solve part of this problem. The Minolta shift lens has automatic diaphragm—which closes aperture to the selected value just before the shutter operates. The lens is not meter-coupled, so the camera doesn't "know" what lens aperture has been selected by the aperture ring on the lens body.

Also, it is not an MD lens, which means it cannot be used in the shutter-priority automatic exposure mode of XD cameras.

It can be used in the aperture-priority mode with XD cameras because they make the final determination of automatic exposure after the lens has been stopped down by the camera.

Without a shift lens, it is necessary to tip the camera upward to photograph the entire building. Building appears to lean backwards.

With a shift lens, you can hold the film plane parallel to the front of the building and shift the lens upward to include the entire building. Leaning backwards effect is avoided.

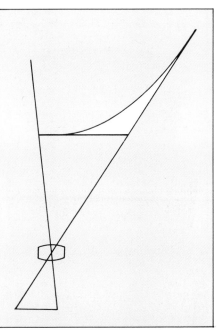

When the shift lens is not shifted, field curvature produced by the VFC control is symmetrical in respect to the center of the image. When the lens is shifted, field curvature becomes unsymmetrical as shown here.

It *can not* be used on automatic aperture-priority with XG cameras because they cameras set exposure before stopping down the lens.

This lens can be used in the manual mode on any Minolta 35mm SLR although you cannot always use the camera exposure meter. If the camera has a stop-down button, push it in while making the manual exposure settings. Then make the exposure. You can release the stop-down button before making the exposure, or hold it in—it doesn't matter.

If a camera under manual control does not have a stop-down button, you cannot make an accurate light reading with the built-in exposure meter. Use a separate hand-held meter to read recommended exposure settings, then make those settings on the camera.

When using the XK Motor camera set for aperture-priority automatic operation with the shift lens, set the Stop-Down Button on the camera to keep the lens stop-ped down during both metering and exposure.

You'll understand these metering precautions and instructions better after reading Chapter 8.

The nomenclature of the 35mm *f*-2.8 Shift CA Rokkor-X lens summarizes features just discussed. You know what Shift means; C is for control of field curvature—the VFC feature. A means the lens has automatic diaphragm. Notice that the lens is not designated MC or MD so it is not meter-coupled. It is truly a special Minolta lens with some very desirable features. I enjoy "urban" photography, meaning buildings and interiors, and I think a shift lens is essential for professional-looking results.

With the shift adjustments centered and the VFC ring set for a flat field, optical performance of the 35mm shift lens is the same as another Minolta wide-angle—the 35mm *f*-2.8 MD W Rokkor-X. This non-shift MD lens has all automatic features: meter coupling, auto diaphragm and full com-patibility with XD cameras.

400mm *f*-5.6 MD Apo Tele—There are two special features of this lens. *Apo* is an abbreviation for *apochromatic* which means the lens has maximum correction for chromatic aberration and therefore produces an extraordinarily sharp image. This is done by a special lens design using an element made of fluorite which has special optical properties.

With the 2X Converter described earlier, this lens becomes an 800mm *f*-11. This converter was specifically designed to work optically with this lens with minimum effect on image quality. It will also work satisfactorily with other Minolta tele lenses.

600mm *f*-6.3 MD Apo Tele—This lens also has a special design for maximum correction of chromatic aberration using a fluorite element. It can be used with the 2X Converter to work as a 1200mm *f*-12.6 lens with image quality that is satisfactory for virtually all applications.

The 50mm macro lens has unusually long focusing travel. When focused at the closest distance, magnification is 0.5. With a Life-Size Adapter extension tube between lens and camera, magnification range is 0.5 to 1.0. The scale on the front of the lens barrel shows magnification ratio—yellow numbers for use with the Life-Size Adapter, white numbers for lens mounted directly on the camera. This lens is set for a magnification ratio of 1:3, which is the same as 1/3 or a magnification of 0.33. The scale around the front edge of the focusing ring shows exposure corrections needed for higher magnifications—as discussed in Chapter 9.

Macro Lenses—These lenses are used to produce a larger image with better image quality than ordinary lenses can provide. They are called *macro* which generally is used to mean greater than normal image magnification and specifically means that the image in the camera is larger than the subject in the real world. This is discussed in Chapter 9.

There are three Minolta macro lenses—two designed to mount on a camera body and focus by a control on the lens and one designed to mount on the forward end of a bellows and focus by changing bellows length.

All three are specially corrected for flatness of field which means you can use them to photograph flat subjects such as stamps with excellent image quality all the way to the corners of the frame.

50mm f-3.5 MD Macro—This special lens will focus on a subject as close as 9 inches from the film plane whereas the minimum focusing distance of the standard 50mm lenses is about 18 inches.

With this lens mounted directly on a camera body, maximum magnification is 0.5 because of the close-focusing capability. With an accessory Life-Size Adapter place between lens and camera, magnification range is from 0.5 to 1.0 which is from half-size to life-size on the film.

100mm f-4 MD Macro—This lens also also provides maximum magnification of 0.5 mounted directly on the camera and a magnification range of 0.5 to 1.0 with its Life-Size Adapter.

The main difference between the 50mm and 100mm macro lenses is *working distance* between lens and subject. For the same size image in the camera, there will be more distance between lens and

When the 50mm macro lens is used with its Life-Size Adapter, magnification ranges from 0.5 to l.0.

The 100mm f-4 Auto Bellows lens has an aperture control but no focusing control. It is intended for use only on the front of a bellows as described in Chapter 9.

The 100mm macro is similar to the 50mm macro except the longer focal length allows greater working distance between the front of the lens and the subject. This lens is shown mounted on its Life-Size Adapter. In the center, on the lens barrel, is a depth-of-field indicator. On each side are magnification ratios and farther to the sides are exposure corrections as discussed in Chapter 9.

MINOLTA LENS NOMENCLATURE

A	Abbreviation for Auto Diaphragm, used in the nomenclature of the 35mm *f*-2.8 Shift CA Rokkor-X lens.
Apo	Abbreviation for Apochromatic—maximum correction for chromatic aberration.
AUTO	Auto Diaphragm.
AUTO DIAPHRAGM	Lens aperture remains wide open during viewing and focusing. Just before the shutter opens, the camera closes lens aperture to the correct value for proper exposure.
BELLOWS	Lens for use on bellows—has no focus control.
C	Abbreviation for Variable Field Curvature used in nomenclature for 35mm *f*-2.8 Shift CA lens.
CELTIC	A limited selection of Minolta lenses with lower price than Rokkors.
FISHEYE	Fisheye lens design.
MACRO	Lens designed for excellent image quality at higher-than-normal magnifications
MC	Meter-Coupled. Lens aperture remains wide open while you rotate the aperture ring but a mechanical linkage "tells" the camera metering system what aperture size you have selected. MC lenses are not the latest design.
MD	The latest Minolta lens design. MD lenses are meter coupled, the same as MC lenses, and have an additional mechanical linkage which allows use with shutter-priority automatic exposure on camera bodies with this capability.
RF	Abbreviation for reflex. Used on Minolta mirror lenses.
ROKKOR	Best-quality Minolta lenses designed to fit all Minolta 35mm SLR camera bodies.
ROKKOR-X	Same as Rokkor. X identifies products manufactured for shipment to the United States and Canada.
SHIFT	Lens shifts parallel to film plane.
TELE	Telephoto lens.
VARISOFT	Variable image softness.
VFC	Variable Field Curvature.
W	Wide-angle.
ZOOM	Lens has a control to change focal length.
∅	Indicates following number is diameter in millimeters of lens filter threads.
1:2.8	Method of stating lens maximum aperture. Disregard number before colon. Number following colon is lens maximum aperture: *f*-2.8 in this example.

subject with the 100mm macro lens.The only disadvantage of using the 50mm or 100mm macro lens on the camera instead of a standard 50mm lens or the conventional *f*-2.5 100mm lens is that the macro lenses won't open as much.

100mm *f*-4 Auto Bellows—This lens is not intended to mount directly on a camera body because the lens doesn't have a focusing control. It is used on the forward end of a bellows to make photos with higher-than-usual magnification. Using these macro lenses is discussed in Chapter 9.

FOCUSING WITH INFRARED FILM

The spectrum of light, such as you see in a rainbow, contains all colors that are visible to humans. Light can be considered as waves, similar to waves on water. Beyond visible red wavelengths of light there are still longer waves which are invisible, called *infrared.* Infrared (IR) waves are light waves but they are not visible light—they are heat waves.

One of the lens designer's problems is to correct chromatic aberration. Typically, a lens is corrected so all *visible* colors of light are brought to acceptable focus at the film plane.

Usually no attempt is made to also bring IR rays to focus on the film. They will come to focus a short distance *behind* the film plane which doesn't matter because ordinary films are not sensitive to IR wavelengths and no exposure will result from the out-of-focus IR image.

There are two kinds of special IR film for 35mm cameras. One, called *color-IR* film, makes a color image using two visible colors of light and IR. This is sometimes called *false-color* film because the colors of the final image are not true to life.

When using this film, most of the image is formed using visible light rays which are correctly focused by the lens. The fact that the IR lightwaves are slightly out of focus is ignored. When using this film, focus the lens in the normal way.

The other special IR film makes an image in black-and-white and is sensitive to both visible light and IR. In use, a filter is placed over the camera lens which excludes all or most of the visible light. The intention is to form an image only with IR which should be in focus at the film.

To bring the IR image into

focus, you must move the lens farther away from the film so the focused IR image lands exactly on the film plane, instead of behind it.

Most Minolta lenses have a red IR focusing mark, normally a letter R, on the lens depth-of-field scale somewhere to the right of the diamond-shaped index mark. This letter R is not part of the depth of-field scale. Sometimes it replaces one of the lines on the scale when there isn't room for both.

Here's how to use the IR focusing mark: Put the camera on a tripod or other support. Without the special IR filter on the lens, look through the camera viewfinder and focus on the subject of interest using visible light. Then place the IR filter over the lens. It blocks all or most visible light but you don't need to look through the viewfinder any more.

Instead, look at the lens focused-distance scale to see how far away you have focused the lens. Let's assume the distance opposite the diamond-shaped index mark is 3 meters.

To correct focus for b&w IR film, rotate the lens focus control so the focused distance is opposite the red R symbol on the lens. If the number 3 was opposite the diamond-shaped index, rotate the focus control to bring the number 3 opposite the red R. This moves the lens farther from the film plane so the IR image now falls in focus on the film rather than behind it.

With Zoom Lenses—The amount of focus correction needed for b&w IR film varies with focal length. Therefore, the position of the R symbol must be different for each zoom setting. This is done on some lenses by extending the R symbol as a curved red line along the length of the lens body. As the lens is zoomed, the back edge of the focusing ring moves along the curved line. The IR correction point is where this edge intersects the curved red line.

Another method used on some

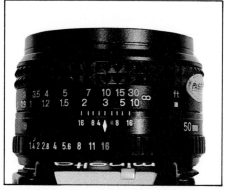

This lens is focused at 3 meters for visible light.

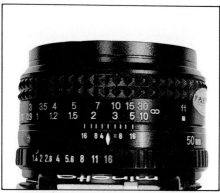

To refocus the lens for IR, move the number 3 on the focused-distance scale so it is opposite the red letter R. Now the lens is focused at 3 meters for IR.

lenses is a series of short, straight red lines along the lens body. These lines indicate IR focus correction for focal lengths along the zoom range of the lens.

With Reflex Lenses—Mirrors don't have chromatic aberration. Minolta reflex lenses are made of a combination of mirror surfaces and glass elements but the combination has such low chromatic aberration that focus correction for IR wavelengths is not required.

PERSPECTIVE

The word *perspective* literally means *to see through*. If you are looking at a photo or painting and the perspective is correct, what you see is indistinguishable from the original scene. You can't be too picky when applying this definition because it applies to the big parts of the picture—its geometry.

If perspective is correct, the shapes you photograph and their relationships to each other will look like the real world. Streets will become narrower as they recede into the distance. The sides of a building seems to become less tall at greater distance from the viewer. Distant people and automobiles are smaller than those nearby. As far as lines, angles and relative sizes of things are concerned, it's as though you are not looking at a photograph, you are seeing through it to the actual scene.

A strict statement of perspective must include the viewing distance at which it is correct. Usually the photographer has no control over the distance from which people look at pictures.

If you make a slide using your 50mm lens, the correct viewing distance of the slide itself is the same as the focal length of the camera lens—50mm, which is about 2 inches. Don't bother to try it because your eye can't focus that close. When the image is made larger, correct viewing distance increases in proportion.

Suppose you have a print made from your slide so everything on the print is ten times as tall. Viewing distance becomes ten times as great—500mm or about 20 inches. This formula—focal length multiplied by enlargement of the image—gives correct viewing distance for any photo taken with any lens, but most people don't pay any attention to it.

Because all of us have grown up looking at photos from the right distances and the wrong distances, we are very tolerant of incorrect perspective unless the effect is extreme. We sometimes notice incorrect perspective in shots made with very long or very short focal lengths.

This is never the fault of camera or lens. It always results from viewing the photo at the wrong distance.

As photographers, we can cause these perspective effects to happen

by choosing lenses which make it impossible or unlikely that the viewer will use the correct viewing distance for proper perspective.

PERSPECTIVE WITH LONG LENSES

When looking at similar objects, we judge the distance between them by their relative sizes. You may have to look outdoors to confirm this: A car at the end of the block is tiny compared to a car in your driveway. Your mind doesn't say it's tiny. Your mind says it's a block away from the nearest car.

Now we play a photographic trick on the viewer. Photograph the two cars from a quarter mile away using a long-focal-length lens such as 500mm. Make a print and enlarge the negative so the cars are ten times as tall on the print. The cars are still a block apart, but they look about the same size on film.

The correct viewing distance for proper perspective is then 500mm—about 200 inches or nearly 17 feet. Nobody will view your print from that distance. It will be viewed from a few feet or maybe even held in the viewer's hand.

This tricks the viewer's mind into thinking it is seeing two cars that are nearby. Because they are about the same size, the mind says they are very close to each other. Of course they aren't, but the picture sure looks that way.

This technique is often used in photographing race cars to make them look close together. It is often used as a trick in newspapers and magazines to make houses or traffic signs appear jammed up against each other when in reality they are not. There are a lot of ways you can use this trick and all are OK except one. Don't use it by accident. You should know when you are doing it.

PERSPECTIVE WITH SHORT LENSES

Put your eye about 8 inches from somebody's nose and notice exactly what you see. You see a

Long-focal-length lenses can "fool the eye" by making distant objects seem closer together than they really are.

Short-focal-length lenses can be used so close that the pictures amuse everybody but the victim.

very large nose with smaller facial features and ears receding into the distance.

Find somebody with his feet on the desk and put your eye about 12 inches from the sole of his shoe. You see a very large shoe connected to a person with a tiny head.

Put your camera lens at either of these viewpoints and you'll get the same view on film. However, most lenses of 50mm focal length or longer won't focus that close. Lenses of shorter focal length *allow* close focusing, therefore they allow the short-lens perspective trick.

Assume you used a 20mm lens to make the photo and enlarged the negative so everything is ten

times as tall on the print. Correct viewing distance of the print is 200mm—about 8 inches. put your eye 8 inches from the print and you get exactly the same view you would in real life. But most people don't know that's what they actually see in the real world. At any other viewing distance, the picture doesn't look right. They think your picture has the wrong perspective and is very funny.

PERSPECTIVE IN PORTRAITURE

Because we don't often look at other people with our eyes 8 inches from the nose, we quickly notice the short-lens effect. It tends to reduce the apparent distance between nose and ears, giving a face-flattening effect. We are a little more tolerant of that because we see it often.

Some combinations of focal length, distance between camera and subject, subsequent enlargement, and viewing distance result in portraits with short-lens effect even when taken with the standard lens that came with your camera—45mm or 50mm. It's usually not obvious, but experienced photographers can see it readily or your subject may see it without being aware of it and reject the portrait as a "bad picture."

That's why most photographers using 35mm film prefer 85mm up to 135mm lenses for portrait work. You can fill the frame with your subject's head without getting the camera up close. This not only makes a portrait without short-lens effect, it makes the subject more comfortable and relaxed because the camera is farther away. If you use a lens much longer than 135mm, you risk the long-lens effect.

Do Lenses Show Different Perspective?—From the same camera location, all lenses get the same perspective. A long-focal-length lens gets a small section of the overall view. A short lens gets a larger section.

HAND-HOLDING

The lens you use and other factors determine whether or not you can hand-hold the camera. If not, you must use a tripod or other firm camera support which is sometimes a bother and sometimes not possible.

As a rule of thumb, when hand-holding the camera, the slowest shutter speed you should use is the same number as lens focal length.

For example, if you are using a 500mm lens, the slowest shutter speed you should use is 1/500 second. With a 200mm lens, the rule allows 1/200 second but the camera doesn't have that shutter speed. Use the next faster speed which is 1/250. With a 50mm lens, you can use 1/60—and so forth.

If you are careful about it and use good technique you can usually shoot at a speed one step slower than the rule suggests. Most people can shoot at 1/30 with a 50mm lens provided they hold the camera as shown in Chapter 7.

A lens with large maximum aperture is sometimes helpful. Suppose you have a 50mm lens set at *f*-2.8 and the camera viewfinder display indicates a shutter speed of 1/15 second for correct exposure. You are hand-holding so you don't want to use that slow speed. Open the lens to *f*-2 and you can use 1/30. If the lens opens to *f*-1.4, you can use 1/60 as the hand-holding rule suggests.

But using the lens at maximum aperture gives minimum depth of field and this may not satisfy your artistic intent in making the photo. In that case, switching to faster film will allow smaller apertures. If you double film speed, which is one step, you can use one step smaller aperture size, or one step faster shutter speed.

Very often the best solution is a tripod, a stone wall or some other means of holding the camera rock-solid. With a firm mount, you can use slow shutter speeds when you need to and not worry about a blurred image.

I used the 75-200 *f*-4.5 MD Zoom lens on an XD-11 to make this shot from a boat. The zoom capability allows framing quickly to compose the image.

CHOOSING A SET OF LENSES

Newcomers to SLR photography sometimes become too interested in the camera body because that's where most of the gadgets are. All the body does is hold the film flat and operate the shutter. It's the lens that makes the picture.

Buying an SLR camera with only one lens is a waste! If you intend to do that, I strongly suggest that you buy a less expensive camera with a fixed, non-interchangeable lens.

Giving advice on choosing lenses is a risky proposition because it depends mainly on personal preferences and budget considerations. I offer some ideas here that you may find helpful but I have only one firm recommendation: Buy more than one lens.

Choosing Your First Lens—The first decision must be made when you buy the camera. Do you want a standard 45mm or 50mm lens? If so, which one? There are several to choose from including zooms that have a 50mm focal length setting. I suggest you ignore the difference in angle of view between the standard 45mm and 50mm lenses.

Minolta 35mm SLR cameras can be purchased with any of the standard lenses or with no lens at all. This allows you to buy lenses according to your personal plan and preferences.

Among the standard lenses, you can choose among maximum apertures ranging from *f*-2 to *f*-1.2. An *f*-1.2 lens opens more but costs more, and weighs more than than twice as much. When you start assembling a case full of photographic equipment, be mindful of both cost and weight.

As mentioned earlier, a lens with larger maximum aperture will always produce a brighter viewfinder image but this is important only in dim light. It will also put more light on the film but you can often use a slower lens by switching to faster film.

There is one compelling argument in favor of the *f*-1.2 or *f*-1.4 lens. The larger aperture is much appreciated when you are shooting indoors in places where flash and tripods are not allowed. Museums, cathedrals and theaters are typical examples. Using maximum lens aperture and fast film will often allow shutter speeds fast enough to hand-hold the camera.

The standard focal length of 45mm or 50mm is very useful, which is why it is standard. However, if you are going to buy a lens at that focal length, don't overlook the 50mm macro. It does everything any other 50mm lens will do and in addition has better flatness of field and the capability of higher magnification than the standard lenses. The penalty is a maximum aperture of *f*-3.5 which can sometimes be a handicap.

You can also cover the standard focal length by using either of two zoom lenses. The handicap is the same: a max aperture of *f*-3.5.

Some photographers prefer the slightly wider angle of view of a 35mm lens and use that focal length as their standard lens. If you have or develop that preference, you can choose among several lenses. Don't overlook the 35mm shift lens as a way of adding versatility to your lens assortment.

Some photographers prefer the slightly narrower angle of an 85mm lens and use it more often than 50mm. If so, there is another decision between a conventional 85mm and the 85mm Varisoft. Or you can choose the 100mm macro and get high magnification instead of variable image softness.

I mention these choices because you can save some money and end up with more focal lengths in your camera case if you start out with a plan.

If you are experienced in using interchangeable lenses, you already know which ones you like. If not, it may seem like a big guessing game without any clues.

One way to get organized is to consider what kinds of photos you

find pleasing to look at and then select lenses that will allow you to make those kinds of pictures.

Unless you are in a perilous hurry, don't buy a lot of lenses at the same time. Start with one, two or three: a standard lens, a wide-angle and/or a telephoto.

Don't go to extremes in your choice of a wide-angle or telephoto. If you are a beginner and you buy a 17mm lens you will probably be disappointed because you won't know how to use it.

Similarly, if you start right out with a 600mm telephoto you'll find very few things to use it on and you may end up wishing you had bought a shorter focal length instead.

Unfortunately the only way you can experience wide-angle and telephoto photography is to do it yourself with your own eyeball looking through the lens and your own evaluation of the resulting slide or print. Nobody can really tell you or teach you about it.

However if you start with a moderately wide-angle lens such as 28mm or 35mm, and a standard lens, you will very quickly learn how to use each of them and what kinds of scenes benefit from each focal length.

Similarly, choosing between a standard lens and a medium telephoto, such as 100mm or 135mm, will not be difficult. Some scenes will seem to demand one or the other and you will start building your good photographic common sense about lens use.

After you get a standard lens, a wide-angle and a telephoto, I suggest that you don't buy any more lenses until you know you need another focal length. It will happen. Someday you will be using your 28mm lens and realize that it won't do what you want. You will yearn for a 17mm lens. That's the time to buy it!

ZOOM VERSUS FIXED FOCAL LENGTH

The potential disadvantage of zoom lenses is smaller maximum

aperture. In dim light, this can force you to use slow shutter speeds and the viewfinder image may be annoyingly dark.

When shooting action, with subjects moving toward and away from the camera, a zoom lens is a great help. Use one for that purpose and you'll decide it's an essential lens.

I recommend zoom lenses and suggest providing some of the focal lengths in your master plan with one or more zoom lenses.

If you are concerned about occasionally being handicapped in dim light by having only a zoom, here's an idea that may help. Some photographers buy a zoom to cover several focal lengths and then buy a fixed lens within the zoom range. The fixed lens has larger maximum aperture and the idea is to use that one in dim light.

A MASTER PLAN

There's an advantage in having a set of lenses with fairly uniform spacing between focal lengths. That way you avoid having lenses that are too close together in angle of view, or too far apart. You can aim at this ideal arrangement by planning a set of lenses in advance even if you don't buy them all at once.

One rule of thumb is that a new lens should be approximately double or half of the focal length of a lens you already own. In other words the ratio of focal lengths is about 2.

By looking at the lens table, you can plan a set of lenses following this rule of thumb. For example: 24mm, 50mm, 100mm, 200mm, 400mm, 800mm. Or: 17mm, 35mm, 85mm, 135mm, 300mm, 600mm. If you like to use long focal lengths, consider using the 2X converter to get more focal lengths with less weight and cost.

5 FILM HANDLING

FILM HANDLING

Occasionally, someone will invest a lot of time and effort into shooting a roll of film and then get unsatisfactory results because of mishandling the film in one way or another. There are lots of opportunities to do it wrong, starting from the day you purchase film in the box at your dealer and ending when you finally get positive images safely in hand.

This chapter discusses film storage, loading and unloading the camera and how the camera handles film.

Choosing a type of film for a specific purpose is discussed in Chapter 10, and you'll find a list of some currently available film types at the back of that chapter.

FILM EMULSION

The light-sensitive material in a photographic emulsion is a compound of silver of the general name *silver halide.* This is used in both b&w and color films although the structure and processing of color film is different to produce a color image.

The characteristics of photographic emulsion change slowly after manufacture in two principal ways. After development, old film shows an overall density that we call fog, which cannot be accounted for by exposure to light. It is a deterioration of the silver halide in the emulsion. The density range which the film can produce is limited by this because areas on the film which should be clear are fogged instead.

Also, the difference in tone between two objects in the picture will be less on old film than fresh

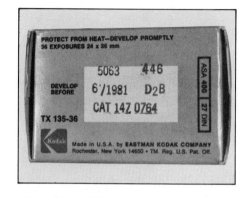

film. This difference is called *contrast* and lack of it causes prints to look "flat." They have an overall gray appearance instead of strong blacks and vivid whites with definite visible differences between the image tones.

With color film, the image recorded by silver halide in the emulsion is converted during processing to appear in color. Changes in the photographic emulsion due to aging affect the colors in the final transparency or color print in ways that are difficult or impossible to correct.

EXPIRATION DATING

Films carry a date on the carton referred to as the expiration date even though nothing drastic actually happens at that instant. Although film should be exposed and processed before that date, the film will probably be about as good during the month after its expiration as during the month before. The date means the film should perform satisfactorily up to that time under normal conditions.

Expiration dating of films intended for amateur use is based on storage at room temperatures: 70° Fahrenheit (20°C) and around

The expiration date is stamped on the side of most film boxes, along with other codes and information. This box is marked "Develop Before 6/1981." The film won't actually "expire" in June of 1981, but should normally be used before then.

50% relative humidity. High temperature and high humidity accelerate the aging process and humidity is the worst culprit. Most film is sealed in a pouch or can to protect the film from external humidity changes. If the emulsion dries out excessively, that's not good either.

FILM STORAGE

Storing film at reduced temperatures, such as in your refrigerator, slows down the aging process, and is recommended both before and after exposure if you keep the film a long time before shooting or a long time after shooting and before development.

An exception is color films intended for professional use and some special b&w films. These should always be stored at reduced temperature—follow the manufacturer's instructions.

Film should be in sealed factory containers when stored, and allowed to return to room temperature before breaking the seal, otherwise moisture may condense in the package and the film may be ruined. If you buy film in quantity, storing it in the refrigerator is a good idea provided you observe this precaution.

After development, room temperature storage of photographic materials is normally OK.

LOADING FILM INTO THE CAMERA

Before opening the camera to load film, it's a good idea to check to be sure the camera doesn't already have film in it. Turn the rewind knob clockwise. If there is no film in the camera, the knob will turn freely. If you feel resistance, there is film inside which light will damage if you open the camera without first rewinding the film.

When film is rewound into the cartridge, the rewind knob turns freely, indicating that it is safe to open the camera to remove the exposed cartridge of film.

After verifying that there is no film in the camera, open the camera back so you can load a fresh cartridge of 35mm film.

Opening the camera is done by lifting up the rewind knob, also called *back-cover release knob*. A folding rewind crank is built into this knob. If you have difficulty grasping the rewind knob, tilt out the rewind crank and lift up on it. The camera back cover will pop open.

With the camera back open, inspect the interior. Look for visible dirt, residue such as a piece of film broken off the preceding roll, or anything that looks wrong.

Occasionally it's a good idea to brush out the interior carefully with a clean soft brush, or use a puff of air from a rubber squeeze bulb or a pressurized can of dust remover. When cleaning the interior, avoid touching the focal plane shutter mechanism or blasting it directly with air.

Drop the film cartridge into the chamber on the left and follow the steps shown in the accompanying photographs.

When the film is caught in the take-up spool and you have advanced it far enough so sprocket holes on both sides of the film are engaging teeth on the sprocket, close the camera.

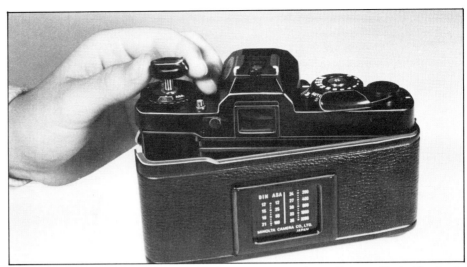

To load a 35mm film cartridge, lift upward on the Back-Cover Release Knob. The back cover will spring open. The procedure for loading 110 film is generally similar—see Chapter 14.

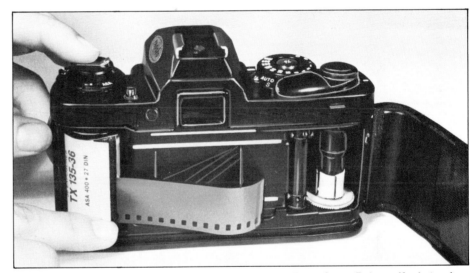

Drop a cartridge into the cavity at left and depress the Back-Cover Release Knob, turning it if necessary to get it all the way down. Read the film type and film speed on the cartridge to be sure you are loading the film you want to use.

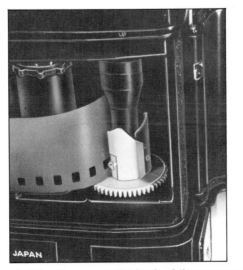 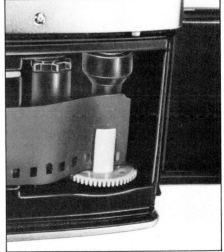

Pull the film across the back of the camera and insert the end into a slot in the take-up spool. There are slight differences in the way the film end fits into the spool among the various camera models. Two methods are shown here. Be sure to use the correct method for your camera.

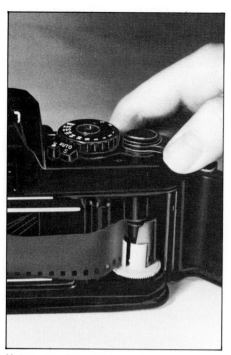

Using the Film-Advance Lever, advance film until you are sure the film end is caught securely in the take-up spool. If you prefer, you can turn the take-up spool using the serrated flange at the bottom.

When you are sure the film is caught in the take-up spool, press your thumb against the edge of the film, near the cartridge, and hold the film tightly so it can't move. Lift the Rewind Crank and turn clockwise, as though you were winding film back into the cartridge, while your thumb is holding the film so it can't move. This takes the slack out of the film in the cartridge—sometimes called *tensioning* the film. When you feel resistance, stop tensioning and fold the Rewind Crank back down to its normal position.

Set the film-speed dial immediately, being certain to set in the correct film speed for the film you have just loaded into the camera.

The camera exposure counter—also called frame counter—automatically resets each time the back is opened, setting itself to minus 2 frames, which is indicated by the symbol S on the counter dial. Advancing film with the back open does not advance the counter, so when you close the back, it still shows S.

All of the film between cartridge and take-up spool was exposed to light just before you closed the back, so none of it can be used to make pictures. It is necessary to advance the film after the camera back is closed so the light-struck film will be wound onto the take-up spool and unexposed film will be in position behind the lens.

By operating the film-advance lever and the shutter button, fire blank shots with the lens cap in place while advancing film from S to frame 1. You can expose this frame to make the first picture on the roll.

It's best to have the lens cap on while loading and advancing film because this protects the front element of the lens.

With a camera set for non-automatic operation, set the shutter-speed dial to a speed faster than 1/60 while firing blank shots so you don't have to wait a long time while the shutter operates. This also saves battery power on some models.

With an automatic camera, you may have a problem. With the lens cap on, no light comes through the lens. The camera may use a very long shutter speed which slows down the reloading procedure and uses battery power. Sometimes the mirror locks up temporarily.

If the mirror locks up, you can get it back down by rotating the camera shutter-speed dial to the letter X. This is called *resetting* the mirror.

Avoid the problem in the first

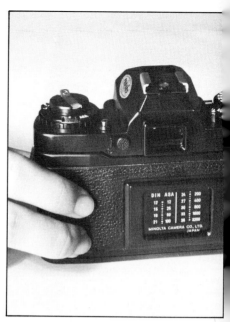

Look again to see what film you have loaded and its ASA film speed. Close the rear cover.

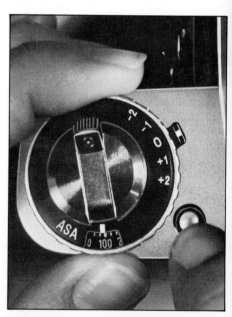

Immediately check the ASA film-speed setting on the camera and change it if necessary so it agrees with the film you loaded. There are differences in the methods of setting film speed among the various 35mm camera models, but all are similar. This is an XD-5 camera.

place by never loading film with a camera set for automatic exposure. Always switch to manual with a fairly fast shutter-speed setting. After you have loaded film, set the camera for automatic operation if desired.

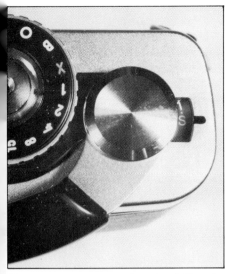

When you open the back to load film, the Frame Counter automatically resets to S and remains there. After closing the back cover, use the shutter button and film-advance lever to advance film, a frame at a time, until the counter reads 1. This means frame 1 is in position to be exposed.

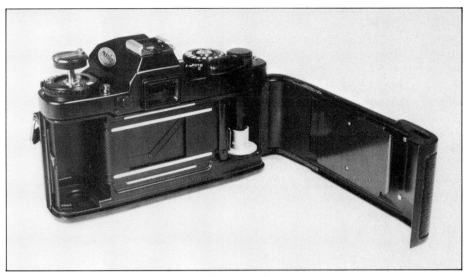

The sprocket-hole area on each side of the film rests on the surface of the two inner metal rails. The edges of the film fit between the two outer metal rails. When closed, the pressure plate on the back cover touches the surface of the outer guide rails, forming a channel that confines the film and holds it flat.

If your camera has a Safe-Load Signal Window, a red band (arrow) should appear at the left side of the window when film is correctly loaded and advanced to frame 1. If your camera does not have this feature, watch the rewind knob while advancing to frame 1. If it turns counterclockwise, film is loaded properly and advancing OK.

While advancing the film to frame 1, watch the rewind knob on top of the camera. It should revolve counterclockwise each time you advance film. This shows that the spool inside the film cartridge is actually turning and you are actually advancing film through the camera—which means you have it loaded properly and nothing is wrong. If it does not turn, you'd better open the back of the camera to make sure the film leader is firmly engaged in the takeup spool.

Some Minolta cameras have a Safe-Load Signal Window at the upper right corner of the back, or on the top. This serves the same purpose as watching the rewind knob to confirm proper loading. If your camera has this feature, a red bar will appear in the left side of the window when film is properly loaded. As film advances through the camera, the red bar will move from left to right across the window. At the end of the roll, the bar is fully to the right.

It is important to understand that the frame counter does not actually count frames of film as they go through the camera. It only counts the number of times you have operated the film-advance lever. If the film leader is caught in the take-up mechanism and film is advancing each time you operate the lever, the frame counter will be telling the truth. If the film leader is not grasped by the take-up, film will not move through the camera as you work the advance lever, and the frame counter gives a false count.

Loading and unloading a camera should always be done in subdued light. If you have to do it outdoors, shade the camera with your body to avoid direct sunlight on the film

cartridge. The film slot in the cartridge is lined with a soft black material which contacts the film on both sides to exclude light and prevent fogging film inside the cartridge. This is a practical but not perfect device and you can help it protect your film by minimizing both the amount of light on the cartridge while loading and unloading and also the length of time the cartridge is in any light.

Leave the cartridge in the package until you are ready to use it. Return it to the package or some other light-tight container as soon as you remove it from the camera.

FILM GUIDING

There are four polished metal rails in the back of the camera, two above and two below the focal-plane-shutter opening. The film rides on the two inside rails. They are separated enough not to be in the picture area. In fact, they are directly underneath the sprocket holes.

The outer two rails are edge guides. They stand slightly higher than the inner rails so the film edges are guided in a straight path from cartridge to take-up. Because film is wound up inside the cartridge, it tends to curl in the

long direction as it is pulled out and across the camera. Because the film is layers of different materials—the base and the emulsion—it may tend to curl crossways also, depending on the humidity.

A spring-loaded *pressure plate* is on the inside of the rear cover. When the cover is closed, this flat smooth plate gently presses against the two outer guide rails and contacts the back of the film. The two outer guide rails hold the pressure plate away from the two inner rails a small amount to allow for film thickness. This creates a channel which closely confines the film to keep it traveling straight across the camera and hold it flat while being exposed.

The pressure plate touches the back side of the film—the base. If the pressure plate scratches the film, those scratches will show in a slide or print. Dirt on the pressure plate or gouges due to extreme abuse can scratch the film.

REWINDING FILM

When you have exposed the last frame in the cartridge, the film-advance lever will become difficult to move. Don't force it!

If the lever completed a full stroke, the camera is cocked and there is a fresh frame in position. You can shoot that frame.

If the lever only moved part of a stroke, rewind the film immediately. Don't try to force the lever hoping to get one more exposure on the roll. If you do, the film may tear out the sprocket holes or pull off the spool inside the cartridge—it's only held with tape!

Film wound on the take-up side of the camera is not protected from light. If you don't rewind immediately and later forget that you didn't, you can ruin the entire roll by opening up the back of the camera.

Rewinding—Much of good camera-handling technique is based on well-formed habits. If

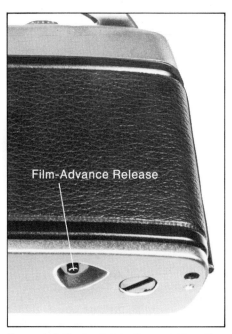

Film-Advance Release

To rewind film back into the cartridge, first depress the rewind button on the bottom of the camera—directly below the film-advance lever. On some models, this button is called the Film-Advance Release. It disconnects the film-advance mechanism so the take-up spool turns backwards freely, which allows rewinding.

you get in the habit of rewinding immediately when you have exposed the last frame, you will never ruin a roll of exposed film by opening the camera.

On the bottom of the camera, directly below the film-advance lever is a small button called the Film-Advance Release. To prepare the camera for rewinding, depress this button.

Lift up the Rewind Crank on the Rewind Knob and turn it in the direction of the arrow—clockwise. Rewind slowly, particularly if the humidity is low. Static electricity can build up on the film and discharge during rewinding. This is a flash of light, like a miniature lightning bolt inside the camera. It can cause strange tracks on the film. Slow rewinding reduces the chance of this happening.

By rewinding slowly and paying attention to the feel of the rewind crank, you will be able to tell when the film end pulls clear of the take-up mechanism. When that happens, there will be about as much leader extending from the cartridge as there was when you

loaded the camera.

It's a good idea to stop rewinding at that point, leaving some leader sticking out of the cartridge. The light trap where the film comes out of the cartridge works best when the opening is filled with film. If you wind it all the way into the cartridge you increase the chance of a light leak into the cartridge which can fog the film.

One side of the film leader is cut off in a standard pattern, making it narrower for the first couple of inches. The light seal of the cartridge works best when the full width of the film is in the trap. If you rewind too far but there's some film sticking out, pull a little bit out of the cartridge so the full width is in the trap.

Rewinding this way makes an exposed cartridge look exactly like an unexposed one. If you think there is any chance of getting confused and putting the same roll back into your camera, you can use a pencil to mark the leader on the emulsion side. Write the letter E for exposed. If you've never looked closely at film, the base side is shiny and the emulsion side is a dull gray or brownish color before processing.

On the other hand, if you wind the film all the way into the cartridge, you will never expose the same roll twice.

You shouldn't ever get confused about whether a roll of film has been exposed or not if you form the habit of never opening the factory package until just before loading the cartridge into the camera.

Another good habit to form is to look at the cartridge just before you close the camera back cover. If you carry more than one type of film and you are busy shooting action or something that takes a lot of concentration, it's easy to grab and load the wrong kind of film while your mind is busy with something else. You should have an automatic check point sometime during the loading procedure to verify what's in the camera.

CAMERA CONTROLS AND FEATURES 6

CAMERA CONTROLS AND FEATURES

This chapter discusses most camera and lens controls and some general features so you can read about them all in one place. The camera shown on this page is the XD-11 which has more controls and features than most other models.

If you know what the controls do on an XD-11, you can use any of the other cameras. Some features of other cameras are shown in photographs in this chapter so you càn see and understand some of the differences among models.

CAMERA BODY CONTROLS

Most camera controls are similar and in similar locations with only a few exceptions.

Film-Advance Lever — To advance film, use your right thumb to rotate this lever. The lever has a storage position pushed flush against the body and a stand-off position extending outward from the body so it is convenient to hook it with your thumb.

Film advance begins from the stand-off position. With some models, advancing the film requires one full stroke of the lever. With other models, you can operate the lever in multiple shorter strokes, each beginning at the stand-off position.

Operating Button — Also called *shutter button* and *shutter-release button*. To make an exposure, use

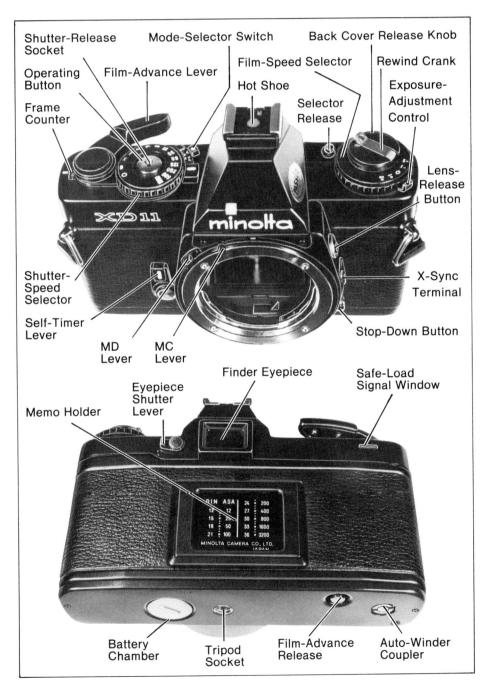

Shutter-Release Socket
Mode-Selector Switch
Back Cover Release Knob
Operating Button
Film-Advance Lever
Film-Speed Selector
Rewind Crank
Frame Counter
Hot Shoe
Selector Release
Exposure-Adjustment Control
Lens-Release Button
Shutter-Speed Selector
X-Sync Terminal
Self-Timer Lever
MD Lever
MC Lever
Stop-Down Button

Memo Holder
Eyepiece Shutter Lever
Finder Eyepiece
Safe-Load Signal Window
Battery Chamber
Tripod Socket
Film-Advance Release
Auto-Winder Coupler

your right index finger to squeeze the button smoothly so you operate the camera without jiggling it.

In the center of the shutter button, most Minoltas have a threaded socket for a cable release.

Frame Counter—Just to the right of the Film-Advance Lever is a window through which you read frame numbers.

This counter is automatically reset when you open the back cover to load film. When making a single exposure on each frame, the frame counter counts frames as they are exposed, so you know where you are on the roll.

When making multiple exposures on the same frame, frame counter operation varies among models. On some models it counts each exposure so the frame count is no longer correct after making a multiple exposure. For example, if you make two exposures on frame 7, the counter will indicate 9 when you advance to frame 8.

On other models, the frame counter does not advance during multiple exposures, so the frame count is always accurate. This is discussed for each camera model in Chapter 15.

Mode-Selector Switch—XD cameras have a Mode-Selector Switch to choose among three modes of operation: Manual, which means you set both shutter speed and lens aperture; Aperture-priority automatic exposure; and Shutter-priority automatic exposure.

The Mode Selector has three positions labeled M, A, and S to select the operating mode. Other Minolta cameras do not have this control.

Shutter-Speed Selector—On manual operation with any camera, use the Shutter-Speed Selector to dial in the desired shutter speed. On automatic, the function and setting of the shutter-speed dial varies among models as described in Chapters 8 and 15.

Hot Shoe—Flash units fit in this shoe and make electrical connections to contacts in the hot shoe.

To turn on an XD camera, depress the operating button partway. To make an exposure, depress it all the way. In the center of the operating button is a socket for a cable release which allows you to operate the shutter from a distance.

To turn on an XG camera, turn the Main Switch to ON, then place your finger on the operating button without depressing it.
In the center of the operating button is an electrical contact, called the Touch Switch which senses the presence of your finger.

This allows the camera to fire the flash without a separate cord connection and also allows special operating features with certain Minolta electronic flash units and some Minolta cameras, as described in Chapter 11.

Back-Cover Release Knob—Pull upward on this knob and the back cover pops open. You can rewind or tension film in the camera by rotating this knob clockwise so it is also called the Rewind Knob.

Rewind Crank—This folding crank tips up out of the Back-Cover Release Knob and is used to rewind exposed film back into the cartridge.

Film-Speed Selector—Use this control to set film speed into the camera.

Selector-Release Button—Depress to allow rotation of the ASA Film-Speed Selector. When this button is not depressed, the film-speed selector is locked so it cannot be turned accidentally.

Lens-Release Button—Depress this button to remove the lens. While holding the button depressed, turn the lens body counterclockwise.

X-Sync Terminal—An electrical connector for a flash sync cord when the flash is not installed in the camera hot shoe. This terminal supplies a firing signal for flash units.

Stop-Down Button—Push this button and the lens aperture will stop down to whatever *f*-number is set on the lens aperture control. This is used to view depth of field and sometimes to meter with the lens stopped down to shooting aperture.

Finder Eyepiece—Look in here to compose and focus.

Eyepiece-Shutter Lever—When you are using an XD-11 camera on automatic operation and your eye is not at the viewfinder window, use this lever to close an internal shutter. This prevents light from entering the viewfinder eyepiece and causing an incorrect exposure.

Some Minolta automatic cameras have a separate eyepiece cover used for this purpose, rather than a built-in shutter.

Exposure-Adjustment Control—When a camera is operating on automatic, it gives an exposure determined by the calculator in the camera. There are some circumstances when you may want to give more or less exposure than that.

The Exposure-Adjustment Control overrides the automatic exposure system and commands it to give more or less exposure. Control range is from +2 to -2 exposure steps. Only cameras with automatic-exposure capability have, or need, this control.

Self-Timer Lever—Causes shutter operation to be delayed about 10 seconds after you depress the camera Operating Button. The common use is to allow you to dash around in front to be in the picture.

Safe-Load Signal Window— When film is properly loaded in the camera and you have advanced the film to frame 1, a red bar appears at the left side of this window. If the bar doesn't appear or if it is at the far right side of the window, film is not loaded properly. Open the back cover and double check the loading procedure.

As you make exposures, the red bar will gradually move to the right if film is advancing properly. Not all Minoltas have this feature.

Battery-Chamber Cover—Use a coin in the slot to remove this cover so you can load or replace batteries. On some models, the coin slot is cut all the way through the metal cover so you can see if a battery is in the chamber.

Tripod Socket—Threaded to accept the mounting screw of U.S. tripod heads (1/4'' - 20 TPI).

Film-Advance Release—Disconnects the film-advance mechanism so film can be rewound. Also called the *rewind button.* When the button is depressed, the film-advance lever will not advance the film.

On XD cameras, this control is also used to make multiple exposures on a single frame.

Auto-Winder Coupler—Minolta XD and XG cameras are designed to use an accessory motor-driven automatic film advancer (winder) which attaches to the bottom of the camera using the tripod socket. This coupler makes the mechanical connection between auto winder and camera.

Memo Holder—Holds the end flap from a film carton to remind you what kind of film you have loaded. Especially useful if you carry two cameras loaded with different kinds of film. Not all Minoltas have a memo holder.

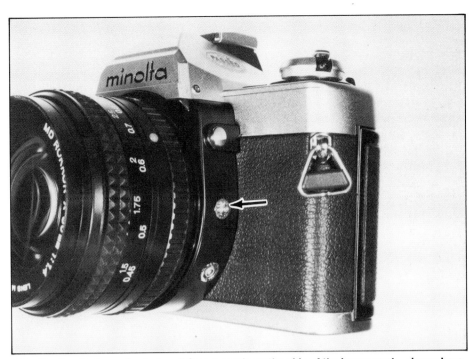

The Shutter-Release Socket on XG cameras is on the side of the lens mount—shown here by an arrow. Lens-Release Button is above, X-sync Terminal for electronic flash is below. This is an XG-1.

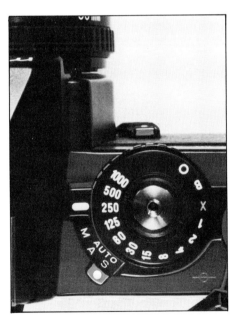

The Mode-Selector Switch on XD cameras can be set to M for Manual, A for Aperture-priority automatic, S for Shutter-priority automatic. This camera is set to S. To set shutter speed, rotate the outer rim of the Shutter-Speed Selector until the desired speed is opposite the white index mark. This control is set to 1/250 second. The circle with a line through it, near the Film-Advance Lever is the film-plane indicator. The line shows where the film is located inside the camera. Not all Minoltas have a film-plane indicator.

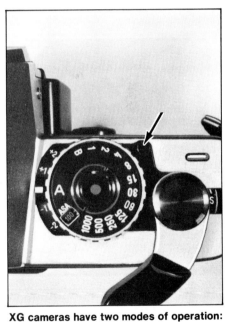

XG cameras have two modes of operation: aperture-priority automatic and manual exposure control. To select automatic, set the Shutter-Speed Selector to A as shown here. To choose manual operation, set the control to any of the designated shutter speeds from B to 1000. To turn the control *away from* A, you must depress the Auto-Setting Release Button (arrow). To set film speed on an XG camera, lift up the outer rim of the Shutter-Speed Selector and turn the rim until the desired film-speed number appears in the window adjacent to the letters ASA. This control is set to ASA 100.

If you are using a camera on automatic and your eye is not at the viewfinder eyepiece, incorrect exposure could result due to light entering the camera through the eyepiece. To prevent this, some Minoltas have a built-in eyepiece shutter which you close to prevent entry of stray light. Automatic cameras without a built-in shutter are packaged with an Eyepiece Cover which fits over the eyepiece. The cover has slots so you can slide it onto the camera neckstrap.

On XD cameras, the Film-Speed Selector surrounds the rewind crank. Depress the adjacent Selector-Release Button while turning the outer rim of the control to place the desired ASA film-speed number in the window. This camera is set to ASA 100. On automatic, you may want the camera to give more or less exposure than it normally would. If so, move the Exposure-Adjustment Control (arrow) away from 0. Push the lever inward and move it along the scale to the desired amount of exposure adjustment. This control is set at +1 to provide one more step of exposure.

XD cameras use a mechanical Self-Timer control. Rotate the lever counterclockwise to set the timer. Start the timer by depressing the camera shutter button. During countdown, the Self-Timer Lever rotates clockwise. As it approaches its normal vertical position, the shutter operates. Maximum delay is 10 seconds with the lever rotated fully counterclockwise. Rotate it a smaller amount to get less delay. SR-T cameras are similar.

XG cameras have an electronic self-timer that provides 10 seconds delay. To set the timer, rotate the camera Main Switch to the SELF TIMER setting. To start, depress the camera shutter button. A red LED indicator on the front of the camera blinks slowly until about 2.5 seconds remain. Then it blinks rapidly to warn you that the shutter is about to open.

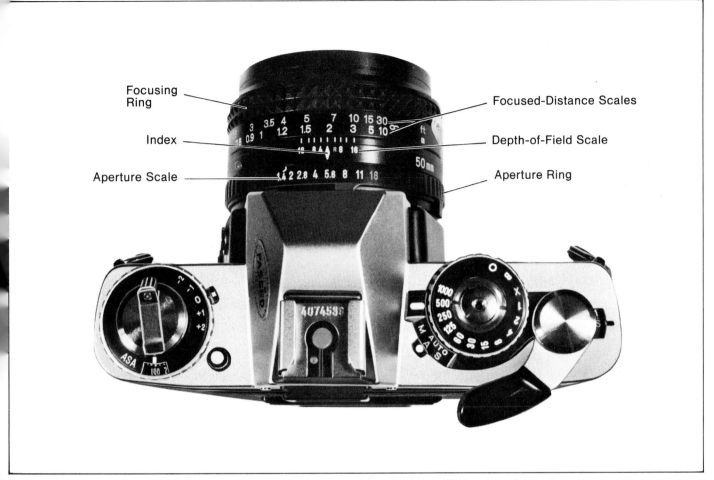

Focusing Ring

Index

Aperture Scale

Focused-Distance Scales

Depth-of-Field Scale

Aperture Ring

These are the standard lens controls and scales. Lenses with special features have additional special controls.

THANKS!

This book required a lot of assistance from some capable and generous people at Minolta Corporation. Some helped get the project underway; some helped during preparation by providing information and also equipment for me to use and photograph. Some helped by reading the manuscript and correcting my mistakes which is difficult and tedious work and for which I am especially grateful.

LENS CONTROLS

Minolta lenses work the same way no matter which camera you install them on. The lens controls are few and easy to use.

Focusing Ring—Turn this ring to focus the lens at different distances from the camera. All conventional lenses focus out to infinity, symbol ∞. The near limit is different among various lenses. When considering a lens, check its near-focus limit.

Distance Scale—Focused distance is shown in feet and meters on the distance scale of the Focusing Ring, opposite the diamond-shaped index mark on the lens body. This is also called the *focused-distance scale.*

Aperture Ring—Use to select any desired *f*-stop.

Depth-of-Field Scale—Works with the focused-distance scale to show depth of field at various aperture settings.

7 VIEWING AND FOCUSING

With an SLR camera you can safely use the entire frame for the subject of interest because you see through the lens that forms the image. In the viewfinder, you see virtually the entire frame with only a small margin around the edges.

VIEWING AND FOCUSING

In an SLR camera one purpose of viewing the image from the lens is to determine if it is in good focus. In 35mm cameras, this is done by placing a focusing screen above the mirror with the mirror angled so it intercepts light rays from the lens and reflects them upward to the focusing screen.

The irregular surface of the focusing screen is called a *matte surface.* Each small point on the screen receives light from the lens and becomes luminous. Each small point retransmits light rays through the viewfinder optical system so they emerge from the viewfinder eyepiece at the rear of the pentaprism.

To hold a camera for good support and fast shooting, operate camera-body controls with your right hand. Cradle the lens in your left hand and use your left hand to operate controls on the lens. Take a good stance, pull in your elbows, hold your breath momentarily, and shoot. Squeeze the shutter button—don't jab or jerk.

For a vertical frame, I suggest turning the camera this way and shooting with the same precautions. Some people are more comfortable with the camera turned the other way, operating the shutter button with the right thumb. Learning to shoot with one eye open is handy. It allows you to see objects not in the field of view of the lens and it helps to keep you oriented in the real world so you don't walk over cliffs or out into traffic.

When you can, take advantage of steady-rests for you and the camera. The world is full of them: buildings, walls, posts, railings, trees, furniture, or anything that's more solid than you. If you have plenty of time to make the shot and you are using a physically short lens on the camera, you may feel more comfortable with both hands on the camera body. With a physically long lens, cradle the lens in your left hand even if you are braced against something solid.

When looking into the eyepiece, what you see is the image on the focusing screen whether it is in focus or not.

The camera is designed so the distance from the lens mounting surface to the film plane is the same as the distance to the focusing screen by way of the mirror. Therefore if the image is in focus on the focusing screen it should also be in focus on the film when the mirror is moved out of the way. When you make focus adjustments you are using the focusing screen as a substitute for the film.

Acute-Matte Focusing Screens— Conventional focusing screens have a matte surface which is rough and irregular, rather than smooth. Although made of plastic it has the appearance of ground glass. This matte surface intercepts all light rays traveling upward from the mirror and shows you the image at that point. If the rays are in focus, the image you see will be in focus. Light rays that are not in focus at the matte surface allow you to see depth of field on a matte focusing screen.

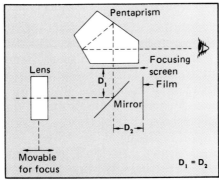

Distance from lens to focusing screen by way of the mirror must be identical to distance from lens to film when the mirror is raised. Judging focus by looking at the focusing screen is equivalent to examining the image on film.

In some camera models, Minolta uses an improved focusing screen with a surface called Acute Matte. This precision molded surface consists of more then two million tiny conical projections. This surface forms an image in a way similar to an ordinary matte surface but the image on the Acute Matte surface is perceptibly brighter.

A conventional matte surface used on focusing screens has an irregular random pattern as shown at top. It absorbs some of the light and transmits the remainder to your eye. The Minolta Acute-Matte focusing screen is precision made with uniform surface variations. This screen absorbs less light, so the image you see is brighter. Both photos are at a magnification of 200.

FOCUSING AIDS

Judging focus by looking at the image on a matte screen depends a lot on how good your eyesight is. Even with good vision it is inferior to other methods of indicating good focus. Two other methods, called *focusing aids*, are used.

Split Image—A split-image focusing aid is two small prisms with their faces angled in opposite directions to form a *biprism*—see Figure 7-1. Even though Minolta literature usually refers to this focusing aid as a split-image type, this book will call it a biprism.

The way a biprism indicates best focus is shown in Figure 7-2. Each of the two prisms refracts or bends light rays which pass through it. If the image from the lens is brought to focus in front of the viewing screen, rather than at the viewing screen, the two halves of the image appear misaligned.

If the image comes to focus on the viewer's side of the screen, the effect is reversed and the image is misaligned in the opposite direction. At the point of best focus, the two halves of the image are not displaced in respect to each other.

The human eye is better at judging alignment of lines or edges in an image than judging focus by general appearance so using a split-image focusing aid is a good way to find focus.

For most effectiveness with vertical lines in the scene, the display should move the top half of a vertical line to the right or left and the bottom half in the other direction.

Minolta biprism focusing aids split vertical lines. If the image consists mainly of horizontal lines, it will be difficult to see any indication of focus. However, you can rotate the camera so the biprism splits a dominant line or edge in the scene no matter how the line or edge is oriented. Focus, return the camera to the best orientation for the scene, and press the shutter button.

A biprism which splits lines doesn't work well when there

Figure 7-1/A biprism is two wedges of glass or clear plastic, tapering in opposite directions. Normally this focusing aid is made to fit into a circular area in the center of the focusing screen. The biprism splits the image when focus is poor, so it is sometimes called a split-image focusing aid.

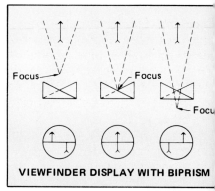

VIEWFINDER DISPLAY WITH BIPRISM

Figure 7-2/A biprism visually separate lines or edges of the scene into two dis placed segments when the image is not i focus. A biprism works best on scenes wit easy-to-see lines or edges that can b split.

aren't any lines in the picture. Examples are: a plain surface or a mottled surface such as a mass of foliage.

Microprism—Another type of focusing aid which is more useful on scenes without strong geometric lines is a microprism, shown in Figure 7-3.

It is an array of many small pyramids whose intersections work in a way similar to the biprism. Visually, the microprism displaces small segments of the image, causing it to "break up" and have an overall fuzzy appearance. When focus is reached, the image seems to snap into focus. If you jiggle the camera—on purpose or because you can't help it—the image will seem to scintillate when it is out of focus.

Because operation of the microprism is similar to the biprism, it has the same problems with blackout at reduced apertures.

Combination Screen—Minolta focusing screens offer a combination focusing aid—a central biprism surrounded by a microprism ring. You can use the focusing aid best suited for the scene or ignore the focusing aids and judge best focus by examining the image on the surrounding matte area—usually called a matte field.

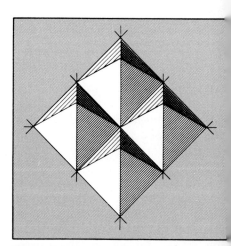

Figure 7-3/A microprism is an array of small pyramids whose intersections work like little biprisms. Microprisms work well on any subject with surface details.

For people used to one type of focusing aid, the combination screen takes some getting-used-to, but it does combine the best of both methods. You have to "shift gears" mentally when switching from one focusing aid to the other in the same viewfinder—but most things photographers do require thinking.

Focusing-Aid Blackout—Imagine that your eye is looking out at the scene through a biprism and the lens. Your line of sight will be displaced in one direction by one prism and in the other direction by the other prism.

Even though the prism angles are small enough to allow you to look through the lens at full aperture, a smaller aperture may block your line of sight so you end up looking at the back side of the aperture diaphragm rather than out to the world beyond. This is common for focusing aids of this type and the biprism will black out on one side or the other when you are viewing through a small aperture rather than the maximum aperture of the lens.

The side that goes black depends on where your eye is. Move your head one way or the other and the opposite side of the biprism will go black. By changing the position of your eye, you alter your line of sight to favor one prism or the other.

This problem puts the camera designer into a technical conflict. Large prism angles cause large image displacements when the image is not in focus and therefore give a very good indication. However, the larger the angle, the sooner the focusing aid blacks out when stopping down the lens. This is not a handicap when focusing at full aperture, but you may notice the effect when you stop down to judge depth of field.

Even when metering at full aperture, the effectiveness of a biprism may be reduced by using a "slow" lens with small maximum aperture or lens extension devices to produce higher magnification of the image. In extreme cases, one side of the biprism may black out. If this happens, you can still focus using the matte area of the focusing screen.

A similar blackout occurs when using a microprism focusing aid at small aperture. One side of each tiny microprism turns black and the focusing aid is not useful.

The standard factory-installed focusing screen for XD cameras is Type PM: a horizontal biprism surrounded by a microprism in an Acute-Matte field. Three other Acute-Matte focusing screens are available for XD cameras. These are not user-interchangeable but can be installed at Minolta service centers. Type M has a microprism only. It allows using slower lenses—those with smaller maximum aperture—without blacking out. Type AP has a diagonal biprism that sometimes gives quicker focusing because it splits either vertical or horizontal lines in the scene. This biprism will not black out when used with lenses of f-5.6 or those with larger maximum aperture. Type G has no focusing aid but focus can be observed on the entire Acute-Matte screen. Recommended for close-up work.

INTERCHANGEABLE FOCUSING SCREENS

Minolta offers a selection of focusing screens for XD cameras as shown in the accompanying illustration. These can be installed in any XD camera at an authorized Minolta service center, replacing the standard screen that came with the camera. These screens are not user-interchangeable.

The XK Motor camera has user-interchangeable focusing screens and viewfinders. These are discussed in Chapter 15.

Focusing screens cannot be changed on XG and SR-T cameras.

IMAGE CUTOFF WITH LONG FOCAL LENGTHS

With short-focal-length lenses, which have wide angles of view, the cone of light rays leaving the back of the lens expands at a wide angle as the rays travel back to the film plane. When the cone of rays reaches the mirror location, they have not yet expanded very much and they don't fill the surface area of the mirror.

With long-focal-length, narrow-angle lenses, the image is nearly full size at the mirror location. Therefore a relatively large mirror area is required to intercept the rays and reflect them up to the focusing screen.

In some camera designs, the mirror's bottom edge is shortened so it doesn't collide with the camera body or the back of the lens when it swings up. When this is done, part of the image cast by lenses with long focal lengths is not intercepted by the bottom of the mirror and therefore is not reflected up to the focusing screen.

Because reflection from a mirror inverts the image, the bottom of the image on the mirror becomes the top of the image in the viewfinder. What you see with long lenses is a dark band across the top of the focusing screen with part of the image lost in the dark band. This is called image cutoff. Even if it happens in the viewfinder, the image on film is not affected and is not cut off because the image on film is not reflected by the mirror.

Another potential cause of image cutoff is photographing at high magnification using a bellows between camera and lens as described in Chapter 9.

All camera designers face the technical problem of image cutoff. The solution is to design the camera body and the mirror so the bottom edge of the mirror doesn't have to be shortened very much. Minolta has done this and uses the term oversize mirror to indicate minimum shortening of the bottom edge.

A technical term, *PO value*, is used by some camera designers to state the effective length of the mirror from its centerline to the bottom edge. High PO values mean the mirror is not shortened very much and image cutoff is less likely to occur. Minolta uses this term in some literature but other camera manufacturers generally don't.

VIEWFINDER MAGNIFICATION

If you look at an object through the viewfinder of a camera and then look directly at the object, it will usually appear to be a different size than what you saw in the viewfinder. The height of an image in the viewfinder depends on how far away the object is, the focal length of the lens you are using and the magnification of the viewfinder optics.

The usual way to specify viewfinder magnification is with a 50mm lens focused at infinity. This doesn't mean the object has to be at infinity—it need only be within the depth of field. With those conditions, Minolta viewfinder magnification is 0.86 to 0.9 depending on camera model. The XD-11, for example, has a viewfinder magnification of 0.87 which means the object in the viewfinder will appear to be 87% as tall as it would be if viewed directly.

With a standard 50mm or 45mm lens focused at infinity, the world as seen through the viewfinder is a little smaller than the real world.

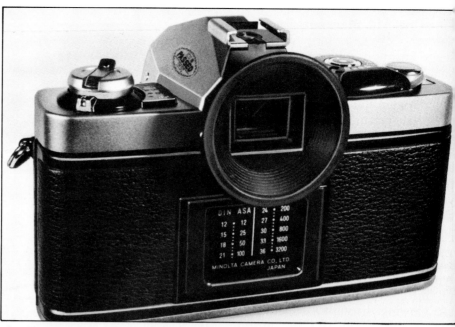

A rubber eyecup is very useful. It helps exclude stray light that might affect the meter reading. It makes viewing more comfortable and helps prevent scratches on your eyeglasses if you wear them while viewing.

With other focal lengths and other focused distances, magnification changes and the world looks larger or smaller than real life.

VIEWFINDER IMAGE COVERAGE

Most photographers don't worry much about the size of an object as seen in the viewfinder. Some worry about viewfinder image coverage: Does the amount of scene seen in the viewfinder agree exactly with the amount of scene actually recorded in the film frame? The answer is: Nearly.

Standard slide mounts extend into the image area of a mounted slide.

When you project the slide, you don't see a narrow strip along each edge of the frame because that part is masked by the slide mount.

The viewfinder in Minolta cameras is designed to show you approximately what you will see when projecting a slide, therefore the viewfinder image omits a narrow strip along each edge of the film frame. What you see ranges from 93% to 98% of the film frame, depending in camera model. In every camera you see nearly all of the frame.

This can be considered as a safety factor for slide shooters—so you don't compose all the way to the edge of your slide and then have part of the composition cut off by the slide mount. If you shoot negative film and do your own printing, you can crop the negative as you choose. A custom photo lab will crop according to your instructions while making prints. Standard commercial photofinishing services crop the 35mm frame to fit standard printing paper sizes.

VIEWING AIDS

Accessories are available which attach to the viewing eyepiece on the back of the camera.

Rubber Eyepiece Hood VN—The basic accessory for every user with every camera model. It makes viewing more comfortable with or without eyeglasses. It excludes stray light from the gap between your eye and the viewfinder eyepiece, which makes viewing easier and can improve the accuracy of exposure measurements by the camera's built-in meter.

When holding the camera in a brightly lit area such as direct sunlight, with your subject in a dimly lit area, stray light entering the

Eyepiece Corrector VN lenses clip into the viewfinder eyepiece frame and put your eyesight correction into the camera viewfinder optics, so you don't have to wear eyeglasses. You can use corrector lenses and a rubber eyecup at the same time.

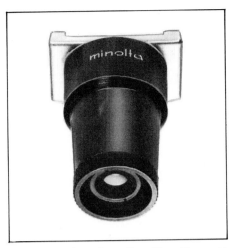

For precise focusing, clip a Magnifier over the eyepiece. Turning the knurled ring on the Magnifier adjusts the optics to fit your eyesight.

If the camera is located so it is inconvenient or impossible to place your eye at the viewfinder eyepiece, install an Angle Finder on the eyepiece frame. Rotate the Angle Finder to view from whatever angle is necessary. Turn the knurled ring to adjust the finder optics to fit your eyesight.

viewfinder eyepiece can cause an error in the exposure reading. If you set the camera controls according to the reading, you will get a bad exposure. Automatic cameras automatically set exposure according to the camera's internal meter reading. If light is leaking into the viewfinder while you are viewing, the automatic camera will give an incorrect exposure.

This situation is made worse when a bright light is at the side or slightly to the rear so your eye does not effectively close off the viewfinder window to block stray light from the bright source.

A Rubber Eyepiece Hood fits snugly against your face and does a very good job of excluding stray light to prevent incorrect exposure readings. Once you use one you'll consider it an essential accessory. Attachment is very simple. It slides down from the top of the viewfinder eyepiece frame and fits into grooves on each side of the frame.

Eyepiece Corrector VN—Those of us who wear eyeglasses have a problem with SLR viewfinders. Without my glasses, I can't see well enough to determine good focus. With glasses, I can't see the entire frame in the viewfinder, but by moving my eye around while

viewing I can see various parts of the frame so I can add it all up mentally and know what is included in the photo.

The apparent distance to the focusing screen in Minolta SLR cameras is about one meter. If your eyeglass prescription doesn't give good vision at that distance, glasses won't help anyway.

Minolta offers a range of Eyepiece Corrector VN lenses that snap inside the viewfinder eyepiece frame to correct the viewfinder optics to agree with your eyesight so eyeglasses are unnecessary. There are nine corrector lenses, each with an identification number and a diopter rating. Diopters are the numbers used to write eyeglass prescriptions, discussed in Chapter 9.

Minolta recommends testing these corrector lenses to find the right one for your vision.

Magnifier VN—You can judge focus better by magnifying the image on the focusing screen—usually with the camera on a tripod or other firm support. Accessory Magnifier VN slides downward over the viewfinder eyepiece frame, held in place by a groove on each side. It magnifies the center part of the image 2.3 times. You don't see all of the image, however this magnifier is hinged

so it quickly flips up out of the way so you can view the entire image.

A slightly different model, Magnifier V, does not have the flip-up feature. To view the entire image, remove Magnifier V from the camera.

Both magnifiers adjust to your individual eyesight by turning the eyepiece at the viewing end of the magnifier. The adjustment range is -7.5 to +3.1 diopters.

Angle Finder V—Mounts on the camera eyepiece frame and "bends" the line of sight by 90°. With the angle finder pointed straight up, you view by looking down into the accessory rather than horizontally into the viewfinder eyepiece.

Angle Finder V rotates in a full circle on its mount so you can position it to view from below the camera, off to one side, or at any angle. This is convenient in difficult shooting situations such as with the camera on the ground or over your head. It is also convenient sometimes when the camera is on a copy stand with the lens pointing downward.

This accessory also adjusts to fit your individual eyesight by turning the eyepiece. Adjustment range is from -6.5 to +2.5 diopters.

8 EXPOSURE METERING AND CONTROL

Photographs are made with light from the scene. The photographer's challenge is to place the scene light values correctly so a good exposure results.

EXPOSURE METERING AND CONTROL

Minolta cameras have a built-in light meter and calculator that work together to figure correct exposure for an average scene. Measuring the light inside the camera, after it has gone through the lens and any accessories such as filters, is an advantage. What the internal light meter "sees" is the light that will expose the film.

If the camera is being operated with manual control, you set both aperture and shutter speed manually.

On automatic operation, you set one of the two exposure controls and the camera sets the other one automatically, based on the exposure calculation made by the built-in calculator.

Exposure of film in the camera is determined by four factors:

Film speed is a message from the manufacturer of the film to the calculator in the camera. It tells the camera how much exposure the film needs. For the camera calculator to work properly, you must set the ASA film-speed number on a control on the camera body.

The amount of light coming from the scene is usually not under control of the camera operator but it is a factor in determining exposure.

The lens aperture setting controls how much of the light from the scene actually passes through the lens to expose film.

Shutter speed determines the length of time light is allowed to fall on the film.

The built-in calculator works with all four of these factors so it can operate the exposure display in the viewfinder and set exposure when on automatic.

Non-Metered Shutter Speeds—
There are some settings of the shutter-speed dial for which we do not expect the camera exposure meter and exposure calculator to work.

When set to **B**, the shutter remains open as long as the shutter button is held down—a procedure used to make "time exposures" in dim light. Because the camera calculator cannot know in advance how long the shutter will be held open, it cannot calculate exposure.

Some models have special settings labeled **X** or **O** which are used with electronic flash. Because most of the exposure will be made with light from the flash rather than ambient light from the scene, the camera meter cannot measure light in advance of the exposure. Therefore the calculator cannot predict exposure.

Metered Shutter Speeds—When using shutter speeds within the normal range—1 second to 1/1000 second for most models—whether manually selected or set automatically by the camera, the camera meter and calculator function normally as described in this chapter.

TURNING ON THE METER

All cameras have some way of turning on the meter, viewfinder display and other camera electronic systems. As cameras have become more automatic, they have used more electronic circuits and require more battery power. To get reasonable battery life with automatic cameras, it is advisable to have the camera electronics turned on only when the camera is actually in use. All Minolta automatic cameras provide this battery-conservation feature.

XD cameras are turned on by depressing the shutter button partway until you feel a slight resistance. You know the meter is operating and the camera is ready because the viewfinder LED display turns on.

XG cameras are turned on by rotating the Main Switch to **ON**, then placing your finger on the shutter button *without* depressing it. XG cameras have a special feature, called a Touch Switch, that electrically senses your finger on the shutter button and turns on the electronic systems and viewfinder display.

If you are wearing gloves or your skin is very dry, the Touch Switch will not operate. Depress the shutter button slightly to turn the meter on. When you are not using the camera, turn the Main Switch **OFF**.

The XK Motor camera has several modes of operation. In the usual mode, you turn on the camera by grasping the camera grip and placing your forefinger on an area called the Senswitch. Depress the Senswitch to turn on the camera. Additional information about the XK Motor camera is in Chapter 15.

SR-T cameras are non-automatic and non-electronic except for the built-in exposure meter. These cameras have an on-off switch on the bottom of the body. Turn the switch **ON** to use the camera; **OFF** when you are through using it to prevent unnecessary battery drain.

LIGHT SENSORS

Minolta 35mm SLR cameras have a light sensor built into the viewfinder housing above the focusing screen. The sensor "looks" at the focusing screen just as you do when you are composing the image and focusing. The sensor measures image brightness on the screen and "tells" the built-in calculator how much light is coming in.

In some models, the light sensor uses two light-sensing elements or cells; other cameras have only one. To the user, it doesn't matter how many sensing elements there are.

Types of Light Sensors—Minolta uses two types of sensing elements:

Cadmium Sulfide (CdS) has

The XK Motor camera has a Senswitch (arrow) on the grip. The normal way to turn it on is depress the Senswitch with your right forefinger. More information is in Chapter 15.

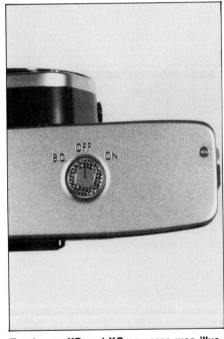

Turning on XD and XG cameras was illustrated in Chapter 6. SR-T cameras have a switch on the bottom as shown here. Press your finger against the switch and turn to ON. The B.C. setting is Battery Check.

been used in cameras for many years. It is very reliable but has two minor disadvantages. In extremely dim light, CdS responds slowly so it may take several seconds for the reading to stabilize. CdS sensors also require a

73

short time to adjust to large changes in light intensity. If you measure a very bright scene and then immediately measure a very dark scene, the meter reading will not be accurate. This property of CdS is called memory. If a minute or so elapses between major changes in light intensity, the CdS measuring cell works with no memory problem.

Both of these potential problems are rare because the shooting situations that cause them are seldom encountered. Both are easily solved by a simple operating procedure—just wait a few seconds. Most camera users never experience either of them.

The newer Silicon Photo Diode (SPD) requires more electronics in the camera but responds virtually instantaneously and is not affected by sudden large changes in illumination.

METERING PATTERNS

Several metering patterns have been developed. It's important to know and understand the metering pattern of the camera you are using.

Full-Frame Averaging—An early method of measuring light on the focusing screen was called *full-frame averaging*. With this method, the sensor is equally sensitive to light from all areas of the frame. A bright spot in one corner affects the meter as much as a bright spot in the center.

Users of full-frame averaging meters often have problems because the meter responds equally to all areas of the screen. A common example is a portrait taken against the sky. Sky brightness causes the meter to recommend reduced exposure which turns out to be OK for the sky but not enough for the subject of interest. The result is underexposure of the facial features of the subject—sometimes the subject appears in silhouette.

Center-Weighted—An improved metering pattern causes the meter to have less sensitivity to the

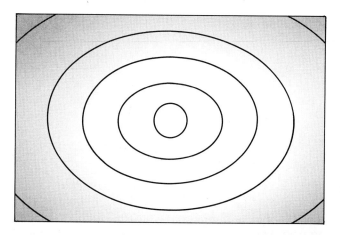

Center-weighted metering responds more t light in the center an sometimes lower cente This drawing shows th general idea. The mete is most sensitive in th center circle, less sensi tive in each band out ward from center. At th corners of the frame it i least sensitive.

edges of the frame and more sensitivity in the center where the subject is usually placed. This kind of metering is called *center-weighted* because the meter attaches more importance, or weight, to the reading in the center of the frame.

All current Minolta SLR cameras use the center-weighted metering pattern.

AN AVERAGE SCENE

By measurement of many typical scenes, it has been found that most outdoor scenes and many shots in a man-made environment have the same average amount of light coming from the entire scene. Some parts are brighter and some are darker but they average out, or integrate, to the amount of light that would come from a certain shade of gray. This gray shade is called *18% gray* because it reflects 18% of the light that falls on it.

I think we are indebted to Eastman Kodak for this discovery. Anyway, Kodak publishes cards which are 18% gray on one side and 90% white on the other. These cards are bound into some Kodak reference books, and sold separately at camera shops.

Another of my photography books, *SLR Photographers Handbook*, has the inside covers printed approximately 18% gray.

The idea is that you can meter on an average scene, or meter on an 18% gray card in the same light, and the exposure meter in your camera will give the same settings.

When metering on a gray card, be sure the card fills the metering area in the viewfinder.

As you know, film has a limited range of density between fully clear and fully black. An important idea of exposure is to cause the various light values from a scene to produce densities within the range of the film. The safest thing to do is put the middle light value of the scene right on the middle density of the film density scale. Then, higher and lower light values from the scene "have a place to go" on the film.

Not only do average scenes reflect 18% of the light, the middle tone or density of an average scene is also 18% gray. Therefore an 18% gray card, or anything else that reflects 18% of the light, represents both an average scene and the average or middle tone in that scene.

The idea of an average scene that reflects 18% of the light is very important to photography. Film manufacturers base film speed on the assumption that the film will be used to photograph an average scene with 18% overall

Many outdoor scenes are average and will be properly exposed using your camera meter without any special precautions or procedures. Average scenes include dirt, rocks, old paving, grass, foliage, people if not too close to the camera, buildings if they are not unusually dark or light, and some sky and clouds, provided they don't dominate the composition. This scene was photographed using the exposure settings recommended by the camera meter. Many indoor and man-made environments are also average if they have medium tones and are not unusually dark or light.

reflectance. Camera manufacturers design built-in exposure meters on the assumption that the camera will be used to photograph average scenes. Cameras with automatic exposure expect the scene to be average and, if so, give correct exposure. If not, the camera operator has to intercede and make an exposure correction.

HOW TO INTERPRET EXPOSURE READINGS

If you decide to go around photographing 18% gray cards, I guarantee every exposure will be a whopping success. It's built into the system. The exposure called for by ASA film-speed ratings will put an 18% gray card right in the middle of the density scale of the film.

It takes good photographic judgment to look at a real-world scene and decide if it will average out to 18% gray. If so, you can shoot it just as you would a gray card—follow the advice of the camera exposure meter. Most outdoor scenes have sky, people, dirt, rocks, foliage and maybe a distant building. This is average. If your scene is mainly sky, that is not an average scene *but the exposure meter in your camera doesn't know the difference.*

The exposure meter, unless you override it with your own good judgment, will place the average brightness or tone of every scene at the middle density of the film. If the scene is mainly sky, sky will be rendered middle gray on the print and faces of people against the sky will be too dark.

You can only believe your exposure meter when it is looking at an average scene. If you shoot a bird on a snow bank, the camera will think the snow bank is an average scene in very bright light. It will reduce exposure so the white snow appears middle-gray on the negative. If faithfully printed, it will also appear middle-gray on the print.

If you shoot a coin on black velvet, the camera will think the scene is in very poor light and open up the lens until the black velvet registers middle-gray on the film.

The clue is the amount and brightness of the background. If the subject is small and the background is large, worry. If the background is significantly brighter than middle gray, you know the camera exposure meter will want to stop down on account of the bright background and underexpose your subject. You have to

give more exposure than the exposure meter will suggest.

If the background is significantly darker than average and your main interest is the subject against that background you have to give less exposure than the meter suggests to avoid overexposing the subject.

Another situation where an exposure meter may give an unsatisfactory reading is when everything in the scene is unusually light or dark. If you photograph a marshmallow on a white table cloth, the exposure meter will suggest camera settings which make everything middle-gray on the negative. If printed that way, the result is a gray marshmallow on a gray table cloth—probably not your intention.

To make both marshmallow and cloth appear white on the print you need about two more steps of exposure than the meter will suggest.

Similarly a dark subject against a dark background will both be changed to a medium gray by the unthinking exposure meter if you allow it to happen. For realism, on the print, you probably need one or two steps less exposure than the meter will suggest.

With an automatic camera, the exposure-measuring system does

When the subject is small compared to the background, the camera meter will give an exposure that records the background as a medium tone. If the background is bright, the subject will be underexposed. If the background is unusually dark, the subject will be overexposed.

more than suggest exposures. It adjusts the camera and takes the picture the way it "thinks" is right. I'll tell you in a minute how Minolta automatic cameras allow you to take charge of the exposure setting when photographing non-average scenes, so you can prevent the camera from making a mistake.

SUBSTITUTE METERING

This is a way to solve some difficult exposure problems. Suppose you are shooting a scene with no middle tone. Everything is very bright or very dark. If areas of light and dark are about equal and the exposure meter includes an equal amount of each, the meter itself will average light and dark and give an exposure as though it was examining the middle tone of the scene. For example, a checkerboard with black and white squares will affect a meter as though it was a uniform gray color.

This requires some judgment on your part as to how bright and how dark the two extremes are and whether they appear in equal amounts to the meter.

You can sidestep the problem by placing an 18% gray card in the scene, so it receives the same amount of light as the rest of the scene. Meter on the card and shoot at the exposure setting which results. If you shoot that picture, it will show the 18% gray card as a middle tone with the surrounding light and dark areas appropriately lighter and darker than middle-gray.

A more artistic effect results from removing the 18% gray card after taking the reading but before exposing the film. The picture will be the same as before except the card won't be there. Light and dark areas will reproduce properly.

If it is not convenient to place the 18% gray card at the scene—perhaps because the scene is on the other side of a chasm or river—you can meter on the card anywhere as long as it is in the same light as the scene. If you are shooting in sunlight for example, you can assume it has the same brightness everywhere as long as it falls on the scene or subject at the same angle. Hold the gray card near the camera in the same light as the scene and meter on the gray card.

Angle the card so it faces a point between camera and main light source and so the camera does not see glare reflected from the surface of the card.

Metering on a substitute surface instead of the scene itself is called *substitute metering*. Many photographers carry an 18% gray card for this purpose.

In dim light, a gray card may not reflect enough light to allow metering. Some gray cards are 90% white on the reverse side and white paper is about the same. If you meter on 90% white instead of 18% gray, the white card will reflect five times as much light into the exposure meter as the gray card would, because:

90%/18% = 5.

Because the exposure meter assumes everything out there is 18% gray, it attributes the high value of light to brighter illumination rather than greater reflectance of the surface. Therefore it will recommend an exposure only 1/5 as much as it would if you were actually metering on 18% gray. Because you know that, compensate by increasing exposure to 5 times the exposure metering reading.

To make the correction, multiply the indicated shutter-opening time by 5 and select the nearest standard number. If the exposure

Many things around you have reflectances that are surprisingly close to 18%. With your camera exposure meter and a gray card for comparison, you'll discover that you can use grass, old paving, brown dirt, foliage and a lot of other things as a substitute metering surface.

Light skin reflects about one step more light than 18% gray. Take the reading, then set the camera to give one step more exposure.

Every part of this scene received satisfactory exposure, but no part of it was actually metered by the camera. I used substitute metering, taking the reading from foliage at the right. Then I used those exposure settings to make this shot.

meter says shoot at 1/60 second, you will want to shoot at 5/60 second which reduces to 1/12 second. The nearest standard speed is 1/15 second.

You can also correct by changing aperture. Opening up by 2 steps is an increase of 4 times, which is often close enough. Opening up aperture by 2-1/2 steps increases exposure 5.6 times, which is closer. The click stops or detents between the numbered settings of the aperture ring are half-steps.

There is no exact setting of the aperture ring which gives a 5-times exposure increase. You can guess at it by setting between 2 steps and 2-1/2 steps increase but you normally don't need such precision.

A very handy substitute metering surface is the palm of your hand. You should check your own palm but light skin typically reflects about one step more light than an 18% gray card. If so, you can hold your palm in front of the camera—in the same light as the subject or scene—meter on your palm and then open up one step. If your palm reflects only a half step more, obviously that's how much to open before shooting.

You will find that dirt, grass, weeds, foliage and other common things have a surprisingly uniform reflectance and often it is the same as an 18% gray card. Spend some time measuring common surfaces around you and you will learn to use them in a hurry as substitute metering surfaces to set your camera for a quick shot of some unusual scene such as a flying saucer passing by.

Another advantage of using your exposure meter to measure the reflectance of common objects is that it helps you learn to distinguish non-average scenes from average scenes.

WHEN TO WORRY ABOUT BACKGROUND

The only time you need to worry about background is when there is a lot of it *in the metering area* and the background is brighter or darker than middle-gray.

As a rule of thumb for center-weighted metering, if your *subject* fills the center part of the viewing screen, you can disregard background.

If the subject is small compared to the metering area and the background is bright, increase exposure over the meter recommendation; decrease exposure if the background is dark—because the meter reading is affected by background. The amount of exposure increase is basically an estimate and you'll get better at estimating if you practice. The usual limits are:

2 steps more exposure if the background is white as paper.

2 steps less exposure if the background is very black.

TECHNIQUES TO AVOID BACKGROUND PROBLEMS

Substitute metering requires you to meter on one object while setting the exposure controls, then point the camera at the scene you intend to shoot and make the exposure without changing exposure settings.

With the camera on manual operation, this is straightforward and easy to do. It's also easy to do with the camera on automatic, using a method I'll explain shortly.

In my experience, the best way to avoid problems when photographing non-average scenes is to use substitute metering as already described. It is virtually my standard metering method. But there are other ways.

When sky background is a problem, you can point the camera downward while metering and setting the exposure controls. Most natural terrain has about 18% reflectance, so this method is approximately equivalent to metering on a gray card. Then change the camera angle to include as much sky as you wish and shoot without changing the controls.

This doesn't work at the beach where the sand is about as bright as the sky. A trick to use at the

The sunny-day *f*-16 rule works very well to give good exposures without metering the scene at all.

beach and in many other circumstances is to move close enough so the subject fills the metering area or occupies most of the frame. Meter and set exposure controls. If your subject has unusually light or dark skin, an exposure correction may be necessary—particularly if you are shooting color-slide film. For example, when you meter on light skin, you should normally give one-half or one full step more exposure. Then back up and shoot the picture you want, without changing the controls.

An alternate to marching forward with your camera is to substitute a long-focal-length lens and get a bigger image of the subject for metering. Then put another lens on and shoot using the same settings you found with the long lens. An alternate to switching lenses is to use a zoom lens on the camera. Zoom in to meter, then zoom to a wider angle of view to make the shot.

Averaging *f*-numbers is another way of solving some difficult exposure problems. Suppose the scene has bright areas and dark areas, both of interest. Move your

camera close enough to get an exposure reading on the bright area and notice the recommended setting. Suppose it's *f*-8 at 1/125. Then meter on the dark area and again note the recommended setting. Say it's *f*-2 at 1/125.

You average these two exposure recommendations and shoot at that average setting. It doesn't matter if the scene has any middle tones or not.

How do you average *f*-numbers? Do it by counting exposure steps. The average of *f*-2 and *f*-8 is *f*-4, two steps from each end.

If you want to do it by mathematics, you can't take a common *arithmetic* average because it gives the wrong answer. For example, the wrong answer is $(2+8) / 2 = 5$. The correct middle step is *f*-4, not *f*-5.

To average *f*-numbers, you have to find the *geometric* average of two numbers. Multiply them together and then take the square root of the result—easy to do if you carry a scientific pocket calculator with you on photo trips. Anyway, $2 \times 8 = 16$ and $\sqrt{16} = 4$.

78

THE SUNNY-DAY f-16 RULE

Even though Minolta cameras measure the light and have a viewfinder display to help you get the right exposure, it is sometimes helpful to estimate exposure-control settings. Here's a simple rule I have found useful:

On a clear sunny day with your subject or scene illuminated directly by sunshine, set the shutter-speed dial at the film-speed number and use f-16.

This means, if you are using ASA 125 film, f-16 at 1/125 second should give a satisfactory exposure. Of course, any other pair of control settings that gives the same amount of exposure will also be OK.

BRACKETING EXPOSURES

When there is any uncertainty about correct exposure, it's a good idea to bracket so you are sure of getting at least one good shot. Make an exposure at the setting you think may be right. Then make additional shots at other exposure settings, usually both more and less.

With color film, it's usually best to bracket in half-steps because changing exposure also changes the colors. Small color changes can be corrected when printing from color negatives, but can not be corrected on slide film. With b&w, bracketing in full steps is usually OK.

Experience is the best guide to bracketing. Try it and observe the results carefully. Professionals bracket a lot and say film is cheap. Besides that, the professional charges his client for the cost of film and other direct expenses in doing the job. If you have made a long trip, hired models and spent all day setting up your shot, film is cheap compared to your other expenses.

To many amateurs, film is not cheap and nobody else is paying for it. It still pays to bracket, but you can do it conservatively. If there is any uncertainty of any kind, bracket. If the shot is very important to you, bracket.

If you are shooting in your back yard, and can do it again if you need to, make one exposure using your best photographic judgment and see what happens. I think this is a good photographic exercise that will improve your skill and judgment.

HOW LENS AND CAMERA WORK TOGETHER

It will help you understand how a Minolta automatic camera works and how to use it if we spend a minute discussing the mechanical couplings between Minolta lenses and cameras. These are shown in the accompanying photos and the parts are labeled. Please notice that I have used the word *pin* to identify parts on the lens and the word *lever* to identify parts on the camera body. This does not agree exactly with Minolta nomenclature but I think it makes it easier to follow.

There are three pins on an MD lens and two or three levers on the camera body, depending on the model. XD cameras have three levers; XG cameras have two levers.

Full-Aperture Metering—This is done by the Diaphragm Control Pin on the lens and the Diaphragm Control Lever on the camera.

If you remove the lens and set the aperture ring to any aperture smaller than wide open, you will notice that the aperture closes immediately to the set value. The lens always "wants" to close to the set aperture value because of a spring in the lens and it will do so whenever it can. If you push the Diaphragm Control Pin fully to the left, looking at the back of the lens, the diaphragm opens up to maximum aperture and is held at maximum aperture against the force of the internal spring in the lens.

If you release the Diaphragm Control Pin, it will move to the right and aperture size will change from wide open to whatever f-number has been set on the lens

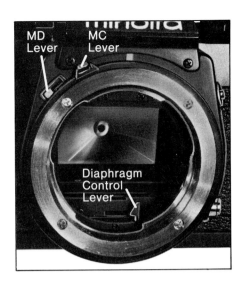

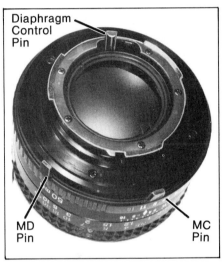

Three pins on an MD lens work with three levers on an XD camera.
Minolta MD lenses work with all 35mm Minolta SLR cameras but only the XD models have all three levers on the camera.

aperture ring. The lens can never close down to an aperture smaller than that set on the aperture-control ring.

When the lens is mounted on the camera, the Diaphragm Control Pin on the lens contacts the Diaphragm Control Lever in the camera body. Normally this lever holds the pin on the lens all the way to the left, so the aperture remains wide open.

During the exposure sequence, the Diaphragm Control Lever in the camera releases the Diaphragm Control pin on the lens. Aperture then closes to the value set on the aperture ring. If you have the lens set to f-8, it closes to f-8. If you have the lens

set to minimum aperture which is *f*-16 or smaller depending on the lens in use, the lens will close to minimum aperture.

In summary, the Diaphragm Control Lever in the camera holds lens aperture wide open until just before the shutter operates, then it allows aperture to close to the set value.

MC Pin—MC stands for Meter Coupling, which allows metering at full aperture. The MC pin projects from the aperture ring and moves whenever you change aperture setting. The pin on the lens contacts the MC Lever on the camera body when the lens is mounted. Thus the pin transmits a mechanical signal to the lever which "tells" the camera what aperture is being selected—even though aperture size does not actually change until you operate the shutter button.

Because the calculator in the camera knows what aperture size has been selected on the lens, it can anticipate the amount of light that will pass through the lens *after* it stops down. Therefore the camera calculator can figure correct exposure based on the shooting aperture of the lens.

MD Pin—This pin is on all Minolta MD lenses but it functions only with XD cameras. Because these cameras have dual modes of automatic operation, aperture-priority and shutter-priority, I surmise that the letter *D* in both lens and camera nomenclature implies *Dual*. Only lenses with an MD pin can be used for shutter-priority automatic operation with an XD camera.

The MD pin on the lens projects from the aperture ring just as the MC pin does. It's at a different location on the ring and is positioned so it touches and operates the MD Lever on the camera *only when the lens is set at minimum aperture*. When the MD pin on the lens operates the MD Lever on an XD camera, the camera is set up for shutter-priority automatic exposure.

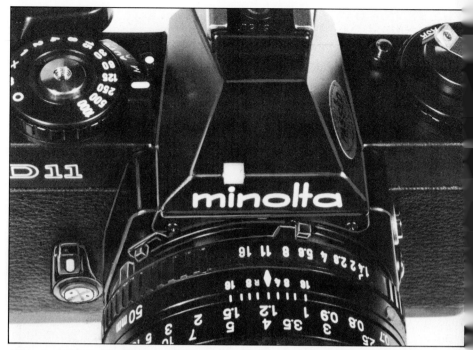

When an MD lens is installed on an XD or XG camera, the MC pin on the lens engages the MC lever on the camera. The MC pin is an extension of the lens Aperture Ring. As you rotate the Aperture Ring on the lens to select aperture size, the MC pin on the lens moves the MC lever on the camera, which signals the *f*-number setting of the lens to the camera exposure meter.

The MD pin, at the left in this photo, is also attached to the lens Aperture Ring. It touches and moves the MD lever on the camera only when the lens is set to minimum aperture. This is one step in setting up the camera to work on shutter-priority automatic. This lens is set to *f*-11, so the MD pin is not touching the MD lever.

EXPOSURE CONTROL

Control of exposure depends partly on what the camera does and partly on what the operator does. The relationship between camera and operator is different in the various operating modes. In the following discussions of operating modes, it is assumed that the correct film speed has been set on the film-speed control. References are made to the exposure display in the viewfinder which shows you recommended exposure settings or settings that the camera has made for you. This discussion centers on how the camera operates, rather than the exposure displays themselves. Later in this chapter, I will show you the exposure displays and discuss how to interpret them.

Manual Control—In this mode, you set aperture and shutter speed to any combination that gives the exposure you want. In some models, the exposure meter will calculate exposure assuming you are photographing an average scene and will display what it "thinks" is correct exposure in the viewfinder exposure display. You can set aperture and shutter speed to agree with the viewfinder display or make any other settings, as you choose.

Substitute metering is very simple on manual operation because the exposure controls stay where you set them, no matter where you point the camera. You can provide more or less exposure just by changing the settings. Your settings may no longer agree with the viewfinder recommendations for correct exposure but that doesn't matter—you are using the exposure you prefer for the circumstances.

All Minolta 35mm SLR cameras with automatic exposure capability can also be set for manual control and operated as just described. When set for automatic operation,

When you have plenty of time and nothing in the scene is changing very fast, you can use any mode of operation—manual or automatic.

When you want to shoot quickly, or prefer not to worry about exposure settings, use automatic exposure control.

some procedures depend on which model you are using.

Among the automatics, XG cameras turn off the camera meter and the viewfinder exposure display when you switch to manual. When using a camera that has automatic-exposure capability, you normally use the camera on automatic unless you disagree with the exposure settings the camera plans to use.

With an XG camera, to see the meter reading you must have the camera on automatic. If you want to use some other exposure settings, switch to manual and make the settings, using the camera recommendation as a guide. Another alternative is to use a separate hand-held accessory exposure meter to decide manual exposure settings.

SR-T cameras are manual only and the meter works all the time when the camera is turned on.

XD cameras meter and display the reading when the camera is switched to manual. Minolta calls this *metered manual* to indicate that the meter remains on. In this case, the meter displays a recommended exposure—which normally is

satisfactory for an average scene. If the scene is not average or if you want to give more or less exposure for any reason, change the controls as you please.

Aperture-Priority Automatic— XD, XG and XK models have this option. After you select aperture size by turning the aperture ring, the camera calculates and the viewfinder displays a shutter speed to give correct exposure of an average scene.

When selected *by the camera*, shutter speed is controlled electronically and it can be any value, such as 1/285 second, rather than one of the standard steps on the shutter-speed control. You can set the aperture ring to any value, such as *f*-4, or anywhere between the detents on the aperture ring.

The viewfinder display shows the nearest standard shutter speed. For example, if the camera intends to use 1/285, the camera display will show 1/250 second.

The camera will use the aperture setting you made on the lens and the shutter-speed setting calculated by the camera.

Aperture Priority with XD Cameras—Most aperture-priority automatic cameras measure the light with the lens wide open, calculate a shutter-speed setting for that amount of light, remember the shutter speed and make the exposure at that value after the lens has stopped down to shooting aperture. XG and XK models operate this way.

XD cameras have a special way of setting shutter speed when on aperture priority. The first determination of shutter speed is with the lens wide open, the same as other cameras.

In XD models, the light-measuring system continues to operate while the lens is stopping down to the aperture value you selected. *After* the lens has stopped down, the camera makes another exposure measurement and re-adjusts shutter speed if needed to produce correct exposure.

If the light changes between the moment when you press the shutter button and the time the shutter begins to open, XD cameras will notice the change and make the necessary shutter-speed adjustment.

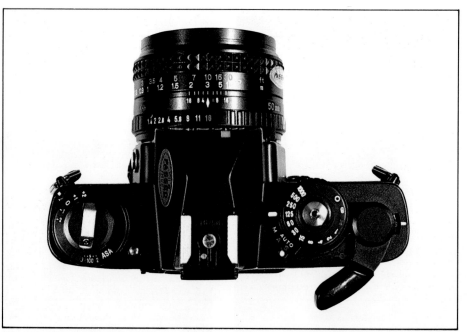

To set an XD camera for Shutter-priority automatic, do two things. Move the Mode Selector to S and set the lens to its minimum aperture size, whatever that size is. Notice that both settings are colored green to remind you to make both of them.

Shutter-Priority with XD-Series Cameras—With shutter priority, you select a shutter speed, the camera measures the light and makes an exposure calculation, and then the camera sets aperture to provide correct exposure for an average scene.

In XD cameras, the exposure-measuring system makes a second check after the lens stops down on shutter-priority automatic, just as it does on aperture-priority automatic. After the lens stops down, the camera rechecks the exposure and readjusts shutter speed if needed. Here's how:

To control aperture, the Diaphragm Control Lever in the camera releases the Diaphragm Control Pin on the lens, which allows the aperture to start from wide open and close down while the camera light-measuring system monitors the amount of light coming through the lens.

When the amount of light is correct, the calculator in the camera issues an electronic command which causes the Diaphragm Control Lever in the camera to stop moving. This, in turn, stops movement of the pin on the lens and aperture size is locked at that value, whatever it is.

The aperture can *never* close down smaller than the *f*-number set on the aperture ring. Usually the Diaphragm Control Lever in the camera won't let it close that much. It will stop the mechanism at the aperture size selected by the camera for correct exposure.

XD cameras have some design features that make the next step possible: Light is measured by silicon sensors which work virtually instantaneously. Exposure calculation is done by an electronic calculator which also works instantaneously. Shutter speed is set electronically, steplessly, and instantaneously. On shutter-priority, the calculator in the camera controls *both* shutter speed and aperture size.

The camera makes a second light measurement and exposure calculation after the lens has closed down to shooting aperture. If the amount of light is not exactly what the camera calculator expects it to be, the calculator instantaneously changes shutter speed to compensate. If the amount of light is less than expected, the shutter is held open longer, so actual exposure is exactly what the camera calculator had decided on. If there is more light than expected, the shutter is closed sooner.

Minolta has several names for the second exposure measurement and resulting correction, but the one I think fits best is *final check* because that's exactly what happens.

Not only does the final check improve exposure accuracy, it helps prevent mistakes due to operator error or changing light conditions.

For example, if you select a shutter speed that is too slow for the amount of light on the scene, the camera will close lens aperture as much as it can. Then the final check will show that overexposure is likely and the camera will automatically select a faster shutter speed to provide correct exposure.

If you choose a shutter speed that is too fast, the camera will test exposure after the lens has opened up as much as it can and then select a slower shutter speed to give correct exposure.

If the light changes between the time you press the shutter button and the final check on exposure, the camera will adjust shutter speed for the changed amount of light.

Please notice that the final-check operation uses the aperture size already selected by the camera and then changes shutter speed to get correct exposure.

The camera, of course, cannot adjust shutter speed beyond the shutter-speed limits of operation—meaning that it can't force the shutter to work faster or slower than the shutter mechanism is designed to do.

Because exposure in any mode depends on correct light measurement, automatic-exposure range is limited by the accuracy range of the light-measuring system. These limits are expressed in EV numbers as discussed later in this chapter.

Normally, in shutter-priority operation, we expect the camera to choose from the full range of aperture sizes available on the lens. XD cameras can do this *provided* the lens is set to its minimum aperture. If the aperture ring is set to an aperture larger than minimum, the camera mechanism cannot force the lens to a smaller aperture than the set value.

Therefore there are two control settings you should make to set up the camera for shutter-priority operation. One is the Mode Selector switch on top of the camera. Set it to **S**. The Mode Selector switch sets up the camera to work on shutter priority and also changes the scale in the viewfinder display so it shows *f*-numbers rather than shutter speeds.

The other is the aperture ring. Set it to the *smallest* aperture. When an MD lens is mounted on an XD camera and the lens is set to minimum aperture, the MD Pin on the lens operates the MD Lever on the camera body. This tells the camera what the lens minimum aperture is and also causes the viewfinder to display the aperture size selected by the camera.

If you don't set the aperture ring to minimum aperture, the viewfinder display doesn't work properly. It either fails to indicate an *f*-number or it indicates overexposure. This is a signal to recheck control settings.

If you leave the lens set that way, the camera forgives you and sets exposure automatically using shutter priority as much as possible. There will be two differences in operation: The viewfinder display will not work and lens aperture cannot be smaller than the setting on the aperture ring.

When shutter speed is important to the effect of the picture, operate with shutter priority. These three photos were taken at 1/500, 1/125 and 1/30 second. Notice the effect of longer shutter speed. When photographing discrete moving subjects, such as cars, longer shutter speeds produce a blurred image which may be desirable to suggest speed and movement.

Let's assume that the lens is set for *f*-8 instead of minimum aperture. Suppose you have selected a shutter speed of 1/125 and the camera calculates *f*-11 for correct exposure.

When you depress the shutter button, the sequence begins. The lens stops down to *f*-8, but can't stop down any further because that's where you have it set. The final-check procedure recognizes the problem and changes shutter speed to 1/250 to give correct exposure. 1/250 at *f*-8 is the same amount of exposure as 1/125 at *f*-11, so you should get correct exposure but not at the shutter speed you intended to use.

Operating this way is not a normal procedure and is not one of the "official" modes. In Chapter 9, I will remind you of this possibility so we need a name to identify it. Let's call it *abbreviated shutter priority* because the range of available aperture sizes is reduced.

INTERMEDIATE CONTROL SETTINGS

With all Minolta 35mm SLR cameras, the shutter-speed dial should be set on one of the marked numbers. If you make an intermediate setting of the dial, the camera will operate at one of the adjacent standard speeds, if on manual. On automatic, the camera itself can make shutter-speed settings that are between the standard values, but the shutter-speed dial should be set on a marked number anyway. On the aperture ring, intermediate settings are OK in all modes, with all cameras.

FILM SPEED AS AN EXPOSURE CONTROL

With a camera on manual operation, the film receives the amount of exposure requested by the film-speed number—provided you set aperture and shutter speed to agree with the camera's recommendation as shown in the viewfinder display.

With a camera on automatic, the film receives the amount of exposure stipulated by the film-speed number if you just let the camera make the exposure.

Every photographer with an adjustable camera has shot film with the wrong number set on the camera film-speed dial. Some of us will even admit it. Usually this causes bad exposures because the camera will obligingly give the amount of exposure requested by the film-speed setting on the dial.

Besides using the film-speed dial as a handy way to make mistakes, we can also use it constructively as an exposure control.

Suppose you want *more* exposure than the camera would normally give, because you are photographing a non-average scene or you have some artistic effect in mind. You can get it by setting the camera film-speed dial to a *lower* number than the film actually has. This persuades the camera that the film needs more exposure and therefore it gets more exposure. Similarly, to give *less* exposure, set the film-speed dial to a *higher* number than the film is labeled.

When using film speed as an exposure control, doubling or halving the number changes exposure one step as discussed in Chapter 2.

Changing film speed as a way of changing exposure is a risky procedure. After making the adjustment and shooting the photo you want, you must remember to change the film-speed setting back to the correct value for the film you are using. If you forget, following shots are likely to be incorrectly exposed.

Even worse is to forget what film speed you have loaded so you don't know how to reset the control correctly—a predicament I have never admitted to anyone.

EXPOSURE-ADJUSTMENT CONTROL

You can change the film-speed setting on any 35mm Minolta SLR camera as a way of changing exposure. On manual, I don't recommend doing it because it's just as easy to change shutter-speed or aperture settings directly to give more or less exposure and you are less likely to make a mistake doing it that way.

On automatic operation, you can't change exposure by changing aperture or shutter-speed settings because the camera will make a compensating change to maintain what it thinks is correct exposure. If you open the lens one step, the automatic camera will change shutter speed to the next faster step and exposure remains the same.

Minolta automatic cameras provide a special control to override the camera and give more or less exposure on automatic. It's called the Exposure-Adjustment Control. It works indirectly so you never actually change the film-speed number on the camera although what it actually does is change the film-speed setting internally. The control is adjacent to the film-speed dial. The adjustment range is from +2 to -2 exposure steps.

The advantage is that you don't have to actually change the film-speed dial setting. Even so, you have to remember to reset the Ex-

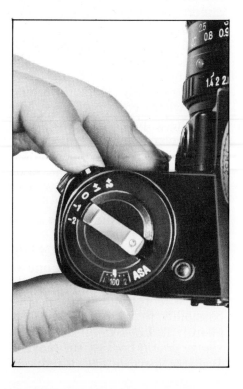

posure-Adjustment Control when you want to return the camera to normal operation or you will get incorrect exposures.

You can set the Exposure-Adjustment Control on marked settings or any intermediate setting. To change exposure more than two steps plus or minus, use the film-speed dial.

Limits of Exposure Adjustment—The Exposure-Adjustment Control does not extend the range of film-speed settings. If the camera is set at the slowest possible film speed—ASA 12 on some models—you cannot cause the camera to operate at ASA 6 by moving the Exposure-Adjustment Control to a plus setting. Similarly, you cannot force the camera to work higher than the highest ASA number on the dial by using a minus setting.

XD Cameras—These limits are mechanically enforced. When set at minimum film speed, the Exposure-Adjustment Control is blocked so you can't move it in the plus direction. When set one step higher than the minimum film speed, you can move the Exposure-Adjustment Control one step in the plus direction because this is equivalent to resetting film speed.

On XD cameras, the Exposure-Adjustment Control is near the ASA film-speed control because they work together. When the camera is on automatic exposure, you can command it to give more or less exposure than it normally would use.

o the slowest value. With film-speed settings of two steps above minimum, or higher, you can use two steps of exposure in the plus direction.

The same method of limiting exposure adjustment is used at maximum film-speed settings—the Exposure-Adjustment Control is blocked so you can't move it in the minus direction.

XG Cameras—The Exposure-Adjustment Control works differently but the limits are similar. These cameras have aperture-priority automatic exposure and the Exposure-Adjustment Control can be used only when the camera is set for automatic operation.

When operating with aperture-priority, changing the film-speed setting or changing the Exposure-Adjustment Control setting both have the end result of changing shutter speed because that's how the camera controls exposure.

You can always make all possible control settings for *exposure adjustment* on an XG camera—plus or minus two steps—but the setting is not valid if it calls for a shutter speed beyond the normal range.

If the camera is already operating at a shutter speed of 1/1000 second and you move the Exposure-Adjustment Control to ask for one step less exposure, the camera will not operate at 1/2000 second. Instead, the shutter button will lock and the overexposure warning triangle in viewfinder display will glow to tell you that the setting is invalid.

In dim light, if you use the Exposure-Adjustment Control to force the camera to shutter speeds slower than the camera can provide, the camera will operate but exposure may not be correct.

XK Motor Cameras—Both metering and exposure adjustment are built into the optional AE-S viewfinder.

SUBSTITUTE METERING ON AUTOMATIC

When you want to meter on a

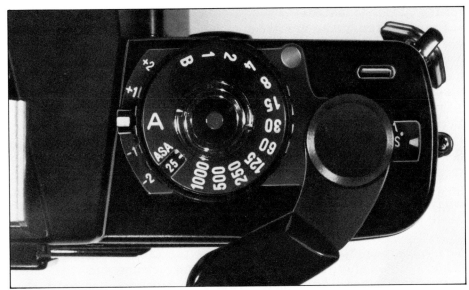

With XG cameras, you choose between aperture-priority Automatic or manual shutter-speed control. To select Automatic, rotate the control so A is opposite the white index mark as shown here. To select manual, depress the Auto-Setting Release button, upper right in this photo, while turning the control to any setting from B to 1000.
To set ASA film speed, lift the outer rim of the control and turn to bring the desired film-speed number into view.

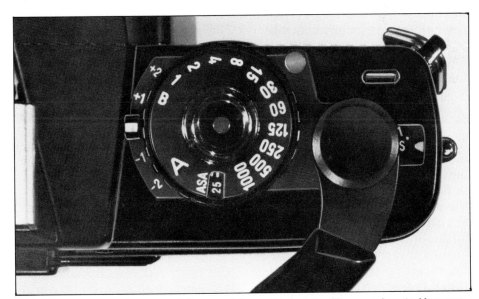

On XG cameras, the Exposure-Adjustment Control is near the film-speed control because they both affect exposure. To use exposure adjustment on automatic, depress the Auto-Setting Release button and turn the symbol A away from the white index mark to align with the amount of exposure adjustment you want. This control is set at -2, to give two steps less exposure than the camera normally would use.
In effect, XG cameras have five automatic exposure settings: one to give normal exposure and four others to give more or less exposure than normal. If you move the symbol A beyond +2 or -2 on the exposure-adjustment scale, the camera is no longer set for automatic operation. It will be set to B, I000, or one of the other numbered shutter speeds.

middle tone and then photograph a non-average scene, you have to make certain that an automatic camera uses the exposure settings from the substitute metering surface.

Here's how: While metering on the substitute surface, notice the exposure settings the camera recommends. Then compose and focus on the non-average scene that you intend to photograph. Move the Exposure-Adjustment Control so the camera shows the same exposure settings for the non-average scene as it did earlier

for the substitute surface.

Example: You intend to make a portrait against a bright sky background. Meter on grass or a gray card. The aperture-priority automatic camera indicates 1/125 at *f*-8. Then focus on your subject. Because of the bright sky, the camera meter indicates 1/250 at *f*-8. Move the Exposure-Adjustment Control to +1. Now the camera indicates 1/125 at *f*-8, which is what you want it to use. Make the exposure.

Don't forget to return the Exposure-Adjustment Control to the center position afterwards!

Alternate Method—After metering on the substitute surface with a reading of 1/125 at *f*-8, switch the camera to manual. Set the exposure controls to 1/125 at *f*-8. Make the picture. The advantage of this method is that you don't have to remember to reset any controls.

WITH THE SUBJECT OFF-CENTER

The same techniques can be used when you want to compose the photo so the subject of interest is off-center and the background is either unusually light or unusually dark. Begin by viewing the subject in the center of the frame and note the exposure settings. Then move the camera so the subject is where you choose. The reading will change because the reflectance in the metering area changed. Using the Exposure-Adjustment Control, or the Film-Speed Selector, or by switching to manual operation, reset the camera so aperture and shutter-speed settings are the same as when you metered with the subject in the center of the frame.

ADJUSTING FOR SUBJECT REFLECTANCE

You can solve nearly any metering problem by remembering that the camera meter "expects" to see middle-gray and will adjust exposure so whatever it does see is recorded as middle-gray on the film. When you meter on a middle tone and make the exposure at that setting, everything else in the same light will record with the correct tone—either lighter or darker than middle-gray.

Light skin typically is a full step lighter than 18% gray, that is, it has a reflectance of about 36%. If you make a portrait of a light-skinned person and the meter sees mainly skin, the meter will recommend an exposure that brings the skin tone down to middle-gray, which will be a step too dark. The correction is to note the exposure settings the camera intends to use, then take charge and reset exposure to give one step more than the camera suggests.

You can find out how much brighter or darker any object is by metering on that object and then metering on a gray card or other middle tone in the same light. If the subject is two steps brighter than middle-gray, which is generally true of snow or white objects, use two steps more exposure than the camera meter recommends. Otherwise white records as middle-gray. Similarly if you meter on a very dark or black surface, decrease the camera-recommended exposure by two steps.

RECIPROCITY FAILURE

So far, I have encouraged you to believe that you can shoot at any shutter speed you choose, adjusting aperture accordingly so you get the correct exposure. That is true when photographing in daylight and in well-lit interiors.

With a normal amount of light on the scene, the Reciprocity Law applies, but here is the fine print that states the exceptions:

People once thought the law applied to all values of light and time, but there are exceptions when the shooting light is either unusually bright or unusually dim. These exceptions are called *reciprocity-law failure*, or *reciprocity failure.*

The problem lies in the nature of film, not in the camera. It is always due to light which i brighter or more dim than the design range of the film emulsion. Even though reciprocity failure i caused by the amount of light, the best clue to the camera operator i shutter speed. Unusually fast shutter speeds mean there is a lot o light and unusually slow speed mean the light is dim.

As a general rule for mos amateur films, if you are shooting faster than 1/1000, or slower than 1/10 second, you should think about the possibility of reciprocity failure. Consult the film data sheet. Some films have a more limited "normal" range of exposure times than those I just mentioned.

The basic effect of reciprocity failure is always *less* actual exposure on the film than you expect.

Therefore the basic correction is to give more exposure by using larger aperture, more time, or both.

For example, if an exposure meter or an exposure calculation suggests using *f*-4 at 4 seconds, the film manufacturer may say to give one step more exposure than that to compensate for reciprocity failure. Use *f*-2.8 if it is available on the lens, or shoot at 8 seconds.

With b&w film, the film data sheet may call for more exposure and also a change in the development procedure. With color film, reciprocity failure can cause both underexposure and a color change on the film. The compensations may be more exposure, use of a color filter on the lens, and a change in development.

Minolta cameras will meter in dim light and make exposures that are well into reciprocity failure for most films. Making pictures in dim light is challenging and enjoyable provided you remember to compensate for reciprocity failure.

There are four ways: Best is to use the film manufacturer's data—see Chapter 10. If you don't have data, make tests to find the best correction. If you don't have time to make tests, you can shoot

EV NUMBERS & EQUIVALENT EXPOSURE SETTINGS

EV	4 min.	2 min.	1 min.	30 sec.	15	8	4	2	1	1/2	1/4	1/8	1/15	1/30	1/60	1/125	1/250	1/500	1/1000	1/2000
-8	*f*-1																			
-7	1.4	*f*-1																		
-6	2	1.4	*f*-1																	
-5	2.8	2	1.4	*f*-1																
-4	4	2.8	2	1.4	*f*-1															
-3	5.6	4	2.8	2	1.4	*f*-1														
-2	8	5.6	4	2.8	2	1.4	*f*-1													
-1	11	8	5.6	4	2.8	2	1.4	*f*-1												
0	16	11	8	5.6	4	2.8	2	1.4	*f*-1											
1	22	16	11	8	5.6	4	2.8	2	1.4	*f*-1										
2	32	22	16	11	8	5.6	4	2.8	2	1.4	*f*-1									
3	45	32	22	16	11	8	5.6	4	2.8	2	1.4	*f*-1								
4	64	45	32	22	16	11	8	5.6	4	2.8	2	1.4	*f*-1							
5		64	45	32	22	16	11	8	5.6	4	2.8	2	1.4	*f*-1						
6			64	45	32	22	16	11	8	5.6	4	2.8	2	1.4	*f*-1					
7				64	45	32	22	16	11	8	5.6	4	2.8	2	1.4	*f*-1				
8					64	45	32	22	16	11	8	5.6	4	2.8	2	1.4	*f*-1			
9						64	45	32	22	16	11	8	5.6	4	2.8	2	1.4	*f*-1		
10							64	45	32	22	16	11	8	5.6	4	2.8	2	1.4	*f*-1	
11								64	45	32	22	16	11	8	5.6	4	2.8	2	1.4	*f*-1
12									64	45	32	22	16	11	8	5.6	4	2.8	2	1.4
13										64	45	32	22	16	11	8-	5.6	4	2.8	2
14											64	45	32	22	16	11	8	5.6	4	2.8
15												64	45	32	22	16	11	8	5.6	4
16													64	45	32	22	16	11	8	5.6
17														64	45	32	22	16	11	8
18															64	45	32	22	16	11
19																64	45	32	22	16
20																	64	45	32	22
21																		64	45	32

several different exposures such as 4, 8 and 16 seconds, hoping one will be right. The poorest way is to guess, but even that is better then making no correction at all.

To make exposures longer than you can select on the camera shutter-speed dial, set the dial to **B**. Then hold the shutter button depressed for the desired exposure time. The best way to hold the shutter button down is to use a locking cable release.

HOW MANY EXPOSURE STEPS CAN A CAMERA MAKE?

It depends on the camera model and the lens in use. The XD-ll has manual shutter speeds from 1 second to 1/1000 second. The 50mm *f*-1.4 lens has an aperture range from *f*-1.4 to *f*-16.

Suppose we set the lens to its smallest aperture and the shutter to its fastest speed. Then move the shutter to slower speeds until we use them all up. Then, at the slowest shutter speed, continue to increase aperture size a step at a time by opening the lens until it is fully open. Count the steps. Each space between lines in the adjoining table is an exposure step.

I make it 17 steps, total. The number of exposure steps has practical significance. You should recognize that each of the exposure settings in the preceding list is a definite amount of exposure—different by a factor of two from the one above or below.

However, most of these exposures can be produced by more than one pair of control settings. For example, *f*-16 at 1/15 is the same as *f*-11 at 1/30, *f*-8 at 1/60 and so forth.

To simplify identification of the *amounts* of exposure, let's assign a number to each one as shown in the right-hand column. Those identification numbers are Exposure-Value (EV) numbers. For some purposes they are more convenient to use because each

f-Number	Shutter Speed	EV Number
16	1000	18
16	500	17
16	250	16
16	125	15
16	60	14
16	30	13
16	15	12
16	8	11
16	4	10
16	2	9
16	1 second	8
11	1 second	7
8	1 second	6
5.6	1 second	5
4	1 second	4
2.8	1 second	3
2	1 second	2
1.4	1 second	1

amount of exposure is represented only by a single EV number rather than the whole assortment of combinations of f-stop and shutter speed that will yield the same amount of exposure.

EV NUMBERS

Minolta uses EV numbers in two different ways, both of which require brief explanations.

EV as a Measure of Exposure— To increase exposure by one EV means to increase by one exposure step which you can do either by opening aperture one step or using the next slower shutter speed. In this sense, EV means exposure step.

EV numbers actually represent only pairs of aperture and shutter-speed settings that would give the same exposure of the same scene on the same film. To use EV as an amount of exposure requires the assumption that the amount of light doesn't change and the film speed doesn't change—both of which are reasonable assumptions but usually not stated.

EV Measuring Range of an Exposure Meter— Minolta states the measuring range of built-in exposure meters in EV numbers as you can see in the accompanying table. Because the camera exposure meter and calculator control operation on automatic, the measuring range of the meter is also the automatic operating range of the camera.

What the exposure meter actually measures is light. All light-measuring sensors have a limited range of operation—the light can be too bright for an accurate reading or it can be too dim.

To use an EV number as a way of specifying the amount of light from the scene that can be accurately measured requires that two other factors be stated or implied: film speed and maximum aperture of the lens.

It is assumed that the light from the scene is enough for correct exposure of the film in the camera. Therefore stating film speed is a

MINOLTA BUILT-IN EXPOSURE METERS			
Camera	Metering Range (EV)	Light Sensor	Metering Pattern
XD-11	1 to 18	Silicon	Center-weighted
XD-5	1 to 18	Silicon	Center-weighted
XG-9	2 to 17	CdS	Center-weighted
XG-7	2 to 17	CdS	Center-weighted
XG-1	2 to 17	CdS	Center-weighted
XK Motor	-2 to 17	Silicon	Center-weighted
SR-T 201	3 to 17	CdS	Center-weighted
SR-T 200	3 to 17	CdS	Center-weighted

way of defining the amount of light represented by a certain EV number.

Light that reaches the film must pass through the lens. A camera can measure farther into dim light through a large aperture than through a small aperture. Because light measurement is normally done with the aperture wide open, it is only the maximum aperture that matters.

For these reasons the measuring range of the built-in meter is stated as a range of EV numbers with the provision that ASA 100 film is in the camera and a lens with maximum aperture of f-1.4 is installed.

When a camera is setting exposure automatically, the measuring range of the meter becomes the operating range of the camera. The camera cannot set exposure accurately for an amount of light that can't be measured accurately.

Practical Considerations— The only time you should worry about metering accuracy is when you are operating near the limits—in very bright light or very dim light. All Minolta cameras meter and operate correctly when scene illumination is brighter than direct sunlight on a clear day, so there is usually no reason for concern when shooting in bright light.

All models meter accurately in very dim light. When shooting in dim light, reciprocity failure of the film is at least as important as possible metering errors in the camera. The practical approach to

dim-light exposures is to bracket enough to cover all technical uncertainties.

READING THE EXPOSURE DISPLAY

The accompanying illustrations show typical Minolta viewfinder displays for 35mm cameras. Displays for 110 cameras are in Chapter 14. If you are shopping for a camera, compare features among the viewfinders. When you own a Minolta, you should become very familiar with the viewfinder display and understand it completely.

SR-T Display— Two moving needles are visible at the right side of the viewfinder. The plain, straight Meter Needle moves up and down according to the amount of light coming through the lens. The Follower Needle has a circle on the end. Its position changes when you change aperture setting, shutter speed or film speed.

When the meter needle passes through the center of the circle on the end of the follower needle, exposure is correct for an average scene. Overexposure or underexposure is indicated by the position of the two needles in respect to each other. If the plain needle is below the circle, the film receives more exposure. If above, the film receives less exposure. To give more or less exposure than the meter suggests, don't match the needles.

If you are set up to make an exposure and the amount of light changes, the meter needle moves.

You would normally adjust lens aperture or shutter speed to cause the follower needle to move in the same direction as the meter needle so they can again be aligned or "matched." This is why the follower needle is called *follower*—and why this metering display is called *match-needle*.

On the SR-T 201 only, there is a shutter-speed scale along the bottom of the viewfinder. An indicator moves along the scale to show the setting of the shutter-speed dial, including the B setting.

Metering limits are shown by the two triangular marks along the right edge of the image area. If the meter needle is above the upper mark, the light is too dim to be measured accurately; if below the lower mark, the light is too bright. In these cameras, increased light causes the meter needle to move downward, from top to bottom.

The rectangular index in the viewfinder is used to check the battery. When you turn the Battery Switch to the B.C. position, the meter needle should drop down from the top and align with the index. If it does not descend that far, the battery is weak and should be replaced.

XG Display—XG cameras meter and operate the exposure display only when set to automatic. In that mode, a red LED lamp glows beside one shutter speed on a scale from 1 second to 1/1000 second to show what shutter speed the camera will use. If the shutter speed selected by the camera is intermediate between two of the marked speeds, LEDs opposite both speeds glow. As you know, the camera operates steplessly on automatic so the shutter-speed indication is approximate.

Above the shutter-speed scale in XG viewfinders is a red triangular LED over-range indicator. If you depress the shutter button with this indicator lit, the camera will not operate on automatic. Use a smaller lens aperture setting to bring the shutter speed down to 1/1000 or slower and you can

SR-T 201 VIEWFINDER DISPLAY

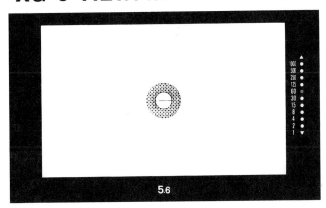

1 Meter Needle
2 Follower Needle
3 Metering Limit
4 Battery Check Mark
5 Focusing Aids
6 Shutter-Speed Scale

SR-T cameras use a match-needle display. When the Meter Needle passes through the center of the circle on the Follower Needle, exposure is correct for an average scene. The SR-T 200 viewfinder display is the same as the SR-T 201 except that it does not display shutter speeds along the bottom.

XG-9 VIEWFINDER DISPLAY

When set to automatic, the XG-9 displays shutter speed selected by the camera, after you have chosen aperture. Below the frame, you see the actual setting of the lens aperture ring. The XG-7 is similar except it does not display aperture setting.

operate normally with correct exposure of an average scene.

The LED under-range indicator opposite 1 second on the scale is also triangular. Even though the display shows 1 second and the camera will time the shutter accurately at 1 second, incorrect exposure is possible because most films are into reciprocity failure when exposure time is 1 second. Also, the metering-accuracy limit for XG cameras with ASA 100 film is EV 2, which corresponds to 1/2 second at *f*-1.4.

Even though the longest marked shutter speed is 1 second, XG cameras on automatic will hold the shutter open for several seconds in very dim light, attempting to get correct exposure. If the light is too dim, the mirror will lock up and the shutter will not close.

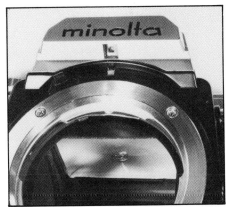

XD-11 and XG-9 cameras display aperture setting by an optical system in the viewfinder which looks downward at the *f*-number scale on the aperture ring. The lens that does this is just below the word *Minolta* in this photo.

To restore normal operation, set the shutter-speed dial to B. If you don't to this, the mirror will eventually move down and the shutter will close again, but you will have wasted battery power.

XG-1 VIEWFINDER DISPLAY

The XG-1 display is similar to the XG-9 with two differences:
It does not display aperture settings. It does not show all shutter speeds between 1/30 and 1 second.

XD-11, XD5 MODE SELECTOR

Set the Mode Selector to M, A or S to select Manual, Aperture-priority automatic exposure control or Shutter-priority automatic. The exposure display is different for each setting.

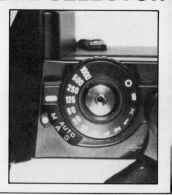

XD-5 VIEWFINDER DISPLAY ON MANUAL

When you are setting exposure on an XD-5, you set both aperture and shutter speed. A red LED glows on the scale at right to show the camera-recommended shutter speed for the aperture you have selected. You can use this shutter-speed setting, or not, as you choose.

ON APERTURE-PRIORITY AUTOMATIC

When you choose aperture, the XD-5 chooses correct shutter speed for an average scene. The shutter speed selected by the camera is indicated by a glowing LED beside the scale of shutter speeds at right.

ON SHUTTER-PRIORITY AUTOMATIC

When you choose shutter speed, the XD-5 chooses correct aperture size for an average scene. The aperture selected by the camera is indicated by a glowing LED beside the scale of f-numbers at right.

XD-11 VIEWFINDER DISPLAY ON MANUAL

When you are controlling exposure, the XD-11 shows settings made by you at the bottom of the screen. At right, a scale of shutter speeds appears and an LED indicates the shutter speed recommended by the camera meter for correct exposure of an average scene. Use it, or not, as you choose.

ON APERTURE-PRIORITY AUTOMATIC

In this mode, the aperture setting you made is displayed at the bottom. On the right, the shutter speed selected by the XD-11 is indicated by a glowing LED beside a scale of shutter speeds. This shutter speed should give correct exposure of an average scene.

ON SHUTTER-PRIORITY AUTOMATIC

The XD-11 shows aperture setting so you can verify that it is set to minimum aperture size, and the shutter-speed setting you made. On shutter-priority, the scale at right changes to show f-numbers from f-1.4 to f-32. LED indicates the aperture selected by the camera for correct exposure of an average scene.

XD Display—XD cameras meter n all three modes.

On manual, an LED indicates the shutter speed the camera recommends. You can use it or not, as you choose. The over-range and under-range indicators signal over- or underexposure of an average scene. If the scene you are photographing is not average, or if you prefer more or less exposure for any reason, disregard the indicators.

On *shutter-priority* operation with MD lenses, a scale of lens apertures from *f*-1.4 to *f*-32 is visible at the right side of the display. An LED indicates which aperture is being selected by the camera. If an intermediate aperture is to be used, two aperture sizes are indicated, one above and one below the actual value.

Triangular over-range and under-range indicators appear above and below the aperture scale. If correct exposure requires an aperture smaller than the lens can be set to, the over-range indicator at the top is illuminated.

For example, if a lens with minimum aperture of *f*-16 is installed, *f*-16 is the smallest aperture that can be selected by the camera and indicated in the display. If the scene is bright enough to require smaller aperture, the exposure display will skip *f*-22 and *f*-32 to illuminate the over-range red triangle.

Then the final-check system takes over and changes shutter speed to produce a good exposure if possible within the operating range of the camera. Suppose you had selected 1/125 on the shutter-speed dial and the light is bright enough to require an aperture smaller than *f*-16. The over-range indicator turns on and simultaneously the final-check system changes shutter speed to a faster value.

You can shoot with the over-range indicator on and normally expect to get a good exposure but you won't know what shutter speed was used. It's easy to find out before shooting, if you have time. Change the shutter-speed dial to faster speeds until the over-range indicator turns off and the smallest lens aperture is indicated. The shutter-speed setting which causes that to happen is the shutter speed the camera would have used automatically, even with the over-range indicator glowing. If correct exposure requires 1/500 instead of the 1/125 you had set, the camera will use 1/500.

In a similar way, the camera will leave the under-range indicator glowing while changing shutter speeds to give you a good exposure if possible. You should be aware that shutter speed will be slower than you selected when the under-range indicator is on, which may make it inadvisable to hand-hold the camera.

Suppose you are using a 200mm lens and have selected a shutter speed of 1/250 so you can hand-hold without blurring the picture due to camera movement. If the under-range indicator turns on, the camera will use a slower shutter speed to get good exposure. You are not likely to get a sharp image unless you use a tripod or other firm support.

On *aperture priority*, the camera selects shutter speeds steplessly and can use any value whether it is a marked speed or not. If shutter speed is between two marked speeds, both will be indicated.

XD cameras can hold the shutter open longer than 1 second in dim light when set for automatic exposure. If the light is too dim, the mirror will lock up and the shutter will remain open.

To restore normal operation, set the shutter-speed dial to **X**. If you don't do that, the mirror will eventually move down and the shutter will close, but you will have wasted battery power.

KEEP THE EYEPIECE COVERED

Light entering the viewfinder eyepiece travels through the viewfinder optics and illuminates the focusing screen from above. Because the light-measuring system measures focusing-screen brightness, excessive light coming in the viewfinder eyepiece can cause underexposure.

Normally your eye at the eyepiece blocks enough light to prevent incorrect exposure measurement—aided perhaps by a rubber eyecup as already described.

Anytime your eye is not at the eyepiece and the camera is operating on automatic, you must cover the eyepiece to prevent underexposure. XD-11 cameras have a built-in eyepiece blind to do this. Other models have a separate eyepiece cap. If you have no other method, use your hand or a piece of black tape.

One use of the self-timer is to allow the camera operator to move around in front to be in the picture. Automatic exposure works fine in this situation provided you remember to cover the eyepiece.

CABLE RELEASES

It is often convenient or necessary to control the shutter from a distance. This is done with a cable release of which there are two types: mechanical and electrical.

A mechanical cable release has a flexible metal core inside a flexible outer cover. On one end is a pushbutton. When the pushbutton is depressed, a plunger on the opposite end of the cable is forced out of the outer cover.

Cameras designed to use a mechanical cable release have a threaded socket on the body or in the center of the shutter button on the camera. Screw in the cable release, depress the operating button on the far end of the cable and the camera shutter operates.

Most mechanical cable releases have some method of locking the pushbutton depressed so you can expose for a long time without the bother of holding the button with your finger. The lock is usually a set screw or a collar. Minolta offers a conventional mechanical cable

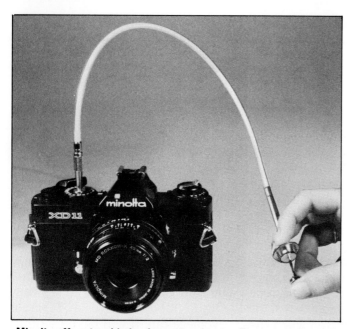

Minolta offers two kinds of remote releases. The conventional mechanical type, Cable Release II, is shown at left. It can be locked to hold the shutter open on B. An electrical control cord, Remote Cord S, is shown at right. Either type can be used with XD and XG cameras. The Shutter-Release Socket on XG cameras is on the side of the lens mount rather than in the center of the shutter button.

release—Cable Release II.

For automatic cameras, there are also special electrical control cords with a pushbutton switch at the far end. These are called Remote Cords or Remote Control Cords. For XD and XG cameras, there are two: Remote Cord S is 50cm long and Remote Cord L is 5m long.

How these cable releases are used depends on camera model.

XD Cable Releases—XD cameras have a shutter button which operates through mechanical movement—depress the button and the shutter operates. Internally, the shutter is electrically controlled. What the shutter button actually does when depressed is close an electrical switch which then releases the shutter.

XD cameras can use a conventional mechanical cable release screwed into a threaded socket in the center of the camera shutter button. To make long exposures with a mechanical cable release, open the shutter on B and then lock the cable release.

The viewfinder display in XD cameras is turned on by depressing the shutter button partway which you can also do with a mechanical cable release if you are

careful about it. Therefore you can view the exposure display and then operate the shutter using a mechanical cable release.

The shutter in XD cameras can also be controlled by an electrical Remote Control Cord which screws into the same threaded socket in the center of the shutter button. When you depress the pushbutton at the far end of the Remote Control Cord, it closes an electrical switch which then operates the shutter.

There are two things you can't do from the far end of an electrical Remote Control Cord connected to an XD camera: You can't make long exposures with the shutter-speed dial set to B. If you try it, the camera makes a 1/100 second exposure and closes the shutter. Also, you can't turn on the viewfinder exposure display.

The reason you can't do these two things remotely is that both require mechanically depressing the camera shutter button. You can turn on the meter and display with a Remote Control Cord screwed into the camera shutter button but you have to do it at the camera rather than the far end of the Remote Control Cord.

The end of the Remote Control

Cord that screws into the shutter button has a round extension on top which invites you to press down on it. By pressing down there, you mechanically depress the shutter button. Press down partway to turn on the viewfinder display. Press down all the way to hold the shutter open with the camera on B. There is no way to lock the shutter open on B.

Pressing down on the end of the Remote Control Cord that is screwed into the shutter button is exactly the same as pressing directly on the shutter button itself except that you can leave the remote cord screwed in.

XG Cable Releases—Shutter buttons on XG cameras work by depressing them with your finger. However, the internal mechanism is electrical and what the button does is close a switch inside the camera to operate the shutter. There is no threaded socket in the center of the XG shutter button and therefore you cannot attach a conventional mechanical cable release there.

On the right side of the lens mount of XG cameras, viewed from the front, is a small electrical socket called Shutter-Release Socket. Either electrical Remote

Control Cords or mechanical cable releases can be screwed into that socket. The pushbutton on the end of the cord or cable then controls the shutter.

You can use the electrical Remote Control Cord to operate the camera on manual or automatic, on any shutter speed including B. When set to B, the shutter will remain open as long as you hold the pushbutton switch depressed but there is no way to lock the pushbutton.

A mechanical cable release can be used to operate the camera on manual or automatic, on any shutter speed or on B.

If you have a locking mechanical cable release, you can use it to hold the shutter open on B. Be careful not to allow any metal part of the cable release to touch any metal part on the camera body. If contact is made, the shutter closes immediately.

Neither cable release will turn on the meter when the camera is on automatic because this can be done only at the camera shutter button. The meter in XG cameras operates only when the camera set to automatic.

XK Motor Cable Release—A motor drive is an integral part of the XK motor camera. Controlling the motor drive is equivalent to controlling shutter release in the camera itself. This is done by a pushbutton on the motor-drive housing or by a special remote cord for the XK Motor camera only.

In addition to the pushbutton and remote-control socket on the motor-drive housing, the XK Motor camera body has a conventional shutter button with a threaded socket for a conventional mechanical cable release. When the camera is set to B, you can use a locking mechanical cable release for long exposures.

This camera has a special procedure to set exposure times from 2 to 16 seconds—described in Chapter 15.

SR-T Cable Releases—SR-T

The Shutter-Release Socket on XD cameras is in the center of the shutter button. You can use either a conventional mechanical type cable release in this socket, or a Minolta electrical Remote Control Cord.

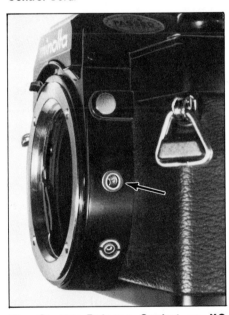

The Shutter-Release Socket on XG cameras is on the camera body (arrow). You can use either a mechanical cable release or electrical remote cord in this socket.

cameras have mechanical shutters with mechanical control by depressing the shutter button. They use mechanical cable releases such as Cable Release II which screw into a threaded socket in the center of the shutter button. To make long exposures, set the shutter-speed dial to B; operate and lock the cable release.

MULTIPLE EXPOSURES

There are two considerations in making more than one exposure on the same frame. One is to adjust each individual exposure for a satisfactory end result. The other is the method of operating the camera to make multiple exposures.

Adjusting Individual Exposures—If a subject against a dark background is photographed with normal exposure, the film frame can be considered as two distinct areas. The subject area is normally exposed. The dark background caused little or no exposure on the film.

A second subject against the dark background can be photographed on the same frame, also with normal exposure provided the areas on the film occupied by the two subjects do not overlap.

Now the film frame can be considered as three areas. One for each subject and some still unexposed or underexposed background. Obviously a third subject could be placed in the unused dark background area and normal exposure could be given to the third subject.

The rule for multiple exposures against a dark background where the subjects do not overlap is to give normal exposure to each shot.

When subjects do overlap, the situation is different. Normal exposure of two subjects occupying the *same* area on film amounts to twice as much exposure as that area needs—one step too much. Three overlapping exposures give three times as much total exposure as the film needs, and so forth.

With overlapping subjects, the rule is to give the correct total amount of exposure to the film, allowing each individual shot to contribute only a part of the total. If there are two overlapping images, each should receive one-half the normal exposure. Three overlapping images should each

receive one-third the normal exposure, and so forth.

This is done by dividing the normal amount of exposure for each shot by the total number of exposures to be made. Please notice that this does not require each exposure to be the same. Measure for each exposure, divide by the number of exposures to be made, and give the resulting amount—whether or not it's the same as some other subject requires.

This procedure tends to give normal exposure to the combined image on the film, but each individual image is less bright according to how many shots there are. If you make more than three overlapping exposures, each individual image becomes pretty dim, but the effect is sometimes pleasing anyway. Also, even though the background is dark, it will get lighter and lighter with successive exposures.

A handy way to adjust exposure is to multiply the film-speed setting by the number of overlapping exposures to be made. For example, if you are using ASA 25 film and plan to make four overlapping shots on the same frame, change the film-speed setting to ASA 100 so each shot will receive only one-fourth the normal amount of exposure.

After changing the film-speed setting, use the camera normally for each shot. You can use the camera's Exposure-Adjustment Control to change exposure if it has enough range. In the example above, each shot receives two steps less exposure so you can do it by setting the control to -2. More than four overlapping exposures exceeds the range of the Exposure-Adjustment Control so you must change film speed, shutter speed or aperture size to get the desired exposure for each frame.

When you have finished the multiple exposure, don't forget to reset the camera controls so following frames receive correct exposure.

I photographed this small waterfall with a long time-exposure so it would look like flowing ice. With the camera set to B, I used minimum aperture, a blue filter and a cable release to hold the shutter open. This photo required compensation for reciprocity failure. See Chapter 10.

The same little waterfall shot with three exposures on the same frame, using fast shutter speed. The first exposure was made through a red filter, then green, then blue. The visual sensation of yellow is a combination of red and green.

RULES FOR MULTIPLE EXPOSURES

Dark uncluttered backgrounds are best.

The background gets lighter with each exposure.

If there is no subject overlap, give normal exposure to each shot.

If there is subject overlap, divide the normal exposure for each shot by the total number of shots to be made.

OPERATING THE CAMERA FOR MULTIPLE EXPOSURES

Some Minolta cameras are designed to make multiple exposures and have a special control for that purpose. For these cameras, there is an approved procedure.

Other models are not designed for multiple exposures. They have no special control and no approved multiple-exposure procedure. There is an unofficial method which I will describe.

Cameras with a Multiple-Exposure Control—These are the XD models and the XK Motor camera.

XD cameras using manual film advance: Make the first exposure normally except with reduced exposure if needed. To make the second exposure on the same frame, depress the Film-Advance Release Button on the bottom of the camera. This is usually called the *rewind button,* however on XD cameras it also serves as the multiple-exposure control.

After pushing in the button, you don't have to hold it. Then operate the film-advance lever. This will prepare the camera for the next exposure except that it will not advance the film because you pressed the Film-Advance Release Button.

Make the next exposure on the same frame. Repeat the procedure for as many exposures as you wish.

When you have completed the multiple exposure, do not depress the Film-Advance Release Button. Use the film-advance lever to bring the next frame into position for exposure. Expose the next frame normally.

On XD cameras, the frame counter will not advance while you are making a multiple exposure. If you make more than one exposure on frame 8, for example, the counter will show frame **9** when you advance to the following frame.

You can also make multiple exposures with Auto Winder D. This procedure is described in Chapter 12.

XK Motor Camera using manual film advance: The procedure is the same as XD cameras, except that the multiple-exposure control is not combined with the rewind button. It's a special control on the back of the camera. To make additional exposures after the first one on any frame, depress the lock

button on the control, slide the control to the right until it clicks and then release it.

The exposure counter will not stop operating during the procedure and it counts each exposure as a separate frame. Therefore if you make three exposures on frame 8, the camera will count 8, 9 and 10 during the multiple exposure. When you advance to frame 9, the counter will show frame 11. This is not a major problem as long as you know it is happening. At the end of the roll, the camera will let you finish all of the frames even though the counter stops at 40.

Motor-driven multiple exposures can also be made with this camera. The procedure is described in Chapter 15.

Cameras without a Multiple-Exposure Control—These are the XG models, SR-T 200 and SR-T 201. Here is an *unofficial* procedure that may serve your purpose if you understand its limitations. I call it the *three-finger method.*

Before making the first shot, set exposure according to the number of shots you intend to make on the same frame. Then turn the Rewind Knob clockwise gently until you feel *slight* resistance. This is to take out any slack in the film. *Hold the knob in that position throughout the remainder of the procedure.*

Make the first exposure.

While holding the Rewind Knob, depress the Rewind Button on the bottom of the camera and hold it depressed.

Then operate the Film-Advance Lever smoothly through one complete stroke and allow the lever to return to its normal position. This "winds up" the camera for the next exposure but does not advance the film because you are holding in the Rewind Button. Now you can release the Rewind Button.

Make the next exposure on the same frame.

For each additional exposure on

Ordinary films can record details in any scene under uniform illumination — for example, all in direct sunlight, or all in the shade. No film can cope with scenes partly in bright light and partly in deep shadow—such as the corner of this photo and the deep shade in the background.

the same frame operate the Film-Advance Lever through a full stroke while holding the Rewind Knob and depressing the Rewind Button. Some people can't find enough fingers to use this method.

When the desired number of exposures has been made, release everything.

The film may move slightly to the left or right during the multiple-exposure procedure. To prevent overlap of the multiple-exposed frame and the next following frame, advance the next frame of film using the Film-Advance Lever normally. Then put a lens cap over the lens and depress the shutter button. This makes a "blank" exposure on the frame following the multiple exposures.

Remove the lens cap, advance the film again and use the camera normally for the next frame.

There is also some chance of overlap with the preceding frame.

Therefore a blank frame both before and after a multiple exposure is good insurance.

This requires a knack that you develop with practice. First, with an unloaded camera, practice the procedure and decide which fingers you are going to use for each part of the procedure.

To see how well you are doing, load film and waste a frame or two checking registration as follows: Remove the lens. Open the shutter on B and hold it open by keeping your finger on the shutter button or preferably by using a locking cable release. Carefully draw a line around the edges of the film frame, marking directly on the film with a lead pencil or ball-point pen.

Close the shutter. Use the multiple-exposure procedure to make two or three additional exposures on the same frame. On the last of the multiple shots, hold

the shutter open again on **B** while you look at the film frame to see how much it moved, if at all.

For some multiple exposures, exact registration of the film is not necessary. But it is comforting to know how much film slippage is likely.

The frame counter in XG and SR-T cameras counts strokes of the Film Advance Lever rather than actual frames of film as they go by. Therefore the counter advances one number for each multiple exposure even though the film isn't moving through the camera at all. If you make several multiple exposures in a roll, the counter will indicate that you are out of film when you have quite a few exposures left. It will count past frame 36 and stop. After that, you can continue advancing film and shooting frames until you reach the end of the roll but the counter will stop advancing.

STOP-DOWN METERING

There are some circumstances when you can't meter at full aperture but instead meter stopped down to the aperture at which you intend to make the exposure. This is called *stop-down metering*, sometimes *stopped-down metering*.

Here are some situations where stopped-down metering is necessary:

Some accessories that fit between lens and camera prevent full-aperture metering even with meter-coupled lenses because they do not interconnect the mechanical linkages between lens camera. Stop-down metering is necessary. These accessories are used to increase image magnification and are discussed in the following chapter.

Not all Minolta lenses have MC pins and auto-diaphragm. Mirror lenses and the 35mm shift lens are examples. These lenses cannot provide full-aperture metering, so you must meter stopped down.

Early Minolta lenses—Before MC lenses were available the lenses in common use were Auto-Rokkors. These had auto-diaphragm but were not meter-coupled. In addition, there was a type of lens called *preset* which had no automatic features. Stop-down metering was standard in those days. These early lenses can be used on modern Minoltas with stop-down metering.

The technique for stop-down metering varies depending on equipment setups and the camera model in use. At appropriate places later in this book, I give specific instructions for specific equipments. Camera descriptions in Chapter 15 cover stop-down metering procedures.

WHEN TO WORRY ABOUT SCENE BRIGHTNESS RANGE

First, let me tell you when not to worry. All film manufactured for general use will record any scene that is under *uniform* illumination—unless the scene itself includes bright light sources.

If the light everywhere in the scene is the same or nearly so—such as on an overcast day or in the shade—any film will get details in the brightest part of the scene and in the darkest part.

When the scene is uniformly illuminated, the amount of light reflected toward the camera is determined only by the reflectance of the various surfaces in the scene. A very light object may reflect about 90% of the light; a very dark object may reflect 3% or 4% of the light; but the difference between 90% reflectance and 3% reflectance is a brightness range of only about 5 exposure steps. All films can handle that. Just put the middle tone of the scene on the middle density of the film and you will get a satisfactory picture.

The brightness-range problem occurs when part of the scene is in light and part in shade. If you go exploring outdoors with the light meter in your camera, you'll find lots of shaded areas where the amount of light is 3 or 4 steps less than direct sunlight.

If the light across a scene changes by 4 steps because part of it is in shadow, the scene brightness range is usually increased by that same number of exposure steps.

This will happen when the lowest-reflectance part of the scene is in shadow, because then it will reflect 4 steps less light than it would if the scene were uniformly illuminated.

Suppose a scene uses 5 exposure steps when uniformly illuminated. If part of the scene then falls in shadow that is 4 steps darker that the bright area, the overall range of the scene becomes 9 steps rather than 5. No commonly available film can do that. You may decide either to sacrifice picture detail in highlights or shadows because you can't get both.

If you want to preserve detail in the highlights, meter on a medium tone in the brightly lit part of the scene. If necessary, put a substitute-metering surface in that light. This gives a full range of tones in the brightly lit part of the scene and the lighter tones in shadow.

If you want to preserve detail in the shadows, meter on a medium tone in the shade. If necessary, put a substitute-metering surface in shadow. This gives a full range of tones in shadow and the darker tones that are in full light.

To make a compromise between losing detail in highlight and shadow, average the highlight and shadow readings as described earlier.

With experience, you learn to judge scenes for brightness range, according to the film you are using. Sometimes you can get fooled. If you use your camera meter to measure the brightest part and the darkest part where you want to record surface texture or details, you won't be fooled. Count the number of steps difference between these two exposure readings and that's the brightness range you must cope with.

Here's a rule of thumb about what films can do:

B&W film can record 7 exposure steps.

Color-slide film can record 6 steps.

Color-negative film can record 5 steps.

When using this rule, it's important to remember to measure only surfaces where detail is important to the picture. If a white shirt or a white painted wall is in the picture, surface details may not be necessary in these.

SUMMARY OF METERING TECHNIQUES

The usual problem is background and you have to think your way to the needed correction.

Center-weighted metering is less sensitive around the edges where the background usually lives. It helps you compensate for unusually bright or dark backgrounds. You learn to use it by using it.

The camera metering system tends to make the average tone it sees into middle-gray on the print. With color film, it will make the average brightness it sees into the middle brightness of print or slide no matter what color it is.

If you meter on caucasian skin, you should probably use one step more exposure. Maybe half a step.

When using substitute metering, the tone you show to the meter will record as a middle tone on the film. An 18% gray card is just right—or anything else with 18% reflectance. There are many common things you can use. If you meter on a surface with reflectance different than 18%, you should correct the reading.

You can always meter at a different aperture, film speed, or shutter speed, and then count steps to find your way back.

Film speed is an exposure control only if the camera ends up set for the exposure requested by that speed.

One of the interesting challenges of photography is to make good exposures in difficult or unusual circumstances.

A good exposure usually results if you meter the brightest and darkest areas of interest in the frame and then set to the average of the two exposures that result. Average by counting steps.

With b&w or color-negative film, the exposure range the film can accept is often wider than the brightness range of the scene. If so, you can miss exposure a step or two without losing picture detail either into white or black. Overall scene brightness will be wrong on the negative but can be corrected on the print, and usually is.

When the exposure range of the film is greater than the brightness range of the scene, we say there is some *latitude*. Latitude is not a property of film. It results from a combination of film and scene.

Everybody says color-slide film must be properly exposed within a half step. The main reason for this is to get correct scene brightness when you project the slide. A moderately underexposed slide will appear too dark when projected. If you could increase the brightness of the projector lamp, the slide would look just fine. But you can't do that, so you must control exposure closely with color slides. Metering on a gray card in the same light does the job, or any other thoughtful method.

ACCESSORY EXPOSURE METERS

Minolta is a leading manufacturer of accessory hand-held exposure meters that you use independent of the camera's built-in meter. Some of these meters have capabilities that exceed those built into the camera—such as measuring a small spot on the scene or measuring the exposure effect of electronic flash.

9 CLOSE-UP AND MACRO PHOTOGRAPHY

A macro lens can take ordinary photos and also work at higher magnifications so you can make non-ordinary shots.

CLOSE-UP AND MACRO PHOTOGRAPHY

The equipment and procedures in this chapter apply to 35mm SLR cameras. Increasing image size in cameras using 110 film is discussed in Chapter 14.

Close-up photography means placing the lens unusually close to the subject, so the image in the camera is unusually large.

Macro photography means making an image in the camera that is larger than the subject in real life. Therefore the dividing line between close-up and macro is magnification of 1.0, sometimes called *life-size*, where the image is exactly the same size as the subject.

This isn't a firm rule except in theoretical discussions. There are lenses called "macro" that won't make a larger-than-life macro image without some help from accessories. Some of the equipment called "close-up" can also be used to make images in the macro range.

Making images larger than life-size is properly called *photomacrography* but many people call it *macro photography* as I do in this book.

Another branch of high-magnification photography is called *photomicrography* which means taking pictures through a microscope.

The dividing line is when you stop using camera lenses and start using the microscope instead. With Minolta equipment, you can use camera lenses with accessories to make images up to about 10 times larger than the subject, therefore that is the limit of macro photography. If you need a bigger image, switch to photomicrography.

MAGNIFICATION

In this book, image size and subject size are compared to each other in only one way: *Image size divided by Subject size equals Magnification.*

Magnification can also be calculated by comparing distances: *Image distance divided by Subject distance equals Magnification.*

Both are written by the same formula:

To find Magnification (M),

$$M = I / S$$

where I is either image size or image distance and S is either subject size or subject distance. Naturally you only divide size by size, or distance by distance. You can't mix them together.

If magnification is greater than 1.0, the image on film is larger than the subject. If magnification is less than 1.0, image size is smaller than subject size.

Some literature uses the symbol X to indicate magnification. 3X means a magnification of 3. 1/5X means the image is 1-unit tall and the subject is 5-units tall. In this book, I complete the indicated division. 1/5 = 0.2. A magnification of 1/5 is the same as a mag-

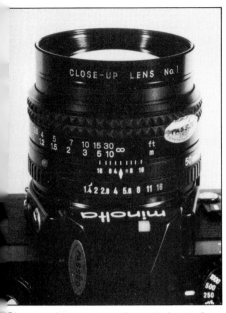

Close-up lenses screw into the front of ordinary camera lenses to increase image magnification. They are very handy and very easy to use.

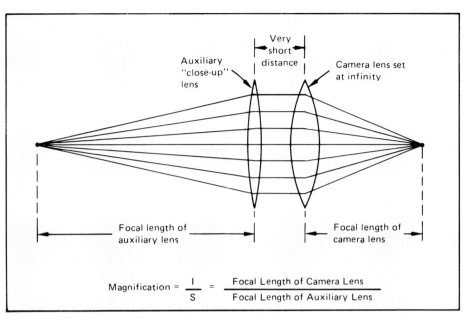

Auxiliary "close-up" lens

Very short distance

Camera lens set at infinity

Focal length of auxiliary lens

Focal length of camera lens

$$\text{Magnification} = \frac{I}{S} = \frac{\text{Focal Length of Camera Lens}}{\text{Focal Length of Auxiliary Lens}}$$

Figure 9-1/With close-up lenses, minimum magnification is very easy to calculate.

nification of 0.2. I will not use the symbol X to imply magnification.

Sometimes it is helpful to convert magnification expressed as a decimal number into a percentage. A magnification of 0.2 is 20% which means that the image is 20% as tall as the subject. A magnification of 1.0 is 100% and so forth.

MAGNIFICATION OF A STANDARD LENS

A lens used by itself on the camera has greatest magnification when focused on the closest possible subject. The closest focusing distance of a standard 50mm lens is about 0.45 meters, which is 450 millimeters. This distance is measured from the film plane inside the camera body.

When focused at the closest possible distance, the magnification of a standard 50mm lens is about 0.15. The image is about 15% as tall as the subject.

Maximum magnification varies among lenses of different focal lengths.

CLOSE-UP PHOTOGRAPHY

If the lens you are using won't make an image as large as you need, one simple solution to the problem is use of clear-glass accessory lenses to increase magnification. These are called *supplementary* lenses or *close-up* lenses.

A close-up lens screws into the filter-mounting threads on the front of the camera lens. This results in a very short distance between close-up and camera lens—Figure 9-1.

The subject is placed at the focal point of the close-up lens. If the close-up lens has a focal length of 500mm, the subject is placed 500mm in front of the lens.

Light rays from every point of the subject enter the close-up lens and emerge on the back side as parallel rays. The parallel rays immediately enter the camera lens.

The simplest example is when the camera lens is focused at infinity. It is "expecting" parallel rays from a distant subject but it actually receives parallel rays from a nearby subject due to the action of the close-up lens.

The camera lens doesn't care. When it receives parallel rays, it brings them to focus behind the lens at a distance equal to its own focal length.

If the camera lens has a focal length of 50mm, it will bring parallel rays to focus at a distance of 50mm behind the lens—actually behind the optical point called the rear lens *node*.

In this situation, when the camera lens is focused at infinity, magnification is very easy to figure.

$$M = \frac{\text{Image Distance}}{\text{Subject distance}}$$

Image distance is the focal length of the camera lens, subject distance is the focal length of the close-up lens. I'll show an example of this calculation in a minute.

Because close-up lenses attach by screwing into the filter threads, they are virtually universal in application. All you have to do is buy close-up lenses with the correct thread diameter to fit your lens. If your lens uses filters with a 55mm thread diameter, get close-up lenses with the same diameter.

Focal Length and Diopters— Close-up lenses are available in camera stores. You can buy Minolta brand or any of several other brands which are sold as general-purpose accessories for all camera brands. There are some

differences between Minolta close up lenses and general-purpose accessory close-up lenses. To make it clear which type is being discussed, the general-purpose variety will be called "accessory" and those manufactured by Minolta will be called "Minolta close-up lenses."

Accessory close-up lenses often come in sets identified with a number such as 1, 2, 3, or 4. Some makers offer a 10 lens also. Focal length of the *accessory* lens is disguised in its identification number.

These numbers are properly called *diopters*, a measure of lens power. Eyeglass prescriptions are written in diopters. The diopter rating of a lens is the reciprocal of its focal length—1 divided by focal length—when focal length is expressed *in meters* rather than millimeters or any other unit.

To find the diopter rating of a 500mm lens, notice that 500mm is 0.5 meter.

$$\frac{1}{0.5 \text{ meters}} = 2 \text{ diopters}$$

This is a 2 close-up lens.

An easier way to do it is divide 1000 by the lens focal length in *millimeters*:

$$\frac{1000}{500 \text{mm}} = 2 \text{ diopters}$$

To figure magnification with an accessory close-up lens rated in diopters, you need to work that problem backwards. You *know* the diopter rating, it's engraved on the close-up lens. What you need to know is the focal length of the close-up lens.

Here's the formula you actually need for Focal Length in mm:

$$\text{Focal Length (mm)} = \frac{1000}{\text{Diopters}}$$

If you have a 2-diopter close-up lens,

$$\text{Focal Length (mm)} = \frac{1000}{2}$$

$$= 500 \text{mm}$$

If you are using the 2-diopter close-up lens with a 50mm camera lens set at infinity, now you can figure magnification.

$$M = \frac{\text{Image distance}}{\text{Subject distance}}$$

$$= \frac{\text{Focal length of camera lens}}{\text{Focal length of close-up lens}}$$

$$= \frac{50 \text{mm}}{500 \text{mm}}$$

$$= 0.1$$

In this example, the image in the camera will be 0.1 (one-tenth) as tall as the subject. That is true *only* when the camera lens is focused at infinity. Focus closer and two things happen.

Image distance gets longer because the focusing mechanism moves the lens farther from the film. Subject distance gets shorter.

Therefore when you focus the camera lens closer than infinity with a close-up lens attached, magnification increases. Greatest magnification occurs with the camera lens focused at its shortest distance, but it isn't simple to calculate.

Figure 9-2 does the arithmetic for you, if you are using accessory close-up lenses rated in diopters. It gives minimum and maximum distances at which the subject can be focused and it gives the magnification obtainable over the lens focusing range. The numbers are approximate but close enough to get set up. Then look through the viewfinder to make final adjustments.

Here's how to use the table. First, figure the amount of magnification you need, using the formula $M = I \times S$. You can compare the height of a 35mm frame with the height of your subject, or compare widths. In Minolta 35mm SLR cameras, frame height is 24mm, a little less than one inch. For most purposes assume it is an inch.

If the subject is 3-inches tall and you want it to fill the narrow dimension of the film frame you want a magnification of approximately 1/3, or 0.33.

With a 50mm lens, the table shows a magnification range of 0.20 to 0.33 with 4 diopters. Using 4 diopters of close-up lens, you will get the desired magnification with the camera lens focused near its closest distance.

ACCESSORY CLOSE-UP LENSES WITH A 50mm CAMERA LENS						
CLOSE-UP LENS DIOPTER RATING	MINIMUM MAGNIFICATION			MAXIMUM MAGNIFICATION		
	M	Subject Distance mm	inches	M	Subject Distance mm	inches
1	0.05	1000	40	0.21	277	10.9
2	0.10	500	20	0.26	217	8.5
3	0.15	333	13	0.32	178	7.0
4	0.2	250	10	0.38	151	6.0
1+3	0.2	250	10	0.38	151	6.0
2+3	0.25	200	8	0.44	131	5.2
1+2+3	0.33	167	6	0.5	116	4.6
1+2+4	0.35	143	5	0.55	104	4.1
10	0.5	100	4	0.73	79	3.1

Figure 9-2/This table does not apply to Minolta close-up lenses. It applies to accessory close-up lenses that are labeled with their diopter ratings. The table shows approximate minimum and maximum magnifications with various combinations of close-up lenses and a 50mm camera lens.

Stacking Close-up Lenses—The forward end of close-up lens frames repeats the thread pattern so you can screw one close-up lens into another, called *stacking.*

When stacked, the diopter numbers add. For example, 3 diopters stacked with 1 diopter becomes 4 diopters.

If you stack two close-up lenses with different diopter ratings, put the higher-rated lens nearest the camera. If you are also using a filter or other accessory attachment, place the item on the forward end of close-up lenses.

EFFECT OF CAMERA-LENS FOCAL LENGTH

To get more magnification with the same close-up lens, use a camera lens with longer focal length. As a rule of thumb, magnification will approximately double when you double the focal length of the camera lens. With a 100mm camera lens, for example, the minimum magnification is twice what you get with a 50mm camera lens.

Maximum magnification, with the camera lens set at its closest focus, will not increase as much, for a complicated reason. Nevertheless, you will always get more magnification with a camera lens of longer focal length.

IMAGE QUALITY

Image quality is never as good with a close-up lens screwed on the front of the camera lens as it would be using the camera lens alone. The close-up lens has aberrations that are not corrected in the design of the camera lens so the combination has reduced optical quality.

Image quality becomes progressively worse at higher magnifications. However, the image quality you need in a particular photo depends on what you are photographing and what your standards are.

Image quality will be significantly improved by using small aperture—normally one smaller than *f*-8.

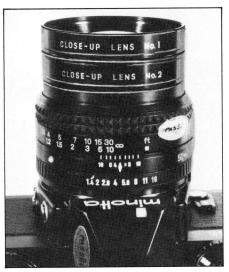

When stacking close-up lenses, put the one with the highest diopter rating closest to the camera.

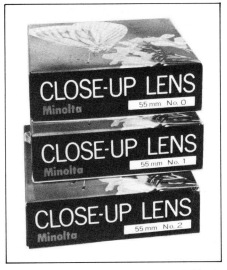

Minolta close-up lenses are available in sets of three with the thread diameter marked on the box and on the lens. This set has 55mm thread diameter. The numbers, 0, 1, and 2 are not diopter ratings, they are identification numbers.

In general, you have to decide for yourself if a particular photographic technique gives satisfactory image quality: As a rule of thumb, some people suggest that a magnification of about 0.5 is as much as you should use with close-up lenses.

Stacking close-up lenses will reduce picture quality because of multiple reflections among the glass surfaces and the resultant light scattering. If you have to stack close-up lenses to get the magnification you need, naturally you will do it. I prefer to increase magnification by using a longer-focal-length camera lens rather than stacking close-up lenses.

Close-up lenses described so far are typical of those available on the accessory market for any brand of camera. You can find them at most camera stores in a variety of thread sizes to fit most brands of lenses, including Minolta.

Typically, these accessory close-up lenses have only a single element and are not corrected for aberrations.

MINOLTA CLOSE-UP LENSES

Minolta offers a set of three close-up lenses, each using two glass elements—called *doublets*—which have correction for chromatic aberration. The sets are available in three thread sizes: 49mm, 52mm, and 55mm.

These lenses produce noticeably sharper images than ordinary single-element accessory close-ups.

As an added safeguard of image quality, Minolta recommends their use with certain camera lenses in combinations which give relatively low magnifications as you can see in the accompanying table. Of course you can use Minolta close-up lenses for magnifications beyond the recommended range with a corresponding reduction in image quality.

Minolta Close-Up Lens Nomenclature—Minolta close-up lenses are identified with a number which is only a label—*it is not a diopter rating.* The labels and equivalent diopters are as follows:

MINOLTA CLOSE-UP LENSES	
Label	Diopter Rating
No. 0	1
No. 1	2
No. 2	4

MINOLTA CLOSE-UP LENSES		Minimum Magnification			Maximum Magnification		
Close-Up Label	Camera Lens	M	Subject Distance		M	Subject Distance	
			mm	Inches		mm	Inches
No. 0	100mm	0.1	1000	40	0.2	450	18
	135mm	0.13	1000	40	0.25	530	21
No. 1	50mm f-1.7	0.1	500	20	0.23	230	9
No. 2	50mm f-1.7	0.19	333	13	0.33	233	9
No. 1 + No. 2	50mm f-1.7	0.30	200	8	0.43	150	6
No. 1	50mm f-4	0.10	500	20	0.23	220	9
No. 2	50mm f-4	0.21	333	13	0.32	233	9
No. 1 + No. 2	50mm f-4	0.30	200	8	0.42	150	6

This table shows the approximate range of magnifications and subject distances using one or two Minolta Close-Up Lenses as shown. These are the recommended uses. Other combinations can be used with reduced image quality. Calculate magnification with other combinations using the formulas given earlier. Subject distance in this table is from the front of the close-up lens, approximately.

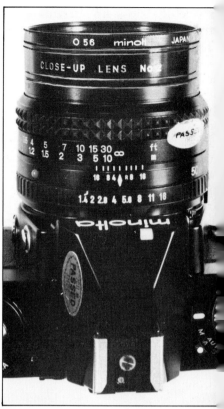

If you stack a close-up lens and a filter, put the filter toward the subject.

The accompanying table shows recommended combinations of Minolta close-up and camera lenses along with minimum and maximum magnifications and subject distances and sub- ject distances. To use these lenses in other ways, use the formulas already given.

EXPOSURE WITH CLOSE-UP LENSES

Close-up lenses don't change exposure enough to worry about. At higher magnifications, they make a very small change you can ignore.

Usually you will be using the camera's built-in exposure meter anyway. It measures the effect of the close-up lens and exposure is adjusted accordingly. This applies whether you operate the camera on manual or automatic.

USING CLOSE-UP LENSES

As with any other high-mag- nification photography, the camera should be on a tripod or solid mount. If you are a solid mount, you can try hand-holding.

Use a lens hood to exclude stray light. These lenses do not interfere with camera automation, so you can meter and set exposure as you normally do.

In general, you'll get satisfactory image quality if you use close-up lenses for a magnification of 0.5 or less. If you must stack them, don't stack more than two.

Depth of field is usually a major problem in close-up and macro photography because it is seldom enough. About the only thing you can do is stop down the lens.

In the high-magnification domain, reducing aperture is not as effective as in normal photogra- phy but it will help some. You may end up looking for more light and shooting at long exposure times so you can use a small aperture.

Changing focus with any lens changes magnification, but when subject distance is small, focusing the lens causes large magnification changes. When you are trying to control image size in the frame and also find focus, it can be frustrating.

A technique you will quickly dis- cover is to set the focus control for magnification, then move the entire camera back and forth to find focus.

A good way to get acquainted with a new set of close-up lenses is to try different combinations while focusing on a yard stick.

MAGNIFICATION BY EXTENSION

As you know, rotating the focusing ring on a lens moves the glass elements of the lens farther from the film to focus on closer subjects. Lens elements travel outward along an internal thread in the lens barrel, called a *helicoid*.

As the lens is extended along the helicoid, magnification increases. The limit is the end of the helicoid because you can't move the lens any farther by turn- ing the focus control. This is the near limit of focus and the max- imum magnification of any lens without using accessory devices to increase magnification.

Minolta offers several ways to

move the lens still farther from the film for more magnification. They are all attachments which fit *between* lens and camera body to increase lens-to-film distance or *extension.*

When using these, you face exactly the same proposition as when using close-up lenses. You can have more magnification than the standard lens and camera combinations will give, but the price is reduced image quality.

When you increase image distance by moving the lens farther from the film, two things happen: Magnification increases and subject distance automatically decreases. This means the point of focus is moved closer to the lens by increasing extension.

One handy way to increase lens extension is the use of spacers called *extension tubes* or *extension rings* which fit between lens and camera body. It can also be done by a bellows between lens and body, which has the advantage of continuous lens positioning at any distance between the maximum and minimum extension or *draw* of the bellows.

Magnification obtained by increasing the distance between lens and camera is calculated by the formula:

$$M = X/F$$

where M is magnification, X is the extension of the lens, and F is the focal length of the lens being used. When X and F are equal, magnification is 1.0, as would be the case with a 50mm lens and 50mm of added extension with the lens set at infinity.

You can rearrange the formula to figure the amount of lens extension needed for a desired amount of magnification:

$$X = FxM$$

where the symbols mean the same as before.

Suppose you are using a 50mm lens and need a magnification of 0.8:

$$X = 50mm \times 0.8$$
$$= 40mm$$

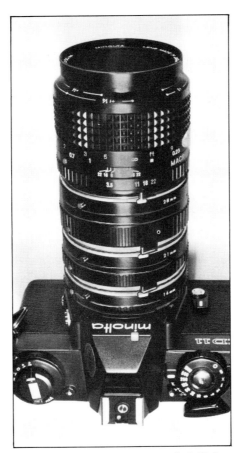

Extension tubes are spacers that fit between lens and camera body to increase magnification. They are not lenses—there's no glass in an extension tube. They are used only to increase the distance from lens to film.

Using bellows or extension tubes, move the lens that far from its normal position and the magnification will be approximately 0.8 with the lens set at infinity.

How Far is the Lens Actually Extended?—Magnification of any lens is determined simply by the ratio of image distance to subject distance. The lens doesn't care how it is positioned in front of the film to get a certain image distance, but the ways can be confusing to a photographer. So, let's spend a minute on it.

When a lens is moved farther from the film, to focus on subjects closer than infinity and to get more magnification, the image distance may be composed of three parts:

First is the lens focal length. With a lens focused at infinity and mounted directly on the camera body, the distance between lens and film is *always* equal to the focal length of the lens. The thickness of the camera body combined with the optical placement of the rear lens node causes this to happen.

When you mount a 50mm lens on the camera and focus it at infinity, lens-to-film distance is automatically 50mm. A 100mm lens has a built-in 100mm between lens and film, and so forth.

Additionally, there is the forward movement along the lens helicoid, if the lens focusing ring is not set at infinity.

Finally, there is the thickness of any extension *added* between lens and camera body due to insertion of extension tubes or bellows.

The focusing helicoid in the lens can move the glass lens elements farther from the film by an amount equal to the length of the helicoid. This varies among lenses, but let's assume it's 7.5mm.

With a 50mm lens on a camera, the total distance from lens to film can range from 50mm to 57.5mm, depending on where you set the focus control. When focused on the closest subject possible, the image distance is 57.5mm.

If a separate extension device is inserted between lens and camera, its thickness adds to the distance already there.

Using 21mm for the extension device, image distance now ranges from:

$$50mm + 21mm = 71mm$$

up to

$$50mm + 21mm + 7.5mm$$
$$= 78.5mm$$

In both cases, total distance between lens and film includes the lens focal length of 50mm plus the added extension of 21mm inserted between lens and camera. The remaining 7.5mm depends on where you set the lens focusing control.

When you add extension between lens and film by any kind of an extension device, the distance scale on the lens focus control no

longer means anything. When you have it set for infinity, the lens is actually focused much closer than infinity. At every setting of the lens focus control, actual focused distance is much less than the scale shows.

With added extension, think of the focus control as a way of changing total distance between lens and film rather than a way of adjusting where the lens is focused.

MINOLTA EXTENSION TUBES

Extension tubes are spacers that fit between lens and camera body. They don't have any glass lens elements and their only purpose is to increase lens-to-film distance. Minolta offers two types of extension tubes.

EXTENSION TUBE SET II

A set of three tubes that screw together and two end-rings used to install the threaded tubes between the camera bayonet mount and the lens bayonet mount.

The ring for the camera body is labeled **EB** to indicate that it connects Extension tubes to the Body. The EB ring bayonet-mounts on the camera the same way a lens does. The forward end of the EB ring is threaded to match threads on the three extension tubes. You can screw one ring into the EB fitting, or stack two, or stack all three.

The EL ring screws onto the forward end of the extension tubes and provides a bayonet mount that duplicates the camera-body mount. The lens attaches in the normal way to the forward end of the EL ring. EL indicates that the purpose is to connect Extension tubes to the Lens.

For minimum added extension, you can screw the EL ring into the EB ring and use the combination as a 7mm spacer between lens and camera body.

The set of three extension tubes has dimensions in multiples of 7mm so you can add extension in steps of 7mm from 7mm up to 56mm. Thicknesses of the extension tubes in this set are:

EXTENSION TUBE SET II	
Device	**Extension**
EB + EL	7mm
Ring 1	7mm
Ring 2	14mm
Ring 3	28mm

The tubes in Extension Tube Set II do not make any mechanical connections between pins on the lens and levers on the camera body so no automatic features are preserved even with MC or MD lenses.

Diaphragm control is manual, by rotating the aperture ring. You must set the lens to shooting aperture before metering with the camera's built-in light meter, using the stopped-down metering procedure for your camera described in Chapter 15.

METER-COUPLED AUTOMATIC EXTENSION TUBES

This set of three MC Extension Tubes has Minolta bayonet fittings on each end of each tube so the EB and EL rings are not needed.

You can mount any MC tube directly on the camera and mount a lens on the forward end, or you can stack tubes as desired.

Extension provided by each tube is engraved on the tube itself: 14mm, 21mm and 28mm. Minimum extension possible is 14mm and the maximum with all three tubes stacked is 63mm.

These MC tubes have mechanical linkages that preserve the meter-coupling function of the MC pin and auto-diaphragm operation, but there is no MD coupling.

Therefore with any combination of Meter-Coupled Automatic Extension Tubes and any MC or MD lens you can use any current Minolta 35mm SLR with full-aperture metering on manual or aper-

Extension Tube Set II has five parts. The three black tubes labeled No. 1, No. 2 and No. 3 **screw into each other and into the two chromed rings at the ends. The EL ring, at the top in this photo, provides a bayonet mount for the lens. The EB ring, at the bottom, fits on the camera.**

MC Extension Tubes bayonet into each other and fit between lens and camera. They can be used singly, or stacked, as needed. Automatic aperture and full-aperture metering are preserved.

ure-priority automatic operation.

GAPS IN THE SYSTEM

The amount of magnification with lens extension depends on the amount of extension. With extension tubes of fixed lengths, it may appear that there are some magnifications you can't use because you can't provide the exact amount of extension needed. This is sometimes true.

Minolta extension tubes can be combined so the amount of extension changes in steps of 7mm. In addition, you can use the lens focus control to add extension to the fixed amount provided by extension tubes.

Lenses with focal lengths of 50mm or longer typically have focusing travel longer than 7mm, so you can use the focus control to fill the gaps between the fixed extensions provided by tubes.

Lenses shorter than 50mm in focal length have focusing travel shorter than 7mm, so there are extension distances that cannot be provided by a combination of extension tubes and focusing travel of the lens. These gaps are small and of no consequence except when a certain magnification must be provided with great precision.

Life-Size Adapters—In addition to the set of three MC extension tubes, two other meter-coupled tubes can be used as general-purpose extensions with any lens or for a special purpose with Minolta macro lenses.

Meter-Coupled Automatic 25mm Extension Tube provides an extension of 25mm as the name indicates. It is included with the 50mm macro lens but is also available separately.

When this extension tube is used between the 50mm *macro* lens and the camera body, the lens can provide magnifications from 0.5 up to 1.0. When sold with a 50mm macro lens, this tube is called a Life-Size Adapter.

Meter-Coupled Automatic 50mm Extension Tube serves as the Life-Size Adapter for the 100mm macro lens and is sold with the lens or separately. When used with the 100mm macro, it provides magnifications from 0.5 up to 1.0.

These two Life-Size Adapters can be stacked with each other and with rings from the Meter-Coupled Extension Tube Set. Except for length, they are identical to each other and to MC extension tubes.

APERTURE PRIORITY IS PREFERRED

No matter how you obtain higher magnification, it always causes reduced depth of field. Because you can obtain higher magnification by lens extension than with close-up attachments, the depth-of-field problem is worse.

For this and other reasons, you will nearly always want to choose lens aperture and use whatever shutter speed is needed for correct exposure. When operating the camera manually use aperture priority.

With automatic exposure, aperture priority is ideal when using lens extension. As mentioned earlier, shutter-priority automatic exposure is not possible in the normal way when using MC extension tubes—or any other kind of lens-extension device. Even if it were available, you would probably never want to use it.

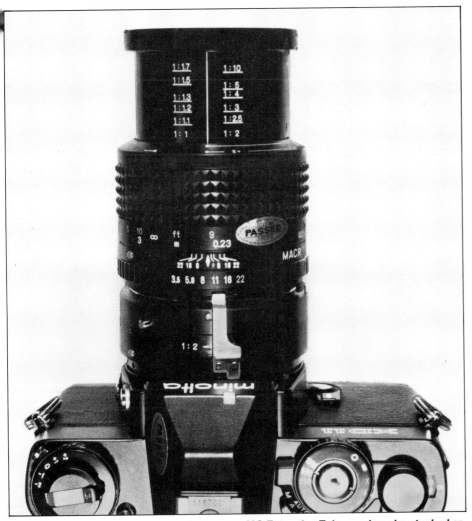

Life-Size Adapters have the same features as MC Extension Tubes and can be stacked or used interchangeably with them. The 25mm Life-Size Adapter is used with the 50mm Macro lens and the 50mm Life-Size Adapter is used with the 100mm Macro lens to provide a magnification range of 0.5 to 1.0 .

REVERSING THE LENS

Lenses for general use are designed with the expectation that subject distance will be considerably longer than image distance. If the lens is not used as the designer intended, lens corrections don't work as well and image quality is degraded.

When magnification is increased by any method of lens extension until the image on film is larger than the subject in real life, image distance is longer than the subject distance.

For magnifications larger than 1.0, conventional lenses make a better image if they are reversed so the longer optical path is still on the side of the lens that the designer intended—even though it becomes image distance rather than subject distance.

Mounting a lens reversed is done by a gadget commonly called a *reversing ring* or a *reverse adapter* and called a *reverse ring* in Minolta literature.

The ring screws into the filter-mounting threads on the front of the lens. The other end of the ring bayonets onto the forward end of extension tubes, or on the front end of a bellows, or on a camera body.

The result is that the lens is mounted by its filter threads and the back of the lens becomes the front. Minolta offers Reverse Rings in two sizes: 49mm to fit lenses with 49mm filter threads and 55mm for lenses with 55mm filter threads. The other side has the standard Minolta bayonet mount.

When an ordinary lens, such as one of the standard 50mm lenses, is mounted by its filter threads, operating the focus control doesn't do anything to the position of the glass lens elements. You may have to look at a lens and work the focus control to visualize why. The lens barrel telescopes as usual but the optics don't move.

Reversing a lens changes the amount of extension. Some is due to the Reverse Ring itself. Some

Reverse Rings have a bayonet mount on one side and threads on the other. Screw the threaded end into the filter threads at the front of the lens. Then use the Reverse Ring to mount the lens on the camera—with the back of the lens toward the front.

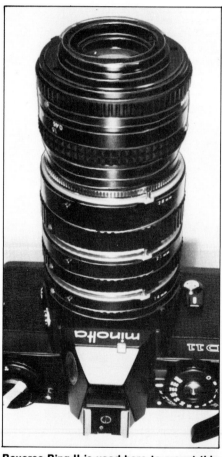

Reverse Ring II is used here to mount this lens in reverse on the forward end of stacked MC Extension Tubes. The back of the lens becomes the front.

additional extension is due to the recess at the front of a lens, between the filter threads and the first glass surface. When a lens is turned around, this recess becomes extension. The amount of extension due solely to reversing the lens isn't a lot on most lenses, but there are a few deeply recessed lenses where it becomes a

major factor. Two important examples are the 50mm and 100mm macro lenses.

When a lens is reversed, the front node takes the place of the rear node. With short-focal-length lenses, this causes the distance between node and film to be *greater* and magnification increases just because the lens is reversed.

With telephoto lenses, the opposite is true—reversing the lens *reduces* the amount of magnification. These changes in the amount of extension are due to the optical design of the lens.

By using a reverse ring to mount a short-focal-length lens directly on the camera body, you can obtain magnifications in the range of 2 to 3. The amount of magnification cannot be changed and the focusing control doesn't do anything but you can find focus by moving the camera itself closer to or away from the subject. The method isn't very practical but it is simple and sometimes useful.

If you are estimating magnification by the formula $M = X/F$, be sure to gather up all of the "X" distances and add them together. These include:

Extension due to extension tubes or bellows.

Extension due to the lens helicoid if the lens is mounted normally and not set at infinity.

Extension due to a reverse ring if used.

Extension due to reversing the lens itself.

Extension due to the lens optical design.

Reversing the lens is recommended when magnification exceeds 1.0. With a reversed lens, use manual aperture control and stopped-down metering.

Help is Nearby—If this seems more complicated than you would like it to be, the tables in this chapter give you setup distances for magnifications that are practical with a variety of Minolta lenses—both reversed and not reversed.

MAGNIFICATION WITH EXTENSION TUBES				
Lens	Exten-sion (mm)	Magnifi-cation Range	FILM-TO-SUBJECT DISTANCE RANGE	
			Inches	mm
50mm *f*-3.5 Macro	7	0-14 — 0.64	18-3/4 — 8-7/16	476 — 213
	14	0.27 — 0.78	12 — 8-1/8	304 — 206
	21	0.41 — 0.91	9-3/4 — 8-1/16	247 — 204
	28	0.54 — 1.05	8-13/16 — 8	223 — 203
	35	0.68 — 1.19	8-5/16 — 8-1/16	211 — 205
	42	0.81 — 1.32	8-1/8 — 8-3/16	206 — 207
	49	0.95 — 1.46	8 — 8-5/16	203 — 210
	56	1.09 — 1.59	8-1/16 — 8-1/2	203 — 214
	63	1.22 — 1.73	8-1/8 — 8-5/8	205 — 219
50mm *f*-1.4 and *f*-1.7	7	0.14 — 0.27	18-3/8 — 11-9/16	465 — 293
	14	0.27 — 0.40	11-9/16 — 9-7/16	293 — 238
	21	0.41 — 0.54	9-5/16 — 8-3/8	236 — 212
	28	0.54 — 0.67	8-3/8 — 7-15/16	212 — 200
	35	0.68 — 0.81	7-7/8 — 7-11/16	200 — 195
	42	0.81 — 0.94	7-11/16 — 7-9/16	195 — 192
	49	0.95 — 1.08	7-9/16 — 7-5/8	192 — 192.4
	56	1.08 — 1.21	7-5/8 — 7-5/8	192 — 194
	63	1.22 — 1.35	7-11/16 — 7-3/4	194 — 197
85mm *f*-1.7	7	0.08 — 0.18	47-13/16 — 24-15/16	1212 — 632
	14	0.17 — 0.27	26 — 19-1/8	660 — 484
	21	0.25 — 0.35	20 — 16-9/16	508 — 420
	28	0.33 — 0.43	17-1/8 — 15-1/16	434 — 382
	35	0.42 — 0.52	15-1/4 — 14-1/16	387 — 357
	42	0.50 — 0.60	14-1/4 — 13-1/2	361 — 342
	49	0.58 — 0.68	13-5/8 — 13-1/16	345 — 332
	56	0.67 — 0.77	13-1/8 — 12-13/16	333 — 325
	63	0.75 — 0.85	12-7/8 — 12-11/16	326 — 321
100mm *f*-4 Macro	7	0.07 — 0.57	64 — 16-7/8	1625 — 427
	14	0.14 — 0.64	36-7/16 — 16-7/16	924 — 416
	21	0.21 — 0.71	35-1/8 — 16-1/16	891 — 407
	28	0.28 — 0.78	22-15/16 — 15-7/8	581 — 402
	35	0.35 — 0.85	20-5/16 — 15-11/16	516 — 398
	42	0.42 — 0.92	18-11/16 — 15-5/8	477 — 397
	49	0.49 — 0.99	17-11/16 — 15-5/8	449 — 396
	56	0.56 — 1.06	16-15/16 — 15-5/8	430 — 396
	63	0.63 — 1.13	16-1/2 — 15-11/16	418 — 398

This table shows extension distances obtainable from various combinations of extension tubes. For lenses not shown, calculate magnification or the needed extension by methods already given.

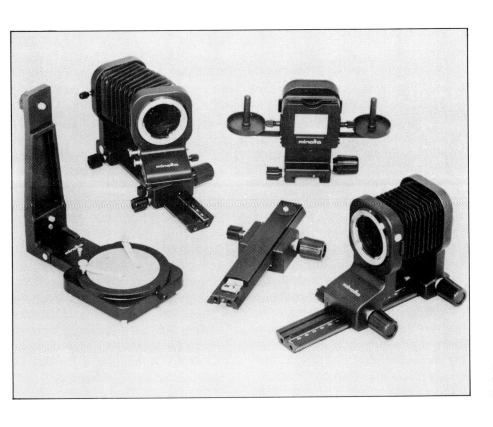

Minolta bellows units and accessories are very useful for macro photography and slide-copying.

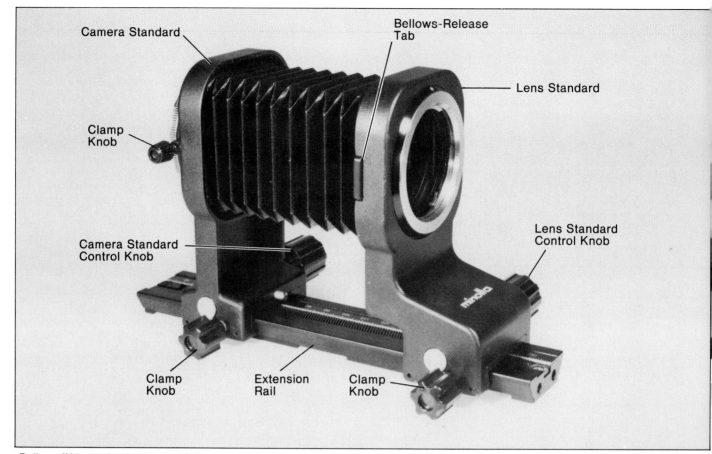

Bellows IV is mechanically simple. Camera mounts on Camera Standard and can be rotated for vertical or horizontal frame by loosening a Clamp Knob. Lens mounts on bayonet fitting on Lens Standard. Extension is set by moving bellows standards along a geared track which is part of the Extension Rail. Small knobs on this side of rail are Lock Knobs. Large knobs on opposite side are Control Knobs, used to set position of standards.

BELLOWS

If you do a lot of high-magnification photography, you'll find a bellows more convenient than extension tubes. Also, the amount of extension available with a bellows is considerably more than with a set of extension tubes, so maximum magnification is greater.

Because bellows extension is continuous, there are no gaps and you can use any distance you choose, within the range of the bellows.

There are two current models: Auto Bellows III and Bellows IV. As you will see in the following descriptions, Auto Bellows III does some tricks that extension tubes can't do. Several accessory items are available to fit these two bellows. I will describe both bellows first, then the lens-reversing procedure and some accessories.

BELLOWS IV

This is the simpler model, consisting of an extension rail and two vertical *standards* connected by a bellows.

The Camera Standard attaches to the camera the same way a lens does except that you will usually rotate the camera to engage the bayonet mount, rather than rotating the bellows. After the camera is mounted, you can position it for a horizontal or vertical frame or at any angle in between by loosening a set screw on the camera standard and rotating the camera body as desired.

The Lens Standard mounts the lens at the front of the bellows the same way a lens is normally mounted on the camera. A lens-release button on the lens standard allows removing the lens in the normal way.

Bellows extension is done by moving the two standards along the extension rail. Each standard has an internal gear that works against gear teeth on the top surface of the extension rail. Each standard has a Control Knob which moves the standard forward or backward on the rail and a Clamp Knob on the opposite side which you use to lock the standard in position.

To move either of the standards, release the Clamp Knob and turn the Control Knob to put the standard where you want it on the rail. Tighten the clamp knob when the adjustment is finished so it can't change.

The amount of bellows extension can be read using the millimeter scale on the top of the extension rail. Position of the camera standard is read by noting where its lower rear edge falls on the scale. A white dot shows you which edge to read from.

Position of the lens standard is

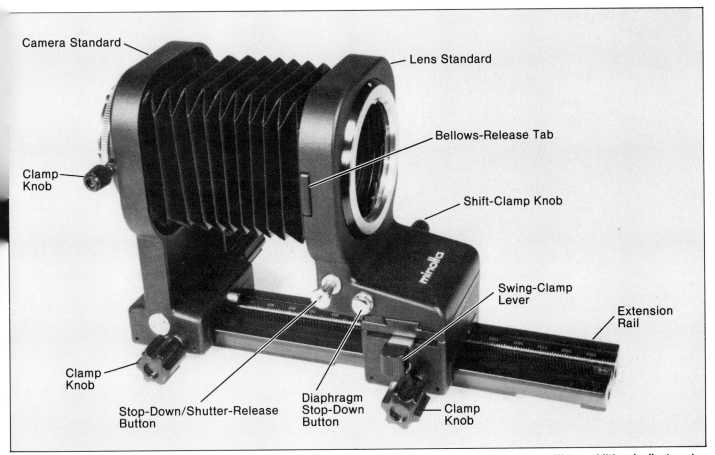

Camera Standard
Lens Standard
Clamp Knob
Bellows-Release Tab
Shift-Clamp Knob
Swing-Clamp Lever
Extension Rail
Clamp Knob
Stop-Down/Shutter-Release Button
Diaphragm Stop-Down Button
Clamp Knob

Auto Bellows III uses the same rail and has the same basic functions as Bellows IV. However, Auto Bellows III has additional adjustments and features that greatly increase its capability.

read in a similar way, referring to the lower rear edge—also indicated by a white dot.

Extension is calculated by subtracting camera-standard position from lens-standard position. If the camera standard is all the way to the back of the rail, its position is zero. Therefore you can read bellows extension directly off the scale—it will be the position of the lens standard.

Extension determined by this method is *actual* lens extension and can be used to calculate magnification using the formula given earlier.

With a lens mounted normally so it extends forward from the lens standard, the range of available extensions is from 40mm with the bellows fully collapsed to 165mm with the bellows fully extended.

The bellows extension rail has three threaded tripod sockets on the bottom; one at each end and

one in the center. Use any of them to mount the rail on a tripod or other firm support.

Magnification with any lens is determined by the amount of bellows extension. When you have set and locked extension, the subject will be in focus only at the correct distance in front of the lens—called *subject distance.*

To find focus, you must either move the subject or move the entire bellows assembly until subject distance is correct for whatever amount of magnification you are using. If the bellows is on a tripod, for example, you'll find it necessary to move the entire tripod to find focus. This is inconvenient, but possible.

An accessory focusing rail, described later, solves this problem and allows you to move the lens, camera and bellows as one unit without having to move the tripod.

Bellows IV does not complete any of the mechanical linkages between lens and camera, so no automatic features of the lens are preserved. Aperture control is fully manual, using the aperture ring. Metering is done stopped down to shooting aperture, using the stop-down metering procedure for your camera.

The camera can be used with either aperture priority automatic or manual exposure control. With a bellows, the shutter-priority mode of XD cameras cannot be used.

AUTO BELLOWS III

This bellows uses the same Extension Rail and Camera Standard as Bellows IV. The Lens Standard is different and provides much more versatility. Mounting camera and lens, moving the standards and reading bellows extension is the same on either model.

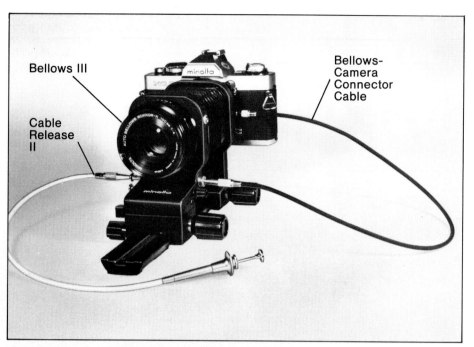

Auto Bellows III preserves the automatic-diaphragm feature through use of two cables. This arrangement stops down the lens before opening the shutter. On XG cameras, the shutter-release socket is on the side of the lens mount, rather than in the center of the shutter button.

Auto-Diaphragm—Auto Bellows III preserves the automatic-diaphragm feature of lenses by a system of two mechanical cable releases that are supplied with the bellows. Cable Release II is attached to the lens standard and used to make exposures. The second cable release, called the Bellows-Camera Connector Cable fits between the lens standard and the camera.

The cable release you use to make exposures is Minolta Cable Release II which has a locking collar to hold the operating button depressed for long time exposures.

Screw Cable Release II into the Stop-Down/ Shutter-Release Button on the right side of the lens standard.

The Bellows-Camera Connector Cable has screw fittings on each end. The end with the red ring around it screws into the Camera-Connector Socket on the left side of the lens standard which also has a red ring around it.

The opposite end screws into the shutter-release socket on the camera—the threaded socket in the center of the shutter button on XD cameras and other Minolta

35mm SLR models, or a special threaded socket on the side of the lens mount on XG cameras.

With both cable releases connected, make exposures by depressing the operating button of Cable Release II. This does two things: First, it moves a lever in the lens standard which stops down the lens to shooting aperture. Then, through the interconnecting cable, it releases the shutter to make the exposure.

It may be necessary to adjust the cable stroke to be sure the shutter is released. Test without film in the camera by depressing the operating button of Cable Release II and noticing if the camera shutter operates.

If so, no adjustment is needed, If not, turn the outer rim of the Camera-Connector Socket on the bellows fully clockwise. Then turn it counterclockwise until the camera shutter operates each time you depress the cable release operating button.

It is possible to operate bellows and camera with only the interconnecting cable between them by using your finger to depress the Stop-Down/Shutter-Release But-

ton on the lens standard. I don' recommend this method because you may jiggle the bellows assembly and blur the image.

Due to the interconnecting cable between bellows and camera, this bellows maintains auto-diaphragm operation, but it does not complete the MC linkage from lens to camera. Therefore metering must always be done with the lens stopped down to shooting aperture. This is true with any camera.

A second control on the lens standard of Auto Bellows III is called the Diaphragm Stop-Down Button. It's just in front of the Stop-Down/Shutter-Release Button.

As the name indicates, the Diaphragm Stop-Down Button has only one function—it stops down the lens to whatever aperture size has been selected by the aperture ring. To keep the lens stopped down without holding your finger on this button, depress it and turn it clockwise while holding it in. It locks until you turn it counterclockwise to release it and allow aperture to open again.

Operating on Manual—Usually you will measure the light and set exposure controls only once before making a series of shots, all with the same equipment setup and the same amount of light. There are two ways to stop down the lens so you can meter and set the controls.

If film is not advanced and therefore the shutter is not cocked, you can push the operating button on Cable Release II and lock it if desired. While lens aperture is stopped down, turn on the meter and set the exposure controls using the viewfinder exposure display as a guide.

If the shutter is cocked and ready to operate, this method allows you to inadvertently make an exposure when you were only intending to measure the light.

The other way is to depress the Diaphragm Stop-Down Button on the lens standard and lock it or

These photos show the range of magnifications available with a 50mm macro lens on Auto Bellows III. As you will see in a data table later in this chapter, the magnification range is from 0.78 to 3.2.

not, as you choose. While the lens is stopped down, measure the light and set the exposure controls using the viewfinder exposure display as a guide. With this method, there is never any chance of making an exposure accidentally.

Once you have set exposure, you can release the Diaphragm Stop-Down Button and control the camera with Cable Release II.

Until you change the setup or the amount of light on the subject, you can make exposures without rechecking the amount of light. This gives the advantage of full-aperture viewing and maximum brightness of the viewfinder image.

Setting Exposure on Manual— The procedures are generally similar but there are some differences among models.

XD cameras meter on manual. Choose an aperture setting, observe the recommended shutter-speed setting in the viewfinder display, set shutter speed to agree with the recommended value.

XG cameras do not meter on manual. Choose an aperture setting, switch the camera to automatic, observe the recommended shutter-speed setting in the viewfinder display, set shutter speed to agree with the recommended value, return the camera

to the manual mode before making the exposure.

SR-T and XK Motor cameras meter on manual. Set aperture and shutter speed for an indication of correct exposure.

These settings do not take into account any of the metering corrections described in Chapter 8, nor do they correct for reciprocity failure as described in Chapter 10. These corrections must be made separately.

Operating on Automatic— One of the major advantages of automatic exposure is to set exposure with high magnification. The procedure depends on which camera model you are using.

With XG Cameras— On automatic aperture-priority operation, these cameras require the lens to be stopped down to shooting aperture before depressing the shutter button.

Depress the Diaphragm Stop-Down Button and lock it. Select a lens aperture size so the camera chooses a shutter speed within the operating range. To check, turn on the camera meter by touching or slightly depressing the shutter button while observing the viewfinder display. Make the exposure without releasing the Diaphragm Stop-Down Button.

If you are making a series of ex-

posures with the same setup, leave the lens stopped down throughout the series. If you need to view at full aperture, open the lens momentarily by releasing the Diaphragm Stop-Down Button and then stop down again before making the next exposure.

With XD Cameras— These cameras cannot be used on *shutter* priority with a bellows. Aperture priority is the preferred mode.

XD cameras on *aperture* priority measure exposure and set shutter speed after the lens has stopped down and before the shutter operates. There is no special procedure to help the camera set exposure.

However, you should check to be sure that the shutter speed the camera will use is within the operating range. To do this depress the Diaphragm Stop-Down Button on the bellows and then turn on the camera meter by partially depressing the shutter button on the camera.

Look in the viewfinder to see what shutter speed is being selected. If it is not within the operating range, or if it's a shutter speed you prefer not to use, change lens aperture or change the amount of light on the subject.

With the XK Motor Camera— The procedure is the same as with XD cameras.

111

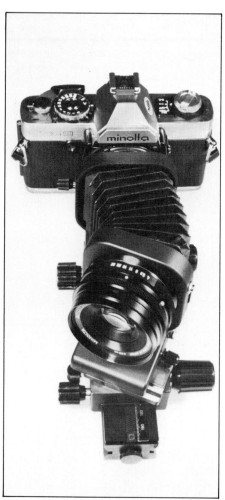

To *shift* the lens standard on Auto Bellows III, loosen the Shift-Clamp Knob and slide the standard to the left or right. Then tighten the clamp knob to lock the setting. To *swing* the lens standard, release the Swing-Clamp Lever and rotate the lens to the left or right. Then reset the clamp lever to hold the setting. You can use swing and shift at the same time. This lens is swung to the right and shifted to the right, as seen through the camera.

SWING AND SHIFT

In addition to the aperture-control mechanisms just described, the lens standard of Auto Bellows III also allows you to shift and swing the lens.

Shift means to move the lens sideways without rotating it. *Swing* means to pivot the lens so it "looks" to the left or right instead of straight ahead. These are called *movements* and the two movements can be combined.

Each of these movements has its own control on the bellows. To shift the lens standard sideways, unscrew the Shift-Clamp Knob slightly, move the standard, and lock it in position by retightening the Shift-Clamp Knob.

The swing movement is controlled by the Swing-Clamp Lever. Pull the lever toward the camera to release the standard, pivot the standard as desired and lock in position by pushing the Swing-Clamp Lever forward.

Swinging the lens is useful because lenses have very little depth of field at high magnification. Lenses are corrected for flatness of field which means the zone of best focus is a flat plane somewhere in front of the lens. This is fine when photographing flat subjects such as a postage stamp with the face of the stamp parallel to the film. The zone of best focus can include all of the flat surface.

There are subjects with a tilted surface which cannot be in good focus when the lens looks straight ahead. These can be sharply focused by swinging the lens so the plane of best focus coincides with the surface of the subject.

Photos of some three-dimensional subjects, such as small insects, benefit by swinging the lens to put best focus where you want it.

When you swing a lens, the composition changes. If you swing the lens to the left, the part of the scene that was in the center of the frame moves to the right side.

Shifting the lens is the handiest way to restore the composition you had before swinging. If you swing the lens to the left, you can restore the original composition by shifting to the right. You can also restore the original view by moving the subject or the camera but this is usually awkward when using high magnification.

With some subjects it may be best to tilt and swing at some angle other than sideways. Even though the direction of the bellows movements is fixed, the position of the camera is not because it can be rotated on the camera standard. Therefore you can get the effect of swinging or tilting in any direction by rotating the camera body.

In this photo made with Auto Bellows III the plane of best focus is parallel to the film because the lens standard is not swung. This photo can be improved by swinging the lens so the plane of best focus fits the subject better.

Here, the lens has been swung to put the plane of best focus so it fits the subject better. But swinging the lens causes it to look in a different direction, so the composition has been changed.

Shifting the lens restores the original composition while retaining the benefit of swinging the lens.

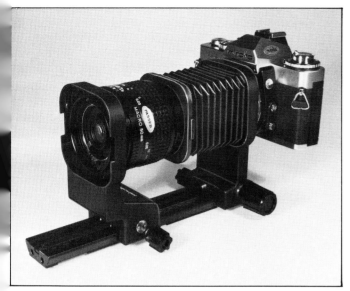

To reverse a lens on Bellows IV, disconnect the bellows fabric from the lens standard. Reverse the standard by removing it from the rail and reinstalling it backwards. Bellows fabric is then attached to the filter threads on the lens.

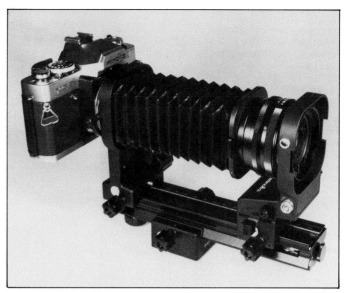

To reverse a lens on Bellows III, disconnect the bellows fabric from the lens standard. Release the Swing-Clamp Lever and rotate the standard 180°. Clamp the standard and connect the bellows fabric to the filter threads on the lens.

REVERSING THE LENS

At magnifications higher than 1.0, lenses should be reversed. You can use a reverse ring to reverse the lens on the front of a bellows just as you reverse a lens on the front of an extension tube. However, you can reverse the lens on either bellows without using a reverse ring.

Bellows IV—To reverse the lens, squeeze the two tabs on the sides of the lens standard. This releases the bellows from the standard.

Turn the control knob to move the lens standard forward and wind it off the end of the rail. Reverse the standard and wind it back on again, using the control knob.

Reconnect the bellows by squeezing the same two tabs and inserting the end of the bellows into the front of the lens—if it has 55mm filter threads. An adapter comes with the bellows to allow using lenses with 49mm threads. Screw the adapter into the lens filter threads. Then attach the bellows to the adapter.

Auto Bellows III—To reverse the lens, separate the bellows from the lens standard by squeezing the two tabs on the sides of the standard. Then move the Swing-Clamp Lever toward the camera.

Rotate the lens standard 180° and lock in position with the Swing-Clamp Lever. Connect the bellows to a 55mm lens by squeezing the tabs and inserting the bellows into the front of the lens. Use the adapter between bellows and a 49mm lens.

Bellows Extension with a Reversed Lens—When the lens extends backward from the lens standard, the method of determining lens extension is a little different. Also, the extension you find by this method is approximate because the lens itself is between the two standards. I refer to it as *reference extension* because it is not actual.

You cannot use reference extension to calculate magnification—except approximately. You can use it to look up magnification in the tables in this chapter because they are based on reference extension when the lens is reversed.

The method is the same for either bellows. When the lens standard is rotated to reverse the lens, read the position of the lens standard by noting where the *front* edge falls on the scale. A red dot is engraved on the front edge as a reminder.

Position of the camera standard is always read the same way whether the lens standard is reversed or not. Reference bellows extension is obtained by subtracting camera-standard position from lens-standard position.

Bellows Extension Tables—The accompanying tables will help you set up for a wide range of magnifications with a variety of Minolta lenses. The data in the table for normally mounted lenses applies to any method of extension, bellows or extension tubes. The table for reversed lenses applies only to lenses mounted on a bellows.

Combining Bellows and Extension Tubes—If you need more magnification than the bellows provides, mount an extension tube or stack of extension tubes to project forward from the lens standard. Then mount the lens on the forward end of the extension tube or tubes.

If you use non-automatic extension tubes, aperture control will be fully manual with either bellows and metering must be done stopped down.

If you use automatic extension tubes, Auto Bellows III will work the same as already described, preserving auto-diaphragm. Bellows IV remains fully manual.

113

Although intended primarily for use with lenses mounted normally on a bellows, this chart applies also to lenses mounted normally on extension tubes. Lens is assumed to be focused at infinity.

*Data in horizontal rows on the chart:
A Exposure Factor—discussed later in this chapter.
B Magnification at the indicated amount of extension.
C Distance (mm) between front of lens and subject plane.
D Distance (mm) between film plane and subject plane.
E Exposure Factor stated in exposure steps.

MAGNIFICATION BY EXTENSION WITH LENS NOT REVERSED

EXTENSION IN MILLIMETERS (40 – 165)

Note: In each table below the columns run left-to-right with increasing lens extension (from 40mm at left to 165mm at right). Row A values are the exposure factors (X), used here as column headers.

28mm f-2 MD

	(2.5X)	(2.8X)	(3.2X)
B	1.40	1.6	1.92
C	6	3	0
D	151	154	160
E	1¼	1½	1¾

28mm f-2.8 MD

	(3.0X)	(3.2X)	(4.2X)	(5.4X)	(6.7X)	(8.1X)	(9.7X)	(11.4X)	(12.4X)
B	1.41	1.5	2	2.5	3	3.5	4	4.5	4.77
C	14	13	8	6	4	2	1	0.5	0
D	141	143	152	163	176	188	202	215	222
E	1⅓	1¾	2	2½	2¾	3	3¼	3½	3½

28mm f-3.5 MD

	(3.0X)	(3.2X)	(4.2X)	(5.4X)	(6.7X)	(8.1X)	(9.7X)	(10.4X)
B	1.40	1.5	2	2.5	3	3.5	4	4.21
C	14	12	8	5	3	1.5	0.5	0
D	138	139	149	160	173	185	199	204
E	1⅓	1¾	2	2½	2¾	3	3¼	3½

35mm f-1.8 MD

	(2.9X)	(3.9X)	(5.3X)	(6.9X)	(8.7X)	(10.7X)	(12.9X)	(15.4X)	(16.0X)
B	1.12	1.5	2	2.5	3	3.5	4	4.5	4.62
C	31	23	17	13	11	9	8	7	7
D	163	168	180	194	210	226	243	259	264
E	1½	1¾	2	2½	2¾	3	3½	3¾	4

35mm f-2.8 MD

	(3.1X)	(3.9X)	(5.3X)	(7.0X)	(8.8X)	(10.8X)	(13.1X)	(15.6X)	(16.7X)
B	1.14	1.5	2	2.5	3	3.5	4	4.5	4.71
C	33	26	20	17	14	13	11	10	10
D	155	161	172	186	202	217	234	250	257
E	1½	1¾	2½	2¾	3	3½	3¾	4	4

45mm f-2 MD

	(3.1X)	(3.5X)	(4.2X)	(4.9X)	(5.7X)	(6.6X)	(7.5X)	(8.5X)	(9.5X)	(10.6X)	(11.8X)	(13.0X)	(14.3X)	(15.7X)	(16.7X)
B	0.86	1	1.2	1.4	1.6	1.8	2	2.2	2.4	2.6	2.8	3	3.2	3.4	3.56
C	69	62	54	49	45	41	39	37	35	33	32	31	30	29	29
D	184	183	184	188	193	199	206	213	221	229	237	245	253	262	268
E	1½	1¾	2	2¼	2½	2¾	3	3	3¼	3½	3½	3¾	3¾	3¾	4

50mm f-1.2 MD

	(2.2X)	(2.7X)	(3.1X)	(3.6X)	(4.1X)	(4.6X)	(5.2X)	(5.8X)	(6.4X)	(7.1X)	(7.7X)	(8.5X)	(9.2X)
B	0.77	1	1.2	1.4	1.6	1.8	2	2.2	2.4	2.6	2.8	3	3.18
C	66	51	42	36	32	28	25	23	21	19	18	16	15
D	196	193	195	199	205	211	219	227	235	244	253	262	271
E	1¼	1½	1¾	1¾	2	2¼	2¼	2½	2½	2¾	2¾	3	3¼

50mm f-1.4 MD

	(2.6X)	(3.2X)	(3.8X)	(4.4X)	(5.1X)	(5.8X)	(6.6X)	(7.4X)	(8.3X)	(9.2X)	(10.2X)	(11.2X)	(12.3X)
B	0.78	1	1.2	1.4	1.6	1.8	2	2.2	2.4	2.6	2.8	3	3.20
C	72	60	51	45	40	37	34	31	30	28	26	25	25
D	198	195	197	201	207	213	221	229	237	246	255	264	273
E	1½	1¾	2	2¼	2¼	2½	2½	2¾	3	3	3¼	3¼	3½

50mm f-1.7 MD

	(3.1X)	(3.8X)	(4.6X)	(5.5X)	(6.4X)	(7.5X)	(8.5X)	(9.7X)	(10.9X)	(12.3X)	(13.6X)	(15.1X)	(16.6X)
B	0.78	1	1.2	1.4	1.6	1.8	2	2.2	2.4	2.6	2.8	3	3.20
C	76	64	55	49	44	41	38	36	34	32	31	29	28
D	201	199	200	205	210	217	224	232	241	249	258	267	277
E	1¾	2	2¼	2¼	2¾	3	3	3¼	3½	3½	3¾	4	4

50mm 5-3.5 MD MACRO

	(3.3X)	(4.1X)	(5.0X)	(5.9X)	(7.0X)	(8.0X)	(9.3X)	(10.6X)	(12.0X)	(13.4X)	(15.0X)	(16.6X)	(18.3X)
B	0.78	1	1.2	1.4	1.6	1.8	2	2.2	2.4	2.6	2.8	3	3.20
C	67	52	44	38	33	30	27	24	22	21	19	18	17
D	205	202	204	208	214	220	228	236	244	253	261	270	280
E	1¾	2	2¼	2½	2¾	3	3¼	3¼	3½	3¾	4	4	4¼

85mm f-1.7 MD

	(2.5X)	(2.5X)	(2.9X)	(3.4X)	(3.8X)	(4.3X)	(4.8X)	(5.3X)	(5.9X)	(6.5X)	(7.1X)	(7.7X)	(8.4X)	(9.1X)	(9.8X)	(10.6X)	(11.1X)
B	0.48	0.5	0.6	0.7	0.8	0.9	1	1.1	1.2	1.3	1.4	1.5	1.6	1.7	1.8	1.9	1.96
C	222	214	186	166	151	139	130	122	116	110	106	102	98	95	92	90	88
D	368	361	342	330	324	320	319	320	322	325	329	333	338	344	349	355	359
E	1¼	1¼	1½	1¾	2	2	2¼	2⅓	2½	2½	2¾	2¾	3	3	3¼	3¼	3½

85mm f-2.8 VARISOFT

	(2.1X)	(2.2X)	(2.5X)	(2.9X)	(3.2X)	(3.6X)	(3.9X)	(4.4X)	(4.8X)	(5.2X)	(5.7X)	(6.2X)	(6.7X)	(7.2X)	(7.7X)	(8.3X)
B	0.46	0.5	0.6	0.7	0.8	0.9	1	1.1	1.2	1.3	1.4	1.5	1.6	1.7	1.8	1.90
C	232	217	188	167	152	139	130	122	115	110	105	101	97	94	91	89
D	404	392	372	360	353	350	349	349	352	355	359	363	368	374	380	386
E	1	1¼	1¼	1½	1¾	1¾	2	2	2¼	2⅓	2½	2½	2¾	2¾	3	3

100mm f-2.5 MD

	(2.3X)	(2.6X)	(3.1X)	(3.5X)	(4.0X)	(4.5X)	(5.1X)	(5.7X)	(6.3X)	(6.9X)	(7.6X)	(8.3X)	(9.0X)	(9.7X)
B	0.41	0.5	0.6	0.7	0.8	0.9	1	1.1	1.2	1.3	1.4	1.5	1.6	1.68
C	320	276	243	220	202	189	178	169	161	155	150	145	141	138
D	468	433	410	396	389	385	384	385	387	391	395	400	406	411
E	1¼	1½	1½	1¾	2	2¼	2¼	2½	2½	2¾	3	3	3¼	3¼

100mm f-4 MD

	(2.1X)	(2.5X)	(2.9X)	(3.3X)	(3.7X)	(4.1X)	(4.6X)	(5.1X)	(5.7X)	(6.2X)	(6.8X)	(7.4X)	(8.1X)	(8.4X)
B	0.40	0.5	0.6	0.7	0.8	0.9	1	1.1	1.2	1.3	1.4	1.5	1.6	1.65
C	314	264	230	206	189	175	164	155	147	141	135	130	126	124
D	485	446	422	408	401	397	396	396	399	402	407	412	418	421
E	1	1¼	1½	1¾	2	2¼	2¼	2½	2½	2¾	3	3	3	3

100mm f-4 AUTO BELLOWS

	(1.1X)	(1.2X)	(1.5X)	(1.7X)	(2.0X)	(2.3X)	(2.7X)	(3.0X)	(3.4X)	(3.8X)	(4.2X)	(4.7X)	(5.1X)	(5.3X)
B	0	0.1	0.2	0.3	0.4	0.5	0.6	0.7	0.8	0.9	1	1.1	1.2	1.23
C	3606	1080	579	412	328	278	245	221	203	189	178	169	161	160
D	3729	1210	719	562	489	448	425	411	403	400	398	399	402	403
E	*(row illegible)*													

135mm f-2.8 MD

	(2.4X)	(2.9X)	(3.6X)	(4.3X)	(5.1X)	(5.9X)	(6.8X)	(7.8X)	(8.8X)	(9.8X)	(10.1X)
B	0.30	0.4	0.5	0.6	0.7	0.8	0.9	1	1.1	1.2	1.22
C	641	483	415	370	338	314	295	280	268	258	256
D	814	670	616	584	566	555	550	548	549	553	553
E	1¼	1½	1¾	2	2¼	2½	2¾	3	3	3¼	3¼

135mm f-3.5 MD

	(2.3X)	(2.9X)	(3.6X)	(4.3X)	(5.0X)	(5.9X)	(6.7X)	(7.8X)	(8.7X)	(9.8X)	(10.1X)
B	0.30	0.4	0.5	0.6	0.7	0.8	0.9	1	1.1	1.2	1.22
C	589	476	408	363	331	307	288	273	261	251	249
D	760	661	607	575	557	546	541	539	541	544	545
E	1¼	1½	1¾	2	2¼	2½	2¾	3	3	3¼	3¼

200mm f-4 MD

	(2.1X)	(2.4X)	(2.8X)	(3.2X)	(3.5X)	(4.0X)	(4.4X)	(4.9X)	(5.4X)	(6.0X)	(6.5X)	(7.1X)	(7.7X)	(8.1X)
B	0.20	0.25	0.3	0.35	0.4	0.45	0.5	0.55	0.6	0.65	0.7	0.75	0.8	0.83
C	1276	1076	943	847	776	720	676	640	609	584	562	543	526	518
D	1490	1300	1177	1092	1030	985	950	924	904	888	876	867	860	858
E	1	1¼	1¼	1½	1½	1¾	1¾	2	2¼	2¼	2½	2¾	3	3

MAGNIFICATION WITH LENS REVERSED ON BELLOWS

REFERENCE EXTENSION FROM BELLOWS SCALE

Bellows scale reference values: 75 80 90 100 110 120 130 140 150 160 170 180 190 200

Data rows for each lens — **A** Exposure Factor, **B** Magnification, **C** Distance (mm) front of lens to subject plane, **D** Distance (mm) film plane to subject plane, **E** Exposure Factor in exposure steps.

20mm f-2.8 MD
- A: (21.1X) (24.0X) (29.1X) (34.8X) (40.9X) (47.6X) (54.7X) (62.4X) (70.5X) (79.2X) (88.3X) (98.0X) (108.1X) (114.4X)
- B: 4.2 4.5 5 5.5 6 6.5 7 7.5 8 8.5 9 9.5 10 10.3
- C: 32 31 31 30 30 30 29 29 29 29 29 29 29 29
- D: 167 173 183 193 203 213 223 233 243 253 263 274 284 289
- E: 4½ 4½ 4¾ 5 5¼ 5½ 5¾ 6 6¼ 6¼ 6½ 6½ 6¾ 6¾

24mm f-2.8 MD
- A: (14.1X) (15.4X) (19.6X) (24.2X) (29.4X) (35.1X) (41.3X) (47.9X) (55.1X) (62.8X) (71.0X) (79.1X)
- B: 3.33 3.5 4.5 5 5.5 6 6.5 7 7.5 8 8.47
- C: 34 33 33 32 31 31 31 30 30 30 30 29
- D: 168 176 184 196 207 219 231 243 255 267 279 290
- E: 3¾ 4 4¼ 4½ 5 5¼ 5¼ 5½ 5¾ 5¾ 6 6¼

28mm f-2 MD
- A: (11.0X) (11.6X) (15.3X) (19.5X) (24.1X) (29.3X) (34.9X) (41.1X) (47.8X) (53.5X)
- B: 2.94 3 3.5 4.5 5.5 6.5 6.89
- C: 36 36 35 34 33 32 32 31 31 31
- D: 184 185 198 212 225 239 253 267 281 291
- E: 3½ 3½ 4 4¼ 4½ 4¾ 5 5¼ 5½ 5¾

28mm f-2.8 MD
- A: (11.4X) (12.4X) (16.2X) (20.5X) (25.3X) (30.5X) (36.3X) (42.6X) (49.4X) (56.7X) (60.8X)
- B: 2.85 3 3.5 4 4.5 5 5.5 6 6.5 7 7.27
- C: 36 36 35 34 33 32 32 31 31 31 30
- D: 172 176 188 202 215 229 242 256 270 284 291
- E: 3½ 3¾ 4 4¼ 4¾ 5 5¼ 5½ 5½ 5¾ 6

28mm f-3.5 MD
- A: (12.2X) (12.4X) (16.2X) (20.5X) (25.3X) (30.6X) (36.3X) (42.6X) (49.4X) (56.7X) (62.1X)
- B: 2.96 3 3.5 4 4.5 5 5.5 6 6.5 7 7.35
- C: 36 36 35 34 33 32 32 31 31 31 30
- D: 172 173 185 199 212 226 240 253 267 281 291
- E: 3½ 3¾ 4 4¼ 4¾ 5 5¼ 5½ 5½ 5¾ 6

35mm f-1.8 MD
- A: (7.4X) (9.9X) (13.3X) (17.2X) (21.6X) (26.5X) (31.9X) (37.8X)
- B: 2.08 2.5 3 3.5 4 4.5 5 5.50
- C: 44 41 38 37 35 34 34 33
- D: 182 194 210 226 243 259 276 293
- E: 3 3¾ 3¾ 4 4¼ 4¾ 5 5¼

35mm f-2.8 MD
- A: (8.1X) (10.0X) (13.4X) (17.3X) (21.7X) (26.6X) (32.0X) (37.9X) (41.4X)
- B: 2.20 2.5 3 3.5 4 4.5 5 5.5 5.78
- C: 42 40 38 36 35 34 33 33 33
- D: 178 186 202 217 234 250 267 284 293
- E: 3 3¼ 3¾ 3¾ 4 4½ 4¾ 5 5¼

45mm f-2
- A: (5.9X) (6.1X) (7.1X) (8.2X) (9.4X) (10.7X) (12.0X) (13.5X) (15.0X) (16.6X) (18.2X) (20.0X) (21.8X) (23.7X) (25.7X) (26.1X)
- B: 1.55 1.6 1.8 2 2.2 2.4 2.6 2.8 3 3.2 3.4 3.6 3.8 4 4.2 4.24
- C: 56 56 52 50 48 46 44 43 42 41 40 39 39 38 38 37
- D: 192 193 199 206 213 221 229 237 245 253 262 270 279 287 296 298
- E: 2½ 2½ 2¾ 3 3¼ 3½ 3½ 3¾ 4 4 4¼ 4¼ 4½ 4½ 4¾ 4¾

50mm f-1.2
- A: (4.1X) (5.1X) (6.0X) (7.0X) (8.0X) (9.3X) (10.6X) (11.9X) (13.3X) (14.7X) (16.4X) (18.1X) (19.8X) (19.9X)
- B: 1.40 1.6 1.8 2 2.2 2.4 2.6 2.8 3 3.2 3.4 3.6 3.8 3.82
- C: 63 59 55 52 50 48 46 45 44 43 42 41 40 40
- D: 199 205 211 219 227 235 244 253 262 271 281 290 300 301
- E: 2 2¼ 2½ 2¾ 3 3¼ 3¼ 3½ 3½ 3¾ 4 4 4¼ 4¼

50mm f-1.4 MD
- A: (4.4X) (4.8X) (5.7X) (6.7X) (7.7X) (8.9X) (10.1X) (11.4X) (12.8X) (14.3X) (15.9X) (17.5X) (19.2X) (20.5X)
- B: 1.36 1.4 1.6 1.8 2 2.2 2.4 2.6 2.8 3 3.2 3.4 3.6 3.79
- C: 64 63 59 55 52 50 48 46 45 44 43 42 41 40
- D: 200 201 207 213 221 229 237 246 255 264 273 282 292 301
- E: 2¼ 2¼ 2½ 2¾ 3 3¼ 3¼ 3½ 3½ 3¾ 4 4 4¼ 4½

50mm f-1.7 MD
- A: (5.1X) (5.6X) (6.5X) (7.6X) (8.8X) (10.0X) (11.3X) (12.7X) (14.1X) (15.7X) (17.3X) (19.0X) (20.8X) (21.7X)
- B: 1.29 1.4 1.6 1.8 2 2.2 2.4 2.6 2.8 3 3.2 3.4 3.6 3.71
- C: 66 63 59 55 52 50 48 46 45 44 43 42 41 40
- D: 202 205 210 217 224 232 241 249 258 257 267 286 295 301
- E: 2¼ 2½ 2¾ 3 3¼ 3¼ 3½ 3¾ 3¾ 4 4¼ 4¼ 4½ 4½

50mm f-3.5 MD MACRO
- A: (5.5X) (5.9X) (6.9X) (8.0X) (9.2X) (10.4X) (11.7X) (13.1X) (14.6X) (16.2X) (17.9X) (19.6X) (21.4X) (21.6X)
- B: 1.32 1.4 1.6 1.8 2 2.2 2.4 2.6 2.8 3 3.2 3.4 3.6 3.63
- C: 66 63 59 55 52 50 48 46 45 44 43 42 41 41
- D: 207 208 214 220 228 236 244 253 261 270 280 289 298 301
- E: 2½ 2½ 2¾ 3 3¼ 3½ 3½ 3½ 3¾ 3¾ 4 4¼ 4½ 4½

85mm f-1.7 MD
- A: (2.2X) (2.2X) (2.5X) (2.8X) (3.2X) (3.6X) (3.9X) (4.4X) (4.8X) (5.2X) (5.7X) (6.2X) (6.7X) (7.2X) (7.8X) (7.8X)
- B: 0.28 0.3 0.4 0.5 0.6 0.7 0.8 0.9 1 1.1 1.2 1.3 1.4 1.5 1.6 1.61
- C: 331 307 237 195 167 147 132 120 111 103 97 91 87 83 79 79
- D: 479 457 395 361 342 330 324 320 320 320 322 325 329 333 338 339
- E: 1 1¼ 1¼ 1½ 1¾ 1¾ 2 2 2¼ 2½ 2½ 2¾ 2¾ 2¾ 3 3

85mm f-2.8 VARISOFT
- A: (1.7X) (1.9X) (2.2X) (2.5X) (2.8X) (3.2X) (3.6X) (3.9X) (4.4X) (4.8X) (5.2X)
- B: 0.30 0.4 0.5 0.6 0.7 0.8 0.9 1 1.1 1.2 1.29
- C: 314 244 200 171 151 135 123 113 106 99 94
- D: 489 427 392 372 360 353 350 349 349 354 354
- E: ¾ 1 1 1¼ 1¼ 1½ 1¾ 1¾ 2 2¼ 2½

100mm f-2.5 MD
- A: (1.8X) (2.1X) (2.4X) (2.7X) (3.1X) (3.4X) (3.8X) (4.2X) (4.6X) (5.1X) (5.3X) (5.3X)
- B: 0.04 0.1 0.2 0.3 0.4 0.5 0.6 0.7 0.8 0.9 1 1.01
- C: 2349 1006 516 353 271 222 190 166 149 135 124 123
- D: 2514 1178 697 544 472 433 410 396 389 385 384 384
- E: ¾ 1 1 1¼ 1¼ 1½ 1¾ 2 2 2¼ 2¼ 2¼

100mm f-4 MD MACRO
- A: (1.4X) (1.6X) (1.8X) (2.1X) (2.4X) (2.7X) (3.1X) (3.4X) (3.8X) (4.2X) (4.2X)
- B: 0.05 0.1 0.2 0.3 0.4 0.5 0.6 0.7 0.8 0.9 0.91
- C: 1898 1026 526 360 276 226 193 169 151 138 136
- D: 2073 1205 715 559 486 446 422 408 401 397 396
- E: ½ ¾ ¾ 1 1¼ 1½ 1½ 1½ 1¾ 2 2

100mm f-4 AUTO BELLOWS
- A: (1.2X) (1.3X) (1.6X) (1.8X) (2.1X) (2.4X) (2.7X) (3.1X) (3.4X) (3.8X) (4.2X) (4.6X) (5.1X) (5.5X) (5.6X)
- B: 0.06 0.1 0.2 0.3 0.4 0.5 0.6 0.7 0.8 0.9 1 1.1 1.2 1.3 1.31
- C: 1687 1028 527 360 277 227 193 170 152 138 127 118 110 104 103
- D: 1865 1210 719 562 489 448 425 411 403 400 398 399 402 405 406
- E: ¼ ¼ ¾ ¾ 1 1¼ 1½ 1½ 1¾ 2 2 2¼ 2¼ 2½ 2½

135mm f-2.8 MD
- A: (3.3X) (3.4X)
- B: 0.03 0.06
- C: 4864 2103
- D: 5119 2363
- E: 1¾ 1¾

135mm f-3.5 MD
- A: (3.3X) (3.6X) (3.7X)
- B: 0.02 0.1 0.132
- C: 6646 1377 1053
- D: 6892 1633 1314
- E: 1¾ 1¾ 1¾

This chart applies only to reversed lenses mounted on a bellows because bellows scale reading with reversed lens is not actual extension.

*Data in horizontal rows on the chart:
A Exposure Factor—discussed later in this chapter.
B Magnification at the indicated amount of extension.
C Distance (mm) between front of lens and subject plane.
D Distance (mm) between film plane and subject plane.
E Exposure Factor stated in exposure steps.

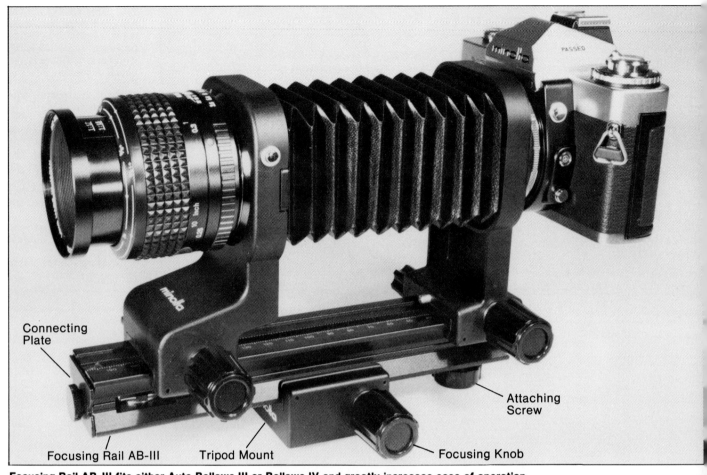

Connecting Plate

Attaching Screw

Focusing Rail AB-III Tripod Mount Focusing Knob

Focusing Rail AB-III fits either Auto Bellows III or Bellows IV and greatly increases ease of operation.

Focusing Rail AB-III—In my opinion, this is an essential accessory unless you are using a fixed setup that is seldom or never changed.

the bottom of the extension rail of either bellows. The Focusing Rail itself has a movable tripod mount on its bottom.

By attaching the tripod mount on the Focusing Rail to a tripod or other support and turning the Focusing Knob on the Focusing Rail, the entire bellows assembly moves forward or backward to find focus. This is so convenient that I recommend it urgently.

To mount the Focusing Rail on either bellows, first attach the Connecting Plate to the front end of the Focusing Rail by turning the built-in screw. When mounted, two pins project backward from the Connecting Plate and fit into two holes on the front of the bellows extension rail. This connects the two rails at the front.

At the back, a built-in Attaching Screw on the Focusing Rail screws into the rearmost tripod socket on the bottom of the bellows extension rail.

Thus assembled, the combined bellows and Focusing Rail work as one unit with three positioning knobs. One knob controls lens-standard position. Another knob controls camera-standard position. A third knob, on the Focusing Rail, controls position of the entire assembly—bellows, camera and lens.

Lateral Tracking—The Focusing Rail can be attached to the bellows extension rail so it projects sideways. To do this, screw the Attaching Screw on the Focusing Rail into any of the three tripod sockets on the bottom of the extension rail. At each of the tripod sockets on the extension rail, the bottom of the rail has a groove to locate the Focusing Rail so the angle between rails is 90°.

The Connecting Plate is not used.

With this arrangement, the tripod mount on the Focusing Rail can be attached to a tripod or other firm support. Turning the control knob on the focusing rail then causes the bellows to move sideways along the Focusing Rail.

You can use this setup to make multiple photos of an object that is too long to photograph entirely within one frame, for example. Or you can use it as an aid to precise positioning of the bellows in the horizontal direction.

Flash With Bellows—Minolta cameras have a hot shoe on the top which is normally used to mount an electronic flash unit. A center electrical contact in the hot shoe fires the flash as described in Chapter 11.

With a bellows on the camera, the hot shoe location may not be suitable for a flash unit because the bellows may block light from the flash.

116

Many flash units can be connected to the camera with an electrical sync cord so the flash can be placed at the side or any other appropriate location. When using flash this way, there may be a problem in mounting and supporting the flash unit.

The focusing rail can solve this problem when it is mounted so it projects sideways from the bellows extension rail. At the far end of the focusing rail is a recessed hot shoe which accepts any flash unit designed for conventional hot-shoe mounting.

The center electrical contact of the hot shoe on the rail is made "hot" by a special electrical sync cord supplied with the focusing rail. Plug one end of this cord into the bottom of the hot shoe and plug the other into the flash sync terminal on the camera body. When set up this way, the flash will fire in the remote hot shoe on the end of the focusing rail in the same way that it would fire if mounted normally in the camera hot shoe.

Usually it is best to attach the focusing rail to the front tripod socket on the bellows rail so the flash is about even with the front of the lens. This minimizes the possibility of the bellows or lens casting a shadow on the subject. The hot shoe on the focusing rail rotates so you can point the flash in any direction.

In Chapter 11, I will tell you how to get good exposures with flash, but there is one factor I should mention now.

If the subject is close to the bellows, as it usually is for high magnification, pointing the flash unit straight ahead will cause light from the flash to miss the subject and it will not be well illuminated. You should rotate the flash toward the centerline of the lens so it points directly at the subject.

In this situation, light reaches the subject at an angle and bounces off the subject at an angle. Light reflected from the subject doesn't travel directly back toward

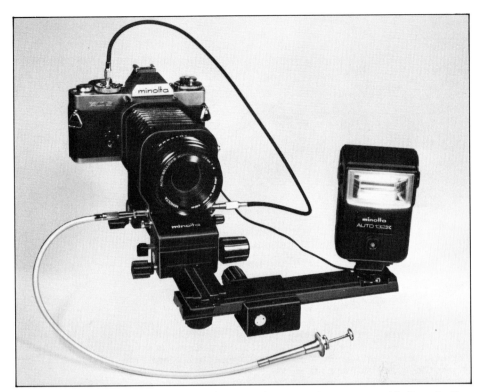

Focusing Rail AB-III can be turned 90° and used to move the camera and bellows to the left or right. It can also be used to mount a flash off to the side for better illumination of close subjects.

the lens and therefore some of the light is lost.

In addition to setting correct exposure for the flash in the normal way, when you are using flash on the focusing rail as described here, you must add exposure depending on the angle of the flash. This compensation is shown in the accompanying table.

Angle of Flash To Focusing Rail	Exposure Increase (Steps)
Less than 45°	0
45°	1
More than 45°	1-1/2 to 2

COPYING SLIDES

A slide copier fits on the front end of a bellows and lets you do a lot of interesting things.

You can copy slides, seeking to make exact duplicates. You can copy slides while making deliberate changes such as cropping the original image or using filters to change the color of the original. You can make slide "sandwiches" of two slides so the copy combines the two images. You can add a textured background, put the moon or sun where they never were in reality, and other tricks.

Among all of those possibilities, and whatever else you may think of, the one I don't recommend is making exact duplicates. If that's what you want, you'll be better off making several identical exposures at the time you shoot the picture. Or else, have duplicate slides made for you by a commercial lab.

I enthusiastically recommend slide copying to alter or improve the end result. Use Slide Copier AB-III which fits either Auto Bellows III or Bellows IV.

117

Slide Copier AB-III fits either Auto Bellows III or Bellows IV. It mounts on the focusing rail and its position is set by a control knob and lock knob on the slide-copier standard. A bellows is attached to the back of the slide copier and used to exclude light from the path between copier and lens. The trays at left and right are accessory roll-film holders to allow duplicating individual frames from rolls or strips of film.

The focusing rail is not needed because camera, bellows and slide to be copied are all mounted on the bellows extension rail. The connecting plate used to attach focusing rail to extension rail will prevent mounting the slide copier if the focusing rail is on the bellows.

The front side of the slide copier has a pane of frosted plastic to diffuse the light. At the back side, a bellows is held in place by a magnetic retainer.

When copying slides, you will normally use a magnification of 1.0 or higher so the image of the slide you are copying will fill the frame on film in the camera. The lens should be reversed.

Mount the slide copier on the bellows extension rail by threading the copier on from the front, using the control knob on the copier to turn the internal gear.

Pull out the copier bellows and attach it by squeezing the two tabs on the bellows while inserting it into the threaded ring on the lens standard. If the lens is not reversed, attach the copier bellows to the lens filter threads in the same way.

When you have done this, the camera body is connected to the lens by a bellows and the lens is connected to the slide copier by a second bellows which is part of the copier.

The copier has a slot in the top into which you drop slides to be copied. Slide mounts are square even though the cutout for the slide is rectangular, so you can insert the slide with any side up.

You can crop the image while copying. The front part of the slide copier shifts vertically, 7mm up or 6mm down, and also shifts 8.5mm horizontally in either direction. Detents hold the slide in the center and at the extremes of each movement but you can use any amount of movement in either direction, up to the limit.

You may, for example, want to copy only the lower left corner of a slide. When cropping, magnification must be higher than 1.0 and high enough to fill the frame in the camera with the cropped image from the slide you are copying.

The metal frame holding the diffuser panel at the front of the copier is hinged so you can tip it forward at the top to insert a film strip. Two roll-film holders are packaged with the copier. They

install, one on each side, in threaded screw holes on the copier.

Two screw holes are on each side. Mounting the roll film holders in the top holes positions them to support and align 16mm or 110-size film. In the lower holes, the holders are positioned to copy 35mm or 126-size film.

SETTING MAGNIFICATION

It's easy to become confused when using a slide copier because all of the parts mount on the same rail and when you change one distance you may change another at the same time.

Three set-up distances are involved: film to lens, lens to slide, and film to slide which is theoretically the sum of the first two. Set any two of the three distances set correctly and the third has to be correct.

Bellows extension tables earlier in this chapter give all three distances for a variety of lenses and magnifications.

Here's a handy rule to remember: For a magnification of 1.0, the distance from the film plane to the subject plane is theoretically four times the lens focal length. In an ideal world, it would be exactly four times but it usually isn't because of the lens nodes.

As you can see in the bellows extension tables, at a magnification of 1.0 using one of the Minolta 50mm lenses, film-to-subject distance ranges from 199mm to 208mm instead of being exactly 200mm, depending on which lens you use.

Also, at a magnification of 1.0, lens-to-film distance and lens-to-subject distance are equal. Therefore each of these distances is approximately twice the focal length of the lens in use.

Maximum extension of either bellows with the lens standard reversed is 200mm. Additional extension distance is inside the camera body between lens mount and film plane. The total available distance between film and slide is

enough to allow magnifications of 1.0 or higher with lenses of 50mm down to 20mm, reversed or not reversed.

Both bellows have a minimum extension of 40mm used normally or 75mm when the lens standard is reversed. Therefore, when using short-focal-length lenses, *minimum* magnification may be significantly higher than 1.0.

How to Set Up—The simplest procedure is to consult the tables to find a lens and bellows extension giving approximately the amount of magnification you think will be needed.

Move the camera standard as far back as it will go on the bellows extension rail. Then set the indicated amount of extension between the camera standard and the lens standard.

Then adjust the slide copier so the distance between the forward surfacc of the lens standard and the slide is the same as the lens-to-subject distance given in the table. Or, you can measure from the film plane in the camera to the slide copier and set the copier so this distance is the same as the film-plane-to-subject distance from the bellows extension tables.

Put enough illumination on the front of the diffuser so you can see the image in the viewfinder. Move the lens standard until the image is sharply focused. Then decide if the amount of magnification is correct.

To get less magnification, move the lens standard a small distance toward the camera to shorten image distance and reposition the slide copier for best focus.

To get more magnification, move the lens standard away from the camera a small amount and find focus again by repositioning the slide copier.

Make small changes and refocus each time until you get the amount of magnification you need.

When using magnification greater than 1.0, you will always find best focus again by moving the slide copier in the same direction that you moved the lens stan-

These are examples of slide copying to change something.

dard to change magnification.

Illuminating the Slide—It is relatively easy to get enough light so you don't have to use long exposures that can get into reciprocity failure of the film. With a continuous light source, use the camera's built-in exposure meter just as if you were photographing the scene on the slide.

You should match the type of illumination to the kind of light the film in the camera was designed for. That is, use daylight illumination or electronic flash with daylight film and tungsten light with tungsten film. Matching the light to the film can be done with filters as you'll see in the following chapter.

For casual slide copying, use ordinary daylight film in the camera and daylight or electronic flash illumination. A handy way to get natural daylight illumination is to point the front of the copier toward a white surface, such as

paper, that is illuminated both by direct sunlight and light from the sky.

If you copy a slide on ordinary color-slide film, the copy will show increased contrast compared to the original and probably a noticeable color change. This isn't always bad news. Sometimes it is tolerable. Sometimes it improves the image.

If you are serious about slide copying and getting the closest possible match in contrast and color, use a special film such as Kodak Ektachrome Slide Duplicating Film 5071. Carefully read the instruction leaflet that comes with the film and be prepared to do some testing with color filters and exposure settings.

To use a color filter, screw it into the front of the lens, then attach the bellows to the filter instead of the lens. Gelatin filters can be taped to the front of the slide copier or sandwiched with the slide.

HOW TO SUPPORT CAMERA AND BELLOWS OR EXTENSION TUBES

Higher-than-normal magnifications require rigid support for camera and subject, so neither moves in respect to the other. Minolta offers a variety of ways to do this.

You can use a tripod to support the bellows although it is often an unsuitable and clumsy arrangement.

A problem usually results when you want to point the camera straight down to photograph a subject on a table or counter. Some tripods will adjust to do this but many won't. You may end up with a makeshift arrangement such as leaning the tripod on the edge of the table or counter.

Copy Stand—A better arrangement for some purposes is the Minolta Copy Stand which has a flat base, a vertical column mounted on the base and a movable arm that travels up and down on the vertical column.

You can attach a bellows to the movable arm or even mount a camera body directly on the arm, using the tripod socket.

As the name implies, copy stands are often used to photograph printed pages, photographic prints and similar objects of relatively large size.

Macro Stand AB-III—For high-magnification photography of small objects of any kind, this stand is very handy. Either bellows, with the Focusing Rail attached can be mounted on the upright arm of the macro stand as you can see in the accompanying photo. Vertical motion of camera and bellows is provided by the Focusing Rail.

The subject is placed on a stage which is part of the base of the macro stand. By releasing a clamp screw, the stage can be rotated to aid in positioning and lighting the subject. The stage itself has a circular cutout for a removable insert.

The stage insert supplied with

To copy photos, pages from a book, or to photograph small objects, a copy stand is very handy. This is the 100mm macro lens used with its life-size adapter.

The attaching screw at the top of the vertical post on Macro Stand AB-III is normally screwed into the tripod mount on a focusing rail.

the macro stand is metal, painted 18% gray on each side. After setting up the lighting, You can make an exposure reading on the gray stage-plate surface instead of the subject, if desired. Movable spring clips are provided to hold specimens in place on the stage when needed.

The stage insert can be removed, leaving a circular opening in the base. You can then place the macro stand on a light table or other light source and photograph the subject illuminated from below.

LENSES FOR HIGH MAGNIFICATION

Lenses for general use are usually optimized for a distant subject and usually don't have optical corrections to produce good flatness of field. This may be apparent if you copy a postage stamp, for example, at a magnification of 1.0 with an ordinary camera lens such as the 50mm *f*-1.4. Look closely and you may see that the edges are not focused as sharply as the center.

In general, if you use a standard camera lens for high magnification photography, you will get the best image with the 50mm *f*-1.7 or the 45mm *f*-2. This is because flatness of field and large maximum aperture are incompatible in lens design. If you don't need flatness of field because the object you are photographing is not flat, then any of the 50mm standard lenses should serve about as well.

Minolta 50mm *f*-3.5 MD Macro Lens—Specially designed for macro use, this lens has better correction for flatness of field than standard camera lenses. It also has unusually long focusing travel so you can get magnifications up to 0.5 with the lens alone, mounted directly on the camera. This is an MD lens with all MD features including shutter-priority automatic operation with XD cameras.

The focusing mechanism in the lens provides maximum extension of 25mm. To get still more magnification, insert the Life-Size Adapter, packaged with the lens, between lens and camera. This is a 25mm automatic extension tube that preserves full-aperture metering and auto diaphragm but does not have the MD coupling to allow shutter-priority automatic operation.

With the adapter installed, the magnification range of this lens is 0.5 to 1.0. Minimum extension of this 50mm lens becomes 25mm, therefore minimum magnification is 0.5. When the focusing travel of the lens itself is used to add more

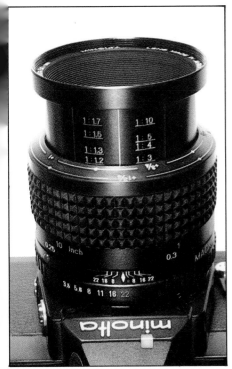

The 50mm macro has *reproduction ratio* scales on the lens barrel—yellow for the lens used with its Life-Size Adapter, white for the lens without the adapter. The adapter is not installed between lens and camera, so we read the white scale at its intersection with the forward edge of the focusing ring—1:3 in this photo, which is a magnification of about 0.33. The circular scales engraved on the forward edge of the focusing ring show approximate exposure corrections needed at higher magnifications. These are called Exposure Factors and are discussed later in this chapter.

The 100mm macro lens is shown here with its Life-Size Adapter installed between lens and camera. Reproduction ratios are read at the rear edge of the focusing ring, on the white or yellow scales on each side of the depth-of-field indicator. This lens is set for a reproduction ratio of about 1:1.2 as shown on the yellow scale—a magnification of about 0.8. Exposure Factors are shown on the outer scales.

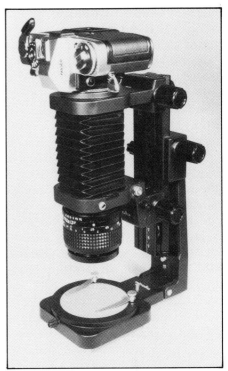

This is a very handy setup for macro work. Focusing Rail AB-III is mounted on Macro Stand AB-III. Either bellows mounts on the focusing rail. Lens is the 50mm macro.

extension, the total extension becomes 50mm and magnification is 1.0. This lens should be reversed for magnifications greater than 1.0.

The 50mm macro lens can be reversed on the front of a bellows by using the reversing ring or reversing the bellows lens standard. It can be reversed on the forward end of extension tubes by using the reversing ring.

Minolta 100mm *f*-4 MD Macro Lens—Except for focal length, this lens has the same features as the 50mm macro. Mounted directly on the camera it provides mag-

nifications up to 0.5. With the Life-Size Adapter for the 100mm lens, which is 50mm long, magnification range is 0.5 to 1.0.

This lens can be mounted on the forward end of extension tubes or bellows and should be reversed at magnifications greater than 1.0.

The advantage of a 100mm macro lens, compared to a 50mm lens, is greater working distance between the front of the lens and the subject.

This is often convenient because it makes it easier to get light on the subject. Sometimes it is desirable or necessary to have a

relatively long working distance between lens and subject—for example when the subject is an insect that you don't want to become alarmed and fly or flee.

Minolta 100mm *f*-4 Auto Bellows Rokkor-X Lens—This special lens does not have a focusing control and is for use only on a bellows. It has good flatness of field, similar to the 50mm and 100mm macro lenses. It is not as versatile as the 50mm and 100mm macro because it can be used only on a bellows. The lens has an automatic diaphragm and therefore cooperates fully with Auto Bellows III.

HOW TO DETERMINE MAGNIFICATION

Sometimes you need to know how much magnification you are using. There are several ways to find out. If you are using any of the setups in the Bellows Extension Table, you can read magnification from the table.

With the 50mm or 100mm macro lens mounted directly on the camera, you can read magnifications up to 0.5 from a scale on the lens barrel.

However, the scale shows *reproduction ratio*, such as 1:6 which means 1/6 and indicates that the image on film is 1/6 as tall as the subject in the real world. To find magnification, complete the indicated division:

1/6 = 0.17

Magnification is 0.17.

If you are using a lens on a bellows or extension tubes and the lens is not reversed, you can use the table or calculate magnification easily using the formula already given:

M = X/F

If the lens is reversed, you will get approximate magnification from the calculation. It will not be exact because of uncertainty in the location of the lens front node— which becomes the rear node when the lens is reversed.

You can always find magnification by testing with film. Photograph a millimeter scale held parallel to the long dimension of the film. On the negative, count how many millimeters are visible in the frame. To find actual magnification, divide the long dimension of the frame by the number of millimeters you counted on the film.

For extreme accuracy, measure the long dimension of the frame. For a close approximation, assume it is 36mm. If you count 72mm on the photograph of the scale, magnification is:

$$\frac{36}{72} = 0.5$$

The 100mm *f*-4 Auto Bellows lens has an aperture ring but no focusing control. It is intended only for use on a bellows.

You can estimate magnification closely by focusing on a millimeter scale and counting how many millimeters you see in the viewfinder. Use this figure to calculate magnification.

After making the calculation, multiply the result by the viewfinder coverage of your camera, expressed as a decimal. The answer will be close to actual magnification on film.

Minolta 35mm SLR cameras don't show the entire frame. They show 93% to 98%, depending on model as you can see in the specifications table at the beginning of Chapter 15.

DEPTH-OF-FIELD PROBLEM

When you increase magnification by any method, depth of field is automatically reduced. At magnifications of 1.0 or more, depth of field is so limited that you will think there isn't any.

This is not a major problem with a flat subject, provided the lens is well corrected for flatness of field so the zone of good focus is flat and can be placed in the same plane as the flat subject. With an ordinary lens, you can do this simply by making sure the film in the camera is held parallel to the flat surface of the object you are photographing. A copy stand or macro stand is a big help.

You should not assume that flat subjects are really flat. Postage stamps are usually curved a little bit. Slides are never flat, even though held in flat mounts. It's usually a good idea to use an aperture one or two steps smaller than the maximum aperture of the lens so you are sure to have enough depth of field even when photographing "flat" subjects and even when using one of the macro lenses.

Depth of field is a major problem with three-dimensional subjects such as a small insect because you can't get all of the subject in sharp focus.

The best treatment depends both on the subject and your purpose in photographing it. I usually prefer to put the zone of good focus near the front part of the subject so the viewer gets a sharp first impression of the subject. From there, everything recedes into fuzz if depth of field is really poor.

Shooting at small aperture helps some, but not nearly as much as when using the lens at normal magnifications.

As you know, using minimum aperture of the lens may degrade the image because of diffraction effects. The best compromise with three-dimensional subjects is usually a lens aperture near the middle of the range.

The swing feature of Auto Bellows III is helpful because it allows you to put the limited depth of field where it works best.

LIGHT LOSS DUE TO LENS EXTENSION

When the distance between lens and film becomes greater, the image on film becomes less bright. The more you extend the lens to get high magnification, the more light you lose.

The amount of movement in the normal focusing range of a lens is so small that the amount of light on the film doesn't change very much. If you set exposure controls after focusing, it doesn't matter because you set exposure for whatever light there is.

When you use extension tubes or a bellows to put additional distance between lens and film, the distance may increase enough to have a major effect on the amount of light at the film plane.

As magnification is increased above 1.0, the light falls off very rapidly and the viewing screen becomes very dark. As long as you are using the built-in camera meter and it is reading within its range of accuracy, the meter measures the actual amount of light that exposes the film, so the camera-recommended exposure settings should be satisfactory except for the possibility of reciprocity failure of the film—see the tables in the following chapter.

When you can't get a reading with the camera meter, determine exposure for the subject in some other way assuming you are not using any lens extension. Then correct that exposure for the amount of light loss at the lens extension you are using. Then correct again for reciprocity failure of the film if needed.

When you can't get a reading through the camera, you can often get it with a separate accessory light meter. Move the camera out of the way, use the accessory light meter and then put the camera back in position to make the shot. This reading, of course, does not consider lens extension.

If you don't own a separate light meter, remove the lens extension device from the camera while making an exposure reading of the subject on a gray card or background of equivalent reflectance. You can change the background later to make the shot if desired. This reading also does not consider the effect of lens extension.

However you do it, you find a camera exposure setting that would work with no extension but you know it will not give enough exposure when using lens extension.

To correct for this, multiply the amount of exposure that would be OK without lens extension by an Exposure Factor which is determined by the amount of magnification you are using.

For normal lenses you can figure the Exposure Factor (EF) as follows:

$$EF = (M + 1)^2$$

Using an easy example, if magnification is 1.0:

$$EF = (1 + 1)^2$$
$$= 2^2$$
$$= 4$$

Please bear in mind that this number is a *factor*, which means it is used as a multiplier. To remind you that the Exposure Factor is a multiplier, Minolta writes it with the symbol X which means *times*.

In the example just calculated, exposure must be 4 times as much with extension as it would be without extension. Each exposure step increases exposure by a factor of 2, so two additional exposure steps are needed. From the exposure setting that would be satisfactory without lens extension, increase by two steps.

This simple formula and correction method applies only when you are using normal lenses. *Normal* means neither telephoto nor retrofocus (wide angle). All of the macro lenses are normal or nearly so, and the formula will give satisfactory results.

If you use telephoto or wide-angle lenses with extension, the formula just given will not work. A discussion of these special cases is in my book *SLR Photographers Handbook* along with formulas you can use to figure the exposure factor for these cases.

Bellows extension tables earlier in this chapter spare you the necessity of calculating exposure factors for any lens shown on the tables. Exposure factors shown for each lens are correct for that lens, whatever type it is.

For each lens, the table gives another number which translates the exposure factors into *f*-stops or exposure steps. For example, the table tells you that an exposure factor of 4X is the same as 2 exposure steps.

PHOTOMICROGRAPHY

This is photographing through a microscope to get magnifications larger than practical with extension tubes or a bellows. A Minolta Microscope Adapter is available to mount a camera body on a microscope.

Because the microscope replaces the camera lens, there is no camera *f*-stop to be concerned with. Exposure is arrived at using whatever light comes into the camera and an appropriately long exposure time. This makes lighting of the subject critical and sometimes difficult. The technique of using microscopes and illuminating the subject is beyond the scope of this book but can be found in books on microscopy.

10 LIGHT, FILTERS AND FILMS

Figure 10-1/The spectrum of sunlight. Photographed at the Flandrau Planetarium in Tucson, Arizona, by Ted DiSante.

LIGHT, FILTERS AND FILMS

Several characteristics of light affect equipment and technique when taking pictures.

COLOR OF LIGHT

We call direct light from the sun *white.* It is composed of all the colors in the visible spectrum.

Light appears to travel in waves, similar to waves in water, which have different wavelengths. Different wavelengths appear as different *colors* in human vision.

The accompanying photo of the visible spectrum shows colors of visible light and their approximate wavelengths—Figure 10-1.

Human vision does not actually respond to all colors of light. We see only three colors: Red at the long-wavelength end of the spectrum, green in the middle, and blue at the short-wavelength end. The sensation of other colors is produced in the mind by noting the relative proportion or the mix of these three *primary* colors.

Beyond the visible blues in the spectrum are shorter wavelengths called *ultraviolet,* abbreviated UV.

We can't see them, but film can, and most types of film will be exposed by UV.

When you expose ordinary color or b&w film in your camera, some exposure results from light you can see and some from UV wavelengths you can't see. At times this is a technical problem and there are technical solutions.

Most films do not respond to wavelengths longer than visible red, which are called *infrared* or IR, but some special films do. You have probably seen photos taken with IR-sensitive film and noticed that natural objects such as water and foliage do not photograph the same in IR as in visible light.

IR waves are "heat waves" and cause the sensation of warmth. When you take a picture using IR film you are photographing reflected or radiated heat from the scene rather than visible light. People use IR films for fun and science, but I don't consider it a major part of photography.

LIGHT SOURCES

Not all light sources produce the

entire spectrum. There are two main categories: Those which produce light due to being heated are called *incandescent.* Incandescent sources include the sun, a candle or campfire, and the common household lamp—sometimes called an incandescent lamp. In photography it's called a *tungsten* lamp. The glowing-hot filament inside an incandescent lamp is made of tungsten.

The other category of light sources does not depend on temperature to make light. These are sources such as fluorescent lamps, and electronic flash units. The quality of light from non-incandescent sources is often a problem in color photography.

COLOR TEMPERATURE

The light produced by an incandescent source—including the sun—depends on its temperature. By stating the temperature of the source, the color balance of the light is implied. When so used, the temperature of the source is called *color temperature.*

Figure 10-2 is the spectrum of

124

several color temperatures. The main thing to observe is that low temperatures produce mainly long wavelengths of light which we see as red, orange and yellow. Candles and matches operate at low color temperatures and you don't see any blue or green in candlelight.

As color temperature increases, the proportion of short-wavelength light increases. At a high color temperature, the light appears to be more blue than red. Light from the sky is a very high color temperature and it is blue.

So far this is all technical and not very practical. However, in practical photography you worry about color temperature in two ways. For ordinary photography, you think of it in general terms: Is the light warm-looking and made up of red and yellow colors or is it cold-looking and bluish? Are you shooting outdoors under the blue sky, or indoors with warm tungsten illumination? In everyday photography you respond to these questions by selecting film and choosing filters to control the color of the image.

If you do technical photography where exact color rendition is important, you worry in more detail and use color temperatures to make equipment choices. Color temperatures are disguised in the technical term *mired*. A discussion of these matters is in my book *Understanding Photography*.

Color temperatures are just labels to indicate the color quality of light, expressed in absolute temperature—degrees Kelvin (K).

You can talk about the warm color of candlelight or a color temperature of 1,800 degrees Kelvin. If you say 3,200 or 3,400 degrees, some people will know you are talking about the light produced by the two types of photoflood lamps used in photography. They have a higher color temperature than ordinary room lamps.

Sunlight alone is about 5,000 degrees but the cold-looking blue light from the sky may be around 12,000 degrees. Therefore com-

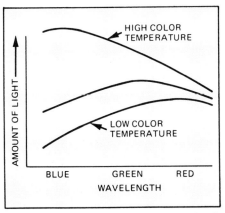

Figure I0-2/The relative proportions of red, green and blue wavelengths in incandescent light are determined by the temperature of the source. When used to indicate the color-quality of the light it produces, the temperature of the source, expressed in degrees Kelvin (K), is called *color temperature*. Low color temperatures produce mainly long wavelengths which we see as red light. High color temperatures produce blue light. Intermediate color temperatures produce green light.

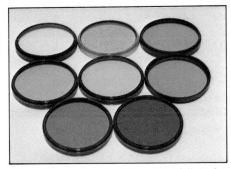

Color filters change the color of light by transmitting some wavelengths and blocking others.

binations of sunlight, light from the blue sky and a few puffy white clouds—which we call average daylight—is between those two color temperatures. It is about 5,500 to 6,000 degrees.

Light from an electronic flash simulates daylight.

A subject in the shade of a tree is illuminated only by the blue light from the sky without the "warming" benefit of direct sunlight. We think the light is cold-looking and the subject looks too blue.

Much of color photography is concerned with these color effects and sometimes changing them.

COLORS OF THINGS

A white piece of paper reflects whatever color of light falls on it. If

illuminated by white light, it looks white. If illuminated by red light, it looks red.

Things which don't look white may owe their color to the light which is illuminating thcm, or to a property known as selective reflection. That means they do not reflect all wavelengths of light uniformly. A blue cloth in white light looks blue because it reflects mainly blue wavelengths. The other wavelengths of white light are absorbed.

The color of transparent things such as glass is determined by selective transmission. Blue glass looks blue because it transmits mainly blue wavelengths. If illuminated by white light, blue wavelengths pass through the glass to your eye.

The other wavelengths are either absorbed by the glass or reflected from its surface back toward the source. As far as the viewer is concerned, the glass looks blue because only blue light comes through.

In general, the color of an object is determined both by the color of the light which illuminates it and the selective transmission or reflection of the object.

VISUAL COLOR OF FILTERS

If you hold a color filter between your eye and white light, you see the colors that are transmitted or passed by the filter. The effect of a filter on film is often more easily predicted by thinking about the colors the filter stops rather than those which get through.

Because human vision responds only to red, green and blue, it is only these three primary colors and their combinations that you have to worry about. If a filter blocks all three primary colors completely, it looks black. If it reduces light transmission, but some light at each color still comes through, the filter appears gray.

Other than that, color filters usually operate by reducing the amount of light transmitted at one or two of the three primary colors.

Wine appears red because of selective color transmission. Rose is red because of selective reflection.

If a filter blocks red, then it transmits both blue and green. To the eye, light coming through the filter appears bluish-green—a color photographers call *cyan*. We say cyan is the complementary color to red because you get cyan if you block red but transmit blue and green. Each of the three primary colors has a complement, according to this table:

PRIMARY COLORS	COMPLEMENTARY COLORS
Red	Cyan (Blue + Green)
Green	Magenta (Blue + Red)
Blue	Yellow (Red + Green)

In printing color films, laboratories use complementary color filters, so the words, *cyan, magenta* and *yellow* are part of the language of photography and you should know their photographic meanings.

ADAPTATIONS OF THE EYE
Three kinds of human visual adaptations are important in photography.

One relates to the brightness of light. We can be visually comfortable in outdoor sunlight. On entering a building, we have the sensation that it is darker only for a few seconds and then we adapt to the lower level of illumination and don't notice it any more.

On returning outdoors, we again adapt to the higher brightness in a short time. The result is, people are very poor judges of the amount of light and should rely on exposure meters which don't have this adaptability problem.

We also adapt to the color of light in the same way. If you are reading at night, using a tungsten reading lamp, you are adapted to the yellowish color and don't even notice it. The paper in this book looks white to your mind.

Go outside and look at your window. It will be obvious that you are reading in light which has a definite yellow cast.

Another adaptation results from your feeling of participation in a real-life situation.

This turns up in several ways which often make a photo look ridiculous. You can pose someone in front of a tree and think it's a fine shot. When you look at the print, a tree limb seems to be growing out of your model's ear, which seems absurd in the picture, even though it didn't bother you when it was real life.

EFFECTS OF ATMOSPHERE
The sun flings energy toward the earth over an extremely wide spectrum, part of which is visible. The atmosphere acts as a filter to block transmission of some wavelengths and allow transmission of others, including all visible wavelengths.

As sunlight travels toward the earth, atmospheric scattering takes blue light waves out of the sunlight and scatters them all over the sky. That's why the sky looks blue and why light *from the sky* is blue.

Blue haze between the camera and a distant scene is due to atmospheric scattering of light.

The atmosphere also has an effect on light rays which is called *scattering*. Instead of coming straight through the air, some light rays are diverted from the straight path and bounce around in the atmosphere. This is light from the sky as opposed to light directly from the sun.

It happens that the atmosphere scatters short wavelengths much more than long wavelengths. Therefore blue light is extracted from the direct rays of the sun and scattered all over the sky. That's why the sky is blue.

More blue light is removed from sunlight by scattering when there is more air between the observer and the sun. At noon, sunlight comes directly to the earth where you are and takes the shortest path through the air. Therefore there is minimum scattering of blue light and more of it is the direct rays of the sun.

At morning or evening, the sun's rays come to you at an angle and therefore travel through more air. More blue light is extracted from the sun's rays, so sunlight appears to be more red-colored.

On a nice clear day, the sky is blue except near the horizon where it often looks white. This is another form of scattering caused by dust and smoke particles which are large enough to reflect most wavelengths of the visible spectrum. They scatter all of the light from the sun and the lower atmosphere looks white.

If you look from here over to that distant mountain, you are looking through a lot of lower atmosphere with both white-light scattering and blue-light scattering. The light rays coming to your eye from trees and rocks on the mountain are diverted from straight paths, details are obscured and the image looks hazy. We call that *atmospheric* haze.

Fog is water droplets in the air and is worse than dust and smoke as a light scatterer and image obscurer.

Air itself scatters blue light. Other particles in the air tend to scatter all colors of light. Therefore, even from point to point in the lower atmosphere, blue light is scattered more than any other wavelength.

If you take a picture *without using* the blue light rays to expose the film, there will be less atmospheric haze in your picture. Details of a distant scene will be more distinct.

You can do that by covering the lens with a filter which excludes blue light. The filter must therefore transmit both green and red light.

If you hold such a filter against white light it will look yellow, because the combination of red and green makes the sensation of yellow light. It is common to use a yellow-colored filter over the lens to cut atmospheric haze on b&w film. On color film it will make a yellow-colored picture.

If your picture on b&w film is still too hazy with a yellow filter, remember that shorter wavelengths of light are scattered more than longer wavelengths. If excluding short wavelength blue

A distant view is obscured by atmospheric haze which *always* looks worse on film than in the real world.

A yellow filter cuts some haze by blocking short wavelengths—which are blue light.

A red filter cuts still more haze by blocking both short and medium wavelengths. Notice that haze-cutting filters also darken blue sky, making clouds stand out.

won't do the job, try also leaving out medium-wavelength greens.

The filter now transmits red only, but image detail is greatly improved. What if you exclude, blue, green and also red? That will use still less scattered light to make the picture. A filter that excludes all three primary colors will look black because no visible wavelengths get through.

Invisible IR wavelengths can come through a very dark-looking red or IR filter and expose IR film. That's the best haze cutter of them all.

Another effect of light scattering between your camera and the scene is reduced contrast of the image on the film. Light rays coming from bright parts of the scene are diverted by scattering so they land on the film at the wrong places.

Some will land where it should be dark and that will make the dark places lighter. You can see this when outdoors on a sunny day. Notice the contrast in brightness between sunlight and shadow near where you are. Then look as far away as you can and compare the brightness of sunlight and shadowed areas over there. Due to atmospheric scattering, distant shadows will appear much lighter than those nearby.

Any filter that blocks scattered rays will improve contrast and sharpness of the image on the film.

COLOR-SENSITIVITY OF B&W FILM

Even black-and-white film is color sensitive. Early b&w emulsions were sensitive mainly to blue and UV light. Photos of women with red lipstick caused the lipstick to appear black because the film did not respond to red. An improved film, called *orthochromatic* was still deficient in red-response.

Current b&w films, called *panchromatic* are said to be responsive to all visible wavelengths and, as a practical matter, they are.

COLOR FILTERS WITH B&W FILM

Because the result of exposing b&w film to light of various colors is always shades of gray between black and white, we tend to think b&w film is colorblind. It is difficult to compare the response of b&w film to human vision which notices both color and brightness.

Technically, they are tied together by saying that the brightness of an object in b&w, even though it is gray, should correspond to the brightness of that object in the original scene as viewed by people, never mind what color it is.

I think it is more important to recognize the fact that the major problem of b&w film is that it records in shades of gray. The print does not show colors which help to distinguish a red apple from green leaves or a yellow skirt from a blue sweater. If the skirt and sweater happen to cause the same shade of gray on the film they will look the same in b&w.

Usually a b&w picture is improved if objects of different color record as different tones or shades of gray because the viewer of the print expects to see some differences between a necktie and jacket, or a rose and foliage.

You can use color filters on your camera to make a visible brightness difference between adjacent objects of different colors, as you can see in the accompanying photos.

The rule when using color filters with b&w film is: A filter lightens its own color. This applies to the final print, not the negative, but it is the print you are concerned about.

A corollary to the rule is: A color filter used with b&w film darkens every color except its own.

It is common with b&w film to use filters to make clouds stand out against a blue sky. With no filter, clouds in the sky are sometimes nearly invisible and the

With no filter and b&w film, a rose is about the same shade of gray as the surrounding green leaves.

A red filter lightens the rose and darkens the leaves so there is more contrast between them.

A green filter lightens the leaves and darkens the rose. Any red and green filters will have these effects, but deeper filter colors have a more noticeable effect.

entire sky is light-colored in the print. It is much more dramatic to have a dark sky with white clouds.

White clouds reflect all colors of light, but the sky is blue. Suppress blue with a yellow filter and the sky darkens. The clouds darken too, but not as much.

Because you are using b&w film, you can go as wild as you want with filter colors and only different shades of gray will result. The hierarchy of sky-darkening filters for b&w film runs from yellow to light red to dark red with more effect as you use darker reds.

Naturally the effect of a red filter appears on everything in the scene. If you include a model with red lipstick, the filter is an open door for red color and your model's lips will be lighter in tone.

A compromise filter often used for outdoor b&w portraits is a shade of green. This suppresses blue to darken the sky some but also holds back red so makeup and skin tones are not affected as much as with a red filter.

HOW COLOR FILMS WORK

Color film and the color-printing process used for books and magazines are possible only because human color vision is based on the three primary colors. A color picture needs to have only these three colors mixed in proper proportions to do a very good job of presenting all colors we can see.

Color film does this with three different layers of emulsion coated on a base. The main difference between a color slide and a color print is: The base of the print is opaque white paper.

The trick of color film is to use one layer to record the amount of each primary color at every point in the scene. When viewing a color slide by transmitted light, or a print by reflected light, each layer controls the amount of light at its own primary color.

Light from the combination of all three layers causes our vision to see the colors of the original scene. Naturally the colors we see when

viewing a slide or print are affected by the color of the projector light or room illumination where we are viewing the picture.

NEGATIVE-POSITIVE COLOR

Color prints can be made from color negatives. A comparison to b&w will be useful. In b&w negatives, the shades of gray are reversed from the original scene. A white shirt appears black in the negative. In color-negative film, after development, each layer transmits a reversed density of the particular color that the layer controls.

If the subject is red, the color-negative layer will be *not-red*, meaning cyan colored. A color print made from the negative reverses the color densities again with the result that red in the scene becomes red on the print.

You have probably noticed an overall orange color of color negatives. Even the clear parts have an orange cast. Dyes used in color films are as good as each film manufacturer can make them, but not as good as the manufacturer would like them to be. These slight deficiencies in the color dyes are corrected by a complicated procedure called *color masking*. Evidence of masking is the orange color, which is removed when a print is made.

Because of color masking, the colors in a negative-positive process can be more true to life.

If a color print is made and the colors don't look quite right, it can be fixed by making another print. Color filters are used to change the color of the printing light and thereby make small corrections in the color balance of the resulting print.

If you miss exposure a step or two when using color-negative film, it is often possible to make a correction during printing, so the print is properly exposed and the colors are satisfactory.

Color-negative film allows the camera operator to make small mistakes, or be less precise about

The overall orange color of this color negative is caused by masking, which is removed by filtering when the color print is made. Notice the reversed densities of colors between negative and positive. Photo by Tom Monroe.

his work, and still end up with an acceptable print.

COLOR-SLIDE FILM

A color slide or transparency is the same piece of film you originally exposed in the camera. It is developed and chemically processed to make a positive image directly.

This procedure is called *reversal processing* because it makes a positive out of a negative. There is no color masking because there is no opportunity to remove the orange color when making a print. The color balance of slide film is theoretically inferior to that of a good color negative-positive procedure but in practice it's hard to see.

Because there is no separate printing step to make a color slide, there is no opportunity to correct a bad exposure and no way to change the color balance of the positive. This makes exposure more critical, both in the amount of light on the film and its color.

Color-slide film will often make a perfectly good image when under- or overexposed a small amount, but it won't look right when projected on a screen. It will be too light or too dark overall, particularly when viewed in succession with other slides which were properly exposed. For this reason, we say that color slides should be correctly exposed — within half a step either way.

When any color film — negative or reversal — is seriously over- or underexposed, two effects may result. One is comparable to over- or underexposing b&w film. Light areas become too light, or dark areas become too dark, and contrast is lost between portions of the scene in the too-light or too-dark areas.

The second effect is peculiar to

color film: One layer does not properly control its color when developed. The end result is an overall color cast, such as pink or blue which affects the entire picture.

This can be corrected in a negative-positive process if the color change is not too severe. But with color-slide film, what you shoot is what you get.

Making Tests—When you are making tests of equipment or your skill, it's important to see what you actually put on the film. When printing b&w or color negatives, most film laboratories will automatically make corrections to compensate for apparent errors in exposure or color balance. If you are testing exposures and deliberately shoot some frames over- or underexposed, you don't want the lab to correct your shots. Color-slide film is the best way to make tests. What you get is what you shot, without any corrections by the lab.

FILTERS FOR COLOR FILM

There are three types of color film. Two are manufactured so they make a good color image with tungsten illumination. If you use tungsten film in the correct tungsten light, the manufacturer has already solved the problem for you and you don't have to use a filter to change the color balance of the light.

If there is not enough room light to shoot with, you can add light by using special photo lamps, commonly called photofloods. There are two types: Photofloods which operate at 3,400K give more light output but with shorter life. Those that operate at 3,200K last longer and produce a color of light that is closer to normal incandescent room lighting.

Type B tungsten film is intended for use with 3,200K lights. If you use 3,400K lamps with Type B film, you should use a filter over the camera lens. You can often "get away" with mixing 3,400K photofloods with room light from

LIGHT SOURCES
Daylight
Tungsten, 3400K
Tungsten, 3200K
Household Tungsten below 3200K
Fluorescent

TYPES OF COLOR FILM
Daylight, 5500K
Tungsten Type A, 3400K
Tungsten Type B, 3200K

table and floor lamps, but technically this is mixed lighting with a visible color difference between the two types of light.

Type A color film is designed for use with 3,400K lighting. If you use it with 3,200K lamps or ordinary room lighting, compensate with a filter over the camera lens.

Daylight color film is balanced for daylight, but you may need to use a filter anyway.

Utraviolet light is reduced by the atmosphere but present in some amount everywhere. The higher you are in altitude, and the cleaner the air that surrounds you, the more UV there is to expose your film. You can't see it and your exposure meter probably ignores it, but the film will be exposed by ultraviolet light.

UV filters reduce transmission of UV. They are clear because they don't stop any visible wavelengths. Even at sea level they are a benefit—partly because they protect the lens itself. In the mountains a UV filter should always be used. This applies equally to b&w film because it is also sensitive to UV.

If atmospheric haze is a problem, you want to exclude short wavelengths. With color film, you can't use a strongly colored filter unless you want the picture to have that color. Haze filters for color film cut UV and also cut some of the barely visible blue wavelengths—the shortest. If you use one, you don't need a UV filter also because the haze filter will do both jobs.

A subject in shade outdoors is illuminated by skylight which has more blue in it than average daylight or direct sunlight. With color film, the effect is usually noticeable as an overall blue cast to the picture and bluish skin tones on people.

Skylight filters for use with color film block some of the blue light to give a more warm looking picture. Some photographers like the effect even in daylight or direct sunlight, so they put a skylight filter on the lens and use it all the time with color film outdoors. It also blocks UV.

There are filters which allow you to use indoor film in daylight, and daylight film indoors.

To use tungsten film in daylight, the filter has to alter daylight so it looks like tungsten light to the film. The filter will reduce the amount of blue and green so what comes through has a color balance similar to tungsten light. Such filters have a yellow-orange appearance when viewed in white light.

To use daylight film indoors, filtering depends on the illumination being used inside the building. If it is tungsten light, the filter must change it so it appears to be daylight as far as the film is concerned. The filter will block a lot of red and will look bluish or blue-green in white light.

If the indoor illumination is fluorescent lamps, it is difficult to filter. Some look bluish and some are designed to look like daylight to humans. Daylight fluorescent sources do not look like daylight to film.

Filter manufacturers offer one or more types of filters for use with fluorescent lighting and the best guide to their use is the maker's instructions. Except for polarizing and neutral-density filters which will be discussed shortly, those are the filter types which can be used with color film without an unusual or noticeable effect on the overall color of the picture.

Tables at the end of this chapter

give filter recommendations for various types of films and light sources.

FILTER FACTORS

Most filters reduce light at visible wavelengths. They reduce it more at some wavelengths than others, but the net result is still less light on the film. This does not apply to visually clear filters such as UV and some haze filters for color films.

Filter manufacturers normally state the amount of light loss as it affects the film exposure by a number known as the *filter factor.* This number is used to multiply the camera exposure that would be used without the filter, to get the correct exposure with the filter.

The symbol X is included in a filter factor to remind us that it is used as a multiplier. Some examples will clarify this.

A 2X filter must be compensated by two times as much exposure, which is one more exposure step. Open lens aperture one step or use the next slower shutter speed. A 4X filter requires two exposure steps. An 8X filter needs three exposure steps.

Minolta cameras meter behind the lens and the camera exposure meter automatically compensates for the effect of a filter on the lens. You can ignore filter factors as long as you are using the camera's built-in meter, which is a great convenience.

You are not getting filtering free. Even though it is simple and uncomplicated to set exposure with a filter on the lens, the filter must have the effect of increasing aperture or exposure time.

Even though behind-the-lens metering spares you the inconvenience of using filter factors to compensate exposure, you still need to know about them because they can affect the technical solution you are using to make the picture.

Filter factors are also a guide in purchasing a filter because they

Skylight coming from Irene's right and warm tungsten light from her left create two different skin tones.

tell you how strong the color will be. Higher filter factors mean deeper colors and more light loss.

NEUTRAL-DENSITY FILTERS

There are circumstances when you want less light so you can use larger aperture for less depth of field. There are also some cases where you want less light so you can use longer shutter-open times.

Gray filters called *neutral density* (ND) reduce the amount of transmitted light uniformly across the visible spectrum, which is why they are called neutral. These filters can be used with either color or b&w film because they have uniform color response.

Some ND filters are rated the same way as color filters—by a filter factor. Commonly available ratings are 2X, 4X and 8X.

You may have to stack filters, meaning put one in front of another, to get the required density. When stacking filters using filter factor ratings, the combined rating is obtained by multiplying the individual ratings. A 2X filter and an 8X filter used together have a rating of 16X.

Some ND filters are labeled with their *optical density* instead of a filter factor. The two ratings can be tied together by the fact that each increase in optical density of 0.3 is equal to a filter factor of 2X.

When filters rated by optical density are stacked, the densities add directly. An ND 0.3 filter plus an ND 0.3 filter make an ND 0.6 filter—with a filter factor of 4X.

You can use ND filters in ordinary photography when the film in

USING NEUTRAL-DENSITY FILTERS TO INCREASE EXPOSURE TIME OR APERTURE		
FILTER NOMENCLATURE	MULTIPLY EXPOSURE TIME BY:	OPEN LENS APERTURE BY (*f*-STOPS):
ND .1	1.25	1/3
ND .2	1.6	2/3
ND .3 or 2X	2	1
ND .4	2.5	1-1/3
ND .5	3.1	1-2/3
ND .6 or 4X	4	2
ND .8	6.25	2-2/3
ND .9 or 8X	8	3
ND 1.0	10	3-1/3
ND 2.0	100	6-2/3
ND 3.0	1000	10
ND 4.0	10,000	13-1/3

Glass screw-in filters with filter factors greater than 8X are hard to find. Camera dealers can supply Eastman Kodak gelatin ND filters in *densities* up to 4.

the camera is too fast for the job at hand. If you have high-speed film already in the camera and you need to make a shot or two in bright sunlight, put on an ND filter and effectively slow down the film. The camera will behave as though the film speed is divided by the filter factor.

If you have ASA 400 film in the camera and put on an ND filter with a factor of 4X, you will end up setting aperture and shutter speed as if the film had a rating of ASA 100. Does this mean you should change the film-speed dial of the camera from 400 to 100? No, even though some instructions seem to say that.

POLARIZING FILTERS

Still another property of light waves is responsible for *polarization*, the direction of *lateral* vibration of the light waves.

Water waves serve as a good analogy. Water particles in a water wave move up and down, so the water wave is vertically polarized. Light can be vertically polarized, horizontally polarized, or polarized in all directions at once—called *random polarization*. Direct sunlight is randomly polarized.

Some materials have the ability to transmit waves with only a single direction of polarization and block waves with all other directions of polarization. These materials are made into *polarizing filters*, sometimes called *polarizers* or *polarizing screens*.

A polarizing filter that transmits vertically polarized light will not transmit horizontally polarized light, and the reverse. If randomly polarized light arrives at a polarizing filter oriented to pass vertical polarization, the horizontally polarized component will be blocked by the filter.

If the filter were perfect, this would block exactly half of the total light in a randomly polarized beam and the filter would have a filter factor of 2X or an optical density of 0.3.

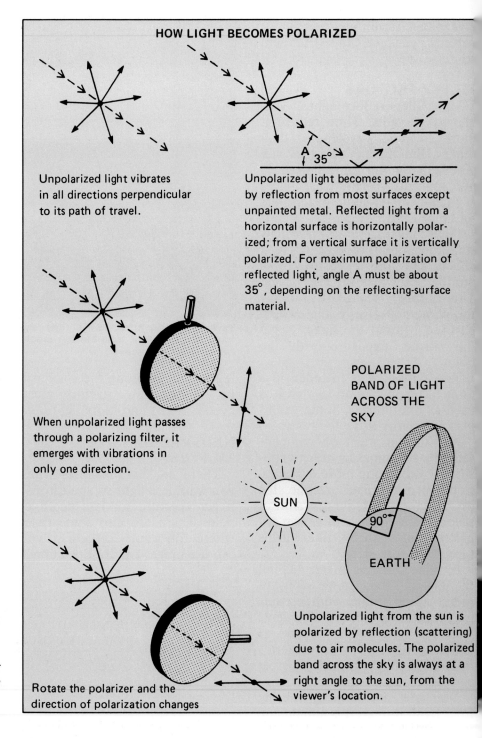

HOW LIGHT BECOMES POLARIZED

Unpolarized light vibrates in all directions perpendicular to its path of travel.

Unpolarized light becomes polarized by reflection from most surfaces except unpainted metal. Reflected light from a horizontal surface is horizontally polarized; from a vertical surface it is vertically polarized. For maximum polarization of reflected light, angle A must be about 35°, depending on the reflecting-surface material.

When unpolarized light passes through a polarizing filter, it emerges with vibrations in only one direction.

POLARIZED BAND OF LIGHT ACROSS THE SKY

Rotate the polarizer and the direction of polarization changes

Unpolarized light from the sun is polarized by reflection (scattering) due to air molecules. The polarized band across the sky is always at a right angle to the sun, from the viewer's location.

Practical filters vary from around 2.5X to 4X. They don't block all light of the wrong polarization, but the filter material is gray colored so it absorbs some light of all polarizations just because of the gray color.

Unpolarized light becomes polarized by reflection from smooth surfaces—except unpainted metal.

Where such reflections occur, we see the reflection as a glare, such as from a store window or glass display case, and on the surface of varnished wood furniture. When a polarizing filter is used to block such reflections the improvement may be dramatic.

When unpolarized light is reflected from a non-metallic surface, vibrations in the light which

When the lens is pointed in the right direction, a polarizing filter is very effective in darkening blue sky. This makes clouds stand out dramatically and often improves a photo.

In addition to darkening blue sky, polarizers remove glare from glass and most other surfaces except unpainted metal.

are parallel to the surface are reflected and those which are perpendicular are suppressed. For example, light reflecting from a horizontal surface will become polarized horizontally.

Polarizers are normally supplied in mounts which allow the filter to be rotated so you can change the angle of polarization while viewing the result. If you are operating on manual, meter and set the exposure controls after you have rotated the polarizer for the desired effect. On automatic, the camera will adjust exposure automatically.

A polarizer is the only way to darken blue skies to make the clouds stand out, when using color film. Scattered blue light from the sky is polarized and the effect is maximum when viewed at a right-angle to the sun. When you rotate the polarizer so it suppresses the polarized blue light, the sky becomes darker and white clouds become highly visible.

FILTER MOUNTING

Most Minolta lenses use the screw-type filter which screws into the threaded ring on the front of the lens. Each filter repeats the thread on the front edge of the frame, so a second filter can be screwed into the first.

Stacked filters may vignette the image because the filter frames extend too far forward and intrude into the angle of view of the lens. Vignetting due to stacked filters is less likely to happen with telephoto lenses and more likely with wide-angle lenses. Usually you can see it in the viewfinder if it is severe. Sometimes you see darkened corners in the photo that you didn't notice in the viewfinder.

A problem results from lenses with different screw-thread diameters. If you have a filter which fits a small-diameter lens, it will be too small for larger-diameter lenses and you may end up buying the same filter type in two diameters.

With screw-in filters, the lens-size problem can be solved by purchasing filters to fit your largest-diameter lens and using adapter rings which are available at most camera shops. These are usually called *step-up* rings and *step-down* rings.

The step-down type puts a smaller filter on a larger lens—which may cause vignetting of the image by blocking some of the light around the edges of the frame. Using a step-up ring to install a filter larger than the lens rarely causes any problem unless several are stacked.

IMAGE DEGRADATION DUE TO FILTERS

Besides vignetting due to stacking filters, image quality may deteriorate when several filters are used together. The light reflects back and forth between glass surfaces of a stack of filters, just as in a lens. All good quality modern filters are coated to reduce these reflections.

Filters have least effect on image quality when they are mounted close to the front of the lens. Stacking and use of step-up rings puts the filter glass far enough from the lens to make aberrations and defects more apparent.

Dirt, scratches or fingerprints on a filter surface will scatter the light and reduce image contrast, the same as dirt does on the lens itself. Filters should receive the same care as lenses.

Filters may fade with age, particularly if exposed to bright light a lot of the time. This change is hard to detect because it is gradual, but it may not be important until you can detect it.

FILTER CATEGORIES

There is very little standardization of the names given to types of filters to indicate their purpose. The most common designations are those of Eastman Kodak, which have been adopted by several other major suppliers. This

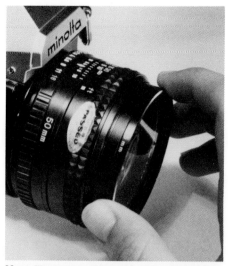

Most filters screw into the filter threads on the front of most lenses. When the thread diameters are the same, the filter screws directly into the lens.

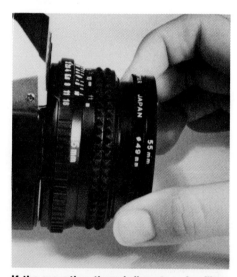

If the mounting-thread diameter of a filter or lens hood is larger than the lens threads, you can use a step-up adapter. The filter diameter for this 45mm *f*-2 lens is 49mm. A 49mm to 55mm adapter is installed on the lens. A 55mm filter is installed on the adapter. Minolta offers step-up adapters in two sizes: 49mm—55mm and 52mm—55mm.

discussion uses Kodak terminology.

Filters are often grouped into categories that are logical but possibly misleading. A filter is a filter and it has some effect on light. Even though one may be labeled for use in making color prints in the darkroom it can be just as useful in front of your camera if you can find a way to hold it there.

Conversion Filters—This type of filter alters the light spectrum to make it suitable for the film you are using. It converts the light to your purpose. Examples are converting daylight to look like tungsten illumination and vice versa.

Light-Balancing Filters—These make smaller changes in the quality of light, such as changing from 3,200K light to 3,400K light and the reverse for Type A and Type B color film. Another example is a skylight filter to take out some of the blue when the subject is in shade.

Exposure-Control Filters—These are neutral-density filters which alter only the amount of light, not the relative amounts of each wavelength. Two polarizing filters mounted so one can be rotated in respect to the other will also change the amount of light. They will not reduce the amount of light to zero even though this is theoretically possible and they may change the color of the image when you use this arrangement to block a lot of light.

Contrast-Control Filters—These

CONVERSION FILTERS			
Color Film Type	Light Source	Filter Needed	Filter Factor (Approx.)
Daylight	Tungsten 3400K	80B	3X
Daylight	Tungsten 3200K	80A	4X
Tungsten Type A 3400K	Daylight	85	2X
Tungsten Type B 3200K	Daylight	85B	2X

are color filters used with b&w film to control or alter visual contrast on the print between objects of different color in the scene. The red apple among green leaves, for example.

Haze Filters—Useful with either color film or b&w, depending on the filter. They cut haze by cutting the shorter wavelengths of light. Obviously a dark red filter used to cut haze with b&w film can also serve as a special-effect filter with color film.

Color-Compensating Filters—These are for making prints from color film but can also be used over the camera lens. They have relatively low densities in six colors that are important in color films: Red, green, blue, cyan, magenta, and yellow.

These filters have an orderly system of nomenclature which uses the letters CC as a prefix in all cases. Following the prefix is a number such as 05 which is the optical density of the filter, expressed as a decimal. That is, 05 means 0.05.

Following the density indicator is a letter which is the initial of the *visual* color of the filter itself. If the filter looks red when viewed against white light, it is called a red, or R filter.

CC filters have good optical quality and can be used in front of a camera lens and below the negative in an enlarger without noticeable degradation of the image.

Color-Printing Filters—These have the same colors and density ranges as CC filters but are not of good optical quality. They are intended to change the color of the printing light by insertion of the CP filter above the negative in an enlarger. At that point in the optical path, the image is not yet formed, so optical quality of the filter is not important as long as the color is correct.

Special Filter Types—These include such things as star-effect filters, and soft-focus or diffusion filters.

MINOLTA FILTERS				
			FILTER FACTOR	
Filter	Sizes	Effect	Daylight Film	Tungsten Film
Yellow	40.5mm 46mm 49mm 52mm 55mm 62mm 72mm	With b&w panchromatic films, lightens red and yellow subjects; darkens blue skies, emphasizes clouds	1.5X	1.2X
UV Haze	40.5mm 46mm 49mm 52mm 55mm 62mm 72mm	With color and b&w films, absorbs excessive ultraviolet radiation in mountain, snow, marine and distant scenes. Tends to cut through haze, and reduces blue cast with color films.	1X	1X
Neutral Density 4X	40.5mm 46mm 49mm 52mm 55mm 62mm 72mm	Controls exposure with color and b&w films. Reduces amount of light entering camera by 2 steps. Allows use of large lens openings or slow shutter speeds even with fast films in bright light.	4X	4X
Red	49mm 52mm 55mm 72mm	Used with b&w panchromatic and infrared film. With b&w, causes pronounced darkening of blues, lightening of reds, yellows, greens. With infrared, creates "moonlight" effects. Increases image contrast and cuts through haze.	6X	4X
Orange	49mm 52mm 55mm 72mm	With b&w panchromatic films, absorbs ultraviolet, darkens blues and some greens, lightens reds and yellows. Darkens blue skies, emphasizes clouds. Some haze penetration effects.	2X	1.5X
Green	49mm 52mm 55mm	With b&w panchromatic films, darkens blue skies slightly, lightens greens.	1.5X	1.5X
1A Skylight	52mm 67mm 72mm	With daylight-type films outdoors, reduces excess blue, absorbs excess ultraviolet. Produces slightly "warmer" overall color rendition.	1X	1X
1B Skylight (multi-coated)	46mm 49mm 55mm 62mm		1X	1X
80B Conversion	46mm 49mm 52mm 55mm 72mm	Adapts outdoor (daylight-type) color film for exposure by incandescent light sources.	1X	2X
85B (Type A Conversion)	46mm 52mm 55mm 72mm	Adapts outdoor (daylight-type) color film for exposure by daylight or electronic flash.	1X	2X
Polarizing	49mm 52mm 55mm	With b&w and color films, reduces or eliminates reflections. Can darken blue skies, emphasize clouds; may also be used to reduce overall amount of light entering camera.	3X	3X

TYPICAL EXPOSURE INCREASE FOR RECIPROCITY FAILURE OF KODAK BLACK & WHITE FILMS				
FILM TYPE	IF INDICATED EXPOSURE TIME IS (SECONDS)	USE ONE OF THESE CORRECTIONS (NOT BOTH)		AND CHANGE DEVELOPING TIME:
		Increase Aperture	Exposure Time	
Panatomic-X Plus-X Tri-X	1/100,000	1 stop	Use Aperture Change	20% more
	1/10,000	1/2 stop	Use Aperture Change	15% more
	1/1,000	None	None	10% more
	1/100	None	None	None
	1/10	None	None	None
	1	1 stop	2 seconds	10% less
	10	2 stops	50 seconds	20% less
	100	3 stops	1200 seconds	30% less

SOME 35mm FILMS

Film Type	Daylight	Tungsten 3400K	Tungsten 3200K
COLOR SLIDE FILM			
Kodachrome 25	25/none	8/80B	6/80A
Kodachrome 64	64/none	20/80B	16/80A
Kodachrome 40	25/85	40/none	32/82A
5070 Type A			
Ektachrome 64 Daylight (ER)	64/none	20/80B	16/80A
Ektachrome 200 Daylight (ED)	200/none	64/80B	50/80A
Ektachrome 160 Tungsten (ET)	100/85B	125/81A	160/none
Agfachrome 64	64/none	20/80B	16/80A
Fujichrome R 100	100/none		32/80A

Film Type	Daylight	Tungsten 3400K	Tungsten 3200K
COLOR NEGATIVE FILM			
Kodacolor II	100/none	32/80B	25/80A
Kodacolor 400	400/none	125/80B	100/80A
Kodak Vericolor II Professional, Type S	100/none	32/80B	25/80A
3M Color Print Film	80/none	25/80B	20/80A
Fujicolor F-II	100/none		32/80A
Fujicolor F-II 400	400/none		125/80A
BLACK & WHITE			
Kodak Panatomic-X	32	32	32
Kodak Plus-X	125	125	125
Kodak Tri-X	400	400	400
Ilford PAN F	50	50	50
Ilford FP4	125	125	125
Ilford HP4	400	400	400

TYPICAL EXPOSURE INCREASE AND FILTERING TO CORRECT RECIPROCITY FAILURE IN COLOR FILMS

FILM TYPE	1/50,000	1/25,000	1/10,000	1/1000	1/10	1/2	1	2	10	64	100
Kodachrome II 5070, Type A	†		None No Filter	None No Filter	1/2 Stop No Filter		1 Stop CC10M		1-1/2 Stop CC10M		2-1/2 Stop CC10M
Ektachrome 64 (Daylight)			1/2 Stop No Filter	None No Filter	None No Filter		1/2 Stop CC15B		1 Stop CC20B		NR
Ektachrome 200 (Daylight)			1/2 Stop No Filter	None No Filter	None No Filter		None No Filter		NR		NR
Ektachrome 160 (Tungsten)				None No Filter	None No Filter		1/2 Stop CC10R		1 Stop CC15R		NR
Kodachrome 25			None No Filter	None No Filter	None No Filter		1 Stop CC10M		1-1/2 Stop CC10M		2-1/2 Stop CC10M
Kodachrome 64			None No Filter	None No Filter	None No Filter		1 Stop CC10R		NR	NR	NR
Fujichrome R-100				None No Filter		None No Filter	1/3 Stop CC5C	2/3 Stop CC5C	2/3 Stop CC10C	1-2/3 Stop CC20C	2 Stop CC20C
Kodacolor II	1 Stop CC20B	1/2 Stop CC10B	None No Filter	None No Filter	None No Filter		1/2 Stop No Filter		1-1/2 Stop CC10C		2-1/2 Stop CC10C + 10G
Kodacolor 400			None No Filter	None No Filter	None No Filter		1/2 Stop No Filter		1 Stop No Filter		2 Stop No Filter
Vericolor II Professional Type S			None No Filter	None No Filter	None No Filter		NR		NR		NR
Fujicolor F-11				None No Filter		None No Filter	1/3 Stop No Filter	2/3 Stop No Filter	1 Stop No Filter	1-1/3 Stop No Filter	1-2/3 Stop No Filter
Fujicolor F-11 400				None No Filter	None No Filter		1 Stop No Filter		2 Stop No Filter		3 Stop No Filter

NR — Not Recommended

†Blank spaces indicate data not published by manufacturer. Where blank is *between* published data estimate correction

All data subject to change by film manufacturer

11 HOW TO USE FLASH

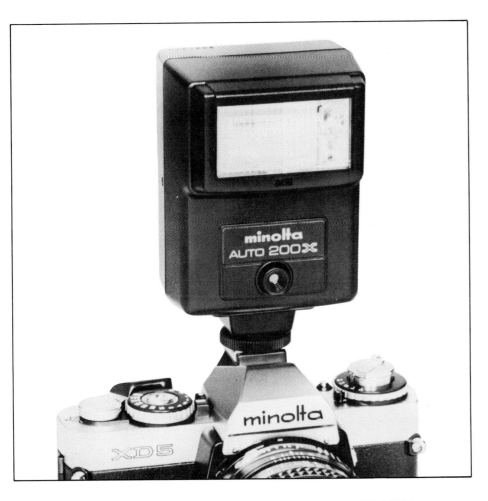

Minolta offers a variety of electronic flash units. Those with "X" in the nomenclature, such as this Auto 200X flash have special capabilities when used with XD and XG cameras. This flash is mounted in the hot shoe on top of the camera. Electrical connections between flash and camera are made through electrical contacts in the hot shoe.

HOW TO USE FLASH

It is convenient to divide artificial light into three categories: flash bulbs, electronic flash, and continuous light sources such as photo lamps. Electronic flash has some further subdivisions according to how it works.

Flash is a short-duration burst of light which must be synchronized with the camera so the burst of light happens while the shutter is open. To accomplish synchronization, the flash unit is fired or triggered by an electrical *sync* signal from the camera.

ELECTRONIC FLASH

Electronic flash requires a high voltage, usually obtained from batteries through a voltage multiplying circuit.

Electronic flash produces a color temperature of around 6,000 degrees Kelvin. It is generally considered to have the same photographic effect as daylight. Filters on the camera or over the flash unit can be used to alter the color if necessary.

Electronic flash units fire virtually instantaneously and reach full brightness immediately. To use electronic flash with a focal-plane shutter, the flash is fired at the instant the first curtain of the focal-plane shutter reaches fully open. This is called *X-synchronization*.

Electronic flash units are available which mount in the hot shoe on the camera and are triggered through the electrical contact in the shoe. Larger, more powerful models usually don't mount on the camera. They have a handle so you can comfortably hold them in your hand and are sometimes called *handle-mount* flash units.

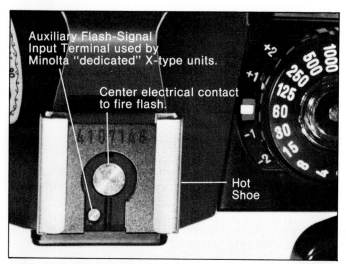

Auxiliary Flash-Signal Input Terminal used by Minolta "dedicated" X-type units.

Center electrical contact to fire flash.

Hot Shoe

When a Minolta X-type "dedicated" flash is mounted in the hot shoe and ready to flash, the flash uses the Flash-Signal Input Terminal in the hot shoe to automatically switch XD or XG cameras to the correct shutter speed for electronic flash. When you depress the shutter-release button, the camera fires the flash by an electrical signal at the center contact in the hot shoe.

When using a flash not mounted in the hot shoe, make the electrical connection between them by an electrical sync cord. One end of the cord is connected to the flash; the other end plugs into the flash-sync socket on the camera body (arrow)—also called flash terminal and X-sync terminal.

XD-11 FLASH SYNCHRONIZATION		
Flash	Camera Mode	Shutter Speed
Minolta X-type	Any	When shutter speed set to any numbered setting, flash automatically switches camera to X-sync shutter speed of 1/100 second. X setting is 1/100, electronically controlled. O is 1/100, mechanically controlled. B will fire flash when first curtain opens.
Other Electronic Flash	M	Use X, O, B, or 1/60 to 1 second.
M or MF Flash Bulbs	M	Use B or 1/15 to 1 second.
FP Flash Bulbs	M	Use B or 1/15 to 1 second.

Brackets are available which mount both camera and handle-mount flash so you can use them together as one unit. Handle-mount electronic flash units are connected to the camera by a sync cord, plugged into the flash sync terminal on the camera.

SYNCHRONIZING WITH FLASH

Minolta cameras typically have both a hot shoe and a flash-synchronization terminal or socket on the camera. On most models, the hot shoe and the sync terminal both provide X-sync only, which is primarily intended to fire electronic flash.

Shutter speeds for flash synchronization are shown in the accompanying table for the XD-11 camera, as an example. Similar tables for other models are in Chapter 15.

Flash Bulbs with X-sync—Flash bulbs can be used at specified shutter speeds when triggered by X-sync even though X-sync is specifically intended for electronic flash. In the accompanying flash synchronization table notice that the XD-11 can be used with electronic flash and also three kinds of flash bulbs, identified by letter symbols:

M medium-speed flash bulb
MF medium fast
FP focal-plane

Speeds indicated by the symbols M and MF refer to rise time—how long it takes the flash bulb to reach full brightness. FP flash bulbs are a special type with a very long burning period.

When flash bulbs are fired by X-sync, the bulb isn't ignited until the first focal-plane-shutter curtain is fully open. The flash must reach full brightness and then make a useful amount of light before the second curtain closes, so X-sync with flash bulbs is limited to slow shutter speeds as you can see in the table.

To set exposure controls for flash bulbs, refer to data packed with the flash bulb.

HOW A NON-AUTOMATIC ELECTRONIC FLASH WORKS

You don't have to be an electronic whiz to understand the basic operation of an electronic flash. Figure 11-1 shows a power source feeding a voltage converter. The power source is usually batteries, but for some equipment it is AC power from a wall socket.

Either way, the electrical voltage needed to operate the flash tube is higher than the supply or source voltage so a special circuit converts the low voltage from the source into a higher voltage. This high voltage is accumulated in a storage *capacitor.*

An electrical capacitor behaves very much like a rechargeable battery. The capacitor charges up to the high voltage from the voltage converter, then suddenly dumps its charge into the flash tube to make the bright light.

A signal is required to tell the capacitor to dump its charge and produce the flash. This signal comes from the X-sync contacts in the camera. The signal wire is shown connected to the flash tube itself, and you can think of it as turning on the flash. The flash tube extinguishes when the storage capacitor has discharged.

Once the flash has been fired, it cannot be operated again for a short period of time needed to recharge the capacitor, called *recycle time.* This can vary from a short time such as one-half second up to a relatively long period such as 30 seconds.

When batteries are the source of electricity for the capacitor, recycle time depends on battery condition. If fully charged, recycle time is short. As the battery or batteries approach full discharge, recycle time takes longer.

Longer recycle time tells you the batteries need recharging or replacing.

If you use flashlight-type non-rechargeable batteries—usually the small penlight cells—consider alkaline cells. They give a lot more

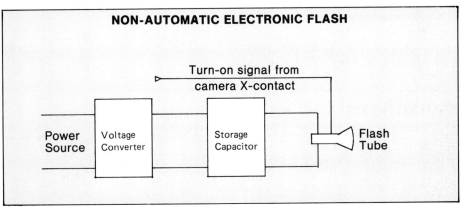

NON-AUTOMATIC ELECTRONIC FLASH

Figure 11-1/When using a non-automatic electronic flash, a camera-generated X-sync signal turns the flash on. The flash tube makes light until the electrical charge in the storage capacitor is depleted. Then the flash tube extinguishes.

flashes than the common variety before recycle time becomes excessively long or the unit won't recycle at all.

The type of capacitor used in electronic flash units may deteriorate if left a long time without an electrical charge. Just before you put the flash away after shooting, it's a good idea to let it recycle so it is ready to shoot, but don't fire the flash. Turn it off and it will be stored in a charged condition.

In long storage it is beneficial to turn on the flash unit and recharge the capacitor about once a month, returning it to storage in a charged condition.

Most electronic flash units have a ready light which glows when the capacitor has enough charge to operate the flash. Minolta refers to the ready light as a *monitor light.*

The nature of electrical capacitors is that they charge rapidly at first and then accept additional charge at a slower and slower rate. It has been conventional among manufacturers of electronic flash to turn on the ready light when the flash has recharged to about 70% of full capacity—about one-half of an exposure step below full capacity.

Therefore there has been some uncertainty about the amount of exposure that will result from firing the flash. If you fire immediately when the light turns on, exposure is about a half-step less than it would be if you waited a while before firing the flash.

When the flash is ready to fire, the monitor light glows. This light is also called the *ready light.* With some combinations of Minolta flash and camera, there is also a flash-ready indicator in the camera viewfinder.

Most Minolta flash units don't do it that way. The flash monitor light turns on when the unit is charged up nearly all the way. Therefore there is very little difference in exposure, no matter how long you wait after the light turns on.

An exception is Auto Electroflash 450. This monitor light signals when there is 70% of full charge and signals again when the unit is fully charged. This is discussed in more detail later in this chapter.

Non-automatic electronic flash and flash bulbs are similar in one important way: The amount of light made each time is constant and repeatable.

A guide-number calculation for a non-automatic flash usually gives a good exposure indoors because guide numbers are based on indoor shots where some light from the flash bounces off the walls and ceiling. The bounced light adds to the direct light from the flash. Outdoor shots based on guide numbers are usually underexposed because only direct light from the flash illuminates the subject. Compensate when shooting outdoors by opening the lens a half stop or full stop more than the calculation suggests.

Tom Monroe used flash to balance inside and outside light. Without flash or other additional light, there were two choices: Expose for the cat and the background would be washed out. Expose for the background and the cat would appear in silhouette.

Automatic electronic flash units, discussed later, have a built-in system to change the amount of light made by the flash as a way of controlling exposure. The amount of light that the unit makes, each time it is flashed, does change and we *do not* expect it to be always the same. That's why we must be careful to distinguish between auto and non-auto electronic flash.

GUIDE NUMBERS

Guide Numbers help you set camera exposure controls properly when using flash bulbs or non-automatic electronic flash. Higher guide numbers indicate more light from the flash.

Suppose a non-automatic flash or flash bulb makes enough light for correct exposure of a subject at a certain distance from the flash. Starting with that situation, the light source could be moved farther from the subject and proper exposure could still be made by opening the aperture to compensate for the reduced amount of light.

Assume the flash is 5 feet from the subject and a suitable aperture is *f*-16. Please notice that the distance in feet multiplied by the *f*-number is: 5 feet x 16 = 80 feet.

All combinations of distance and *f*-number that produce the same exposure with that flash will have the same product—80 feet or whatever the number turns out to be. That number is called a *guide number.*

Obviously guide numbers will be different for different film speeds because, with faster film, you need less light on the subject.

With electronic flash, guide numbers are specified for a certain film speed. Shutter speed is not important because the entire flash happens in a time interval much shorter than the shutter speed you are allowed to use with a focal-plane shutter. More on this point in a minute.

When you know the guide number, you can use this simple formula to figure aperture setting for correct exposure of an average scene:

f-number = GN/Distance

For example, if the guide number is 80 feet, and the flash is 5 feet from the subject, the *f*-number you should use is

80 feet / 5 feet = *f*-16.

If you move the light back, say at 10 feet to keep the arithmetic simple, the new aperture is

80 feet / 10 feet = *f*-8.

Notice that a guide number includes *distance* between light source and subject. If the distance is measured in feet, a certain guide number results. If measured in meters, a different guide number results. Unless you know whether the number is based on feet or meters, you can miss exposure by working at the wrong *f*-stop.

Sometimes guide numbers are specified only for one film speed. If you decide to shoot with film of a different speed, you should know how to convert the guide number. Let's use the terms New GN and New ASA to mean the GN and film speed you intend to use. Old GN and Old ASA will mean the published guide number.

$$\text{New GN} = \text{Old GN} \times \sqrt{\frac{\text{New ASA}}{\text{Old ASA}}}$$

Sometimes the film speeds make the calculation easy. Suppose the guide number as stated in the specs is 60 feet with ASA 100 film. You intend to shoot with ASA 400 film.

$$\begin{aligned} \text{New GN} &= 60 \text{ feet} \times \sqrt{400/100} \\ &= 60 \text{ feet} \times \sqrt{4} \\ &= 60 \text{ feet} \times 2 \\ &= 120 \text{ feet} \end{aligned}$$

If you switch to ASA 400 film instead of ASA 100 film, the guide number doubles. You can place the flash at double the distance or

140

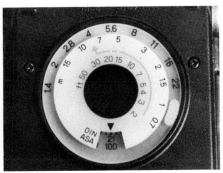

On manual, the calculator on the back of the flash does the guide-number arithmetic for you. Dial in film speed first. Then the outer two scales show pairs of *f*-number and subject distance in meters that will give good exposure. For example, *f*-16 and 2 meters. If you prefer to read feet, use the inner scale: *f*-16 and 7 feet. The curved line with arrow is used on automatic.

close down the aperture by two stops.

Guide numbers for electronic flash units are stated at ASA 25 or ASA 100 or some other film speed. The flash unit "looks better" when a higher film speed is used as the base—because the guide number is higher. If you are shopping for an electronic flash, compare guide numbers based on the same film speed.

Guide numbers are just that—a guide. They are based on photographing people indoors in ordinary rooms because more flash is used for that purpose than any other. Some of the light from the flash bounces off ceiling and walls and then illuminates the subject while the shutter is still open. If you use flash in a large room with dark walls and a high, dark-colored ceiling, the room will absorb a lot of light from the flash and the film will be underexposed.

If you shoot in unusual indoor circumstances, determine correct exposure by testing.

If you use flash outdoors, you will lose the light that would otherwise bounce off ceiling and walls and the picture may be underexposed. For outdoor locations, try figuring *f*-stop with the guide number and then give more exposure. Try one, two and three steps more exposure. Check the results and decide which works best for your flash.

Let the Calculator Do It—Most Minolta flash units operate in both automatic and non-automatic modes. Non-auto is called *manual* operation.

On manual, these flash units require a guide-number calculation as just described, but a calculator on the back of the flash does it for you.

Dial in film speed to prepare the calculator for use with the film you are using. Focus and notice the distance to the subject. Then consult the calculator dials.

There are two distance scales on the calculator, one in feet and the other in meters, as you can see in the accompanying photograph.

Opposite the distance scales is a scale of *f*-numbers. From the subject distance, found on either of the distance scales, read directly across to the *f*-number scale to find the correct aperture setting to shoot indoors in an ordinary room.

ESTABLISHING YOUR OWN GUIDE NUMBERS

Because guide numbers are based on average conditions, the published guide number for your flash may not work well under your shooting conditions—such as a room with a high dark ceiling.

You can figure and assign your own guide number to your equipment and shooting environment by testing. Remember that a guide number is just the product of distance and *f*-stop which gives a good exposure at a specified shutter speed.

A handy shooting distance for the test is ten feet from the subject. Use several different *f*-stops above and below the one suggested by the published guide number. Make notes or have the subject hold a card showing the *f*-stop for each exposure. After processing, pick the one you like best. The guide number for that situation is the *f*-stop used multiplied by the distance used.

If you like *f*-8 best, and you are testing at 10 feet, the guide num-

ber is 80 feet. Use color-slide film for the test.

Measuring Light from a Flash—There are special accessory light meters that measure light from a flash and calculate exposure settings—an example is Minolta Flash Meter III which eliminates guide number calculations and guesswork.

FLASH WITH A FOCAL-PLANE SHUTTER

When using flash with a focal-plane shutter, synchronization between flash and shutter is vital. The reason is in the way a focal-plane shutter opens to make an exposure.

The first curtain is is released and the second curtain follows behind at a time interval equal to the desired length of exposure. When the first curtain reaches the end of its travel, the film frame is uncovered *as far as the first curtain is concerned*, so it closes electrical contacts in the camera body which fires the flash.

If the second curtain is following too closely behind the first, at 1/500 second for example, part of the frame will already have been covered up by the second curtain at the instant of the flash. The only part of the frame which could be exposed is the narrow slit between the two curtains.

To use electronic flash with a focal-plane shutter, a shutter speed must be selected so the first curtain reaches the end of its travel and then a short time passes before the second curtain *begins* its journey across the frame. During that short time, all of the frame is open to light and the flash occurs.

This means the exposure time on the shutter-speed dial must be slightly longer than the time required for the first curtain to travel across the frame. The time depends both on how fast it travels and how far it has to travel.

Shutters that move vertically travel across the narrow dimension of the frame—24mm. Horizontally moving shutters

travel across the wide dimension of the frame—36mm. Therefore vertically moving focal-plane shutters synchronize with electronic flash at faster shutter speeds than horizontal shutters.

The accompanying table shows electronic flash-sync speeds for Minolta 35mm SLR cameras. In this book, these speeds are called *X-sync* speed for the camera being discussed. These are the *fastest* speeds that will completely uncover the frame. At slower shutter speeds, the second curtain waits even longer before starting across the frame, so electronic flash works OK as far as the flash is concerned.

When using electronic flash, the shutter must operate at the X-sync speed or slower.

GHOST IMAGES

Focal-plane shutters in Minolta 35mm cameras require exposures for electronic flash of 1/100 or 1/60, or longer, but the actual exposure due to the bright light of the flash is much shorter—1/600 second down to as little as 1/40,000 second in some cases.

If there is enough illumination on the scene from sources other than the flash to cause some exposure during the *full time* the shutter is open, then there are two exposures. One short-time exposure due to the flash and another longer-time exposure due to the ambient light on the scene. If there is enough ambient light, the image it causes will be visible on the film.

If the subject moves during the time the shutter is open, or the camera moves, the image due to ambient light will not be in register with the image due to flash. This can cause a blur or a faint "echo" of the subject on the film which is sometimes called a ghost image.

With a motionless subject, the cure is to hold the camera still during the entire period of exposure. With a moving subject, there isn't much you can do about it except try to shoot so the flash is the dominant light and the other light

X-SYNC SPEED FOR MINOLTA 35mm SLR CAMERAS	
Camera	X-Sync
XD-11	1/100
XD-5	1/100
XG-9	1/60
XG-7	1/60
XG-1	1/60
SR-T 200	1/60
SR-T 201	1/60
XK Motor	1/100

on the subject is too dim to make a visible image on the print, or else *pan* with the subject. Pan means follow motion by moving the camera.

You can check to see how much exposure will result from ambient light by setting the camera to X-sync shutter speed and using the camera meter. To minimize ghosts, choose a lens aperture so the film will be underexposed by ambient light. You depend on the flash to produce correct exposure.

LIGHTING RATIO

A thing to worry about with artificial lighting, and sometimes outdoors, is the difference in the amount of light on the best-lit areas of the subject and the amount in the worst-lit areas.

Direct sunlight from above or the side can spoil a portrait by casting deep and well-defined shadows of facial features. This can be helped by using reflectors to cast some light into the shadows, or using flash to fill some of the shadowed areas with more light—called *fill lighting*.

A single light source of small dimensions tends to make dark and well-defined shadows with "sharp" edges. A second light source—even a small distance from the first—softens the shadow edges to give portraits a more pleasing appearance.

A single light source of relatively large dimensions, such as a wall reflecting light onto your subject, acts like many smaller light sources at different locations and therefore makes shadows which

are not as dark or sharp as a single small source.

This leads to some general rules or observations: Small light sources cast sharp shadows, big ones don't. Multiple light sources act like a big one. Light from all directions casts no shadows at all.

If you are using more than one light source, you can usually control some or all of them to adjust both the amount of light and the directions of illumination on the subject. In portraiture and other kinds of photography, arrangement of lighting is important for artistic effect.

For a portrait, suppose there are two light sources such as flood lamps or flash. With the subject looking straight ahead, one light source is to the left at an angle of 45 degrees. Let's say this source puts 4 units of light on the subject.

Another source, at a 45 degree angle on the opposite side, puts only one unit of light on the subject. This gives a *lighting ratio* of 4 to 1—the ratio of the two amounts of light.

On the subject, there are three values of light. Where illumination is only from the brighter source, the amount of light is 4 units. Where it is only from the less-bright source, which will be in the shadows cast by the brighter source, the illumination is one unit. Where both lights overlap and both illuminate the subject, the total amount of light is 5 units.

The *brightness ratio* is 5 to 1 because the brightest part is five times as bright as the darkest part.

In photographic exposure steps, a brightness ratio of 5 to 1 is only a fraction more than two steps, usually no problem with b&w film. It is often recommended as the upper limit for brightness variation in color photography because of the nature of color film.

Color film has two jobs to do. It must record differences in scene brightness, just as b&w film records the different brightnesses along the gray scale. In addition, it has to record color.

A simple way to think about that is to remember that brightness gets on the film first. After that, color is introduced by chemical processing. When there is conflict between brightness and color, *color loses!*

By restricting the lighting ratio to about 4 to 1, giving a brightness ratio of 5 to 1 as measured by the exposure meter you allow "room" on the film for both brightness and color variations. If the colors in the scene are very bold and vivid, you may need to hold the lighting ratio to 2:1.

With color, the colors themselves produce visual differences between objects in the scene, so we don't have to rely as much on brightness differences.

HOW TO CONTROL LIGHTING RATIO

If the lights are floods or flash, you can control the brightness of each source by selecting sources of different light output and you can control the amount of light from any source by adjusting the distance from source to scene. Sometimes this is more difficult in the real world than on paper.

With continuous light sources, you can confirm lighting ratio by measuring at the scene with a hand-held meter, or by moving your camera up close so it only "sees" parts of the scene. Measure the brightest part and the darkest part of interest.

With lights of the same intensity, control lighting ratio by moving one farther back. If they are located so they put the same amount of light on the scene, and then one is moved back to double the distance, the light from that one drops to one-fourth its former value due to the inverse-square law.

Using Flash for Fill Lighting— When using flash, you can measure the light with a flash meter or use guide numbers to predict the amount of light on the scene when the flash happens. Use the guide numbers to figure *f*-stop and then consider the *f*-stop as an indicator of the amount of light.

Suppose you are using two flash units to make a portrait. One is located so it requires *f*-5.6 and the other requires *f*-8 to produce full exposure.

Remembering that *f*-8 is one step away from *f*-5.6, and each step doubles the amount of light, settings of *f*-5.6 and *f*-8 represent a lighting ratio of 2 to 1.

The usual rule is, set camera exposure controls for the brightest light. The flash unit which needs *f*-8 for proper exposure is obviously brighter than one which can use *f*-5.6. Therefore you set to *f*-8 to avoid overexposure by the brighter source. This is generally true of fill lighting whether continuous light or flash.

Multiple flash units can be triggered by using connecting wires if the manufacturer designed them that way. They can also be triggered by light. One flash is operated by the camera. One or more additional flash units are equipped with an accessory light sensor which "sees" the light from the main flash and triggers the other flash units. When so arranged, the additional flash units are called *slaves.*

USING FLASH IN SUNLIGHT

A special case of fill lighting with flash is when the main light is the sun. A Minolta flash meter solves this problem very neatly but you can also do it without an accessory meter.

With the shutter at the speed required for flash, and sunlight on the subject *at an angle which makes shadows,* the camera exposure setting should be for the main light source—the sun. Then locate the flash at the right distance from the subject so it gives the desired lighting ratio.

LOCATING FLASH OR FLOOD LAMPS		
Desired Change In Illumination (Exposure Steps)	To Decrease Illumination, Multiply Distance By:	To Increase Illumination, Divide Distance by:
1	1.4	1.4
2	2	2
3	2.8	2.8
4	4	4
5	5.6	5.6
6	8	8

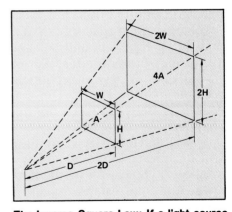

The Inverse-Square Law: If a light source makes an expanding beam and the distance to the illuminated surface becomes 2 times larger, the area of the illuminated surface becomes 4 times as large. Brightness of the surface becomes only one-fourth as much. If distance is multiplied by 3, brightness reduces to 1/9, and so forth. Brightness changes inversely to the square of the distance change.

Here's a procedure for using flash-fill lighting in sunlight.

1. Set the shutter speed as required for use with flash—1/60 or 1/100 depending on camera model.

2. Focus, meter the subject and set aperture for normal exposure using sunlight. Notice the distance from the camera to the subject by reading the distance scale on the lens or actual measurement.

3. Using the guide number for the film speed you are using, calculate the flash f-stop for the distance between camera and subject. For a 2 to 1 lighting ratio, that f-number as calculated should be one step larger than the camera setting.

4. If it is not one step larger, use the guide number to figure the distance between the flash and subject that will require the desired aperture.

5. Put the flash at that distance. Remember about flash outdoors being less effective than flash indoors where ceiling and wall reflections help. Therefore the actual lighting ratio will be higher than 2 to 1. It will be 3 to 1 or possibly 4 to 1. To compensate, move the flash a little closer. That's not very scientific but it's practical.

6. Shoot at the camera setting you made for sunlight, not the larger aperture you calculated for normal exposure with the flash.

Minolta Auto Electroflash 320 and 320X have an unusual and very handy procedure for flash fill in sunlight or any other bright continuous light source. The procedure is described later in this chapter.

If you have the type of flash which connects to the camera by a sync cord, you can locate the flash away from the camera by using sync cord and extensions if needed.

If you cannot remove the flash from the camera because it is a direct-connected hot-shoe type, then you can't use a different distance for flash and camera. It is always possible to find some dis-

Bright sunlight causes shadows that are sometimes too dark for a good portrait. Solve the problem by *filling* the shadows with light from your flash.

tance that will give the lighting ratio you want, but that may not give good composition of the picture. Changing to a lens with a different focal length or using a zoom lens may help you find a location for camera and flash that will result both in the desired composition and the desired amount of fill flash.

Another way to control the ratio of ambient light to flash illumination is to use shutter speeds slower than the normal X-sync speed. If the camera normally uses 1/100 second for electronic flash, you can use any slower shutter speed and exposure due to the flash will not change.

Exposure due to ambient light will change. If you use one step slower shutter speed, you get one step more exposure from ambient light. If the subject doesn't move and the camera doesn't move during the exposure interval, this is a very useful trick.

Minolta flash units with X in the nomenclature, such as 200X, can set shutter speed to X-sync automatically, when mounted in the hot shoe of XD and XG cameras. The automatically selected shutter speed is always the fastest allowable speed for electronic flash—which depends on camera model: 1/100 for XD cameras and 1/60 for XG cameras.

With an X-type flash *in the hot shoe* of an XD or XG camera, you can't use a slower shutter speed to get more exposure from ambient

light—with a sync cord, you can.

Some X-type flash units can also be connected to the camera with a sync cord plugged into the sync terminal on the camera body. These models, when connected with a sync cord, do not set camera shutter speed automatically and you must set it manually. In these cases, you can use the slow-shutter-speed trick.

The Minolta Flash Specifications table, later in this chapter, shows which X-type flash units can be cord-connected to the camera.

When your calculation indicates that the flash should be moved back to reduce its light output, but you can't move it back independent of the camera, you can reduce the amount of light coming from the flash.

With electronic flash, you can cover about half of the window that lets light out and about half of the light will come out—a reduction of one step. Some photographers develop high skill at covering part or all of the flash window to get the right amount of light.

You can also reduce the amount of light from an electronic flash by covering the entire window with a white facial tissue or handkerchief. Usually one thickness reduces the light one step; two thicknesses reduce it two steps. Verify this by testing. You can also use neutral-density filters over the flash window although it may be necessary to improvise a mount.

CAUTION: You can do this with electronic flash, but flash bulbs get very hot. Don't touch one with your fingers or put combustible material near a flash bulb that will be fired.

Variable Output Power—Some Minolta flash units have a control to vary the amount of light produced by the flash. This is more convenient and precise. The 200X flash has two power settings, 320X and 320 models have nine settings. When set for reduced power, these flash units reduce the length of time the flash makes light, which reduces the total amount of light produced by the flash.

EFFECTIVE APERTURE

As you know, aperture size as stated by an f-number is an indication of the light-gathering ability of a lens. When using extension tubes or a bellows for increased magnification, lens f-number is not a true indication.

Because added extension reduces light on the film, it has an effect similar to using smaller aperture. The lens may be set at f-4 but the amount of light on the film corresponds to f-8 because the lens is being used with extension. In that situation, *effective aperture* (EA) is f-8 because that's how much light there is.

$$EA = (lens\ f\text{-}stop) \times (M + 1)$$

Where M is magnification.

The idea is to convert the effect of added extension into a fictitious but practical f-number for the lens rather than use the exposure factor as discussed in Chapter 9.

This will sometimes be handy when using a camera with flash—when exposure is found by a guide-number calculation. The calculation tells you what f-stop to use, but this is the effective aperture because it states the actual amount of light needed on the film for proper exposure.

What you need to know is how to set the lens to get that amount of light.

$$f\text{-stop on lens} = EA / (M + 1)$$

Suppose a flash guide-number calculation calls for an aperture of f-8 but you are using a magnification of 0.4.

$$\begin{aligned} f\text{-stop on lens} &= f\text{-}8 / (0.4 + 1) \\ &= f\text{-}8 / 1.4 \\ &= f\text{-}5.7 \end{aligned}$$

Round off to f-5.6 and exposure should be the same as if you had used f-8 without the lens extension.

Even if you set the camera so it provides the effective aperture needed by the flash, you may not get correct exposure if the flash is very close to the subject. In general, guide number calculations work OK if the distance between flash and subject is greater than 10 times the maximum dimension of the flash window—width or height if the flash window is rectangular. If flash-to-subject distance is less than that, a guide-number calculation may not give correct exposure. Making exposure tests is one way to solve this problem.

If you are using magnification greater than about 0.15—with the 50mm macro lens on the camera, for example—you should remember that the flash unit is requesting effective aperture, not the actual lens setting.

PRECISION IN EXPOSURE SETTINGS

People often think photography is an exact science. Usually it isn't. One exposure step is a change of 100%. A half-step is sometimes hard to detect in looking at a print. One-third of a step is the smallest amount most people recommend worrying about. Nearly everybody agrees you can forget differences of 20% in light, time or exposure. When making calculations, you may get an answer that isn't an exact control setting on the camera. Usually it makes no difference if you round off to the nearest half-step.

PROBLEMS WITH FLASH

Flash has several kinds of problems. Flash on camera, very close to the axis of the lens can cause "red eye" when using color film. Light rays from the flash enter the subject's eyes and reflect back to the lens from the retina of the eye. The light will be colored red from blood vessels in the eye. To avoid this, pocket cameras come with an extension which raises the flash bulb a few inches above the lens. Most SLR cameras mount a flash high enough to avoid this problem, but it can happen.

To avoid red-eye problems with any camera: Brighten the room to reduce the size of the pupils in your subject's eyes. Ask the subject not to look directly into the lens. Don't mount the flash on the camera—locate it away from the camera and use a flash sync cord.

Flash on camera produces "flat" lighting because it is usually aimed straight at the subject's face, eliminating all shadows. The exception of course is when the flash is used for fill lighting.

When people stand close to a wall while being photographed with flash on camera, there are often sharp shadows of the people visible on the wall behind them.

Mounting a flash on the camera is convenient because it is all one unit, but has those disadvantages.

If the flash connects to the camera with a sync cord, and the cord is long enough, it is preferable to hold the flash high and to one side. This casts shadows similar to those caused by normal overhead lighting and the effect is more realistic. Also, a flash held high tends to move shadows on the wall downward and they may not be visible in close "head shots" of people.

Light from a single flash unit falls off drastically with increasing distance. If you photograph a group of people at different distances from the flash, and make a guide-number calculation for the middle of the group, people nearest the camera will get too

Flash aimed directly into the subject's face produces a harsh, flat lighting effect that is sometimes not pleasing. Bouncing the flash light off a ceiling or wall gives the light some directionality and softens the effect.

much exposure, those in the center will be OK and those in the background will be underexposed.

Using guide numbers to find *f*-stop is a bother, particularly when you are shooting in a hurry.

BOUNCE FLASH

A technique used to avoid flat lighting and harsh shadows from a single flash is to aim it at the ceiling. With a flash detached from the camera, just point it at an angle toward the ceiling so the bounced light will illuminate your subject. Some flash units intended for hot-shoe mounting have a swivel head so the light can be bounced.

This has all the advantages of holding the flash unit high plus the added diffusion of the light from a broad area of the ceiling. If the ceiling is colored, it will also color the reflected light and change colors in a color photograph.

To bounce with non-automatic flash, the distance to use in the guide-number calculation is the distance from flash to ceiling and then from ceiling to subject. With a little practice and a tape measure if necessary, you can learn to estimate this distance fairly well. You must also allow for light absorption by the ceiling which can require opening up one or two steps larger than the guide-num-ber calculation suggests. A flash must be more powerful—meaning make more light—to be used this way, but it is an improved method.

For people who do a lot of flash photography, particularly portraits, it's worthwhile getting equipment so you don't have to depend on a ceiling to diffuse and bounce your flash. One way is portable reflecting umbrellas. These fit on a light stand with the open side of the umbrella pointed toward the subject. A flash unit, usually mounted on the same stand, is pointed *away from* the subject. Light reaching the subject is bounced off the inside of the umbrella and is well diffused. The umbrella acts as a larger source of light and casts softer shadows.

Some umbrellas are translucent, so some of the light goes through the umbrella fabric and bounces around in the room if you are indoors, giving still more diffusion.

OPEN FLASH

A technique that is sometimes useful could be called "open the shutter and then fire the flash," but that long name is shortened to *open flash.*

Most electronic flash units have a pushbutton on the case that will fire the flash whether or not the flash is connected to a camera. However, if the flash is connected to the camera, either mounted in the hot shoe or through a sync cord, the camera will normally fire the flash at the instant the first curtain of the focal plane shutter opens.

To retain control of the flash so you can fire it when you want to, you must disconnect the flash from the camera. Remove it from the hot shoe or disconnect the sync cord.

The basic purpose of the button is to make exposures using the open flash technique: Put the camera on **B**. Open the shutter and hold it open with your finger or a locking cable release. Fire the flash and then close the shutter. If there isn't much light on the scene, exposure will depend primarily on light from the flash.

If it is dark enough, you can hold the shutter open quite a while and use the flash more than once to illuminate different parts of the scene or just to get more light.

You can also use the open flash button to test to be sure the flash is operating or to make the flash operate independent of the camera so an accessory flash meter can be used to measure the amount of light it produces.

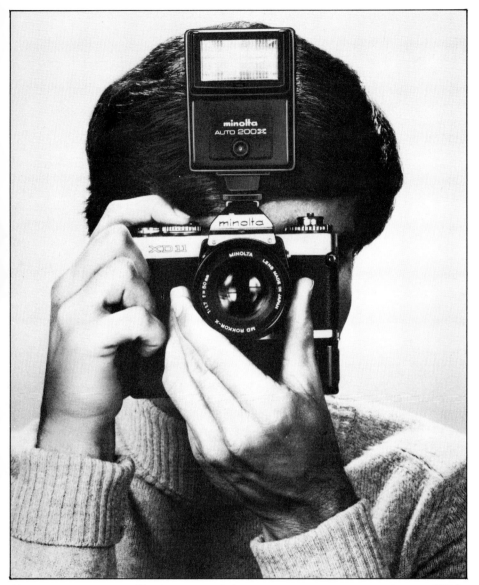

The light sensor in this Minolta *automatic* flash is in the circular opening below "AUTO 200X." It measures light reflected from the scene. When it measures enough light for correct exposure of an average scene, the light sensor turns the flash off.

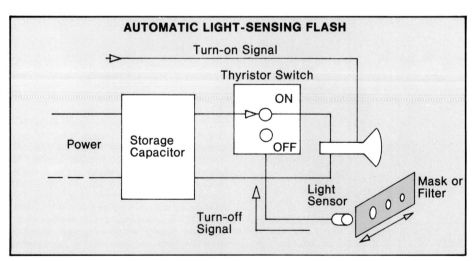

AUTOMATIC LIGHT-SENSING FLASH

Minolta light-sensing automatic flash units are turned on by the X-sync signal from the camera. When the built-in light sensor in the flash has measured enough reflected light from the scene, the flash turns itself off. Film speed and the setting of the Sensor Sensitivity Control determine the required aperture setting on the lens.

AUTOMATIC ELECTRONIC FLASH

Automatic electronic flash units measure the amount of light reflected from the subject and automatically turn off the flash when the desired amount of light has been measured.

Automatic flash units vary the *time duration* of the flash to produce a desired amount of exposure on the film. These flash units eliminate guide-number calculations and are handy for bounce flash. But to use one effectively, you have to understand what it does.

How Light-Sensing Automatic Flash Works—The light-measuring sensor of most automatic flash units is mounted in the housing, so it faces the scene being illuminated by the flash.

A turn-on X-sync signal comes to the flash from the camera. The flash tube is turned on and starts making light. The light sensor measures light reflected from the scene. When it has measured enough light for correct exposure, it turns off the flash.

Specifications for automatic-flash distance ranges, camera *f*-stops and film speeds seem complicated because there are many different combinations of those three variables. The data is usually presented to the user by calculator dials on the automatic flash.

You set film speed into your camera and also into the calculator on the flash. Then the calculator displays an *f*-stop for the camera along with a maximum shooting distance and sometimes a minimum distance. There is always a minimum distance even if not shown on the dials. Check the flash instruction booklet.

If you set the camera lens for the *f*-stop recommended by the calculator, you can shoot automatically anywhere within the specified distance range without changing the *f*-number setting on the lens.

Suppose the distance range shown by the calculator is from 2

to 18 feet, with *f*-4. If the subject is at the maximum distance in that range, the automatic flash will operate as long as it can.

If you move closer, the flash sensor receives more light from the subject and decides that exposure is correct with a shorter time duration of the flash. It turns off sooner.

At the shortest distance, the unit turns on and then turns back off again as fast as possible. The exposure time will be extremely short, such as 1/30,000 second.

Sensor-Sensitivity Control— Some automatic flash units allow you to choose from two or more *f*-stops at the camera so you have some control over depth of field. If the flash allows you to close the lens aperture by one step, then the light sensor must be adjusted so it also receives one step less light from the scene.

Because light into the camera and light into the flash sensor change by equal amounts, the sensor can still judge exposure on behalf of the camera.

The control that adjusts the amount of light received by the flash sensor has not been used before in photography and there is no common name. A reasonable name is *sensor-sensitivity control*, because that's what it does. The switch or slide positions of the sensor control must be identified some way. One way is to use colors.

As an example, if there are two control settings on the flash, we could color one red and the other yellow. The red setting admits more light to the sensor, and works with *f*-4. The yellow setting admits less light and uses *f*-5.6.

A third position, colored green, could be added to use with *f*-8, and the flash would then allow choice of three *f*-stops for each film speed.

A choice of *f*-stops expands the versatility of the flash but complicates display of information on the calculator. These additional *f*-stops don't come free, even though it

seems so at first. Each smaller *f*-stop allowed by the flash calculator dial is accompanied by a shorter maximum working distance of the automatic flash.

Bouncing the Flash—Some automatic flash units have swivel heads to allow bouncing the light off the ceiling. The sensor in the body of the flash does not swivel but continues to look where the camera does—assuming the flash is mounted on the camera. Thus the flash compensates automatically for light loss due to bouncing and will not shut off until the proper amount of light is received by the sensor looking at the scene. Naturally the flash must have enough power to bounce light off the ceiling.

Some automatic flashes are detachable from the camera and have a small detachable light sensor unit which mounts on the camera. This allows you to point the flash in any direction. Mean-

while the sensor continues to look at the scene being photographed and keeps the flash turned on until the film gets enough exposure.

Automatic flash units with a sensor-sensitivity control normally have one control setting to block all light from the sensor. This simply allows the flash to run for maximum time duration at every firing. It puts the automatic flash on non-automatic or manual operation. Then you use it with its guide number just like any other non-auto flash.

This discussion, so far, has indicated that the amount of light reaching the flash sensor is changed by the sensor-sensitivity control. Some flash units control the amount of light by a variable aperture or variable-density filter in front of the sensor. Another method is to control sensitivity electrically in the flash unit. From the user's point of view, it doesn't matter how the control works.

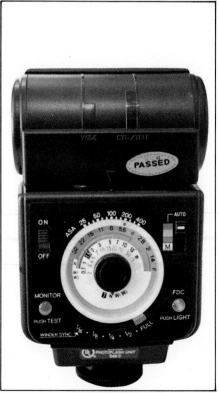

The 320X illuminates the *f*-stop to be used—*f*-4 in this photograph. Monitor light at lower left glows to indicate that the flash is charged and ready to fire. FDC light at lower right glows after each shot to indicate that there was sufficient light for correct exposure of an average scene.

The Auto 320X light sensor is in the rectangular module below the flash window. The flash head can be rotated upward to bounce light off the ceiling. If the flash is mounted in the camera hot shoe, the light sensor views the scene even when the flash head is tipped up to bounce the light. If the 320X is not mounted in the hot shoe, the light sensor module can be removed from the flash and installed in the camera hot shoe. Thus the sensor continues to view the scene, no matter where you point the flash. The light sensor is connected to the flash by a special cable that also carries the X-sync firing signal.

The Auto 132 X flash head can be tipped upward for bounce but the light sensor is not removable. Therefore bounce flash under automatic control is normally done only when the flash is mounted in the camera hot shoe. Bouncing the light with the flash removed from the camera and connected with a sync cord is possible, provided you hold the flash so the sensor views the scene being photographed.

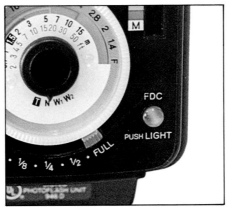

If the light sensor in the flash measures enough reflected light for correct exposure of an average scene, the Flash Distance Check Lamp, labeled FDC, will glow for about two seconds. You can test before making the shot, to see if there will be enough light. Not all Minolta auto flash units have this feature.

MINOLTA FLASH UNITS WITH FLASH DISTANCE CHECK LAMP
320X
320
132X
128

The Flash Distance Check Lamp gives assurance of sufficient light for correct exposure. This is useful for direct flash and even more useful when bouncing the light.

ENERGY-SAVING AUTO FLASH

The first automatic electronic flash units on the market switched off the flash tube to control exposure but did it in such a way that the entire electrical charge was used no matter how short the time duration of the flash. This had the advantage of controlling flash duration but wasted electrical energy.

Recent developments in automatic flash use a thyristor switching circuit which does two things: It shuts off the flash at the desired instant and also turns off current flow so any electrical energy not used to make light is saved for the next flash. The word *thyristor* and the phrases *energy saving* or *series circuit* usually identify this type of flash.

An energy-saving flash unit is preferred because the battery charge lasts longer and makes more flashes. Also, when all of the charge is not used by one flash, recycle time is shorter because only the energy used must be replaced.

FLASH DISTANCE CHECK LAMP

Some Minolta flash units, listed in the accompanying table, have a built-in check system to confirm that the flash-to-subject distance is not too long for correct exposure on automatic. This is always useful and especially so when there is some uncertainty—such as bounce flash when you don't know for sure how much light is being absorbed by the bounce surface.

The flash sensor measures the amount of light reflected from the subject and turns on the Flash Distance Check (FDC) lamp for about two seconds if there was enough light for correct exposure of the film. You can test *before* making the shot by using the open flash button to trigger the flash without taking the picture.

If the FDC lamp glows, there was enough light from the flash and it should be OK to make the shot. If the lamp does not glow, make an appropriate adjustment such as moving the flash closer to the subject.

This check is made each time the flash fires on automatic, so you can verify correct exposure *after* each shot just by looking at the FDC lamp on the back of the flash.

BEAM ANGLE

To conserve light and put most of it where it will be useful in exposing film, electronic flash units produce an approximately rectangular beam to agree with the shape of the 35mm film frame.

When a flash is mounted in the hot shoe, the wide dimension of the beam is in the same direction as the wide dimension of the frame. When you rotate the camera for a vertical-format shot, a hot-shoe-mounted flash rotates also because it is attached to the camera. Bracket-mounted flash units are also attached to the camera. In these cases, the wide dimension of the beam is still oriented in the same direction as the wide dimension of the frame.

If you are using a flash connected to the camera with a sync cord, be sure to hold the flash so its orientation agrees with the camera.

Light from a flash makes an expanding beam which covers a larger area of the scene at greater distances from the camera. When using wide-angle lenses, you should consider whether or not the light from the flash will illuminate all of the scene that will be photographed by the lens. If not, the edges of the photo will be dark.

As you can see in the Flash Specifications table, most Minolta flash units project a light beam wide enough to cover the angle of view of a 35mm lens or any *narrower* lens angle of view without

using any accessories on the flash.

Some Minolta flash units have a clip-on diffuser that fits over the flash window and makes the beam wider. The 320 models have accessory diffusers and also an accessory to make the beam narrower for use with telephoto lenses. These accessories are described with the flash units later in this chapter.

SENSOR ACCEPTANCE ANGLE

The light sensor in an automatic flash looks out at the world through a simple lens with an angle of view that determines how much of the scene the sensor sees. To avoid confusion with beam angle and to emphasize that the sensor *receives* light from the scene, the sensor angle of view is usually called *sensor acceptance angle.*

For most Minolta flash units, this angle is about 20° which is approximately the same as the angle of view of a 135mm camera lens.

EFFECT OF NON-AVERAGE SCENES

The light sensor in an automatic flash controls exposure for the camera. It is designed to work properly on average scenes. It will make the same errors when viewing non-average scenes that the camera meter will, as discussed in Chapter 8.

The flash-sensor metering pattern is not center-weighted, but it may work that way because it measures only the center of the scene. For example, a 50mm lens has an angle of view of about 47° which is more than double the angle of a typical flash sensor. Therefore the flash sensor sees only the center part of the scene that is imaged on film. With lenses having wider angles of view, the effect is more pronounced.

On the other hand, with lenses having focal lengths of 135mm or longer, the flash sensor will see *more* of the scene than the lens does. It can measure light from objects that are outside the angle of view of the lens.

In general, the flash sensor will give too much exposure of a small subject against a dark background in the flash sensor's metering area.

With flash, any *distant* background is a dark background because light from the flash decreases rapidly with increasing distance.

Automatic flash will give too little exposure to a small subject against an unusually light background in the metering area.

If the subject of interest is off-center, the flash sensor will adjust exposure for what it sees in the center of the frame which may underexpose or overexpose the subject, depending on what the sensor is measuring. You can prevent this, of course, by composing so the subject is in the center of the frame or by switching to manual.

MAKING EXPOSURE CORRECTIONS

On automatic, the flash calculator offers you one or more aperture settings which should give good exposure of an average scene or subject. If you think the flash may over- or underexpose for any reason, or if you prefer a different exposure, you can set the lens at a different aperture than the flash "expects" you to.

Typical Exposure Corrections— Best exposure for a particular subject depends on several things, including the photographer's intent. When there is technical or artistic uncertainty, you may wish to bracket with flash, just as you would without flash. Some reasons to make exposure corrections are listed in the table below.

BATTERIES

Most Minolta flash units can operate with ordinary carbon-zinc batteries, alkaline and rechargeable nickel-cadmium batteries.

Carbon-zinc will give the least number of flashes. To use your flash for one occasion and then not use it again for a few months, they are probably the best buy because they will lose charge in a few months anyway.

Alkaline cells provide more flashes and faster recycle time than carbon-zinc. If you use your flash enough to get full benefit from the more expensive alkaline cells, they are a better buy.

Nickel-cadmium (NiCad or Ni-Cd) cells are rechargeable and therefore best for photographers who use flash a lot. In addition, NiCad cells produce a stronger surge of current, so recycle time is normally shorter than with alkaline cells.

Minolta offers NiCad cells and a recharger. Because NiCad cells can produce a strong surge of current, they may damage flash units that are not designed to use them. All current Minolta flash units can use NiCad cells except Auto Electroflash 25 and Electroflash 20.

Whatever kind of batteries you use, remove and store them separately when you will not be using the flash for two weeks or more. Clean the ends with soft cloth or paper before installing.

In cold weather, carbon-zinc and alkaline cells lose power. Keep them as warm as possible and carry a spare set in your pocket if you will be shooting a long time outdoors. These cells usually regain power when warmed up again. Cold weather has less effect on NiCad cells.

Reason For Exposure Correction	Typical Correction In Exposure Steps
Shooting when flash monitor light first turns on	+1/2 to +1
Batteries weak	+1/2 to +1
Small subject against dark or distant background	-1/2 to -1
Small subject against unusually light background	-1/2 to -1
Shooting outdoors	+1/2 to +1

DEDICATED FLASH

Most electronic flash units are designed to mount on the camera in a standard ISO (International Standards Organization) hot shoe of the type used on Minolta cameras. These flash units have an electrical contact in the mounting foot of the flash which makes an electrical connection with a mating contact near the center of the hot shoe. Thus the camera can fire the flash without an external sync cord between them. This type of flash is sometimes called *cordless* to indicate that the flash can be mounted in a hot shoe.

In addition to the center X-sync contact in the flash foot and camera hot shoe, Minolta XD and XG cameras have a second auxiliary contact in the hot shoe which mates with a special second contact on the flash mounting foot of Minolta X-type flash units.

The second pair of contacts allows the flash to control the camera shutter speed automatically and also control an LED in the viewfinder display. Minolta calls the second contact on the flash foot the *Camera-Control Contact*.

Flash units with some special functional relationship with the camera—such as setting shutter speed automatically—are commonly called *dedicated* flashes even though they can work also as ordinary non-dedicated flashes with other cameras.

What the X-type Flash Units Do—When mounted on an XD or XG camera, these flash units can set shutter speed automatically for X-sync, provided you have selected a mode of camera operation in which the shutter is electronically controlled. These modes are: all shutter-speed settings *except* B and O.

The B setting is mechanically operated and is available on all Minolta 35mm SLR cameras.

The O setting—a feature of XD cameras only—is a mechanically produced shutter speed of 1/100 second. The O setting is provided so you can use the camera if the

Minolta X-type flash units are "dedicated" when installed on an X-type camera—XD and XG models—and the controls are set correctly. This requires two electrical contacts in the hot shoe and on the mounting foot of the flash. The center contact is used by the camera to fire the flash. The smaller auxiliary contact is used by the flash to control shutter speed and a flash-ready indicator in the camera.

batteries fail, or even without batteries, although you must determine the correct exposure setting independent of the camera metering system. In providing this "batteryless" shutter speed, Minolta thoughtfully made it 1/100 second so you can use it with electronic flash.

In addition, XD models also have an X setting which is an *electronically* produced 1/100 second speed for X-sync. This is the normal setting of the shutter-speed dial for use with electronic flash, but if you fail to make that setting, an X-type flash unit will make it for you automatically.

What this means is, if you have selected any shutter speed except X, B or O, the flash can automatically switch the camera to the correct shutter speed for X-sync. It will switch the camera to the X-sync shutter speed only when the flash Monitor Light comes on to indicate that the capacitor has sufficient charge to fire the flash.

In addition to turning on the Monitor Light on the back of the flash, X-type flashes also control an LED indicator in XD and XG camera viewfinders to indicate that the flash is ready. The advantage is that you don't have to remove

your eye from the viewfinder to see if the flash is ready. To see the viewfinder flash-ready indication you must turn on the viewfinder display by partially depressing the shutter button of an XD camera or touching the shutter button of an XG camera.

The viewfinder flash-ready indication depends on camera type. In XD cameras, the triangular over-range indicator blinks on and off to show that the flash is ready. In XG cameras, the signal is the LED indicator for a shutter speed of 1/60 second. This blinks on and off to tell you that the flash is ready and shutter speed will be 1/60 second—which is X-sync speed for XG cameras.

When the viewfinder display is used to show when the flash is ready instead of its normal function, the camera metering system does not operate and ambient light from the scene has no effect on the display. The camera "expects" exposure by the flash to be correct.

After you fire the flash, the Monitor Light on the flash goes out and the camera is immediately switched back to normal operation without flash. It measures ambient light from the scene and all camera control settings, including shutter speed, come into operation again.

This means you can take pictures with flash at the X-sync shutter speed when the Monitor Light is on and continue taking pictures during flash recycling, using ambient light and the control settings made on the camera.

Turning the flash unit off is equivalent to removing it from the camera. It will not operate and it will have no effect on camera operation.

MINOLTA ELECTRONIC FLASH UNITS

The accompanying specification table gives basic data about Minolta flash units. The following descriptions cover general information, operating procedures, special features and accessories.

MINOLTA FLASH SPECIFICATIONS										
	320X	320	200X	132X	118X	450	280	128	25	20
Mount	Hot Shoe	Hot Shoe	Hot Shoe	Hot Shoe	Hot Shoe	Bracket	Hot Shoe	Hot Shoe	Hot Shoe	Hot Shoe
Energy Saving	Yes	Yes	Yes	No	No	Yes	Yes	No	No	No
Guide Number Meters at ASA 100 Feet at ASA 25	32 with full power 52 with full power	32 with full power 52 with full power	20 with full power 33 with full power	32 52	18 30	45 74	28 46	28 46	25 41	20 33
Variable Power	Yes	Yes	Yes	No	No	No	No	No	No	No
Auto Working Range Meters Feet	11 to 0.7 36 to 2.3	11 to 0.7 36 to 2.3	7 to 0.7 23 to 2.3	8 to 0.7 26 to 2.3	9 to 0.7 30 to 2.3	16 to 0.5 52 to 1.6	7 to 0.7 23 to 2.3	5 to 0.7 16 to 2.3	4.5 to 0.7 15 to 2.3	Not Automatic
Selectable Apertures on Auto at ASA 100	f-2.8, f-5.6 f-11	f-2.8, f-5.6, f-11	f-2.8, f-5.6	f-4, f-8	f-2, f-4	f-2.8, f-4, f-5.6, f-8, f-11	f-4, f-5.6, f-8, f-11	f-5.6	f-5.6	
Power Sources	4 AA-size, carbon-zinc, alkaline or nicad; plus Power Grip	4 AA-size, carbon-zinc, alkaline or nicad; plus Power Grip	4 AA-size carbon-zinc, alkaline or nicad	4 AA-size alkaline or nicad	2 AA-size carbon-zinc, alkaline or nicad	6 AA-size alkaline or nicad; or 510V battery	4 AA-size alkaline or nicad	4 AA-size carbon-zinc, alkaline or nicad	4 AA-size carbon-zinc or alkaline	2 AA-size carbon-zinc or alkaline
Recycle Time (sec.)	0.2 to 8	0.2 to 8	0.3 to 6	5 or 8	4.5, 7 or 9	0.33 to 23	0.5 to 11	4, 7 or 8	6 or 7	10
Number of Flashes	60 to 1600	60 to 1600	70 to 2200	70 to 160	45 to 200	50 to 2000	70 to 1200	40 to 200	70 to 210	40 to 170
Angle of Coverage	35mm	35mm	35mm	35mm	35mm	50mm	35mm	35mm	35mm	35mm
With wide-angle Diffuser	28mm, 24mm	28mm, 24mm	28mm	28mm, 24mm	28mm	24mm		28mm	35mm	35mm
Automatic Bounce Flash	Yes	Yes	No	Yes	No	Yes, with separate sensor	Yes	Yes	No	No
Sets X-Camera Shutter Speed	Yes	No	Yes	Yes	Yes	No	No	No	No	No
Flash Distance Check	Yes	Yes	No	Yes	No	No	No	Yes	No	No
Socket for PC Cord	Yes	Yes	No	Yes	No	Yes	No	Yes	Yes	No
Width, mm (in.)	76 (3)	63 (3)	56 (2.2)	65 (2.6)	61 (2.4)	98 (3.9)	72 (2.8)	65 (2.6)	55 (2.2)	32 (1.3)
Depth, mm (in.)	85 (3.3)	85 (3.3)	70 (2.8)	65 (2.6)	47 (1.9)	103 (4.1)	54 (2.1)	65 (2.6)	61 (2.4)	65 (2.6)
Height, mm (in.)	123 (4.8)	123 (4.8)	90 (3.6)	119 (4.7)	84 (3.3)	230 (9.1)	153 (6.0)	119 (4.7)	105 (4.1)	65 (2.6)
Weight without batteries, g oz.	380 13.4	380 13.4	210 7.4	235 8.3	130 4.6	780 27.5	135 11.5	220 7.8	155 5.5	90 3.2
Optional Accessories	Remote Sensor Adapter; Panel Set; Wide-Angle Diffuser; Tele Adapter; Nicad Batteries; Nicad Battery Charger; Power Grip.	Same as 320X	Nicad Batteries; Nicad Battery Charger.	Color Filter Set; Wide-Angle Diffuser for 24mm lens; Nicad Battery Charger.	Wide-Angle Diffuser for 28mm lens; Nicad Batteries, Nicad Battery Charger.	Separate Sensor with Sensor Sync Cords; Nicad Battery Cartridge and Charger; 510V Battery Pack	Nicad Batteries Nicad Battery Charger.	Color Filter Set; Wide-Angle Diffuser for 24mm lens; Nicad Batteries; Nicad Battery Charger		

This table compares the main operating features and specs of Minolta electronic flash units. Additional specs for the 320X are included in the description of that unit.

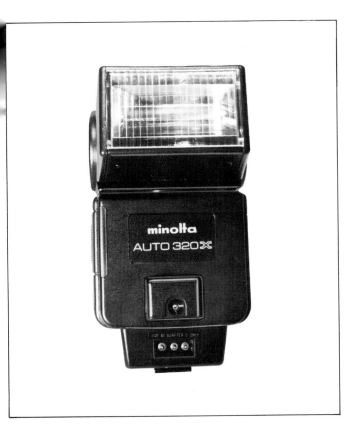

AUTO ELECTROFLASH 320X

This sophisticated shoe-mount flash has wide range of accessories. It is automatic or manual, with a flash head that tilts and swivels for bounce flash. It can control shutter speed in XD and XG cameras and also controls a viewfinder LED flash-ready indicator. Guide number is 32 meters with ASA 100 film.

When the flash is charged, the monitor lamp turns on and camera viewfinder LED signals flash-ready. At the same instant, shutter speed is electronically switched to X-sync speed unless the shutter-speed dial is set to X, B, or O. If set to X, it is not necessary for the flash to select X-sync shutter speed because that's what the X setting on XD cameras does. Electronic flash can be used on O which is a mechanical X-sync shutter speed and on B.

When the flash monitor lamp is not on, the camera reverts to normal operation without flash. Turning the flash off is equivalent to disconnecting it from the camera. It will not fire and has no effect on operation.

Power—Derived from a set of four AA-size batteries which are inserted into the battery chamber, or from household AC power.

To use AC power, plug AC Adapter 3 into the wall outlet and plug the other end of the three-meter-long cord from Adapter 3 into the External Power Receptacle on the lower front of the flash unit. AC Adapter 3 can be purchased for a nominal 115 volts.

Remote Sensor—This plug-in module normally fits into a receptacle on the front of the flash unit and looks straight ahead. When mounted in the hot shoe, the flash head can be tilted upward for bounce flash while the sensor continues to measure light directly from the scene.

When the flash is removed from the camera, the sensor module can be unplugged from the flash and mounted on the camera using the Remote Sensor Adapter with its attached cable. The Remote Sensor Adapter mounts in the camera hot shoe. The flash sensor module plugs into the adapter so it sits above the hot shoe and views the scene being photographed.

The cable from the Remote Sensor Adapter plugs into the front of the flash unit, where the sensor itself is normally mounted. The cable carries all necessary electrical signals between camera and flash. Two electrical contacts on the bottom of the adapter make both of the normal connections between a 320X flash and the camera body so no operating features are lost when the Remote Sensor Adapter is used. X-sync from the camera fires the flash. The flash can control both shutter speed and a flash-ready LED in the viewfinder of XD and XG cameras just the same as when the flash is mounted directly in the hot shoe.

This allows automatic bounce flash or other special uses where the flash is pointed in any direction you choose while the sensor continues to measure light from the scene being photographed.

Sync Terminal—Still another way to interconnect camera and flash is to use a conventional sync cord between the sync terminal on the camera body and the sync socket on the flash.

153

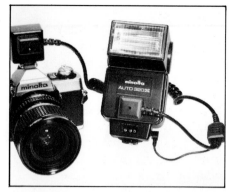

To use the Removable Sensor Module separated from the 320X flash, first unplug the module. Install the Remote Sensor Adapter in the camera hot shoe and then plug the sensor module into the Remote Sensor Adapter. Connect the cable from the Remote Sensor Adapter to the flash. This cable has two connectors at the flash end and serves two purposes. One connector plugs into sync socket on the flash and allows the camera to fire the flash with an X-sync signal when you depress the shutter button. The other connector plugs into the socket normally used by the sensor module and allows the sensor to turn off the flash when enough light has been measured.

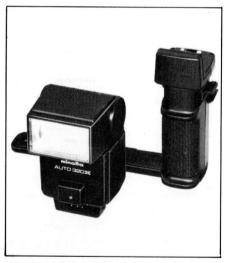

When the 320X flash is installed in Power Grip 1, the flash must be connected to the camera with the Remote Sensor Adapter Cable or a standard sync cord.

AUTO ELECTROFLASH 320X SPECIFICATIONS

Type	Automatic or manual flash with Variable GN/Power Control in both modes. Energy-saving, removable sensor, movable flash head for bounce. Can set XD and XG shutter speed automatically and operate flash-ready indicator in camera viewfinder.

Guide Number: Meters at ASA 100 (Feet at ASA 25)

Panel-compensation scale setting	VARIABLE GUIDE-NUMBER/POWER-CONTROL SETTING				
	FULL	1/2	1/4	1/8	1/16
N	32 (52)	22 (36)	16 (26)	11 (18)	8 (13)
W1	22 (36)	16 (26)	11 (18)	8 (13)	5.6 (9)
W2	16 (26)	11 (18)	8 (13)	5.6 (9)	4 (6.5)
T	45 (74)	32 (52)	22 (36)	16 (26)	11 (18)

Aperture Settings and Distance Ranges on Automatic

Auto mode	ASA Setting						Distance Range		
	25	50	100	200	400	Normal	W1	W2	T
Red	f1.4	2	2.8	4	5.6	1—11m (3.3—36ft.)	0.7—8m (2.3—26ft.)	0.7—5.6m (2.3—19ft.)	1.5—16m (4.9—52.5ft.)
Yel	f2.8	4	5.6	8	11	0.7—5.6m (2.3—19ft.)	0.7—4m (3.2—13ft.)	0.7—2.8m (2.3—9.5ft.)	1.5—8m (4.9—26ft.)
Grn	f5.6	8	11	16	22	0.7—2.8m (2.3—9.5ft.)	0.7—2m (2.3—6.6ft.)	0.7—1.4m (2.3—4.9ft.)	1.5—4m (4.9—13ft.)

Flash Duration:	Approx. 1/20,000 to 1/1000 sec. in auto operation, approx. 1/1000 sec. in manual (non-automatic) operation with variable GN/power control set at "FULL"
Color Temperature:	Balanced for daylight-type color film
Power Sources:	Four self-contained 1.5v AA-size alkaline-manganese, or nickel-cadmium batteries; optional Power Grip 1, and AC Adapter-3
Sensor Angle of Acceptance:	Approx. 15°
Flash Coverage:	For lenses down to 35mm focal length on full-frame 35mm cameras, down to 28mm with wideangle diffuser panel included, down to 24mm with optional W2 wideangle diffuser, and over 100mm with optional telephoto concentrator panel T

Number of Flashes:

Variable GN/-power setting	AUTO		MANUAL			
	Flash Battery		Flash Battery		Grip 1 with Flash Battery	
	A/M	Ni-Cd	A/M	Ni-Cd	A/M	Ni-Cd
FULL	160—1600	60-450	160	60	210	140
1/2	420—1600	150—450	420	150	530	240
1/4	700—1600	200—450	700	200	800	400
1/8	1000—1600	240—450	1000	240	1100	500
1/16	1250—1600	340—450	1250	340	1400	640

Recycle Times: (seconds) with fresh batteries

Variable GN/-power setting	AUTO		MANUAL			
	Flash Battery		Flash Battery		Grip 1 with Flash Battery	
	A/M	Ni-Cd	A/M	Ni-Cd	A/M	Ni-Cd
FULL	0.2—8	0.2—5	8	5	1.6	1.2
1/2	0.2—4.5	0.2—3	4.5	3	1.2	1.0
1/4	0.2—3	0.2—1.5	3	1.5	1.0	0.8
1/8	0.2—1.5	0.2—0.8	1.5	0.8	0.5	0.5
1/16	0.2—0.8	0.2—0.4	0.8	0.4	0.2	0.2

Flash-Head Movement:	90° upward from horizontal, with click stops at 50°, 65°, and both extremes; 90° to either side from straight ahead with click-stops at 30°, 45°, 60°, 75°, and 90°.
Sync Contacts:	Direct contact for hot shoe, socket for attaching separate sync cord provided. Hot-shoe contacts automatically disconnected by inserting sync cord.
Dimensions:	Approx. 76mm x 85mm x 123mm (3 in. x 3-5/16 in. x 4-13/16 in.) overall with flash head forward.
Weight:	380g (13-3/8 oz.) without batteries.

With this setup, the camera fires the flash but the flash *cannot* control shutter speed or the flash-ready indicator in XD or XG cameras. Set the camera to X-sync manually and observe the monitor lamp on the flash to see when it can be fired.

Power Grip 1—When the flash is not mounted in the hot shoe, you can hold it in your hand, improvise a mount, have an assistant hold it, or use Power Grip 1 to mount both camera and flash. The Power Grip has a mounting shoe on top to accept the flash mounting foot but this is not a hot shoe. You must use the Remote Sensor Adapter cable or a standard sync cord to interconnect camera and flash. You can place the grip and flash on either side of the camera, as you choose.

Packaged with Power Grip 1 is a cable release that can be attached to either side of the grip. This allows you to hold the grip in either hand and operate the shutter with the same hand.

The grip contains a set of rechargeable NiCad batteries and is supplied with Recharger QC-1 which can recharge the battery pack in about one hour. When the flash is mounted on the grip, an electrical connection is made auto-

matically between the NiCad batteries in the grip and the External Power Receptacle on the flash unit.

The battery in the power grip gives more flashes from one charge than the batteries in the flash head. Also, recycle time is shorter as you can see in the specifications table.

Automatic Ranges—The 320X has three automatic ranges, each requiring a different aperture setting on the lens. The desired automatic range, or manual operation, is chosen by moving the Mode Selector on the back of the unit.

Automatic ranges are indicated by three colors. Manual is indicated by the symbol **M**. At ASA 100, with full power, the three automatic operating ranges and f-stops are shown in the accompanying table.

By moving the Mode Selector away from **M** to one of the three colors, you select both operating distance range and required lens aperture. These are shown on the flash calculator.

The required f-number is illuminated on the flash calculator dial and you must then make that setting on the lens.

Operating range is indicated by a colored band extending from maximum to minimum operating distance on the distance scale of the calculator. Read the band with the same color as set on the Mode Selector.

Operating ranges do not change when you change film speeds. For example, at the red setting it is always 1 to 11 meters.

Aperture setting does change when you change film speed. For example, at ASA 100 on the red setting, the required aperture is f-2.8. At ASA 400, the required aperture is f-5.6 for the same distance range.

Two other factors may affect operating ranges: the Variable Power Control and the accessory Panel Set. These are discussed in the following two sections.

Panel Set and Adapter—This is a set of color filters, beam wideners and a beam-narrowing accessory, along with an adapter to mount them on the 320X flash.

These accessories are flat, rectangular panels. The adapter fits on the front of the flash head to mount one or two of the panels which fit into slots in the side of the adapter. When mounted in the adapter, the panels cover the flash window.

Beam-Angle Panels—Three of the panels alter the beam angle. Without a panel, the beam covers the angle of view of 35mm lenses. Panel W1 widens the beam for use with 28mm lenses. Panel W2 widens the beam still more so you can use 24 mm lenses. Panel T *narrows* the beam for use with telephoto lenses of 100mm or longer.

Because beam-widening panels put less light on any part of the scene, they have the effect of reducing the amount of light from the flash and therefore reducing the maximum range.

The telephoto attachment makes the beam more narrow with an increase in range.

When a panel is in use, the operating range on the flash calculator is changed—provided you set the special Panel Compensating Scale on the flash calculator dial when you install the panel. This scale is set by using two raised projections on the face of the calculator.

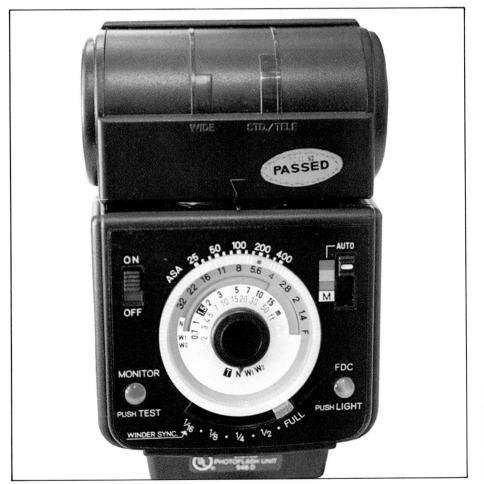

Operating ranges on the 320X calculator are shown by bands whose colors match settings of the Mode Selector.

320X AUTOMATIC SETTINGS			
	RANGE		
Color	Meters	Feet	Aperture
Red	1 to 11	3.3 to 36	f-2.8
Yellow	0.7 to 5.6	2.3 to 19	f-5.6
Green	0.7 to 2.8	2.3 to 9.5	f-11

There are four settings on the Panel Compensating Scale: N is normal, meaning no panel is in use. W1, W2 and T indicate settings for those panels.

For example, with no panel in use and the control set to N, the distance range may be 11 meters. If you install W1 panel and set the control to W1, maximum distance becomes 8 meters. With W2, maximum distance becomes 5.6 meters. If you install the telephoto panel and set the control to T, maximum distance becomes 16 meters.

Expressed in exposure steps, the panels have these effects:

Panel	Exposure Steps
T	+1
W1	-1
W2	-2

Minimum range is also affected. At the N setting of the Panel Compensating Scale, with no panel in use, minimum automatic operating range is indicated by the ends of the three colored bands, read against the distance scale. Minimum distance for panels W1 and W2 is indicated by the symbols W1 and W2 which are inserted into the color bands at shorter distances. Minimum distance when using the T panel is 1.5 meters.

Filter Panels—The Panel Set also includes a set of six color panels. Two are standard filters—an ND2X, and an 85B which changes the color of the flash to match the color balance of tungsten Type B film.

The others are red, yellow, blue, and green—used for special effects. The filter panels also change the amount of light from the flash but compensation is made by using larger lens aperture settings than the flash calculator dial suggests.

All filter panels except yellow require one step larger aperture. Yellow requires no compensation.

Even though you can compensate for the ND2X filter by opening the lens one step, it makes no sense to install the filter and then cancel its effect by opening the lens. The ND2X is intended for use on manual operation to reduce the flash-to-subject distance or to reduce the amount of flash fill.

If you have the flash set for a certain subject distance, installing the ND2X panel reduces operating distance to 70% of what it was without the panel. It reduces the amount of light by one step.

If you use two filter panels, make a separate adjustment for each. If you use one of each type, put the panel that affects beam width in the front slot of the adapter and put the filter panel in the second slot, closer to the flash.

Variable Power Control—On the back of the flash is a Variable Power Control which is unusual in that it works both on manual and automatic operation of the flash. Because the control changes the light output of the flash, it changes the flash guide number and minimum operating distance.

Therefore, its official full name is Variable Guide Number/Power Control. Control range is from full power down to 1/16 power, with a total of nine settings.

Power is reduced by reducing the amount of time the flash makes light. At full power on manual operation, the time duration of the flash is 1/1000 second. At 1/16 power, flash duration is approximately 1/20,000 second.

On automatic operation, the power control establishes the *maximum* time duration of the flash. Then the light-sensing automatic system in the flash itself takes over and controls flash duration within the established maximum.

Using the Variable Power Control on Manual—The ability to set a maximum duration of the flash is is very useful on manual. With this control, you can reduce output power in calibrated steps. The control is mechanically linked to the flash calculator so correct aperture is indicated for each power setting.

What you may be concerned about is too much depth of field and therefore you may prefer not to use the small aperture necessary with full power. The power control allows you to reduce the amount of light by four exposure steps, with half-step settings in between.

After you have focused and determined distance to the subject, use the calculator to read aperture for that distance, at full power. If you don't want to use an aperture that small, reduce power by moving the power control. As you do that, the distance scale on the calculator rotates to place the subject distance opposite larger apertures.

Example: With ASA 64 film and full power, the calculator shows *f*-8 for a subject distance of 10 feet. Move the power control from FULL to 1/2. The distance scale rotates so 10 feet is now opposite *f*-5.6. You can shoot at *f*-8 with full power or *f*-5.6 with half power. By using the full range of the power control, you can select aperture sizes in full steps and half steps from *f*-8 to *f*-2.

With a different film speed or a different subject distance, the aperture sizes you can use will change but the range is always four steps unless the calculator calls for aperture settings you cannot make, such as *f*-1 or *f*-64.

Another use of the power control on manual is to change recycle time. At full power, the flash will be heavily discharged by each flash and therefore recycle time will be maximum. If you use less flash power, recycle time is shorter but of course you must use larger aperture to get correct exposure.

Fill Flash Procedure—With the flash set for manual operation, the power control is a very handy way to control light output of the 320X for use as fill flash with any other light source.

Use the sync cord supplied with the flash to connect flash to the sync terminal on the camera body. This disables the electrical contacts in the flash mounting foot even if the flash is installed in the camera hot shoe. Therefore you must set

shutter speed manually, using the shutter-speed dial. This also allows the camera meter to work normally so you can measure exposure from a continuous light source.

Set the camera for X-sync shutter speed and set aperture for full exposure with the main light source. Focus and note subject distance. Then move the power control to set that subject distance on the calculator dial opposite the aperture size you intend to use. This setting puts as much light on the subject from the flash as from the main light source—a lighting ratio of 1 to 1.

If you shoot at this setting, bracket exposures downward a half step and a full step by changing aperture because the first setup may overexpose slightly.

Usually you don't want a lighting ratio of 1 to 1 because there are no shadows. To restore shadows, reduce power using the power control. For a lighting ratio of 2 to 1, move the control to select 1/2 power. Leave the aperture set for full exposure with the main light source.

Using the Variable Power Control on Automatic—When the flash is on automatic, the power control sets maximum flash duration. Use it to assure adequate light for the subject distance and to minimize the effect of background beyond that subject distance.

Begin with the power control set to FULL. Choose one of the three automatic operating modes. Notice the aperture indicated by the flash calculator and set that aperture on the lens. Notice distance to the subject. Then move the power control to set that subject distance on the calculator dial opposite the aperture size you have set on the lens.

This setting limits the maximum working distance of the flash to agree with the subject distance. Therefore the flash unit can't "work longer", trying to illuminate a dark or distant background which could result in overexposure of the subject.

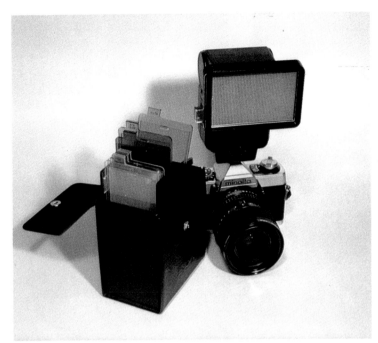
The Panel Set and Adapter gives the 320X flash more versatility.

Changing the power-control setting is not mandatory—it is merely an added feature. If you shoot on automatic at full power, the light-sensing system will work in the normal way to turn off the flash when the flash sensor measures enough light to produce correct exposure of an average scene.

The flash sensor combines light returned from the subject with light reflected from the background. If the background is a middle tone and not far behind the subject, this works fine. Most automatic electronic flashes work this way, including all other Minolta flash units. With a background that is unusually light or dark, or distant, consider using the power control of the 320X to limit the working range and eliminate the effect of background.

Repeating Flash with Auto Winders—Still another use of the power control is to make a sequence of flashes in synchronism with a film winder. This works with the flash set for manual or automatic, as you choose.

Minolta Auto Winders for XD or XG cameras can expose film in a continuous sequence at up to two frames per second. The problem is to get the flash recycled fast enough so it is ready in time for the next frame.

Because recycle time is determined by the amount of power used to make the flash, you can control recycle time by using the power control on the 320X.

To recycle fast enough for two frames per second, use 1/16 power. This setting on the power control is labeled 1/16 and also WINDER SYNC, for that reason.

When using 1/16 power so the flash can keep up with the winder, you must arrange film speed, aperture size and subject distance so the film will be properly exposed with that amount of light output from the flash. The flash calcuator dials will help you solve this problem. Set the power control to 1/16 and consult the calculator.

When using the 320X as a repeating flash, use only fully charged NiCad batteries of the type furnished by Minolta. These will provide about 40 flashes at two per second before the batteries can no longer recycle the flash unit in time for the next exposure. With Power Grip 1

When the beam of the flash covers the scene being photographed, relatively even illumination results. This is the case when the beam angle of the flash is equal to or larger than the angle of view of the lens. Wide-angle lenses may have angles of view that are larger than the beam angle of the flash which results in dark corners in the image. Minolta offers wideangle diffusers for some flash models to solve the problem. The wideangle diffuser clips over the flash window and widens the beam of light.

installed and also powering the flash, sequential flashes up to five per second are possible.

Open Flash and Test Button— The Monitor Light glows when the flash has recharged and is ready to fire. It is also labeled PUSH TEST—push it in to fire the flash independent of the camera.

This feature is used for open flash, to test the flash to see if it is operating, or to test with the FDC light before making the actual exposure on film.

To test without making an exposure on film, first be sure the flash and camera are set correctly for the exposure you plan to make. Then depress the PUSH TEST button. The flash will fire, but the camera will not operate. Watch the FDC to see if it measured enough light.

Flash Distance Check—Another useful feature of the 320X flash is a built-in system to tell you if there was enough light from the flash for correct exposure of the film. If not, the simplest correction you can usually make is to move closer.

Therefore this feature is called

the Flash Distance Check (FDC). It works only in the automatic modes and gives an indication every time the flash is fired.

The indicator is a green light on the back panel of the flash, labeled FDC. After each automatic flash, the light will be illuminated for about two seconds, if the flash sensor measured enough light for correct exposure. Test to see if exposure is OK.

If so, wait for the flash unit to recharge and make the exposure on film. If not, make a correction and test again. Using the test feature with the FDC light is generally useful, and particularly so with bounce flash.

When using open flash with the camera shutter-speed dial set to B, the camera will fire the flash as soon as the first shutter curtain opens. To avoid this, remove the flash from the hot shoe and fire it when you wish, using the PUSH TEST button.

Bounce Flash—This is best done with the flash on automatic, using the test button and FDC light to confirm correct exposure before making the shot. Usually a white

or neutral bounce surface is best.

The FDC system can be fooled by unusually light or dark or distant background or by a subject off center against a light, dark or distant background.

To set up, use the largest aperture permitted by the flash calculator with the Mode Selector on the red setting. If there is plenty of light, you can try smaller apertures.

Because the reflecting surface absorbs a large amount of light and the light must travel farther to the subject, assume that the maximum *direct* subject distance you can use is about half of the maximum operating range indicated on the flash calculator dial.

Check exposure using the test button and the FDC light. Make adjustments as needed.

The flash head tilts upward and swivels from side to side. Four detents on the tilt axis hold the flash pointing straight ahead, straight up, or at two intermediate positions. One, marked WIDE, is an approximate setting for bounce flash off the ceiling using lenses from 24mm up to 35mm. The other setting, marked STD./TELE is for bounce flash with lenses of 45mm or longer focal length. These settings are approximate. Results depend on ceiling height and subject distance.

The flash head also rotates horizontally with detents at 0°, 30°, 45°, 60°, 75°, and 90°.

Dial Illumination—The FDC light is also a push-button. Push it in to illuminate the calculator dials. This uses flash battery power, so use it only when necessary.

AUTO ELECTROFLASH 320

This model is identical to the 320X except that the "X" features are not included. The 320 does not set shutter speed or control an LED in the viewfiender. This model is primarily intended for people who want the features of the 320X flash but do not intend to use the flash on an XD or XG camera.

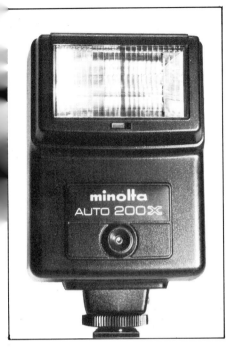
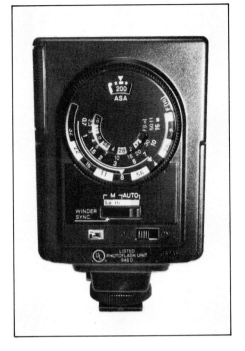

AUTO ELECTROFLASH 200X

This model is shoe-mount only with no provision for bounce flash and no sync cord socket. Sync must be derived directly from the camera hot shoe. It has two automatic settings, two manual settings, and a guide number of 20 meters with ASA 100 film.

When the flash is charged, its monitor light turns on and a viewfinder LED of an XD or XG camera also signals flash-ready. When the monitor light is on, XD or XG cameras are electronically switched to X-sync shutter speed unless the shutter-speed dial is set to B, or O. If the dial is set to X, the camera shutter speed is already set to X-sync, so switching by the flash is not necessary. B and O are mechanical speeds which cannot be controlled electronically. O is an X-sync speed.

When the flash monitor light is not on, the camera reverts to normal operation without flash. Turning the flash off is equivalent to removing the flash from the hot shoe. It will not fire and it has no effect on camera operation. Operating power is derived from a set of four AA-size batteries which are inserted into the battery chamber of the flash.

Automatic Ranges—The Mode Selector selects automatic or manual operation. Two auto settings, colored red and yellow, each require a specific aperture setting, depending on the film speed.

Operating range is indicated by a colored band along the distance scale of the calculator—one red and the other yellow. The required aperture setting is indicated by an arrow at the end of each colored band. If you have selected the red auto mode, refer to the red band. For the yellow auto mode, refer to the yellow band. If you change film speed, the required aperture changes but the operating distance range does not.

With ASA 100 film, the red-mode operating range is 1 to 7 meters; 0.7 to 3.5 meters in the yellow mode.

Manual Ranges—On manual, the Mode Selector offers two power settings. Hi provides maximum power with a flash duration of 1/1000 second. Lo provides reduced power with a duration of 1/6000 second.

At Lo, the 200X will make a sequence of flashes at up to two per second, in synchronism with an auto winder. With fully charged Minolta NiCad cells, the flash will make about 40 flashes at two per second.

Guide number at ASA 100 is 20 meters at full power or 7 meters at low power. Therefore the required aperture is also different. You can calculate aperture using the guide number or you can refer to the flash calculator. There are two aperture scales—F(Hi) and F(Lo). Use the one that agrees with the mode-selector setting.

Example: With ASA 200 film and a subject distance of 5 meters, the Hi power setting requires f-5.6. Lo uses f-2—a difference of three exposure steps. The ASA 200 guide number on Hi is 28 meters; on Lo it is 10 meters.

Beam Width—Beam width normally covers the angle of view of a 35mm lens. A Wideangle Diffuser supplied with the 200X snaps over the flash window to cover the angle of view of a 28mm lens.

The diffuser decreases light on the subject by one half—one exposure step. On automatic, this reduces maximum operating range to 70% of that shown on the calculator dial. On manual, compensate by opening the lens aperture one step.

Open Flash—A small red pushbutton near the flash mounting foot can be used to test the flash or trigger it independent of the camera for open flash.

When set to B, the camera will fire the flash as soon as the first shutter curtain opens, if the flash is mounted in the hot shoe. If you don't want that to happen, remove the flash from the hot shoe but continue to point it directly at the scene. Operate the flash with the Open Flash Button.

AUTO ELECTROFLASH 132X

This flash has two automatic ranges and one manual setting. The flash head tilts upward for automatic bounce flash. Guide number is 32 meters at ASA 100. Both a sync contact and a camera-control contact are on the flash mounting foot so the 132X works as a dedicated flash with XD or XG cameras. When the flash is charged, the Monitor Light on the back of the unit turns on and an LED in the viewfinder of an XD or XG camera also signals flash-ready. When the monitor light is on, XD or XG cameras are electronically switched to X-sync shutter speed unless the shutter-speed dial is set to B or O. If the dial is set to X, the camera is already set to X-sync shutter speed, so switching by the flash is not necessary.

When the flash monitor light is not on, shutter-speed reverts to normal operation without flash. Turning the flash unit off is equivalent to removing it from the hot shoe. It will not fire and it has no effect on camera operation.

An alternate way to connect the 132X flash to a camera is by a sync cord inserted in the sync socket on the flash. A short sync cord is supplied with the flash. When so connected, all "X" functions of the flash are disabled. It no longer controls shutter speed or the LED flash-ready indicator in XD or XG cameras.

Operating power is derived from four AA-size batteries inserted into the battery chamber.

Automatic Ranges—The Mode Selector selects manual operation or two auto settings, colored red and yellow. Each requires a specific aperture setting, depending on the film speed.

Automatic operating ranges are indicated by two colored bands along the distance scale of the flash calculator—one red and the other yellow. Required aperture is indicated by an arrow at the end of the appropriately colored band and also by a red LED lamp which

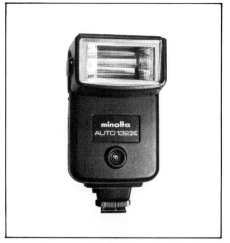

Auto Electroflash 132X has special operating features when used with a Minolta X-type camera.

illuminates the *f*-number on the dial.

If you change film speed, the required aperture size changes but the operating distance range does not. Operating range is 0.7 to 8 meters on red auto or 0.7 to 4 meters on yellow.

Manual—The manual setting is labeled M. At ASA 100, the guide number is 32 meters. You can calculate aperture using the guide number or refer to the calculator.

Open Flash—A small red pushbutton near the flash mounting foot can be used to test the flash or trigger it independent of the camera for open flash.

When set to B, the camera will fire the flash as soon as the first shutter curtain opens, if the flash is mounted in the hot shoe. If you don't want that to happen, remove the flash from the hot shoe and operate it with the Open Flash Button.

Removing the flash from the hot shoe disables the "X" features so it no longer controls shutter speed or operates the viewfinder flash-ready signal. Be sure the camera shutter speed is set correctly for X-sync.

Flash Distance Check—After each flash in either of the two auto modes, a green Flash Distance Check (FDC) light will glow for about two seconds, if the flash sensor measured enough light for correct exposure. The FDC

An accessory Color filter Set is available to change the color of the light from the flash.

system can be fooled by unusually light, dark or distant backgrounds or a subject off-center against a light, dark or distant background.

Beam Width—Beam width normally covers the angle of view of a 35mm lens. A Wideangle Diffuser supplied with the flash snaps over the flash window to cover the angle of view of a 28mm lens. An accessory W2 diffuser increases beam angle to cover the angle of view of a 24mm lens.

When using either of these diffusers on automatic, maximum operating distance is decreased as shown by small gaps in the two colored bands which indicate operating range. With the 28mm diffuser, maximum distance is indicated by the gap nearest the arrow at the end of the bands. With the 24mm diffuser, it's the second gap from the arrow. Read maximum operating distance on the distance scale opposite the appropriate gap.

When using either diffuser on manual, correct by opening lens aperture. With the 28mm diffuser, open one step. With the 24mm diffuser, open 1.5 steps.

Bounce Flash—This is best done with the flash on automatic. The reflecting surface should be a light tone so it doesn't absorb too much light. With color film, the reflecting surface should be a neutral color or white. To set up, use the largest aperture permitted by the

calculator with the Mode Selector on the red setting. If there is plenty of light, you can try smaller aperture on the yellow setting. Check exposure using the Open Flash Button and the FDC light, before making the shot.

The flash head tilts upward for bounce flash. Detents hold the head pointing straight ahead, straight up, or at two intermediate positions. WIDE, is an approximate setting for lenses with focal lengths from 24mm up to 35mm; STD./TELE is for lenses of 45mm or longer focal length. These settings are approximate. Results depend on ceiling height and subject distance.

Color Filter Set—An accessory set of color filter panels is available. These snap over the flash window. Colors are red, yellow, green, blue and an 85B filter to convert light from the flash for natural color with Type B tungsten film.

In addition, there are 2X and 4X neutral-density panels which can be used alone or in combination with any of the colored panels.

Exposure compensation for the color filters is +1 step except for the yellow panel which requires no compensation. When needed, compensation can be made by opening aperture one step more than the calculator indicates. If not compensated, maximum operating range will be reduced. You can use the FDC lamp to verify working distance.

AUTO ELECTROFLASH 128

This flash is identical to the 132X except for the following differences: Guide number is 28 meters with ASA 100 film. There is only one automatic mode of operation. Required lens aperture is indicated by an arrow on the calculator, at the end of the yellow band that shows operating range. It is not also indicated by illumination from behind. The 128 flash has no "X" features—it does not control shutter speed or a viewfinder flash-ready indicator on XD or XG cameras.

The 118X flash is scaled down in size to match the Minolta 110 Zoom SLR Mark II. It can also be used on any other camera with a standard hot shoe and has the special "X" features when used on a Minolta 35mm X camera.

AUTO ELECTROFLASH 118X

This flash is shoe-mount only with no provision for bounce flash and no sync-cord socket. Sync must be derived directly from the hot shoe. It is very compact, intended for the 110 Zoom SLR Mark II or any of the 35mm SLRs.

It has two automatic settings and one manual setting with a guide number of 18 at ASA 100. As implied by the symbol X in the nomenclature, this flash has special features when used with XD or XG cameras.

When the flash is charged, the monitor light turns on and a viewfinder LED in an XD or XG camera also signals flash-ready. When the monitor light is on, shutter speed of XD or XG cameras is electronically switched to X-sync speed unless the shutter-speed dial is set to B, or O. If the dial is set to X, the camera is already set to X-sync shutter speed, so switching by the flash is not necessary. B and O are mechanical speeds which cannot be controlled electronically. O is a mechanical X-sync shutter speed.

When the monitor light is not on, the camera reverts to normal operation without flash. Turning the flash off is equivalent to removing the flash from the hot shoe. It will not fire and it has no effect on camera operation.

Operating power is derived from two AA-size batteries inserted into the battery chamber.

Automatic Ranges—The Mode Selector selects automatic or manual. There are two auto settings, red and yellow. Each requires a specific aperture, depending on film speed.

Operating ranges are indicated in red and yellow on the calculator. With ASA 100 film, required apertures are f-2 and f-4. The respective operating ranges are 1 to 9 meters and 0.7 to 4.5 meters.

Beam Width—The beam covers the angle of view of a 35mm lens. No beam-widening accessories are available.

Open Flash—An Open Flash Button is provided to make one or more flashes with the shutter held open or to test the flash to see if it is operating.

When used with the camera shutter-speed dial set to B, the camera will fire the flash as soon as the first shutter curtain is fully open if the flash is mounted in the camera hot shoe.

Electroflash 20 is manual only, very small and easy to carry.

The Auto Electroflash 25 is simple and compact. It has one auto setting and one manual setting. It is not an energy-saving flash.

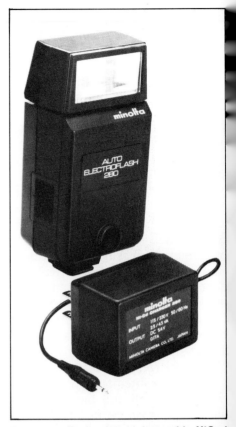

If you use flash a lot, rechargeable NiCad batteries are convenient and economical. NiCad batteries and a recharger are optional accessories for Auto Electroflash 280.

AUTO ELECTROFLASH 280

This medium-power flash has bounce capability when mounted in the camera hot shoe; four automatic ranges plus manual with a guide number of 28 meters at ASA 100. The flash can be connected to the camera with a sync cord, however the flash sensor is not removable and always looks in the direction the flash is pointed. There is no open flash button. Operating power is derived from four AA-size batteries inserted into the battery chamber.

Automatic Ranges—The Mode Selector selects automatic or manual operation. There are four auto settings. At ASA 100, for example, you can choose from f-4, f-5.6, f-8 or f-11 to control depth of field. You must set the correct aperture on the lens. Operating range for each aperture is indicated on the flash calculator dials.

Bounce Flash—The flash head tilts upward to a maximum of 60° and rotates up to 90° to the left or right. If the flash unit is mounted in the camera hot shoe, the built-in flash sensor points toward the scene being photographed even though the light is being bounced.

Beam Width—The beam covers the angle of view of a 35mm lens. No beam-widening accessories are available to widen the beam.

Accessories—NiCad batteries and NiCad Charger 280 are available to provide more flashes per charged battery than from throwaway types.

AUTO ELECTROFLASH 25

A compact unit with one automatic setting and one manual setting. Guide number is 25 meters with ASA 100 film. This flash mounts in the camera hot shoe but can also be connected to the camera with a sync cord. It does not have bounce-flash capability or an open flash button. Working range on automatic is 0.7 to 4.5 meters. Beam width is suitable for lenses with focal lengths of 35mm or longer. No accessories are available to widen the beam. Power source is four AA-size carbon-zinc or alkaline batteries. The unit is not designed to use NiCad batteries.

ELECTROFLASH 20

Pocket size and manual only with a guide number of 20 meters at ASA 100, this tiny flash is simple and easy to use. The calculator is easy to read and does the guide-number arithmetic for you.

The flash mounts in a hot shoe and does not have a socket for a sync cord. There is no open flash button. Beam width is suitable for lenses with focal lengths of 35mm or longer. No beam-widening accessories are available. It uses two AA-size carbon-zinc or alkaline batteries and is not designed to use NiCad cells.

AUTO ELECTROFLASH 450

This is a versatile "handle mount" automatic or manual flash which can be held by its handle or attached to a bracket which also mounts the camera. The bracket is supplied with the flash. For each film speed, you can select operation with any of five aperture sizes, or manual.

On manual the guide number is 45 meters at ASA 100 when the flash is fully charged. The flash has a built-in sensor on the front which "looks" where the flash is pointed.

For bounce flash, an accessory sensor can be installed in the camera hot shoe and cord-connected to the flash. The accessory sensor takes the place of the built-in sensor and views the scene being photographed while you point the flash in whatever direction you choose.

Monitor Light—A monitor light on the side of the flash glows steadily as soon as the flash has charged up to 70%—half an exposure step below full power. When the flash has charged to full power, the monitor light blinks on and off repeatedly.

For uniform exposures, you should form the habit of firing the flash either when the monitor first comes on or when it is blinking.

The guide number of 45 meters at ASA 100 is for full power. At 70% power, the ASA 100 guide number is 38 meters.

Sync—When fired by the camera, the flash always receives the X-sync firing signal through a special sync cord. There are two to choose from.

The cord supplied with the flash is coiled so it is convenient to interconnect flash and camera when both are mounted side-by-side on the bracket. It will stretch so you can hold the flash at arm's length if you are not using it on the bracket.

One end of the cord has a special three-prong connector which plugs into a socket near the bottom of the flash handle. The other end plugs into the camera X-sync terminal.

The camera end has a standard sync connector surrounded by a threaded collar. With most Minolta cameras, push the sync connector into the terminal and disregard the threaded collar because it doesn't do anything. If you are using a Minolta XK Motor camera or any other Minolta with a threaded ring surrounding the camera sync terminal, you can screw the collar into the terminal so it cannot accidentally become unplugged.

The other method of deriving sync from the camera is to use a special sync cord attached to the Separate Sensor unit—to be discussed later.

Automatic Ranges—First, set in film speed by turning the outer ring of the calculator. A green band on the calculator will then indicate a range of five f-numbers that can be used on automatic.

The Control Knob in the center of the calculator is used to select one of the automatic ranges. Rotate the knob to align the white index mark with the desired aperture size.

Maximum full-power operating range is then indicated by two red bands which overlay the distance scales—one in meters, the other in feet. Read the one you prefer.

If operating range is the more important consideration, rotate the Control Knob until the red bands extend to the desired operating distance and notice which f-number is indicated by the index mark on the knob. After using the calculator to determine the f-number, make certain the subject is within the operating range, and make that f-number setting on the lens.

Turn the Power Switch on and wait for the monitor light to glow.

If you operate the flash at 70%

The calculator dials on Auto Electroflash 450 are color-coded for ease of reading.

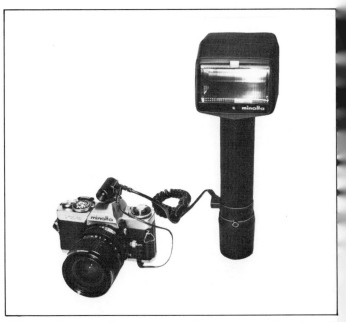

With the Separate Sensor mounted in the camera hot shoe, it measures light reflected from the scene being photographed, no matter where you aim the flash.

power when the monitor light first turns on, maximum range is reduced but the calculator does not show the reduced range. Here's an easy way to find it: Mentally extend the red bands one-half step to the right on the aperture scale and read the distance directly opposite on the distance scale.

Operating at 70% power on automatic affects only the *maximum* operating range. At shorter distances, the flash compensates automatically and gives correct exposure of an average scene or average subject.

Minimum range on automatic varies with aperture and film speed but is not shown on the calculator. It is given in the accompanying specification table for ASA 100.

AUTO ELECTROFLASH 450 MINIMUM RANGE AT ASA 100		
Aperture	Meters	Feet
f-2.8	1.8	5.9
f-4	1.3	4.3
f-5.6	0.9	3.0
f-8	0.65	2.1
f-11	0.5	1.6

When using the Control Knob to select aperture size for automatic operation, it is not possible to choose an aperture smaller than the smallest within the green band. It is possible to set the knob to an aperture *larger* than those within the green band. This setting should not be made.

Manual Operation—Use the MANUAL setting of the Control Knob. This setting is beyond the *f*-number scale so the knob does not appear to be selecting any aperture size. Also, this setting causes the red bands that indicate automatic operating range to disappear from view so you are not likely to think the unit is still operating on automatic.

On manual, at full power, the flash operates according to its guide number: 45 meters at ASA 100. You can calculate aperture size using the guide number or you can refer to the calculator dials on the flash. For each distance on the distance scales, use the *f*-number directly opposite on the *f*-number scale. The calculator scales change appropriately when a different film speed is dialed in, so the indicated *f*-number will always be correct for the film speed you are using.

At 70% power, on manual, there are two ways to determine aperture size. If you calculate it using the guide number, use a lower guide number: 38 meters with ASA 100. If you use the calculator on the flash unit, read it just as if you were using full power; then set the lens aperture one-half step larger than the calculator scale shows.

Flash Duration—On automatic, flash duration ranges from about 1/20,000 second to 1/600 second depending on reflectivity of the subject and the distance to the subject. On manual, duration is always 1/600 second. This applies at any amount of charge from 70% to 100%.

Open Flash—A red Open Flash Button on the back of the flash head allows you to trigger the unit independent of the camera for multiple flashes with the shutter open, to test the flash, or for any other reason.

When using the open flash mode with the shutter set to B, normally you should disconnect the sync cord from the camera. If you leave it connected, the camera will trigger the flash when the first shutter curtain opens.

Bounce Flash—For automatic ex-

osure control with bounce flash here is an accessory Separate Sensor with a cord permanently attached and also an accessory Sensor Sync Cord, packaged together.

The Separate Sensor can be mounted in the camera hot shoe and connected with its attached cord to the socket at the bottom of the flash handle. In this setup, an electrical contact on the bottom of the Separate Sensor receives the X-sync firing signal from the hot shoe and transmits it to the flash unit through the connecting cord.

When the Separate Sensor is plugged into the flash unit, the light sensor built into the flash is turned off and no longer functions. Light sensing is done by the sensor mounted on the camera which views the scene being photographed no matter where you point the flash.

An alternate location for the Separate Sensor is a clip on the flash bracket. This also causes the sensor to view the same scene as the camera lens even if the flash unit is tipped backward on the bracket to bounce light off the ceiling. However, in this setup, the sensor does not receive an X-sync signal from the camera hot shoe.

Instead, you must use the small Sensor Sync Cord to bring sync from the camera. One end of this cord has a sync connector with a threaded collar around it, as described earlier. Connect this end to the sync terminal on the camera body. Plug the other end into the socket on the Separate Sensor. From there, the sync signal travels to the flash unit along the cord between Separate Sensor and flash.

Use the Sensor Sync Cord when the Separate Sensor is mounted in the clip on the bracket. Don't use it when the Separate Sensor is mounted in the camera hot shoe.

Flash Bracket—The bracket assembly is in two parts which can be separated. One part, called the *connector*, attaches to the flash handle. The bracket itself attaches to the bottom of any Minolta

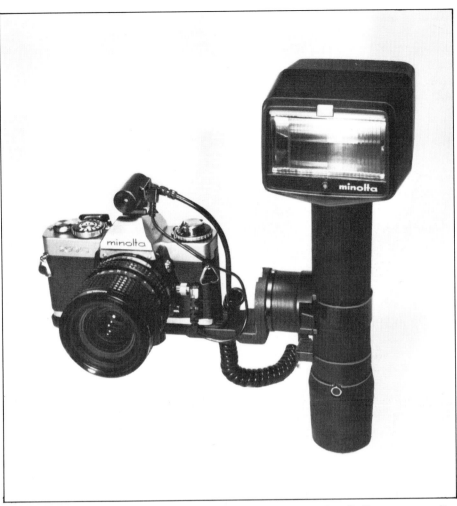

The Flash Bracket mounts both flash and camera so you can handle them as one unit.

camera using the tripod socket. There are two tripod sockets on the bottom of the bracket.

To attach the connector to the bracket, squeeze the two Bracket Release Tabs on the connector while inserting the extension of the connector into a slot on the bracket.

When mounted, the flash can be tipped backward to bounce the light by squeezing the same two tabs while rotating the flash unit. The connector has white dots at 30° intervals between horizontal and vertical as an aid in positioning.

The flash can quickly be removed from the bracket by squeezing the Bracket Release Tabs while sliding the flash unit downward until it is freed from the bracket. The same release tabs are used to rotate the flash on the bracket or to remove the flash

from the bracket. It is possible, accidentally, to remove the flash when you only intend to rotate it so the light bounces off the ceiling. You can avoid this by being aware of the possibility and holding the flash on the bracket while rotating it.

Wide-Angle Adapter—The beam angle of the flash is suitable for lenses with focal lengths of 50mm or longer. A Wide-Angle Adapter panel is stored in a slot above the flash window. This can be placed over the flash window to make the beam wider so it is suitable for lenses with focal lengths of 28mm or longer.

The adapter reduces the light output by two exposure steps. When the adapter is in place, you can restore correct operation of the flash calculator by moving the Normal/Wide Switch on the back of the flash from **NORMAL** to

WIDE. This changes the position of the distance scales so they will give correct readings. When the wide-angle panel is not in use, be sure this control is set to NORMAL.

If you use the Wide-Angle Adapter and also fire the flash at 70% power, use both corrections. Move the Wide/Normal switch to WIDE. If on automatic operation, mentally extend the end of the red bands one half step to find the reduced operating range due to 70% power. If on manual, increase lens aperture a half step above that shown on the calculator scale.

Power Sources—There are three ways to provide power. The standard method is to use the AM Battery Cartridge packaged with the flash. This battery holder bayonets onto the flash handle and makes electrical connections to supply power. It holds six AA-size alkaline batteries—also known as alkaline-manganese or AM.

An accessory NiCad battery and charger is available. The NiCad battery is the same size and shape as the AM Battery cartridge and

fits on the handle in the same way.

Another accessory power source is a 510-Volt Battery Pack. This battery carrier has its own on-off switch, a shoulder strap and a cord to connect it to the flash. Standard 510-Volt batteries are used: Mallory PF497 or equivalent. Install the battery in the carrier with the battery-pack switch turned off. Turn the flash Power Switch off also. Insert the connector of the battery-pack cord into the Power Receptacle on the back of the flash head. Turn the flash unit on or off with the battery pack Power Switch.

It is not possible to insert the battery-pack cord with the flash turned on, nor is it possible to turn on the flash Power Switch when the battery pack is connected. This is to prevent using both external battery pack and internal batteries at the same time.

Advantages and disadvantages of these three power sources are mainly in recycle times and the number of flashes obtainable. This information is in the accompanying table.

Sequential Flashes with Auto Winder or Motor Drive—Sequential flashes at rates up to three per second can be made with the flash set for automatic operation. The number of flashes in sequence depends on how much of the charge is used for each flash and how quickly the battery can recharge the unit.

To reduce the amount of charge expended for each flash, use a large lens aperture and a short distance to the subject. For best results use a fully charged NiCad battery or, preferably, a fresh 510-Volt battery.

To learn how many frames can be exposed this way with any setup, test without film in the camera. Count the flashes before the unit fails to recharge quickly enough. Then replace or recharge the battery and proceed.

Precautions—Never fire the flash when it is pointed directly at the Separate Sensor. Never remove the cover of the NiCad battery cartridge. Avoid contact with the terminals of a 510-Volt battery—this voltage can be fatal.

AUTO ELECTROFLASH 450			
Power Source:	6 alkaline-manganese AA cells	6 nickel-cadmium AA cells	510v battery
Number of Flashes			
Auto:			
At full power	70 to 900*	50 to 420*	200 to 2000*
Within 1/2 stop of full power	100 to 1100*	50 to 420*	300 to 3000*
Manual	70	50	200
Recycle Time (sec.)			
Auto:			
At full power	1* to 23	0.33* to 7	0.33* to 3
Within 1/2 stop of full power	1* to 14	0.33* to 4	0.33* to 2
Manual	23	7	3
*Depending upon subject distance			

12 AUTO WINDERS AND DATA BACKS

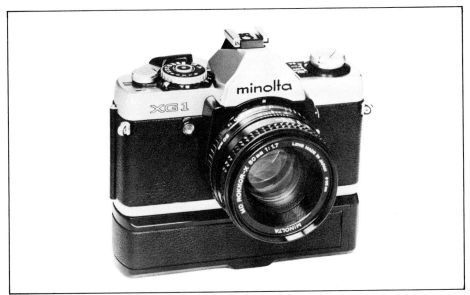

Auto Winders increase the capability of XD and XG cameras by advancing film automatically. You can shoot a continuous sequence of exposures at rates up to two frames per second or single shots with immediate film advance so you are ready for the next shot.

AUTO WINDERS AND DATA BACKS

This chapter covers two major accessories for XD and XG cameras: auto winders and data backs. These accessories are not available for SR-T cameras or 110 cameras. The XK Motor camera has a built-in motor which is described in Chapter 15.

AUTO WINDER D AND AUTO WINDER G

Minolta auto winders attach to the bottom of XD and XG cameras and can be used to advance one frame at a time or to make a sequence of exposures. When used to make a sequence of exposures the auto winder is, in effect, a motor drive capable of exposing frames at a rate up to about two per second.

Auto Winders D and G are basically the same although they are not interchangeable. Winder D fits XD cameras, Winder G fits XG cameras. This discussion covers both winders.

Mounting—You don't have to remove anything from the bottom of the camera to mount the auto winder. Simply place them together, in proper alignment, and turn the attaching screw on the bottom of the winder. This screw threads into the camera tripod socket. The winder itself has a tripod socket which you can use to tripod-mount the combination.

Be sure the winder is turned off before mounting. If the film is not advanced and you attach the winder with its Power Switch turned on, the winder will start advancing film before you have it securely mounted on the camera. This can damage the camera or winder.

After attaching the winder, you can turn it on. If the film is not advanced, the winder will automatically advance to the next frame. A red LED indicator on the back glows each time the winder advances one frame.

Operation—When the winder is turned on, it will advance the film after each exposure so the camera is ready for the next exposure. To expose single frames with the auto winder, depress the shutter button to make the exposure and then quickly remove your finger while the winder is advancing the next frame.

If you hold your finger on the shutter button, the camera will make exposures continuously, all the way to the end of the roll.

When exposing frames continuously, the winder always waits for the shutter to close before advancing the next frame. Therefore, frame rate depends partly on shutter speed. If the camera is set for a shutter speed of one second, for example, you cannot make a sequence of exposures faster than one per second.

Frame rate also depends on the time required by the winder to advance one frame of film—about 0.4 second. Therefore, the maximum rate is about two frames per second even if you have selected a shutter speed of 1/1000.

A continuous sequence of exposures is not possible if the camera is operating on B. The winder will advance one frame when you remove your finger from the shutter button. XD cameras have a shutter-speed setting labeled O which is an X-sync shutter speed produced mechanically in the camera. At this setting also, the winder will advance one frame when you remove your finger from the shutter button.

When using an auto winder to advance film, push the camera film-advance lever fully against the camera, and leave it there.

With the Winder Turned Off—Operation with the winder turned off is exactly the same as if the winder were removed from the

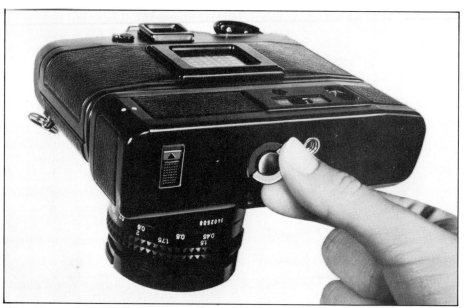

Mounting an Auto Winder is easy. Just turn the attaching screw on the winder into the tripod socket on the camera.

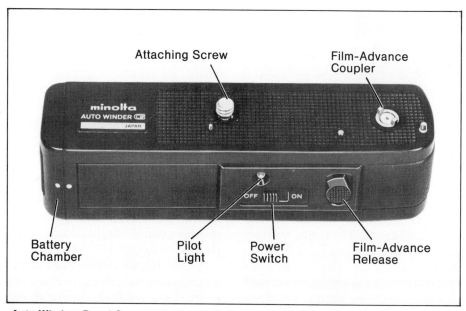

Auto Winders D and G are similar but not interchangeable. The operating controls are the same.

Power Sources—Four AA-size batteries fit in the battery holder at one end of the winder body. You can use carbon-zinc, alkaline or rechargeable NiCad batteries. Suitable rechargeable NiCad batteries and a companion NC-2 recharger are available from Minolta.

Approximate winding capacities are: carbon-zinc, 50 rolls of 36 exposures; alkaline, 70 rolls; NiCad, 150 rolls.

When replacing batteries, be sure to replace all four at the same time. If you don't plan to use the winder for two weeks or longer, remove the batteries and store them separately.

Low Power—If the batteries don't have enough power, the winder will stop during an advance and the LED indicator will glow steadily. This can be caused by discharged batteries or by too much friction in the film cartridge, or by a combination of the two.

If it happens, turn the winder off and then back on again. If it resumes winding, you can continue to use the unit. If not, replace batteries or film cartridge, or both. Or else, you can turn the winder off and advance film manually using the film-advance lever on the camera.

Resetting the Mechanism—After replacing batteries or when the winder is first installed, it may occasionally not operate. If this happens, turn the winder off and advance one frame manually. Then turn the winder back on. This will reset the winder so it will operate normally.

Guide Pins and Terminals—Auto Winder D has a guide pin on one corner which helps align winder and camera properly. It also serves as an electrical connection between winder and camera and should be cleaned occasionally with a soft cloth.

Auto Winder G has a guide pin which serves to align the winder. A separate electrical terminal pin is on the top surface near the attaching screw. If this pin becomes dirty

camera. Camera controls work normally, with one exception: To prepare the camera to rewind film, you use a control on the winder rather than the rewind button on the bottom of the camera.

End of Roll—When you have made the last exposure on a roll, the winder will stop advancing and the red LED on the winder will glow continuously. Turn the winder off immediately to conserve battery power.

Rewinding Film—To rewind film without removing the winder from

the bottom of the camera, use the Film-Advance Release on the winder body. Press your finger against this control, rotate it clockwise and then slide it upward. When you do this, a pin emerges from the top of the winder and depresses the Film-Advance Release button on the bottom of the camera.

Using the control on the winder is just a way of depressing the button on the camera without having to remove the winder. Then rewind film in the normal way.

or corroded, it should be cleaned with a soft cloth.

Multiple Exposures—XD cameras are designed to hold each frame in position while more than one exposure is made on the frame. This produces good registration of the images in respect to each other and the boundaries of the frame. XG cameras are not designed for multiple exposures.

The multiple-exposure procedure described here is recommended by Minolta only for XD cameras.

To make more than one exposure on the same frame, using winder D installed on an XD camera, you must start the procedure *before* the first exposure is made:

1. Rotate and push upward on the Film-Advance Release on the winder. You will feel a click when the camera Film-Advance Release button has been depressed fully by this action. Then remove your finger from the winder Film-Advance Release .

2. Make the first exposure on the frame. The winder will operate after the exposure and prepare the camera to make the next exposure except that it will not advance the film.

3. Make the second exposure.

4. Repeat steps 1, 2 and 3 as many times as needed for *one less than* the number of exposures you plan to make on the same frame.

5. Before the last of the multiple exposures, do not operate the Film-Advance Release on the winder.

After the last exposure, the winder will advance film to the next unexposed frame which you can expose in the normal way.

You can make multiple exposures using the winder to advance frames continuously in sequence by holding the winder Film-Advance Release pushed upward during the entire sequence.

If you make a continuous motor-driven multiple exposure, you will end up having exposed

Data Backs replace the standard back cover of the camera and imprint the date or other information in one corner of the frame. Data Back D and Data Back G are similar but not interchangeable.

To remove the standard camera back cover, push the release pin downward (arrow).

the last frame with the Film-Advance Release control pushed up—which is contrary to the instructions given earlier. Or, if you forget to follow those instructions when making single exposures with the auto winder you may unintentionally operate the Film-Advance Release before shooting the last frame.

In either case, put on the lens cap and depress the camera shutter button two times without touching the Film-Advance Release button on the winder. The first time prepares the camera to make one more exposure on the same frame and does not advance the film. The second time opens and closes the shutter but no light reaches the film because you have the lens cap on. When the shutter closes, the winder will advance film to the next unexposed frame. This will be the frame immediately following the multiple exposure, so no film is lost by this procedure.

DATA BACK D AND DATA BACK G

Minolta data backs replace the standard camera back and are used to imprint data on the lower right corner of a print or slide. They make a record on the film of the date or any other data using the numbers and letters available.

Although basically identical, Data Back D fits XD cameras and Data Back G fits XG cameras except the XG-1.

Data backs are not available for XG-1, SR-T, XK or 110 cameras.

These special backs have a small built-in flash lamp and selectable data characters. When fired, the flash lamp exposes the letters and numbers onto the film from the back, through the film base. The flash is fired by an X-sync signal from the camera.

Mounting—Open the standard camera back and push downward on the hinge-release pin shown in the accompanying photo. You can

then tip the camera back cover outward and lift the lower hinge pin out of the lower hinge socket. Install the data back by reversing this procedure.

Connect the attached sync cord to the X-sync terminal on the camera.

Operation—Set the desired data to be imprinted by turning the three Data-Setting Dials labeled DAY, MONTH and YEAR.

The dial labeled DAY has numbers 1 through 32 and a blank space. The MONTH dial has numbers 1 through 12, letters A through G and two blanks. The YEAR dial has numbers 79 through 99, letters A through I and two blanks. Select whatever combination suits your purpose.

The on-off control is combined with a Data-Exposure Selector. When you turn the unit on, you must choose one of two settings: COLOR, B&W 32 is for all color films with speeds lower than ASA 400 and b&w film with ASA 32 speed rating. Film with speeds lower than ASA 32 should not be used. COLOR 400, B&W is for all b&w films with speeds higher than ASA 32 and color films with ASA 400 speed. At OFF, data will not be recorded.

Data is exposed through a small rectangular opening in the pressure plate at the upper left corner of the film in the camera, as viewed from the back. On a print or slide, the data appears in the lower right corner of the frame.

The order of the characters on a print or slide is reversed laterally, compared to the order of the dials. That is, the dials show day, month and year in that order, but the film shows year, month and day.

Because data characters appear white, they are more visible against a dark background and it's a good idea to compose so this happens when possible.

On the back panel, a red LED indicator flashes each time data is being recorded, however the LED is not the light source that exposes film. The *exposure lamp* is a separ-

When the Data Back is installed in place of the standard back, plug the sync cord attached to the Data Back into the camera X-sync socket. This allows the camera to control the exposure lamp in the Data Back.

The Data Back exposes the film through this small rectangular opening in the pressure plate. Light passes through the film base to expose the emulsion.

ate flash lamp inside the unit.

To be certain both lamps are operating, connect the data back sync cord to the X-sync terminal of a camera without installing the data back on the camera. Without film in the camera, trip the shutter a few times while checking the lamps. Inside of the data back, you should see a flash of light behind the data characters in the small rectangular window. On the back, the LED should flash. If both work each time, the unit is operating properly.

You can use the data back connected to the camera X-sync terminal and simultaneously use a flash unit mounted in the camera hot shoe. To use one or the other, turn off the one you don't want to use.

If you intend to fire the flash unit independent of the camera, using the open-flash button, disconnect the data back or turn it

off—otherwise, the data back will be triggered each time you fire the flash.

If you are making multiple exposures on a single frame, turn off the data back after the first exposure to avoid overexposing the data characters.

The data back flashes each time the shutter operates and it can keep up with an auto winder operated continuously.

Power—The data back draws power from two self-contained 1.5-volt silver-oxide batteries, S-76 or equivalent. To check battery condition, depress the Battery-Check Button just below the LED indicator on the back panel. If the LED glows steadily, the batteries are OK.

If you will not be using the data back for a month or longer, Minolta recommends that you remove the batteries and store them separately.

HOW TO CARE FOR YOUR CAMERA

With proper care, Minolta equipment will give you many years of good service and great photographs. The best care you can give any piece of equipment is to use it properly so you don't cause problems to develop.

If your camera is new, or if you haven't used it lately, read the instructions to be sure you are familiar with the controls and what they do.

CHECK OUT YOUR CAMERA

You will not harm your camera by operating it without film. Get acquainted with its operation and practice using the controls by firing "blank shots" as much as you wish.

Open the back and trip the shutter a few times while looking into the camera. You'll see the shutter open and close. While the shutter is open, you'll see the rear pupil of the lens. At different aperture settings, the pupil should be different sizes.

Don't touch the shutter or interfere in any way with its motion. It's fast, precise and vulnerable.

If the battery is more than 6-months old it's good insurance to replace it before leaving on a trip. If the battery is more than a year old, it's living on borrowed time.

If the camera is new, or you haven't used it in a long time, test by exposing a roll of film. Particularly if you are going on a trip or planning to make some very important photos, check out the camera first by testing with film in the camera.

For any kind of testing with film which you will send out for processing, color-slide film is best.

Good camera care begins with a suitable case for your camera and accessories. Simple *eveready* cases like this hold a camera body with lens installed. Case is deep enough for a standard lens or shorter. If you intend to carry more than one lens, you need a larger case.

When you load film, be sure the leader is caught in the takeup spool. When slack is taken out of the film and the camera back has been closed, watch the rewind knob to be sure it rotates as film is being advanced. If your camera has a Safe-Load Signal Window, it will show that film is properly loaded and advancing through the camera.

Make test shots under a variety of lighting situations. This gives you the opportunity to check the camera's built-in exposure meter, shutter-speed timer and aperture settings over a wide range of operating conditions.

Send the film for developing through your local dealer. Carefully inspect the finished slides. If you see something that doesn't look right, it could be your shooting technique, improper use of the camera controls, a fault in the camera, or a problem resulting from incorrect processing. If you can't figure out which, your dealer or the camera manufacturer will be glad to look over the slides and help you.

THINGS THAT CAN HARM YOUR CAMERA

Camera mechanisms can be damaged due to improper storage and improper use. Here are some of the camera's "natural enemies" and what you should do about them.

Dirt—Cameras and lenses are not dustproof. Under normal conditions of use and storage, dirt, dust and grit are not a problem.

When you use your camera at the beach, in the desert when sand is blowing, at dirt race tracks, cement plants, and all such places where dirt is in the air, protect the camera by keeping it enclosed except while using it. Use a camera case, or a plastic bag, or even an article of clothing wrapped around the camera. You can shoot with the camera inside a plastic bag if you cut an opening for the lens.

Use lens caps both front and rear on lenses not mounted on a camera. Use body caps for your spare camera bodies. Keep everything covered and protected.

Water—Cameras and lenses are not waterproof. There are several places where water can get inside and do a lot of damage. Protect both body and lenses from rain or splashing water.

If the camera exterior gets wet, dry it immediately with a clean soft cloth. If a camera is thoroughly wet due to being submerged or left for a long time in rainfall, it may be damaged beyond repair. Get it to an authorized Minolta service facility as soon as possible.

Condensation—When exposed to sudden temperature changes or high humidity, condensation may form on lenses, on the inside glass surfaces of lenses, and inside the camera. If you store camera and lens in such a way that they can't

dry out properly, problems may result. Leave camera and lens uncovered at room temperature for two or three days.

Amateur Repairs—Well-meaning amateur camera servicing and repairs can cause more damage than they cure. Never take a camera body or lens apart. Never attempt to lubricate camera parts yourself. If the camera seems to have mechanical damage, visible or invisible, take it to your authorized Minolta dealer for repair.

Lengthy Storage—Like people, cameras need regular exercise. If you are not using a camera, it will survive the inactivity better if you exercise it every two or three months. Fire some blank shots at various shutter speeds. Operate the film-advance lever and other camera controls to free them up and redistribute lubricants. If you know you won't be using a camera for two weeks or longer, it's a good idea to remove the batteries and store them separately.

Never store a camera with the shutter cocked. Make a point of depressing the shutter button just before you put it away, just to be sure the camera mechanism is relaxed.

Storage Conditions—Store camera and lenses in a cool dry place. A shelf or drawer in a room occupied by people is much better than a basement or attic where the camera may be attacked by humidity or temperature extremes. Store the equipment in cases, wrappings or bags. It's a good idea to package it with small bags of dessicant to reduce humidity. New camera equipment usually has these dessicant bags in the packaging—don't throw them away.

Shooting Conditions—Be careful not to bang your camera against walls or drop it. A short neckstrap used around your neck instead of over your shoulder is very good insurance against inadvertent bangs and knocks that can damage your camera. A good rule is:

Assemble a compact camera-care kit and keep it with your photo equipment so you have it when you need it. Include lens-cleaning tissue and fluid, a brush for the camera body, a separate brush for glass surfaces, a rubber squeeze bulb to make a jet of air and some cotton swabs to clean the viewfinder window. The rubber squeeze bulb may be built into the lens brush.

Whenever you are using the camera, have the strap around your neck, except when the camera is on a tripod or copy stand.

When carrying a camera in a vehicle such as a car or airplane, keep it in the passenger compartment and pad it some way so it does not receive steady vibrations from contact with the vehicle. Vibration can loosen screws and possibly damage the camera mechanism.

When you're using the camera, always have the proper lens hood on the lens. Not only will it improve image quality but also it will help protect the front of the lens.

If you're going outdoors in very cold weather, keep the camera under your coat when you're not actually shooting. This will help keep the battery functioning and when you return to the warmer area you'll have less worry about condensation forming on or inside the camera.

If you've been out long enough so the camera has gotten cold, place it inside a plastic bag before going into a warm room. Allow it to return to room temperature slowly, and don't take it out of the bag until it is the same tempera-

ture as the surrounding air.

Otherwise, condensation will form both inside and outside the camera and cause problems later on. This is especially important if you are going to go back outside into the cold again. Condensation inside a camera may freeze when you go outside, jamming the camera.

In hot weather, protect the camera from the direct heat of the sun. High temperature may affect the camera and the film. Color film is especially sensitive to high temperatures.

Don't leave your camera in the open sun. Don't leave it in the trunk of a car, the glove compartment, on the car's dash or back window ledge, especially in cars with lots of glass.

Catalytic converters are mounted under the floor of a car and get extremely hot. Keep your camera away from this heat source.

If you must leave your camera in a closed car, make sure the camera is in a case and place it on a cool portion of the floor, or under the seat. Drop a jacket or blanket over it. This serves two purposes, it protects it from the sun and camouflages it from thieves—but this is a last-resort method.

ASSEMBLE A CLEANING KIT

Put together a small cleaning kit and keep it with you whenever you're using your camera. Include a spare battery or batteries if your camera uses more than one. Also lens-cleaning tissue, lens-cleaning fluid, a brush for lens barrel and camera body, a soft lens-cleaning brush for glass surfaces, cotton swabs, and an air blower or a can of pressurized air.

Don't use any other kind of tissue such as nose-blowing or bathroom, and don't use the tissues sold for cleaning eyeglasses because they are often impregnated with silicone—fine for your glasses but not for your camera lens.

The can of air can be left at home because it is bulky to carry in your camera bag. Practical portable substitutes for a can of pressurized air are: A puff of air from your mouth delivered without any bonus of liquid or other matter, a rubber squeeze bulb such as an ear syringe or a combined squeeze bulb and brush of the type sold at camera shops.

How To Clean a Lens—With lens cap in place, or both caps if the lens is removed from the camera, use a blast of air and a brush to clean dust from the lens barrel and the crevices around the controls. Be careful to use this brush only on metal surfaces. Use the lens-cleaning brush only on glass surfaces.

Then remove the front lens cap and blow the loose dust off the front glass element. With the lens brush, gently lift any remaining dirt particles off the front surface.

If dirt or fingerprints remain on the lens, apply a drop or two of lens-cleaning fluid to a piece of lens-cleaning tissue and lightly wipe the lens starting at the center and spiraling outward.

Don't rub hard and don't use more than a drop or two of lens-cleaning fluid. Never apply fluid directly to the lens.

The rear lens element can be cleaned in the same way. It should not require frequent cleaning because it is protected by a rear lens cap or the camera body.

Clean a lens only when it actually needs it—when it's covered with dust or has finger smudges.

How To Clean the Camera Body—Use a brush to clean loose dust off the body and out of crevices. Work around all controls to remove dirt.

Then open the back of your camera. Use the brush to clean out any dust or film particles. You can also use a puff of air to do the job. Be very careful not to spray the air directly on the shutter curtains and don't touch them with anything.

Using a small piece of lens-cleaning tissue dampened with lens-cleaning fluid, clean the pressure plate and guide rails in the camera body.

Never attempt to clean the camera mirror. It is surfaced on the front rather than on the back of the glass and is easy to scratch. Never apply a piece of lens-cleaning tissue or even try to brush it. Use your can of air or squeeze bulb to clear away loose dirt, or have it cleaned by a camera repair shop.

How To Clean The Viewfinder Eyepiece—This will get dirtier and greasier than your lenses. A cotton swab such as a Q-Tip can be used. Blow out the dust first, then use a slightly dampened swab to lift off any remaining dirt or smears.

IF YOU HAVE A PROBLEM

Through use, even the best camera may develop problems, but many are not serious.

What if the film stops advancing? There's a good chance you've simply reached the end of a roll of film. It may be a 20 exposure when you thought it was a 36, or maybe you advanced the film a little farther than normal before closing the camera back.

Never use unusual force to advance the film—or on any other camera control. Rewind the film, operate the camera without film, and it may check out OK. If so, try another roll of film.

You should replace the battery once a year, even if it tests OK. This will frequently solve exposure or meter problems instantly. It's nearly impossible to remem-

To clean a lens: First use a blower of some kind to blow away dust particles without touching the lens surface. If that removes the dirt, stop cleaning the lens.

If the blower doesn't do the job, use a brush with soft bristles to gently lift off the dirt. Have one soft brush that you use *exclusively* for glass surfaces.

If there are finger marks or smears on the glass that the brush won't remove, apply a small amount of *lens-cleaning* fluid to a piece of *lens-cleaning* tissue and gently remove the marks.

To clean the interior of the camera, use a soft brush. Avoid touching the focal-plane shutter.

If the pressure plate needs cleaning, use lens-cleaning fluid and a piece of lens-cleaning tissue.

When a lens is not in use, keep front and rear covered with lens caps.

ber when the battery needs replacing unless you employ some kind of memory aid. Try replacing it on your birthday, or giving the camera a Christmas present.

While using your camera, be aware of how the controls feel. Film-advance and lens controls should be smooth with no grinding, crunching or scraping. Generally, if something does go wrong, you'll know it almost immediately because the smooth feel will be gone.

How To Test Exposure Accuracy—If you are getting some bad exposures, check the simple things first. Try a new battery. Is your metering technique causing the problem—such as shooting a subject against a bright background without making any compensation? If you get bad exposure on prints, it may be the lab—not likely but possible.

Exposure errors due to a fault in the camera metering system will usually occur at all shutter-speed settings and all apertures. One check is to compare the settings read from the camera meter to the reading from another SLR camera. They should agree within about one-half step. Check at different scene brightnesses. If you get fairly good agreement, the meter in your camera is probably OK—if the comparison camera is making good exposures.

Find a brick wall or other uniform textured surface. Put the camera on a tripod and focus carefully on the wall. Then make a series of exposures under manual control, starting at the largest aperture and going down to the smallest. Use the meter in the camera to measure the light. Set the exposure controls for each frame you shoot.

If your camera has shutter-priority automatic operation, switch to that mode and make a series of tests ranging from slow to fast shutter speeds. If your camera has aperture-priority automatic operation, test that mode over a range of aperture sizes.

If you plan these tests beforehand you can skip some of the intermediate aperture and shutter-speed settings so you can get the entire test sequence on a single 36-exposure roll of film. Record the settings for each frame.

Send the film for processing. It will be easier to check results if you enclose a note to the film lab asking that the slides not be mounted. You'll get back a continuous roll of film, so each frame has to be in proper order, as shot. Hold the film strip against a light source or a window and examine each frame.

All frames should be reasonable exposures of the scene. All exposures should look the same. If some are lighter or darker, look for a pattern or some clue as to what is wrong.

How To Test Focus—Put the camera on a tripod. With a standard lens, ask someone with good vision to focus the image sharply. Then you do it. If you had to refocus, one of you did it wrong because there is only one camera setting that gives best focus. If your vision is getting fuzzy, it's hard to tell good focus from bad.

To test the camera, use a tripod and focus on a wall as before. Move the camera to at least four different distances from the wall, focusing carefully each time. Make notes. Use slide film and ask that it not be mounted. Check the returned film with a magnifying glass. Every frame should be in good focus. If some or all are not, it's either your eyesight or the camera. Have one or both checked.

A simple Eyepiece Correction Lens will often solve this problem if it's your eyesight.

HOW TO GET IT FIXED

If you can tell by the pictures you get or the feel of the controls that the camera needs repair, have it fixed by an authorized Minolta service agency. Save your receipts when you purchase camera gear, so you will have a record of the purchase date. Read the warranty card that comes with new equipment. Save the warranty card with your receipt so you will later be able to doublecheck warranty provisions and also check to see if your equipment is still in warranty.

MINOLTA 110 SLR CAMERAS

In addition to SLR cameras using 35mm film, Minolta produces SLR cameras that use 110-size film in cartridges. These offer many of the advantages of the larger SLR cameras, combined with compact size, economy, and the convenience of drop-in cartridge loading.

The 110 film frame is 13mm x 17mm—about one-fourth the area of a standard 35mm film frame. For many photographic purposes, this is not a handicap.

Color-negative, color-slide and b&w film are available. Most users of 110 film prefer color negative because they want to end up with color prints. For this purpose, 110 film is a very good choice unless you plan to make enlargements larger than 8 x 10. Medium and small enlargements in color or b&w have excellent quality when made with these Minoltas.

There are special slide projectors for 110-size slides but they are not necessary. Most film processors routinely mount 110 slides in holders with the same outside dimensions as 35mm slides. To be certain, specify 2"x2" mounts.

Film loading is simple and foolproof. Open the back of the camera, drop in the cartridge and close the back. You don't have to thread the film across the camera or insert the film end into a take-up spool. For some people, this is an important feature.

Both camera models discussed in this chapter have non-detachable zoom lenses so you have a choice of focal lengths without having to carry several lenses and interchange them. Both models also have a special lens setting to increase magnification for close-up photography such as flowers or insects.

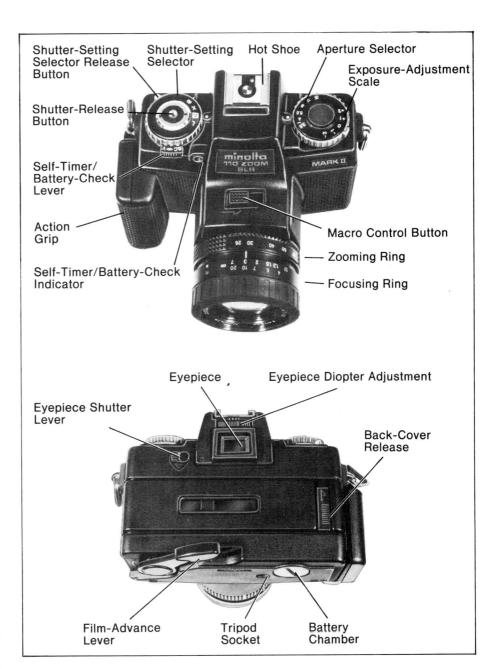

MINOLTA 110 ZOOM SLR MARK II

In nearly every way, the Mark II camera can be regarded as a smaller version of the Minolta 35mm SLR cameras. This model was introduced later than the other 110 Zoom SLR described later in this chapter, and there are significant differences between the two models.

Metering in the Mark II model is done behind the lens with a center-weighted pattern. The metering and operating range is from EV 5.6 to EV 17 with ASA 100 film. The camera selects shutter speeds steplessly within the operating range.

The camera is automatic only and operates with aperture priority. Aperture range is f-3.5 to

f-16. The shutter-speed range is 1/1000 to 1/4 second. The back of the camera has a window so you can see the back of the film cartridge which shows the type of film loaded and the total number of frames available in that cartridge. Through a window on the cartridge, you see start and end marks and frame numbers.

THE LENS

An *f*-3.5 zoom lens with focal lengths from 25mm to 67mm is built in. At 25mm focal length, the lens has approximately the same angle of view as a 50mm lens on a 35mm camera. At 67mm focal length, the 110 lens behaves about like a 135mm telephoto lens on a 35mm camera.

The lens has two control rings. The Focusing Ring, at the front, sets focused distance from infinity to about one meter in normal operation.

The Zooming Ring changes focal length from 25mm to 67mm. Focal lengths are marked on this control.

Close-Up Setting—The MACRO control on the camera body, just behind the lens, provides image magnifications from about 0.05 when the zoom control is set at 25mm up to about 0.1 with the lens set at 67mm. To obtain this range of magnifications, push the MACRO button forward and then slide it to the left. In this mode, the lens focusing control has very little effect. Find focus by moving the camera closer to or farther from the subject and also by zooming.

OPERATION

Select the mode of operation by turning the Shutter-Setting Selector ring surrounding the Shutter-Release Button. A white pushbutton near the back of this control must be depressed to turn the control away from A. All other settings can be made without depressing the pushbutton.

There are four settings: L locks the shutter button so the camera cannot be operated. A puts the camera on aperture-priority automatic exposure, the normal setting. At the B position, the shutter remains open as long as you hold the shutter button depressed. At X, shutter speed is locked at 1/125 second, X-sync speed for this camera. At X and B, the camera does not control exposure automatically.

Open the camera back by moving the Back-Cover Release button upward. The cover will spring open and is hinged at the left.

Drop in the film cartridge with it oriented so you can read the printed information on the cartridge through the window in the camera back cover. Close the back securely.

Operate the Film-Advance Lever repeatedly about three strokes until it locks. The number 1 should be visible in the window of the back cover to show that the camera is set to expose frame 1.

Film-speed setting is done automatically when you load ASA 400 or ASA 100 film cartridges. A flange on the right end of the cartridge is shaped differently for these two speeds. The camera detects the difference and automatically sets itself to the correct film speed.

Two other film speeds are available in the 110 format: ASA 125 and ASA 64. Both have the same flange as ASA 100 cartridges, therefore the camera is set for ASA 100 when you use either of these film speeds.

ASA 125 film is b&w and can easily tolerate a one-third step overexposure.

ASA 64 films are for color slides and will be underexposed by two-thirds of an exposure step. If you prefer, you can set the Exposure-Adjustment Control to +1 when using ASA 64 film. This will cause overexposure of one-third step.

Select a lens aperture by turning the Aperture Selector on top of the camera to bring the desired *f*-number into alignment with the adjacent white dot. Aperture range is from *f*-3.5 to *f*-16. The control has strong detents at full and half steps which effectively prevent settings between the detents. Focus and set the zoom control for the desired composition.

Camera electronics and the viewfinder display are turned on by depressing the shutter button partway—until you feel slight resistance. Check the viewfinder display and change aperture if necessary to get correct exposure. Depress the Shutter-Release Button to make the exposure. A standard mechanical cable release can be used.

The Film-Advance Lever is on the bottom of the camera. The shutter button cannot be depressed until film is advanced. Multiple exposures cannot be made except by removing the cartridge in a darkroom or changing bag while recocking the shutter between shots.

VIEWFINDER

The viewfinder display operates only when you depress the shutter button partway.

Exposure Display—A scale of shutter speeds is visible along the left side of the frame. Standard shutter-speed numerals are shown from 1/1000 to 1/60. Below 1/60, the next indication is 1/4 second.

If the speed is 1/125 or higher, a circular red LED glows adjacent to the shutter speed. If the camera selects a shutter speed between two of the standard values, both LEDs glow. If shutter speed is from 1/60 to 1/4, an elongated red LED glows at 1/60.

Over- and Underexposure—A red triangular LED glows above 1/1000 on the scale to indicate overexposure. Change to smaller aperture if possible to bring the indication on scale.

A red triangular LED glows below the shutter-speed scale to indicate underexposure. Open the aperture if possible to bring the indication on scale.

Focusing Aid—A biprism focusing aid is in the center of the frame in the viewfinder. It produces a split image which separates horizontally when the image is not in focus. When using it, be sure your eye is centered in the viewfinder eyepiece. Otherwise, one side may become dark and the focusing aid will be unusable.

Eyepiece Diopter Adjustment—A control above the viewfinder eyepiece adjusts the viewfinder optics to match your eyesight.

Slide the control to the left or right while checking by looking into the viewfinder. Adjustment is correct when the shutter-speed scale and the biprism itself are sharply focused. Make this adjustment before depending on the viewfinder image to help you focus the lens.

Eyepiece Shutter—The viewfinder has a built-in shutter to prevent light from entering the camera and causing incorrect exposure when your eye is not at the eyepiece. This can happen, for example, if you set the self-timer and then step in front of the lens to be in the photo. The Eyepiece Shutter is operated by the Eyepiece-Shutter Lever, on the left of the eyepiece.

EXPOSURE-ADJUSTMENT CONTROL

This control is combined with the Aperture Selector. To give more or less exposure than the camera normally would use, lift the outer rim of the control and turn until the desired amount of exposure adjustment is opposite the red index mark. Then allow the outer rim of the control to

Loading a 110 camera is super-simple. Just open the back and drop in a cartridge of 110 film. You don't rewind. When the last exposure is made, advance film to the end and remove the cartridge.

move downward, turning it if necessary. The range is from +2 to -2 exposure steps with detents at each full step.

When photographing a non-average scene such as a small subject against an unusually light or dark background, this control should be used—as discussed in Chapter 8.

Still another use of this control is to bracket exposures.

FLASH SYNC

A hot shoe on top accepts any electronic flash with a conventional mounting foot. X-sync is provided to the center contact. Physically small flashes such as Minolta Auto Electroflash 118X are preferred because of the small size of the camera.

A Minolta X-type flash, such as the 118X, will automatically set X-sync shutter speed on the 110 Zoom SLR Mark II no matter where the Shutter-Setting Selector is set.

When using any flash other than Minolta X-type flash units such as the 118X, be sure to set the Shutter-Setting Selector to X.

FLASH-READY INDICATOR

When using a Minolta X-type flash unit, there are two indications that the flash is recharged and ready to fire. One is the monitor light on the flash itself. The other is the flash-ready signal in the viewfinder. When the flash is charged, the LED opposite **125** in the viewfinder blinks on and off indicating flash-ready and that the shutter will operate at 1/125 second.

When the flash-ready indicator is not lit, the camera operates just as though the flash were not installed. It makes correct exposures with ambient light while the flash is recharging.

SELF-TIMER

An electronic self-timer is built into the Mark II, controlled by a lever that extends forward from the shutter button. This lever has two functions and two engraved symbols.

The symbol **T** is engraved on the right side of the lever. To set up the self-timer, move this lever toward the right. Start the timer by depressing the shutter button. A

red LED on the front of the camera will blink on and off for about 7.5 seconds. Then it will blink more rapidly for about 2.5 seconds, giving a total delay of about 10 seconds. After 10 seconds, the shutter operates.

When using the camera without your eye at the viewfinder eyepiece, you should always close the viewfinder shutter, using the lever adjacent to the eyepiece.

POWER

Operating power is derived from two 1.5-volt silver-oxide batteries, S-76 or equivalent, installed in the battery chamber on the bottom of the camera body.

Battery Check—Batteries should be tested on installation and periodically thereafter. This is the second function of the lever that extends forward from the shutter button. The left side of this lever is engraved **BC**. To check the batteries, push the lever to the left. If the batteries are OK, the red LED on the front of the camera will glow continuously.

Low Battery Voltage—If the batteries discharge to the point that they cannot operate the camera correctly, the shutter will automatically lock to prevent further use of the camera. To restore normal operation, replace the batteries.

TRIPOD SOCKET

A tripod socket is on the bottom surface.

ACCESSORIES

An accessory Action Grip screws onto the right side of the camera to provide a comfortable and secure grip. A neck strap is available. The camera body has metal loops at the upper rear corners for an accessory neck strap. A lens hood and lens cap are available and both should be used. The Minolta Close-Up Lens Kit has a 40.5 to 55mm step-up adapter and includes 55mm close-up lenses. With this adapter, any 55mm filter can be used.

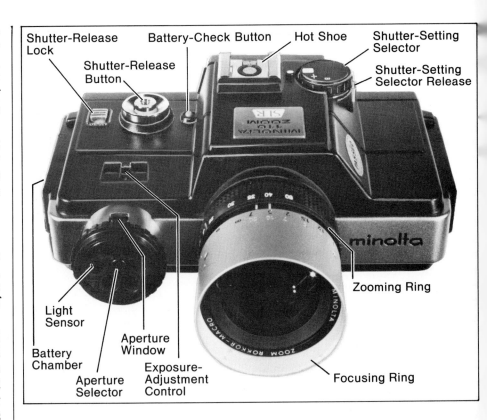

Shutter-Release Lock — Shutter-Release Button — Battery-Check Button — Hot Shoe — Shutter-Setting Selector — Shutter-Setting Selector Release — Light Sensor — Battery Chamber — Aperture Selector — Aperture Window — Exposure-Adjustment Control — Zooming Ring — Focusing Ring

110 ZOOM SLR

This was the first SLR for 110 film—the predecessor of the Mark II camera described earlier. It is unconventional when viewed as a 110 camera and also unconventional when viewed as an SLR.

The camera is automatic only and operates with aperture priority. Aperture range is *f*-4.5 to *f*-16. Shutter-speed range is 1/1000 to 10 seconds.

THE LENS

An *f*-4.5 zoom lens with focal lengths from 25mm to 50mm is permanently installed.

The lens has two control rings. The Focusing Ring, at the front, sets focused distance from infinity to about one meter in normal operation. The Zooming Ring changes focal length from 25mm to 50mm.

Close-Up Setting—The Zooming Ring has a special setting, marked **M**, which places an internal close-up lens in the optical path to increase image magnification. When the M setting is used, magnification ranges from 0.106 to 0.126 depending on where the focusing ring is set.

OPERATION

Select the mode of operation by turning the Shutter-Setting Selector while depressing the adjacent release button. There are three modes: A puts the camera on aperture-priority automatic exposure, which is the normal setting. At the B position, the shutter remains open as long as you hold the shutter button depressed. At X, the shutter operates mechanically at 1/150 second—X-sync speed for this camera.

Film-speed setting is done automatically when you load ASA 400 or ASA 100 film cartridges.

Two other film speeds are available in the 110 format: ASA 125 and ASA 64. Both cartridges have the same flange as ASA 100 cartridges, therefore the camera is set for ASA 100 when you use either of these film speeds.

You can correct exposure for either of these situations by using the Exposure-Adjustment Control. This has a range of plus or minus two exposure steps and can be set between steps.

Turn the camera on by moving the Shutter-Release Switch from LOCK to ON.

VIEWFINDER

To conserve battery power, the viewfinder display does not operate unless incorrect exposure is likely.

The top, red LED lights up to indicate that the shutter speed required for correct exposure of an average scene is faster than the camera can provide—that is, faster than 1/1000 second.

The bottom, yellow LED indicates that shutter speed will be slower than 1/50 second as a reminder to put the camera on a tripod or other firm support.

These LEDs have other functions. If the batteries are OK, the yellow LED flashes briefly each time an exposure is made,

The red LED serves as a battery-check indicator when you depress the Battery-Check Button on top of the camera. If the batteries are OK, the LED will glow. The red LED also glows when you have set the camera shutter to X or B as a reminder that the camera does not control exposure automatically in these two modes.

Focusing Aid—A microprism focusing aid is in the center of the frame in the viewfinder.

EXPOSURE METER

The CdS exposure meter does not view through the lens. It's in a turret projecting forward from the camera body, combined with the Aperture-Selector. When you turn the Aperture-Selector ring, two things happen. The aperture size is set and the amount of light admitted to the sensor is changed in proportion. Therefore the sensor always "sees" the same amount of light that the lens transmits to the film.

EXPOSURE-ADJUSTMENT CONTROL

On top of the camera, just behind the Aperture Selector, this control moves to the left or right and causes the camera to give more or less exposure than it normally would. The amount of exposure increase or decrease is indi-

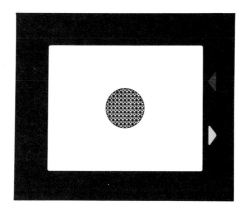

cated in a window adjacent to the control. The range is from +2 to -2 exposure steps. Intermediate settings between marked steps can be used.

When photographing a non-average scene such as a small subject against an unusually light or dark background, this control should be used—as discussed in Chapter 8. You can also use the control to make film-speed adjustments as described earlier in this section.

When using a filter over the lens, a filter-factor correction is often necessary to compensate for light absorbed by the filter. Correction is necessary because the light sensor does not see the same light reduction as the lens. This is another use of the Exposure-Adjustment Control. For example, to adjust for a filter factor of 2X, which means the filter reduces exposure by one step, set the control to +1.

Still another use of this control is to bracket exposures.

FLASH SYNC

A conventional hot shoe accepts any electronic flash unit with a conventional mounting foot. X-sync is provided to the center contact. Physically small flashes such as Minolta Auto Electroflash 25 or 118X are preferred because of the small size of the camera.

A Minolta X-type flash, such as the 118X, *will not* set shutter speed automatically on the 110 Zoom SLR as it does on 35mm

Minolta X-type cameras and the 110 Zoom SLR Mark II.

To be sure shutter speed is not too fast for electronic flash synchronization, set the Shutter-Setting Selector control to X.

Satisfactory operation with electronic flash will occur at any shutter speed slower than the X-sync speed of 1/150 second but there is no way to be sure the shutter speed is that slow when operating in the normal automatic mode, until the yellow LED indicator is turned on at 1/50 second or slower.

POWER

Operating power is derived from two 1.5-volt silver-oxide batteries, S-76 or equivalent, installed in the battery chamber on the right end of the camera body.

Batteries should be tested on installation and periodically thereafter. Depress the red Battery-Check Button on top of the camera and observe the red LED in the viewfinder. If it glows, the batteries are OK.

Low Battery Voltage—If the batteries discharge to the point that they cannot operate the camera correctly on automatic, the viewfinder blind will close and remain closed when you depress the shutter button.

Rotate the Shutter-Setting Selector control to X. This will open the viewfinder blind. Install and test fresh batteries. Advance to the next frame and resume shooting.

With Dead Batteries—If you don't have fresh batteries, you can continue to use the camera in a limited way on B or X which are both mechanically operated shutter speeds.

If the batteries are weak enough that they do not light the battery-check LED in the viewfinder, they may still operate the camera on A but exposure will not be correct.

TRIPOD SOCKET

A tripod socket is on the right end of the camera.

SPECIFICATIONS FOR MINOLTA 35mm SLR CAMERAS

	XD-11	XD-5	XG-9	XG-7
Type	Compact 35mm SLR with electronic focal-plane shutter. Has aperture- and shutter-priority automatic plus metered manual.	Compact 35mm SLR with electronic focal-plane shutter. Has aperture- and shutter-priority automatic plus metered manual.	Compact 35mm SLR with electronic focal-plane shutter. Has aperture-priority automatic plus manual.	Compact 35mm SLR with electronic focal-plane shutter. Has aperture-priority automatic plus manual.
Exposure Range	EV 1 to EV 18	EV 1 to EV 18	EV 2 to EV 17	EV 2 to EV 17
Shutter	Electronic vertical-travel metal focal-plane type with electromagnetic release. Electronic speeds are 1 to 1/1000 second, stepless on automatic or in steps on metered manual. X setting is 1/100 electronic X-sync speed. O setting is mechanical 1/1000 second X-sync. B setting available. Shutter can be set electronically to X-sync by Minolta X-type flash units.	Electronic vertical-travel metal focal-plane type with electromagnetic release. Electronic speeds are 1 to 1/1000 second, stepless on automatic or in steps on metered manual. X setting is 1/100 electronic x-sync speed. O setting is mechanical 1/100 second X-sync. B setting available. Shutter can be set electronically to X-sync by Minolta X-type flash units.	Electronic horizontal-travel cloth focal-plane type with electromagnetic release. Electronic speeds are 1 to 1/1000 second, stepless on automatic or in steps on manual. X-sync speed is 1/60 second. B setting available. Shutter can be set electronically to X-sync by Minolta X-type flash units.	Electronic horizontal-travel cloth focal-plane type with electromagnetic release. Electronic speeds are 1 to 1/1000 second, stepless on automatic or in steps on manual. X-sync speed is 1/60 second. B setting available. Shutter can be set electronically to X-sync by Minolta X-type flash units.
Film Advance	Lever with 130° single stroke or motorized using Auto Winder D.	Lever with 130° single stroke or motorized using Auto Winder D.	Lever with 130° single stroke or motorized using Auto Winder G.	Lever with 130° single stroke or motorized using Auto Winder G.
Metering	Full-aperture, through-the-lens, center weighted, with silicon diode. Film-speed range: ASA 12 to 3200. Exposure adjustment range: + or −2 exposure steps.	Full-aperture, through-the-lens, center weighted, with silicon diode. Film-speed range: ASA 12 to 3200. Exposure-adjustment range: + or −2 exposure steps.	Full-aperture, through-the-lens, center weighted, with CdS cells. Film-speed range: ASA 25 to 1600. Exposure-adjustment range: + or −2 exposure steps.	Full-aperture, through-the-lens, center weighted, with CdS cells. Film-speed range: ASA 25 to 1600. Exposure-adjustment range: + or − 2 exposure steps.
Viewfinder	Fixed eye-level pentaprism	Fixed eye-level pentaprism	Fixed eye-level pentaprism	Fixed eye-level pentaprism
Focusing Screen	Acute Matte, interchangeable at Minolta service centers. Four types available. Standard screen is Acute Matte with horizontal split-image biprism surrounded by a microprism ring.	Acute Matte, interchangeable at Minolta service centers. Four types available. Standard screen is Acute Matte with horizontal split-image biprism surrounded by a microprism ring.	Acute Matte with split-image biprism surrounded by a microprism ring.	Split-image biprism surrounded by microprism ring.
Viewfinder Coverage	94%	94%	93%	93%
Viewfinder Magnification	0.87	0.87	0.9	0.9
Viewfinder Information	On aperture-priority, displays aperture set and shutter speed selected by camera. On shutter-priority, displays lens aperture set, shutter speed set, plus aperture selected by camera. On metered manual, displays aperture set, shutter speed set, plus shutter speed recommended by meter. Over- and Under-range LED indicators. With Minolta X-type flash units, flash-ready signaled by blinking over-range LED.	On aperture-priority, displays shutter speed selected by camera. On shutter-priority, displays aperture selected by camera. On metered manual, displays shutter speed recommended by meter. Over- and Under-range recommended by meter. Over- and Under-range LED indicators. With Minolta X-type flash units, flash-ready signaled by blinking over-range LED.	On automatic, displays aperture set and shutter speed selected by camera. Over- and Under-range LED indicators. With Minolta X-type flash units, flash-ready signaled by blinking LED indicating X-sync speed of 1/60 second.	On automatic, displays shutter speed selected by camera. Over- and Under-range LED indicators. With Minolta X-type flash units, flash-ready signaled by blinking LED indicating X-sync speed of 1/60 second.
Flash Sync	X-sync at hot shoe or X-sync terminal. X-sync speed is 1/100 or slower.	X-sync at hot shoe or X-sync terminal. X-sync speed is 1/100 or slower.	X-sync at hot shoe or X-sync terminal. X-sync speed is 1/60 or slower.	X-sync at hot shoe or X-sync terminal. X-sync speed is 1/60 or slower.
Power Source	Two 1.5V silver oxide batteries. Eveready S-76 or equivalent.	Two 1.5V silver oxide batteries. Eveready S-76 or equivalent.	Two 1.5V silver oxide batteries. Eveready S-76 or equivalent.	Two 1.5V silver oxide batteries. Eveready S-76 or equivalent.
Stop-Down Button	Yes	Yes	Yes	No
Metered Manual	Yes	Yes	No	No
Self-Timer	Mechanical	Mechanical	Electronic	Electronic
Memo Holder	Yes	Yes	Yes	Yes
Multiple Exposure Control	Yes	Yes	No	No
Detachable Back	Yes	Yes	Yes	Yes
Safe-Load Signal	Yes	No	Yes	Yes
Body Size	2 x 3-3/8 x 5-3/8 inches (51 x 86 x 136 mm)	2 x 3-3/8 x 5-3/8 inches (51 x 86 x 136 mm)	2 x 3-7/16 x 5-5/8 inches (52 x 88 x 138 mm)	2 x 3-7/16 x 5-5/8 inches (52 x 88 x 138 mm)
Body Weight	19.7 oz (560 g) without batteries	18.5 oz (525 g) without batteries	17.6 oz (500 g) without batteries	17.8 oz (505 g) without batteries

SPECIFICATIONS FOR MINOLTA 35mm SLR CAMERAS

	XG-1	XK Motor	SR-T 201	SR-T 200
Type	Compact 35mm SLR with electronic focal-plane shutter. Has aperture-priority automatic plus manual.	35mm SLR with electronic focal-plane shutter and built-in motor drive. Has aperture-priority automatic plus metered manual when used with AE-S Finder.	35mm SLR with mechanical focal-plane shutter. Manual exposure control with match-needle metering.	35mm SLR with mechanical focal-plane shutter. Manual exposure control with match-needle metering.
Exposure Range	EV 2 to EV 17	EV 2 to EV 17 for single-frame operation: EV 3 to EV 17 for continuous motor drive.	EV 3 to EV 17	EV 3 to EV 17
Shutter	Electronic horizontal-travel cloth focal-plane type with electromagnetic release. Electronic speeds are 1 to 1/1000 second, stepless on automatic or in steps on manual. X-sync speed is 1/60 second. B setting available. Shutter can be set electronically to X-sync by Minolta X-type flash units.	Electronic horizontal-travel titanium focal-plane type with electromagnetic release. Electronic speeds are 8 to 1/2000 second, stepless on automatic or 16 to 1/2000 in steps on manual. X-sync speed is 1/100 second. B setting available.	Mechanical horizontal-travel cloth focal-plane type. Manual speeds from 1/1000 to 1 second. X-sync speed is 1/60 second. B setting available.	Mechanical horizontal-travel cloth focal-plane type. Manual speeds from 1/1000 second to 1 second. X-sync speed is 1/60 second. B setting available.
Film Advance	Lever with 130° single stroke or motorized using Auto Winder G.	Lever with 110° single- or multiple stroke, or motorized using built-in motor.	Lever with 150° single- or multiple stroke.	Lever with 150° single- or multiple stroke.
Metering	Full-aperture, through-the-lens, center weighted, with CdS cells. Film-speed range: ASA 25 to 1600. Exposure-adjustment range: + or −2 exposure steps.	With AE-S Finder, Full-aperture, through-the-lens, center weighted, with silicon sensor. Film-speed range: ASA 12 to 6400. Exposure-adjustment range: + or −2 exposure steps.	Contrast Light Compensating (CLC) type. Full-aperture, through-the-lens, center weighted, with CdS sensors. Film-speed range: ASA 6 to 6400.	Contrast Light Compensating (CLC) type. Full-aperture, through-the-lens, center weighted, with CdS sensors. Film-speed range: ASA 6 to 6400.
Viewfinder	Fixed eye-level pentaprism	Interchangeable.	Fixed eye-level pentaprism	Fixed eye-level pentaprism
Focusing Screen	Split-image biprism surrounded by microprism ring.	Interchangeable.	Split-image biprism surrounded by microprism ring.	Split-image biprism surrounded by microprism ring.
Viewfinder Coverage	93%	98%	94%	94%
Viewfinder Magnification	0.9	0.8	0.83	0.83
Viewfinder Information	On automatic, displays shutter speed selected by camera. Speeds between 1/30 and 1 second are indicated by a single LED Over- and Under-range LED indicator. With Minolta X-type flash units flash-ready signaled by blinking LED indicating X-sync speed of 1/60 second.	AE-S Finder displays setting of Shutter-Speed/Function Selector: A, X, B or numbered shutter speed. On automatic, displays A, aperture set, and shutter speed selected by camera. On X, displays X, aperture set and X-sync shutter speed of 1/100 second. On B, displays B and aperture set. On manual, displays shutter speed set, aperture set and shutter speed recommended by meter.	Match needles with metering range limit indicators. Battery-check index. Shutter-speed scale with indicator to show shutter speed set.	Match needles with metering range limit indicators. Battery-check index.
Flash Sync	X-sync at hot shoe or X-sync terminal. X-sync speed is 1/60 or slower.	X-sync at hot shoe. X-sync or FP at sync terminal X-sync speed is 1/100 or slower.	X-sync at hot shoe or X-sync terminal. X-sync speed is 1/60 or slower.	X-sync at hot shoe or X-sync terminal. X-sync speed is 1/60 or slower.
Power Source	Two 1.5V silver oxide batteries. Eveready S-76 or equivalent.	Two 1.5V silver oxide batteries for camera: Eveready S-76 or equivalent. Ten 1.5VA AA batteries for motor drive.	One 1.35V mercury battery. Eveready EPX-625 or equivalent.	One 1.35V mercury battery. Eveready EPX-625 or equivalent.
Stop-Down Button	No	Yes	Yes	Yes
Metered Manual	No	Yes, with AE-S Finder	Yes	Yes
Self-Timer	Electronic	By accessory Intervalometer.	Mechanical	No
Memo Holder	No	Yes	Yes	No
Multiple Exposure Control	No	Yes	No	No
Detachable Back	No	Yes	No	No
Safe-Load Signal	Yes	No	No	No
Body Size	2 x 3-7/16 x 5-5/8 inches (52 x 88 x 138 mm)	3-1/4 x 5-3/4 x 6-3/4 inches (83 x 148 x 171 mm) with AE-S Finder and Standard Battery Pack.	1-7/8 x 3-3/4 x 5-3/4 inches (48 x 95 x 145 mm)	1-7/8 x 3-3/4 x 5-3/4 inches (48 x 95 x 145 mm)
Body Weight	17.3 oz (490 g) without batteries	51 oz (1450 g) without batteries, with AE-S Finder and Standard Battery Pack.	24.9 oz (705 g) without batteries	24.3 oz (690 g) without batteries

NOTE: Exposure range given in EV numbers assumes ASA 100 film and f-1.4 lens.

15 MINOLTA 35mm SLR CAMERAS

This chapter describes current 35mm Minolta cameras. The preceding specifications table has basic information on each model and is arranged so you can quickly compare the specifications.

The camera descriptions are intended to be factual and complete but without explanations and basic theory that were covered earlier in this book.

Major accessories are listed for each camera. Most of these accessories were described in earlier chapters because they can be used on more than one model. The XK Motor camera has several accessories that are used with this camera only. They were not included in earlier chapters but are described in this chapter.

XD CAMERAS

For a long time, users of automatic cameras debated the question: Which is better, aperture-priority or shutter-priority? Of course the answer depends on how the camera is to be used and what you intend to photograph.

A major advantage of XD cameras is that they have a built-in answer to that question. They have both aperture-priority and shutter-priority automatic exposure and can also be used with manual control.

Cameras in the XD series are the first 35mm Minoltas that set lens aperture automatically and a new series of lenses was introduced with these cameras. The new MD lenses are the only lenses that can be used in the shutter-priority mode on XD cameras.

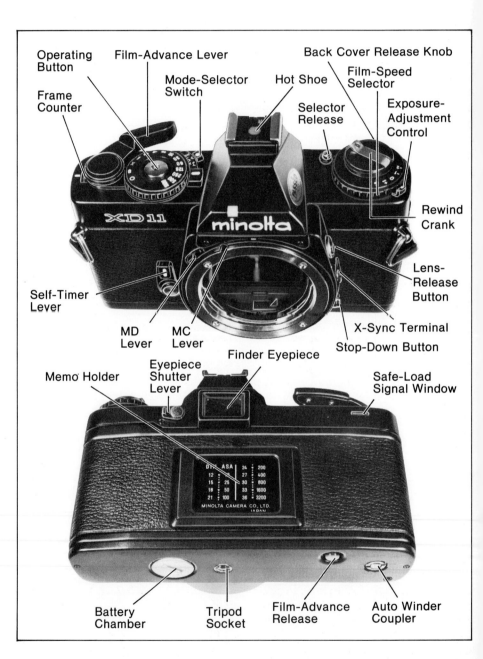

XD-11

The XD-11 was the first camera with both shutter-priority and aperture-priority automatic exposure plus metered manual operation. Detailed specifications are in the table preceding this chapter.

Convenience features of this model include a memo holder on the back cover and a built-in Eyepiece Shutter for use when your eye is not at the viewfinder. The camera can use an accessory data back and auto winder.

The XD-11 is available either with a black-and-silver body or all

black. The metal parts of the black body are not painted black—the surface is black chrome which is more durable than a painted black surface.

LENSES

MD lenses are the only lenses that can be used with shutter-priority automatic operation on XD cameras. Of course, they can also be used on aperture-priority automatic and manual. These lenses have automatic diaphragm and provide full-aperture metering. They use the standard Minolta bayonet mount and attach to the camera in the standard way. Minolta MC lenses can be used for aperture-priority automatic and manual, but not on shutter-priority automatic. Using other types of lenses is discussed later.

OPERATING THE CAMERA

The camera uses two 1.5-volt silver-oxide batteries, S-76 or equivalent. Remove the Battery-Chamber Cover on the bottom, using a coin or something similar, and insert the batteries observing the polarity markings on the inside of the cover. If the LED viewfinder display works properly, the batteries are OK. The effect of discharged batteries is discussed later.

Load a cartridge of 35mm film in the standard way as shown in Chapter 5. During the loading procedure, be sure to set film speed by turning the Film-Speed Selector while depressing the Selector Release Button.

Choose one of the three modes of operation by moving the Mode-Selector Switch to M for Manual operation; A to select Aperture-priority automatic; or S to select Shutter-priority automatic operation.

When selecting S for shutter-priority, you must also set the Minolta MD lens to minimum aperture. Both the symbol S on the Mode Selector and the minimum aperture setting of MD lenses are colored green as a

The XD-11 and most Minoltas have a hole in the battery-chamber cover so you can see if batteries are loaded. The darker surface in the bottom of the groove is a battery.

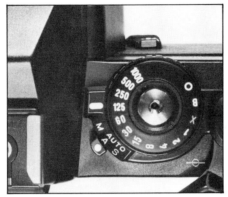

XD cameras have three modes: Manual (M), and two AUTO settings; Aperture-priority (A) and Shutter-priority (S). This camera is set to A.

reminder that both settings should be made for shutter-priority operation.

Compose and focus the image. Partially depress the Operating Button—also called *shutter button*—to turn on the viewfinder exposure display. Observe the display and adjust camera controls as necessary for correct exposure. Depress the shutter button fully to make the exposure. Advance the next frame using the Film-Advance Lever.

SAFE-LOAD SIGNAL

After loading the camera, check the Safe-Load Signal Window. When film is loaded correctly and advanced to frame 1, a red bar should appear at the left end of the window. If the bar does not appear, or appears at the far right, open the camera and double-check the loading. As you expose

frames, the red bar will move across the window, from left to right, indicating that film is loaded correctly and advancing correctly.

METERING SYSTEM

The camera metering system controls exposure on both automatic settings. It also provides an exposure display as a reference on manual operation to show the exposure settings the camera "thinks" you should use—called *metered manual*.

The light sensor is a silicon photo diode in the viewfinder housing. Metering range and automatic-exposure range is EV 1 to EV 18. Metering pattern is center-weighted.

SHUTTER SPEEDS

Numbered speeds are from 1 second to 1/1000 second in standard steps. You should always set the dial exactly on a marked speed, not in between.

On Manual—The camera will operate at the standard shutter speed you have selected on the dial.

On Shutter-Priority Automatic—The camera will use the standard shutter speed selected on the dial as a reference point while it sets aperture size. Then, the final-check feature of the camera takes over and adjusts shutter speed as necessary for correct exposure. The actual shutter speed used to make the exposure is selected steplessly—that is, it does not have to be one of the standard speeds on the dial.

On Aperture-Priority—The camera uses whatever shutter speed is needed—within its range—for correct exposure whether it is a standard speed or not. This selection of shutter speed is also stepless.

Special Settings—Three settings are identified with letters: X is an electronically controlled speed of 1/100 second which is X-sync speed. O is also X-sync speed but is mechanically operated and can be used with dead batteries. B is

XD-11 VIEWFINDER DISPLAY

Set the Mode Selector to M, A or S to select Manual, Aperture-priority automatic exposure control or Shutter-priority automatic. The exposure display is different for each setting.

ON APERTURE-PRIORITY AUTOMATIC

In this mode, the aperture setting you made is displayed at the bottom. On the right, the shutter speed selected by the XD-11 is indicated by a glowing LED beside a scale of shutter speeds. This shutter speed should give correct exposure of an average scene.

ON MANUAL

When you are controlling exposure, the XD-11 shows settings made by you at the bottom of the screen. At right, a scale of shutter speeds appears and an LED indicates the shutter speed recommended by the camera meter for correct exposure of an average scene. Use it, or not, as you choose.

ON SHUTTER-PRIORITY AUTOMATIC

The XD-11 shows aperture setting so you can verify that it is set to minimum aperture size, and the shutter-speed setting you made. On shutter-priority, the scale at right changes to show f-numbers from f-1.4 to f-32. LED indicates the aperture selected by the camera for correct exposure of an average scene.

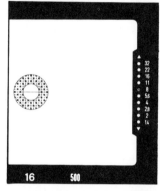

also mechanically operated and causes the shutter to remain open as long as you hold the shutter button depressed with your finger or a cable release.

VIEWFINDER DISPLAY

The XD-11 viewfinder has an optical system that overhangs the lens and looks downward at the lens to view the actual setting of the aperture ring. In all modes of operation, the lens aperture setting is visible in the viewfinder. You see it in a window at the bottom of the viewfinder, just below the frame.

If you choose one of the *numbered* shutter-speed settings, what you see in the viewfinder depends on the mode of operation.

On Manual—The display shows the shutter speed you have set on the camera Shutter-Speed Selector and the aperture setting you made on the lens. In addition, the display shows the shutter speed the camera "recommends" that you use, assuming you are photographing an average scene.

The camera-recommended shutter speed is indicated by an LED that glows opposite one shutter speed on a scale of shutter speeds visible at the right side of the frame. If two LEDs glow to indicate two adjacent shutter speeds, the actual operating speed will be between the two indicated speeds.

On Aperture-Priority—The display shows the *f*-number set on the lens aperture ring and an LED indicator opposite a shutter-speed scale in the viewfinder shows the shutter speed selected by the camera to make the exposure.

The viewfinder display does not show the setting of the Shutter-Speed Selector in the aperture-priority mode, because it doesn't matter what it is—the camera chooses shutter speed automatically.

However, you must have the Shutter-Speed Selector set at one of the *numbered* shutter speeds. If not, the over-range indicator at

XD-11 FLASH SYNCHRONIZATION		
Flash	**Camera Mode**	**Shutter Speed**
Minolta X-type	Any	When shutter speed set to any numbered setting, flash automatically switches camera to X-sync shutter speed of 1/100 second. X setting is 1/100, electronically controlled. O is 1/100, mechanically controlled. B will fire flash when first curtain opens.
Other Electronic Flash	M	Use X, O, B, or 1/60 to 1 second.
M or MF Flash Bulbs	M	Use B or 1/15 to 1 second.
FP Flash Bulbs	M	Use B or 1/15 to 1 second.

the top of the shutter-speed scale in the viewfinder glows to tell you that the camera controls are not set correctly for use on automatic exposure.

On Shutter-Priority—The viewfinder display shows the numbered shutter-speed setting on the Shutter-Speed Selector, and the aperture size the camera will use. Aperture is indicated by a glowing LED against a scale of aperture numbers along the right side of the viewfinder.

In addition, you can see the setting of the lens aperture ring so you can verify that it is set to minimum aperture—which is necessary for shutter-priority operation. Both the letter S, on the Mode Selector Switch, and the minimum aperture number on the lens are colored green to remind you that these two settings should be made together.

If you forget to set the lens to minimum aperture, the camera still operates with shutter priority but in a limited way. The exposure display does not work normally and the range of apertures that can be selected by the camera is only from maximum aperture to whatever aperture value is set on the aperture ring. This is referred to as abbreviated shutter priority in Chapter 8.

The Scale Changes—Please notice that when you switch from aperture priority to shutter priority the scale of numbers along the right side of the viewfinder also changes. On aperture priority, it displays shutter speeds. On shutter priority, it displays aperture sizes.

X, B, or O Settings—In all three modes of operation, if you select X, B or O on the Shutter-Speed Selector, the LED over-range indicator in the upper right corner of the viewfinder will glow to remind you that you have chosen one of these special shutter-speeds. If the camera is on either of the automatic modes, this is also a reminder that the camera does not control exposure automatically on these settings.

On manual or shutter-priority automatic, the viewfinder display shows which of these three settings you have made.

OVER-RANGE AND UNDER-RANGE INDICATORS

The red triangle at the top of the scale in the viewfinder is called the *over-range indicator*. The red triangle at the bottom of the scale is called the *under-range indicator.* They do not necessarily indicate overexposure or underexposure.

On Manual—The display is independent of the actual camera control settings. If the red triangle above the scale glows, it means the camera "thinks" there is no shutter speed setting fast enough to give correct exposure with the aperture you have chosen.

If the red triangle opposite 1 second glows, it means that a shutter speed of 1 second or slower would be selected by the camera if it were on automatic. This shutter speed is likely to cause reciprocity failure of the film which requires compensation, and the camera meter may be operating near or below its lower limit of accuracy.

On manual, the exposure display is only for your information. The best reason to operate on manual is to make settings that will be different than those the camera would make on automatic. Therefore you can disregard the over-range and under-range indication and shoot as you choose.

On Aperture-Priority—The upper red triangle indicates that a shutter speed faster than 1/1000 second is required for correct exposure of an average scene. This shutter-speed is not possible.

If you shoot with the over-range indicator lit, overexposure is likely. You should normally select smaller aperture if possible so the display indicates a shutter speed of 1/1000 or slower.

The lower red triangle is opposite a shutter speed of 1 second. If it glows, it means shutter speed will be 1 second or

slower. This shutter speed is likely to cause reciprocity failure of the film which requires compensation, and the camera meter may be operating near or below its lower limit of accuracy.

On Shutter-Priority—Increasing light from the scene causes the camera to select smaller and smaller aperture sizes until the minimum aperture of the lens is reached. If the light is still brighter, the red over-range indicator above the *f*-number scale will glow. This suggests that you should change to a faster shutter speed if possible, so the camera can select an aperture setting that can be made on the lens.

If you shoot with the over-range indicator lit, the camera will automatically readjust shutter speed if possible to give correct exposure. It will not use the shutter-speed setting you made on the dial—it will use any shutter speed within the shutter-speed range to get correct exposure. This is the result of the final-check feature described in Chapter 8. If the camera cannot select a shutter speed that gives correct exposure, then the over-range indicator warns of over-exposure.

If the red under-range indicator glows it means the largest lens aperture is not large enough to give correct exposure with the shutter speed you have selected. This is a suggestion to use a slower shutter speed.

If You Shoot with the Under-Exposure Indicator Lit—In either of the automatic modes, if you depress the shutter button with the under-range indicator glowing, the shutter will open. If there is enough light to make what the camera considers to be correct exposure, not including compensation for reciprocity failure, the shutter will close again at the end of the exposure.

If the amount of light is below the operating range of the camera, the mirror will remain up for a relatively long time and the shutter will remain open. Eventually

the shutter will close and the mirror will come down again. To restore normal operation without waiting, change the shutter-speed setting to X and then back to its previous setting. Advance the film and resume shooting.

FOCUSING SCREEN

The focusing aid in the standard screen supplied with the camera is a horizontal biprism surrounded by a microprism ring. Minolta literature refers to a biprism as a split-image rangefinder. Focusing screens can be interchanged at authorized Minolta service centers. You can choose among those shown in Chapter 4. They are the Acute Matte type which is visibly brighter than an ordinary matte surface.

DEPTH-OF-FIELD PREVIEW

The Stop-Down Button closes lens aperture to the value selected on the aperture ring so you can see depth of field when desired.

SELF-TIMER

The self-timer is mechanically operated. To set, turn the Self-Timer Lever counterclockwise as far as it will go. It will latch in that position and remain so until you depress the shutter button. Then the lever will rotate clockwise and trip the shutter just before the lever reaches its normal position. There will be about 10 seconds delay between pressing the shutter button and the exposure.

You can choose less delay by rotating the lever a smaller amount when setting the timer. If it does not latch at all, you have not rotated it far enough to set the mechanism. If you rotate the Self-Timer Lever counterclockwise to the *first point* where it will latch, you have set the timer mechanism for zero delay. The shutter will operate immediately when you depress the shutter button.

If your eye is not at the viewfinder eyepiece when using the self-timer with the camera on either of the automatic modes, be

Eyepiece-Shutter Lever at left of the eyepiece closes the Eyepiece Shutter. When the shutter is closed, a white dot is visible in the eyepiece so you know why you can't see anything through the camera. This shutter is open.

sure to close the Eyepiece Shutter using the lever just left of the eyepiece. Otherwise, light entering the camera through the eyepiece may cause incorrect exposure.

The self-timer mechanism cannot be canceled. You must use it on the next frame you shoot, however you can defeat it by making the next exposure with the lens cap in place so there is no image on the film. Then use the multiple-exposure procedure to reset the camera and expose the frame as you choose.

EXPOSURE-ADJUSTMENT CONTROL

On the ring surrounding the rewind knob is a movable Exposure-Adjustment Control and an exposure-adjustment scale ranging from -2 to +2 exposure steps. To use the control, press it toward the scale and move it along the scale until the white index mark aligns with the desired amount of exposure adjustment.

Detents—also called click stops—hold the control at full steps. The control works and can be used between full steps but there are no detents to hold the setting.

The effect of using the control shows in the viewfinder on the scale at the right of the frame. On manual and aperture priority, the indicated shutter speed will

change. On shutter priority, the indicated aperture will change as you move the control.

The normal setting is 0. Be sure it is returned to the zero setting when you don't want exposure adjustment.

This control has the same effect as changing film speed but it cannot be used to extend the film-speed range of the camera. That is, when the film-speed dial is set to the maximum speed, you cannot reduce exposure still more by selecting -1 or -2 on the Exposure-Adjustment Control. Similarly, when the lowest film speed has been selected, you cannot get more exposure by moving the Exposure-Adjustment Control to +1 or +2.

FLASH TERMINAL & HOT SHOE

The camera provides X-sync only. Electronic flash can be used at the X-sync speed of 1/100 second or any slower shutter speed. Flashbulbs can also be used even though they are fired with X-sync. See the accompanying Flash-Sync Table.

The hot shoe has a center contact to fire the flash and an auxiliary contact called the Flash-Signal Input Terminal. This contact allows the camera to be set to X-sync shutter speed automatically by Minolta X-type electronic flashes such as Auto Electroflash 200X. See Chapter 11. The hot shoe is "hot" only when a flash unit is mounted in the shoe. The flash terminal on the camera body is "hot" all the time. Two flashes can be used simultaneously, one in the hot shoe and one connected to the flash terminal.

FLASH-READY SIGNAL

When using an X-type Minolta Auto Electroflash mounted in the hot shoe, the over-range LED indicator in the viewfinder serves as a flash-ready indicator. It blinks to indicate that the flash is ready to fire and the camera will operate at the X-sync shutter speed.

MULTIPLE EXPOSURES

The Film-Advance Release—also called the rewind button—on the bottom of the camera also serves as the multiple-exposure control. The procedure is:

1. Make the first exposure in the usual way.
2. Depress the Film-Advance Release Button until it clicks. Don't hold it in.
3. Operate the Film-Advance Lever one full stroke.
4. Make another exposure.
5. For additional exposures on the same frame, repeat steps 2, 3, and 4.

After the last multiple exposure, *do not* depress the Film-Advance Release Button. Advance film to the next frame.

The Frame Counter stops counting while you make multiple exposures.

STOPPED-DOWN METERING

When using lenses without a meter-coupling MC pin, full-aperture metering is not possible. Therefore stopped-down metering is necessary.

If the lens has automatic diaphragm, aperture will remain open unless you stop down the lens manually. Push in the Stop-Down Button on the camera body and hold it in while setting the camera exposure controls.

You can release the Stop-Down Button to make the exposure because the camera will close lens aperture to the set value during the metering sequence. On either of the automatic modes, the camera makes final exposure adjustments after it stops down.

Mirror lenses don't have an adjustable aperture. The amount of light is changed by using ND filters on the lens. These lenses are always metered stopped down but you don't have to do anything special at the camera.

Similarly, MD and MC lenses lose their automatic features when installed on non-automatic accessories such as non-auto

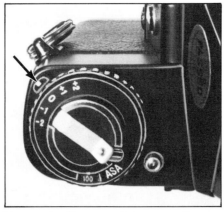

To use the Exposure-Adjustment Control, with the camera on either of the automatic modes, press inward on the lever (arrow) and move it so the white index mark aligns with the amount of exposure adjustment you want. This camera is set to 0, which is the normal setting.

extension tubes or bellows. When so used, these lenses change aperture size as you rotate the lens aperture ring. They are metered stopped down but you don't have to push the camera stop-down button.

USING OLDER LENSES

Besides MD lenses, virtually all Minolta SLR lenses can be used on aperture-priority or manual modes.

MC Lenses—Should be used only on aperture priority automatic or manual modes. If used on shutter-priority mode, only the under-range or over-range indicators will function and improper exposure will result.

Auto Rokkor—Because these lenses don't have a meter-coupling pin, metering is by the stop-down method:
1. After focusing, push the stop-down button all the way in.
2. Choose a suitable aperture for aperture-priority operation, or set both shutter and aperture for manual operation.
3. Check the exposure display to verify that the settings are within range, release the stop-down button and make the exposure.

RF (Mirror) and Manual Preset Lenses—Proceed as described for Auto Rokkor lenses except that you don't have to depress the stop-down button.

When using the Rokkor-X APO 400mm *f*-5.6 lens with its 2X Tele Converter, use only aperture-priority or manual modes. When using the 35mm *f*-2.8 CA Shift lens, use manual only and meter with the lens not shifted.

BATTERY CHECK

If the LED indicators have normal brightness, batteries are OK.

DEAD BATTERIES

If the batteries are discharged or missing, the camera will not operate on any of the electronically controlled shutter speeds. It will work on B or at 1/100 second on O because these are mechanically controlled speeds.

CABLE RELEASES

The Operating Button is threaded to accept a cable release. Two types can be used. Minolta Remote Cords S and L make an electrical connection to the camera and operate by an electrical pushbutton switch on the far end of the cable. To make long time exposures on B, hold the pushbutton down with your finger.

This camera will also accept the standard mechanical cable release. If you use the type that can be locked to hold the shutter open, you can make long time exposures on B without the necessity of holding the plunger in with your finger.

SPECIAL PRECAUTIONS

Use only manual or aperture-priority automatic with an extension device between camera and lens. This includes the 50mm and 100mm macro lenses used with their life-size adapters. This does not include the 300S and 300L Tele Converters.

MAJOR ACCESSORIES

Available accessory items include Minolta interchangeable lenses, Auto Winder D, Minolta Auto Electroflash units, Remote Cords S and L, Data Back D, extension tubes and bellows units.

XD-5

The XD-5 is basically the same as the XD-11 except that some features of the XD-11 are not included in the XD-5. Detailed specifications are in the table preceding this chapter.

Here is a summary of the differences: The XD-5 does not have the optical "periscope" and viewfinder display that lets you see *f*-numbers set on the lens. It also does not display the setting of the Shutter-Speed Selector in a window in the viewfinder. The only viewfinder exposure display is an LED to indicate aperture or shutter speed selected by the camera.

On shutter-priority automatic, the LED viewfinder display indicates aperture size selected by the camera. If you want to know shutter speed, look at the Shutter-Speed Selector dial, or remember where you set it.

On aperture-priority automatic, the LED viewfinder display indicates shutter speed selected by the camera. If you want to know lens aperture, look at the lens aperture ring, or remember where you set it.

On manual, an LED indicates shutter speed recommended by the camera. To see the actual control settings, you must look at the lens and look at the Shutter-Speed Selector dial.

In all three modes of operation, the XD-5 gives you the same information as the XD-11 but it is not as convenient. Instead of having all the information displayed in the viewfinder you have to hold the camera away from your eye and check control settings for some of the information.

The XD-5 does not have a Safe-Load Indicator but you can confirm correct loading and film advance by watching the rewind knob turn as you advance film.

The XD-5 does not have a built-in eyepiece shutter. Instead, a separate Eyepiece Cap is placed over the viewfinder eyepiece when needed. The Eyepiece Cap has a slot that threads it onto the camera

strap for safe keeping. Aside from these differences, the XD-5 is basically the same as XD-11.

LENSES

MD lenses can be used with aperture-priority automatic, shutter-priority automatic or metered manual operation on XD cameras. These lenses have automatic diaphragm and provide full-aperture metering. They use the standard Minolta bayonet mount and attach to the camera in the standard way. Minolta MC lenses can be used for aperture-priority automatic and manual, but not on shutter-priority automatic. Using other types of lenses is discussed later.

OPERATING THE CAMERA

The camera uses two 1.5-volt silver-oxide batteries, S-76 or equivalent. Remove the Battery-Chamber Cover on the bottom,

using a coin or something similar, and insert the batteries observing the polarity markings inside the cover. If the LED viewfinder display works properly, the batteries are OK. The effect of discharged batteries is discussed later.

Load a cartridge of 35mm film in the standard way as shown in Chapter 5. During the loading procedure, be sure to set film speed by turning the Film-Speed Selector while depressing the Selector Release Button.

Choose one of the three modes of operation by moving the Mode-Selector Switch to **M, A** or **S** to select Manual, Aperture-priority or Shutter-priority automatic operation. When selecting **S** for shutter-priority, you must also set the Minolta MD lens to minimum aperture which is colored green on the lens aperture scale as a reminder.

Compose and focus the image. Partially depress the Operating Button—also called *shutter button*—to turn on the viewfinder exposure display. Observe the display and adjust camera controls as necessary for correct exposure. Depress the shutter button fully to make the exposure. Advance the next frame with the Film-Advance Lever.

METERING SYSTEM
The camera metering system controls exposure on both automatic settings. It also provides an exposure display as a reference on manual operation to how the exposure settings the camera "thinks" you should use—called Metered Manual.

The light sensor is a silicon photo diode in the viewfinder housing. Metering range and automatic-exposure range is EV1 to EV 18 at ASA 100 with *f*-1.4. Metering pattern is center-weighted.

SHUTTER SPEEDS
Numbered speeds are from 1 second to 1/1000 second in standard steps. You should always set

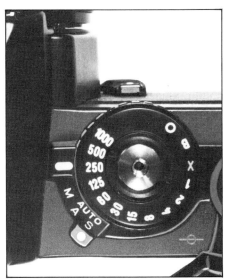

Operation of the XD-5 is controlled by the Mode Selector and the Shutter-Speed Selector, in combination with lens aperture and film-speed settings.

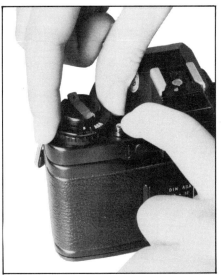

Set ASA film speed by depressing the pushbutton near the ASA Film-Speed Window while rotating the rim of the Film-Speed Selector to place the desired film-speed number in the window. The Exposure-Adjustment Control is similar to the XD-11.

XD-5 FLASH SYNCHRONIZATION		
Flash	**Camera Mode**	**Shutter Speed**
Minolta X-type	Any	When shutter speed set to any numbered setting, flash automatically switches camera to X-sync shutter speed of 1/100 second. X setting is 1/100, electronically controlled. O is 1/100, mechanically controlled. B will fire flash when first curtain opens.
Other Electronic Flash	M	Use X, O, B, or 1/60 to 1 second.
M or MF Flash Bulbs	M	Use B or 1/15 to 1 second.
FP Flash Bulbs	M	Use B or 1/15 to 1 second.

the dial exactly on a marked speed, not in between.

On Manual—The camera will operate at the shutter speed you have selected on the dial.

On Shutter-Priority—The camera will use the standard shutter speed selected on the dial as a reference point while it sets aperture size. Then, the final-check feature of the camera takes over and adjusts shutter speed as necessary for correct exposure. The actual shutter speed used to make the exposure is selected steplessly—it does not have to be one of the speeds on the dial.

On Aperture-Priority—The camera uses whatever shutter speed is needed for correct exposure—also stepless selection of shutter speed.

Special Settings—Three settings are identified with letters: X is an electronically controlled speed of 1/100 second which is X-sync speed. O is also X-sync speed but is mechanically operated and can be used with dead batteries. B is also mechanically operated and causes the shutter to remain open as long as you hold the shutter button depressed with your finger or a cable release.

XD-5 VIEWFINDER DISPLAY

ON MANUAL	ON APERTURE-PRIORITY	ON SHUTTER-PRIORITY
When you are setting exposure on an XD-5, you set both aperture and shutter speed. A red LED glows on the scale at right to show the camera-recommended shutter speed for the aperture you have selected. You can use this shutter-speed setting, or not, as you choose.	When you choose aperture, the XD-5 chooses correct shutter speed for an average scene. The shutter speed selected by the camera is indicated by a glowing LED beside the scale of shutter speeds at right.	When you choose shutter speed, the XD-5 chooses correct aperture size for an average scene. The aperture selected by the camera is indicated by a glowing LED beside the scale of *f*-numbers at right.

VIEWFINDER DISPLAY

In all three modes of operation, if you select X, O or B on the Shutter-Speed Selector, the LED over-range indicator in the upper right corner of the viewfinder will glow to remind you that you have chosen one of these special shutter-speeds. If the camera is on either automatic mode, this is also a reminder that the camera does not control exposure automatically on these settings.

If you choose one of the *numbered* shutter-speed settings, what you see in the viewfinder depends on the mode of operation.

On Manual—The display shows what shutter speed the camera "recommends" that you use, assuming you are photographing an average scene. The camera-recommended shutter speed is indicated by an LED that glows opposite one shutter speed on a scale of shutter speeds visible at the right side of the frame.

On Aperture-Priority—The display shows the shutter speed selected by the camera to make the exposure. You must have the Shut-ter-Speed Selector set at one of the numbered shutter speeds. If not, the over-range indicator at the top of the shutter-speed scale in the viewfinder glows to tell you that the camera controls are not set correctly for automatic exposure.

On Shutter-Priority—The viewfinder display shows the aperture size the camera will use to make the exposure. Aperture is indicated by a glowing LED against a scale of aperture numbers along the right side of the viewfinder.

If you forget to set the lens to minimum aperture, the camera still operates with shutter priority but in a limited way. The exposure display does not work normally and the range of apertures that can be selected by the camera is only from maximum aperture to whatever aperture value is set on the aperture ring. This is referred to as abbreviated shutter priority in Chapter 8.

The Scale Changes—Please notice that when you switch from aperture priority to shutter priority the scale of numbers along the right side of the viewfinder changes also. On aperture priority, it displays shutter speeds. On shutter priority, it displays aperture sizes.

OVER-RANGE AND UNDER-RANGE INDICATORS

The red triangle at the top of the scale in the viewfinder is called the *over-range indicator*. The red triangle at the bottom of the scale is called the *under-range indicator*. They do not necessarily indicate overexposure or under exposure.

On Manual—The display is independent of the actual camera control settings. If the red triangle above the scale glows, it means the camera "thinks" there is no shutter speed setting fast enough to give correct exposure with the aperture you have chosen.

If the red triangle opposite 1 second glows, it means that a shutter speed of 1 second or slower would be selected by the camera if it were on automatic. This shutter speed is likely to cause reciprocity failure of the film which requires compensation, and the camera meter may be operating near or below its lower limit of accuracy.

On manual, the exposure display is only for your information. Therefore you can disregard the over-range and under-range indication and shoot as you choose.

On Aperture-Priority—The upper red triangle indicates that a shutter speed faster than 1/1000 second is required for correct exposure of an average scene. This shutter-speed is not possible.

If you shoot with the over-range indicator lit, overexposure is likely. You should normally select smaller aperture if possible so the display indicates a shutter speed of 1/1000 or slower.

The lower red triangle is opposite a shutter speed of 1 second. If it glows, it means shutter speed will be 1 second or slower. This shutter speed is likely to cause reciprocity failure of the film which requires compensation, and the camera meter may be operating near or below its lower limit of accuracy.

On Shutter-Priority—Increasing light from the scene causes the camera to select smaller and smaller aperture sizes until the minimum aperture of the lens is reached. If the light is still brighter, the red over-range indicator above the f-number scale will glow. This suggests that you should change to a faster shutter speed if possible, so the camera can select an aperture setting that can be made on the lens.

If you shoot with the over-range indicator lit, the camera will automatically readjust shutter speed if possible to give correct exposure.

If the camera cannot select a shutter speed that gives correct exposure, then the over-range indicator warns of over-exposure.

If the red under-range indicator glows it means the largest lens aperture is not large enough to give correct exposure with the shutter speed you have selected. This is a suggestion to use a slower shutter speed.

If You Shoot With The Under-Exposure Indicator Lit—In either of the automatic modes, if you depress the shutter button with the under-range indicator glowing, the shutter will open. If there is enough light to make what the camera considers to be correct exposure, not including compensation for reciprocity failure, the shutter will close again at the end of the exposure.

If the amount of light is below the operating range of the camera, the mirror will remain up for a relatively long time and the shutter will remain open. Eventually the shutter will close and the mirror will come down again. To restore normal operation without waiting, change the shutter-speed setting to **X** and then back to its previous setting. Advance the film and resume shooting.

FOCUSING SCREEN

The focusing aid in the standard screen supplied with the camera is a horizontal biprism surrounded by a microprism ring. Minolta literature refers to a biprism as a split-image rangefinder. Focusing screens can be interchanged at authorized Minolta service centers. You can choose among those shown in Chapter 4. They are the Acute Matte type which is visibly brighter than an ordinary matte surface.

DEPTH-OF-FIELD PREVIEW

The Stop-Down Button closes lens aperture to the size selected on the aperture ring so you can see depth of field when desired.

SELF-TIMER

The self-timer is mechanically operated. To set, turn the Self-Timer Lever counterclockwise as far as it will go. It will latch in that position and remain so until you depress the shutter button. Then the lever will rotate clockwise and trip the shutter just before the lever reaches its normal position. There will be about 10 seconds delay between pressing the shutter button and the exposure.

You can choose less delay by rotating the lever a smaller amount when setting the timer.

If your eye is not at the viewfinder when using the self-timer with the camera on either of the automatic modes, cover the eyepiece with the Eyepice Cap supplied with the camera. Otherwise, light entering the camera through the eyepiece may cause incorrect exposure.

The self-timer mechanism cannot be canceled. You must use it on the next frame you shoot, however you can defeat it by making the next exposure with the lens cap in place so there is no image on the film. Then use the multiple-exposure procedure to reset the camera and expose the frame as you choose.

EXPOSURE-ADJUSTMENT CONTROL

On the ring surrounding the rewind knob is a movable Exposure-Adjustment Control and an exposure-adjustment scale ranging from -2 to +2 exposure steps. To use the control, press it toward the scale and move it along the scale until the white index mark aligns with the desired amount of exposure adjustment. Detents hold the control at full steps. The control works and can be used at settings between steps but there are no detents to hold the setting.

The effect of using the control shows in the viewfinder on the scale at the right of the frame. On manual and aperture priority, indicated shutter speed will change. On shutter priority, indicated aperture will change as you move the control.

The normal setting is 0. Be sure it is returned to the zero setting when you don't want exposure adjustment.

This control has the same effect as changing film speed but it cannot be used to extend the film-speed range of the camera.

FLASH TERMINAL & HOT SHOE

The camera provides X-sync

only. Electronic flash can be used at the X-sync speed of 1/100 second or any slower shutter-speed. Flashbulbs can also be used.

The hot shoe has a center contact to fire the flash and an auxiliary contact called the Flash-Signal Input Terminal. This contact allows the camera to be set to X-sync shutter speed automatically by Minolta X-type electronic flashes such as Auto Electroflash 200X. See Chapter 11. The hot shoe is "hot" only when a flash unit is mounted in the shoe. The flash terminal on the camera body is "hot" all the time. Two flashes can be used simultaneously, one in the hot shoe and one connected to the flash terminal.

FLASH-READY SIGNAL

When using an X-type Minolta Auto Electroflash mounted in the hot shoe, the over-range LED indicator in the viewfinder also serves as a flash-ready indicator. It blinks to indicate that the flash is ready to fire and the camera will operate at the X-sync shutter speed.

MULTIPLE EXPOSURES

The Film-Advance Release Button—also called the rewind button—on the bottom of the camera also serves as the multiple-exposure control. The procedure is:
1. Make the first exposure in the usual way.
2. Depress the Film-Advance Release Button until it clicks. Don't hold it in.
3. Operate the Film-Advance Lever one full stroke.
4. Make another exposure.
5. For additional exposures on the same frame, repeat 2, 3 and 4.

After the last multiple exposure, do not depress the Film-Advance Release Button. Advance film to the next frame.

The Frame Counter stops counting while you make multiple exposures.

STOPPED-DOWN METERING

When using lenses without a meter-coupling MC pin, full-aperture metering is not possible. Therefore stopped-down metering is necessary.

If the lens has automatic diaphragm, the aperture will remain open unless you stop down the lens manually. Push in the Stop-Down Button on the camera body and hold it in while setting the camera exposure controls. You can release the Stop-Down Button to make the exposure because the camera will close lens aperture to the set value during the exposure sequence. On either of the automatic modes, the camera sets exposure after it stops down the lens.

Mirror lenses don't have an adjustable aperture. The amount of light is changed by using ND filters on the lens. These lenses are always metered stopped down but you don't have to do anything special at the camera.

MD and MC lenses lose their automatic features when installed on non-automatic accessories such as non-auto extension tubes or bellows. When so used, these lenses change aperture size as you rotate the lens aperture ring. They are metered stopped down but you don't have to push the stop-down button.

USING OLDER LENSES

Besides MD lenses, virtually all Minolta SLR lenses can be used on aperture-priority or manual modes.

MC Lenses—Should be used only on aperture priority automatic or manual modes. If used on shutter-priority mode, only the under-range or over-range indicators will function and improper exposure will result.

Auto Rokkor—Because these lenses don't have a meter-coupling pin, metering is by the stop-down method:
1. After focusing, push the stop-down button all the way in.
2. Choose a suitable aperture for aperture-priority operation, or set both shutter and aperture for manual operation.
3. Check the exposure display to verify that the settings are within range, release the stop-down button and make the exposure.

RF (Mirror) and Manual Preset Lenses—Proceed as described for Auto Rokkor lenses except that you don't have to depress the stop-down button.

When using the Rokkor-X APO 400mm f-5.6 lens with its 2X Tele Converter, use only aperture-priority or manual modes. When using the 35mm f-2.8 CA Shift lens, use manual only and meter with the lens not shifted.

BATTERY CHECK

If the LED indicators in the viewfinder have normal brightness, the batteries are OK.

DEAD BATTERIES

If the batteries are discharged or missing, the camera will not operate on any of the electronically controlled shutter speeds. It will work on B or or at 1/100 second on O because these are mechanically controlled speeds.

CABLE RELEASES

The Operating Button is threaded to accept a cable release. Two types can be used. Minolta Remote Cords S and L make an electrical connection.

This camera will also accept the standard mechanical cable release.

SPECIAL PRECAUTIONS

Use only manual or aperture-priority automatic with an extension device between camera and lens. This includes the 50mm and 100mm macro lenses used with their life-size adapters. This does not include the 300S and 300L Tele Converters.

MAJOR ACCESSORIES

Available accessory items include Minolta lenses, Auto Winder D, Minolta Auto Electroflash units, Remote Cords S and L, Data Back D, extension tubes and bellow units.

XG CAMERAS

This series offers manual control or aperture-priority automatic operation—you set lens aperture; the camera sets shutter speed and displays the speed in the viewfinder. Even though you set aperture, you always have indirect control over shutter speed—choose a different aperture size and the camera will choose a different shutter speed.

MD lenses or the earlier MC lenses can be used with any XG camera on both manual and aperture-priority automatic. Other lenses can be used with certain restrictions as described later.

XG cameras have an unusual Operating Button with a capability that Minolta calls Touch Switch. To turn on the exposure display in the viewfinder, merely touch the operating button *without depressing* it. The camera senses the presence of your finger and turns on the display. To make an exposure, depress the operating button all the way.

If your finger is unusually dry or if you are wearing gloves, the Touch Switch feature does not operate but you can turn on the display another way—by partially depressing the operating button.

XG cameras do not offer metered manual operation. You can use the camera meter by switching to automatic and observing the viewfinder display. Then switch to manual and make whatever control settings are appropriate for the scene.

XG-9

The XG-9 has more features than other XG cameras including a handy memo holder on the back. Detailed specifications are in the table preceding this chapter. A difference that may be important to some users is that the XG-9 is the only model in the XG series with a Stop-Down Button.

LENSES

Either Minolta MD or MC lenses can be used. These lenses have automatic diaphragm and

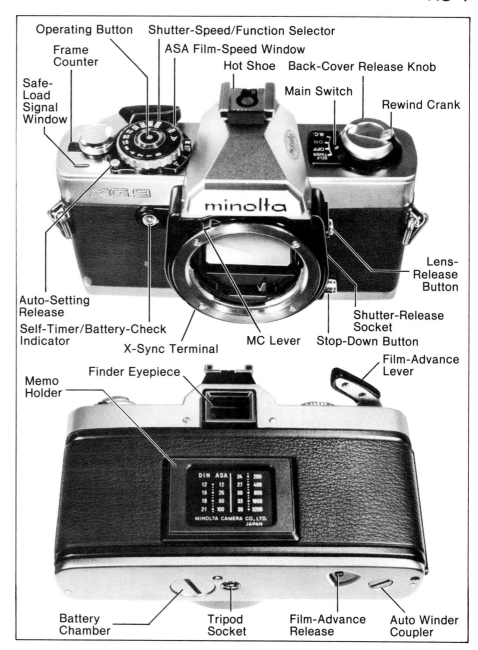

provide full-aperture metering. They use the standard Minolta bayonet mount and attach to the camera in the standard way. Other Minolta lenses can also be used, but with fewer automatic features.

MAIN SWITCH

The Main Switch has several functions. It turns the camera electronics on or off and must be in the **ON** position to use the camera. Set it to the **OFF** position when you are not using the

OFF—which locks the shutter release. It also has a **SELF TIMER** setting which prepares the camera to use the electronic self-timer. And, it has a battery-check position labeled **B.C.**

OPERATING BUTTON

The shutter will not operate when the operating button is depressed if battery power is too low, if the Main Switch is set to **OFF**, or if the required shutter speed for the scene is above the operating range of the camera.

OPERATING THE CAMERA

The camera uses two 1.5-volt silver-oxide batteries, S-76 or equivalent. Remove the Battery-Chamber Cover on the bottom, using a coin or something similar, and insert the batteries, observing the polarity markings inside the cover.

Check the batteries as described later. Load a cartridge of 35mm film in the standard way as shown in Chapter 5. Set film speed by lifting the outer rim of the Shutter-Speed/Function Selector knob and turning the rim until the desired film speed appears in the window. Set the Main Switch to ON.

Choose the mode of operation. If you set the Shutter-Speed/Function Selector knob to any numbered shutter speed or B, the camera is on manual. Set it to A and the camera is on Aperture-priority automatic.

Compose and focus the image. If on automatic, place your finger on the Operating Button to turn on the viewfinder display. Adjust camera controls as necessary. Depress the Operating Button fully to make the exposure. Advance the next frame with the Film-Advance Lever.

SHUTTER-SPEED/ FUNCTION SELECTOR

Please notice that there is no separate switch to select manual or automatic operation. It's done by the Shutter-Speed/Function Selector, which is why the control has a two-part name. I will refer to it as the *shutter-speed control* in the remainder of this discussion.

If you have the control set to A, for automatic operation, you cannot turn it away from that setting without simultaneously depressing the adjacent Auto-Setting Release.

OPERATING SEQUENCE ON AUTOMATIC

When operating on automatic with an MD or MC lens, the camera measures the light at full aperture. It calculates and sets shutter speed *before* the lens is

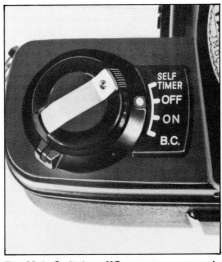

The Main Switch on XG cameras surrounds the rewind crank and is operated by the projection at the lower left. It turns the camera ON or OFF, selects SELF-TIMER operation and checks the batteries when set to B.C.

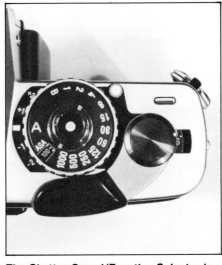

The Shutter-Speed/Function Selector is a ring around the shutter button on XG cameras. To set film speed, lift up the outer rim of the ring and turn until the desired speed is in the ASA Film-Speed Window. This camera is set for ASA 100. To choose aperture-priority automatic, set A opposite the white index mark as shown here.

stopped down to make the exposure. There is no readjustment of shutter speed after the lens stops down.

SAFE-LOAD SIGNAL

After loading the camera, check the Safe-Load Signal Window. When film is loaded correctly and advanced to frame 1, a red bar should appear at the left end of the window. If the bar does not appear, or appears at the far right,

open the camera and double check the loading. As you expose frames, the red bar will move across the window, from left to right, indicating that film is loaded correctly and advancing correctly.

METERING SYSTEM

The camera metering system controls exposure on automatic. It does not operate on manual.

Metering range and automatic-exposure range is EV 2 to EV 17 at ASA 100 with f-1.4. Metering pattern is center-weighted.

SHUTTER SPEEDS

Numbered speeds are from 1 second to 1/1000 second in standard steps. You should always set the dial exactly on a marked speed, not in between.

On Manual—The camera will operate at the shutter speed you have selected on the dial.

On Automatic—The camera uses whatever shutter speed is needed for correct exposure—within its range. This is called *stepless* operation.

Special Setting—The B setting causes the shutter to remain open as long as you hold the operating button depressed or keep the shutter open with a cable release.

VIEWFINDER DISPLAY

At the bottom of the frame, you always see the aperture setting on the lens. This is done by an optical system in the viewfinder which overhangs the lens and looks at the f-number markings on the aperture ring.

When the camera is set for automatic operation, the exposure meter and viewfinder display are turned on. The display is a red LED which glows opposite one shutter speed on a scale of shutter speeds from 1 to 1/1000.

Even though the scale shows only standard shutter speeds, the camera chooses shutter speed steplessly and will use whatever speed is needed for correct exposure, whether a standard value or not. The LED indicates the shutter

speed closest to the one the camera will actually use.

In addition to the shutter-speed indication, a triangular over-range indicator is above the shutter-speed scale. The LED indicator for 1 second is also triangular and is the under-range indicator.

OVER-RANGE AND UNDER-RANGE INDICATORS

When the over-range indicator glows, the shutter locks and the camera will not operate. If possible, select smaller aperture or reduce the amount of light on the scene so the camera chooses a shutter speed of 1/1000 or slower and the over-range indicator turns off.

Be sure not to hold the operating button depressed while adjusting aperture or scene illumination. If you do, the camera will operate the instant the shutter speed is within the operating range—whether you are ready or not.

If the triangular under-range indicator glows opposite 1 second on the scale, it means a shutter speed of 1 second or slower will be used. This shutter speed is likely to cause reciprocity failure of the film. If possible, use larger aperture or put more light on the scene so the camera can use a faster shutter speed.

If you shoot with the under-range indicator glowing, the camera will make an exposure.

FOCUSING SCREEN

The focusing screen is not interchangeable. It is the Acute Matte type which is visibly brighter than an ordinary matte surface. The focusing aid is a horizontal biprism surrounded by a microprism ring. Minolta literature refers to a biprism as a split-image rangefinder.

DEPTH-OF-FIELD PREVIEW

The Stop-Down Button closes lens aperture to the value selected on the aperture ring so you can see depth of field when desired.

The Stop-Down Button on the XG-9 is used *only to view depth of field.* The Stop-Down Button is *never* used while metering or making an exposure.

SELF-TIMER

To use the self-timer, set the Main Switch to the position labeled **SELF TIMER**. Advance the film and set shutter speed to any setting except **B**. To start the timer, depress the operating button. Delay will be approximately 10 seconds. At the beginning of the delay interval, a red light on the front of the camera will blink on and off intermittently. About 2.5 seconds before the shutter operates, the self-timer light starts blinking at a noticeably faster rate.

The amount of time delay cannot be changed. If the over-range indicator is lit, the self-timer will not operate. If shutter speed is set

to **B**, the self-timer will not operate. After you start it, the self-timer can be canceled any time before the shutter opens by turning the Main Switch to **OFF**.

If the camera is on automatic and your eye is not at the viewfinder, cover the eyepiece with the Eyepiece Cap supplied with the camera. This prevents incorrect exposure due to light entering the camera through the viewing window.

EXPOSURE ADJUSTMENT

On manual, you can give more or less exposure than the camera meter suggests just by changing exposure control settings.

On automatic, to give more or less exposure for a non-average scene or any other purpose, you must override the camera. This is another use of the shutter-speed control.

The normal setting for automatic operation is to place the symbol **A** opposite the white index mark adjacent to the control. On either side of the white index mark are additional settings marked -1, -2 and +1, +2. These are exposure steps.

To set the camera for 1 step more exposure than it would otherwise give, place the letter **A** opposite the symbol +1 instead of placing it opposite the white index mark. It is necessary to depress the Auto-Setting Release pushbutton

XG-9 VIEWFINDER DISPLAY

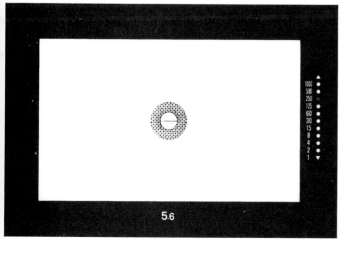

XG-9 FLASH SYNCHRONIZATION		
Flash	**Camera Mode**	**Shutter Speed**
Minolta X-Type	Automatic	Flash automatically switches camera to X-sync shutter speed at 1/60 second.
Minolta X-Type	Manual	When shutter-speed is set to any numbered setting, flash automatically switches camera to X-sync speed of 1/60 second. B setting will fire flash when first curtain opens.
Other Electronic Flash	Manual	Use 1/60 to 1 second, or B.
M or MF Flash Bulbs	Manual	Use 1/15 to 1 second, or B.
FP Flash Bulbs	Manual	Use 1/15 to 1 second, or B.

to move the A symbol away from the index mark but after that you don't need to hold the pushbutton depressed.

In other words, there are five settings for automatic operation. When the symbol A is at the index mark, exposure is normal for an average scene. Four other settings allow you to adjust the amount of exposure from -2 to +2 exposure steps. There are half-step detents between the marked full steps.

This control has the same effect as changing film speed but it cannot be used to extend the film-speed range of the camera.

FLASH TERMINAL & HOT SHOE

The camera provides X-sync only. Electronic flash can be used at the X-sync speed of 1/60 second—marked in yellow on the shutter-speed control—or any slower shutter speed. Flashbulbs can also be used even though they are fired with X-sync.

The hot shoe has a center contact to fire the flash and an auxiliary contact called the Flash-Signal Input Terminal. This contact allows the camera to be set to X-sync shutter speed automatically by Minolta X-type electronic flashes such as Auto Electroflash 200X. See Chapter 11.

The hot shoe is "hot" only when a flash unit is mounted in the shoe. The flash terminal on the camera body is "hot" all the time. Two flashes can be used simultaneously, one in the hot shoe and one connected to the flash terminal.

FLASH-READY SIGNAL

When using an X-type Minolta Auto Electroflash mounted in the hot shoe, the LED indicator opposite 60 on the shutter-speed scale in the viewfinder also serves as a flash-ready indicator. It blinks to indicate that the flash is ready to fire and the camera will operate at the X-sync shutter speed.

SHUTTER-RELEASE SOCKET

Because of the special Touch Switch shutter-button on XG cameras, the socket for a cable release must be located elsewhere. It's on the front of the camera body, below the rewind knob. The socket is primarily designed for the 50mm Remote Cord S or the 5-meter Remote Cord L, both of which have electrical pushbutton switches at their far ends. It can also be used with a conventional mechanical cable release.

MULTIPLE EXPOSURES

There is no control or factory-recommended procedure for multiple exposures. The unofficial "three-finger method" described in Chapter 8 may be satisfactory.

STOPPED-DOWN METERING

Metering with equipment that has neither MC pin nor diaphragm control pin is straightforward. You must meter stopped down but the equipment mounted on the camera is always stopped down to shooting aperture. There is no need to use the Stop-Down Button on the camera.

An example is a mirror lens. Observe the viewfinder display to be sure the camera selects a shutter speed within the operating range. If not, select an ND filter for the mirror lens.

On manual, the camera does not meter and does not control exposure. When using equipment that has neither MC pin nor diaphragm control pin, you can meter on automatic as already described and then use these or any other settings on manual, as you choose.

Metering with a lens that has a diaphragm control pin but no MC pin cannot be done correctly. Therefore you cannot use these items in the automatic mode because the camera will choose shutter speed based on an incorrect meter reading.

An example is the 35mm f-2.8 Shift CA lens which has a diaphragm control pin but no MC pin. Other examples no longer in

production are Auto Bellows 1 and Auto Rokkor lenses without a stop-down button (preview button) on the lens itself.

Some Auto Rokkor lenses have a stop-down button on the lens body and these are a special case, described in the following section.

When using equipment with a diaphragm control pin but no MC pin, you cannot rely on an exposure reading taken with the camera on automatic. You can use the equipment with the camera on manual but you must determine exposure settings independent of the camera.

USING OLDER LENSES

Besides MD lenses, virtually all Minolta SLR lenses can be used on aperture-priority or manual modes.

MC Lenses—Can be used on aperture-priority automatic or manual modes.

Auto Rokkor—Because these lenses don't have a meter-coupling pin, metering is by the stop-down method:

1. After focusing, depress the preview button on the lens to stop down the aperture.
2. Choose a suitable aperture for aperture-priority operation, or set both shutter and aperture for manual operation.
3. If on aperture-priority automatic, hold in the preview button on the lens while making the exposure. If on manual, you can release the preview button before making the exposure.

RF (Mirror) and Manual Preset Lenses—Proceed as described for Auto Rokkor lenses except that you don't have to depress the preview button on the lens.

Use only the manual mode with the 35mm f-2.8 CA Shift lens, Auto Bellows I, and Auto Rokkor lenses without a preview button.

DEAD BATTERIES

If the batteries are dead or missing, the camera will not operate on any mode or any shutter-speed setting.

BATTERY CHECK

To check batteries, turn the Main Switch to the position labeled **B.C.** and observe the self-timer light on the front of the camera. If the light glows steadily, batteries are OK.

CABLE RELEASES

The Shutter-Release Socket is on the camera body. It accepts two types of cable releases. Minolta Remote Cords S and L make an electrical connection to the camera and operate by an electrical pushbutton switch on the far end of the cable. To make long time exposures on **B**, hold the pushbutton down with your finger.

This camera will also accept a standard mechanical cable release. If you use the type that can be locked to hold the shutter open, you can make long time exposures on **B** without the necessity of holding the plunger in with your finger.

SPECIAL PRECAUTIONS

Clean the shutter button occasionally with a soft cloth to assure proper operation of the Touch Switch feature.

When a standard mechanical cable release is used with the camera set to **B**, be sure not to let any metal part of the cable release touch any metal part of the camera body while the shutter is open. If this happens, the shutter will close immediately which will end the exposure.

MAJOR ACCESSORIES

Available accessory items include Minolta lenses, Auto Winder G, Minolta Auto Electroflash units, Remote Cords S and L, Data Back G, extension tubes and bellows units. A neckstrap with spare battery holder is packaged with the camera.

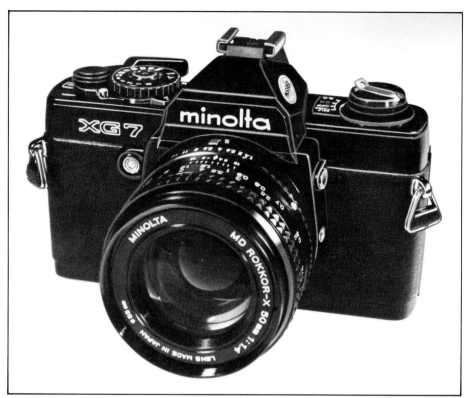

Controls for the XG-7 are the same as the XG-9 except that the XG-7 doesn't have a Stop-Down Button.

XG-7

The XG-7 was in production less than a year and was replaced by the XG-9. The two models are very similar. I describe the differences here and suggest that owners of XG-7 cameras read the preceding description of the XG-9, keeping in mind these few differences:

The XG-7 does not have the viewfinder optical system that displays the f-number setting of the lens in the viewfinder. You can look directly at the lens, instead.

The XG-7 does not have a Stop-Down Button, therefore you cannot view depth of field on the focusing screen. The stopped-down metering procedure is the same for all XG cameras and does not use the Stop-Down Button even if there is one.

The focusing screen is a conventional matte surface, rather than an Acute Matte screen. Therefore the image seen in the viewfinder is less bright than the XG-9.

Numbers on the shutter-speed scale in the XG-7 are black on a clear background. In the XG-9, they are clear on a black background. In my opinion, there is no difference in readability. Detailed specifications are in the table preceding this chapter.

XG-1

This popular camera is the lowest-priced 35mm Minolta SLR with automatic exposure control. It offers aperture-priority automatic and manual. Detailed specifications are in the table preceding this chapter.

Not all available shutter speeds are shown in the viewfinder. Nevertheless, all shutter speeds are available in the automatic mode, selected steplessly by the camera, and all standard shutter speeds are available on manual, set on the Shutter-Speed/Function Selector.

The XG-1 does not have a removable back, therefore Data Back G cannot be used. It does not have a Stop-Down Button, therefore depth of field cannot be viewed on the focusing screen.

The XG-1 does not have the viewfinder optical system that displays the *f*-number setting of the lens in the viewfinder. You can always look at the lens to see what aperture is set.

The focusing screen is a conventional matte surface, rather than an Acute Matte screen.

LENSES

Either Minolta MD or MC lenses can be used. These lenses have automatic diaphragm and full-aperture metering. They use the standard Minolta bayonet mount and attach to the camera in the standard way. Other Minolta lenses can also be used, but with fewer automatic features.

MAIN SWITCH

This camera has a Main Switch with several functions. It turns the camera electronics on or off. Set it to OFF when you are not using the camera. It has a SELF TIMER setting which prepares the camera to use the electronic self-timer. And, it has a battery-check position labeled B.C.

OPERATING BUTTON

The shutter will not operate when the operating button is

ASA Film-Speed Window
Operating Button
Shutter-Speed/Function Selector
Film-Advance Lever
Hot Shoe
Main Switch
Rewind Crank
Back-Cover Release Knob
Frame Counter
Safe-Load Signal Window
Auto-Setting Release
MC Lever
X-Sync Terminal
Lens-Release Button
Shutter-Release Socket
Self-Timer/Battery Check Indicator
Finder Eyepiece
ASA 25 50 100 200 400 800 1600
DIN 15 18 21 24 27 30 33
MINOLTA CAMERA CO.,LTD. JAPAN
Battery Chamber
Tripod Socket
Film-Advance Release
Auto Winder Coupler

depressed if battery power is too low, if the Main Switch is set to OFF, or if the required shutter speed for the scene is above the operating range of the camera.

OPERATING THE CAMERA

The camera uses two 1.5-volt silver-oxide batteries, S-76 or equivalent. Remove the Battery-Chamber Cover on the bottom, using a coin or something similar, and insert the batteries observing the polarity markings inside the cover.

Check the batteries as described later. Load a cartridge of 35mm film in the standard way as shown in Chapter 5. Set film speed by lifting the outer rim of the Shutter-Speed/Function Selector knob and turning the rim until the desired film speed appears in the window. Set the Main Switch to ON.

Choose the mode of operation. If you set the Shutter-Speed/

Function Selector knob to any numbered shutter speed or B, the camera is on manual. Set it to A and the camera is on Aperture-priority automatic.

Focus and compose the image. If on automatic, place your finger on the Operating Button to turn on the viewfinder display. Adjust camera controls as necessary. Depress the Operating Button fully to make the exposure. Advance the next frame with the Film-Advance Lever.

SHUTTER-SPEED/ FUNCTION SELECTOR

Please notice that there is no separate switch to select manual or automatic operation. It's done by the Shutter-Speed/Function Switch, which is why the control has a two-part name. I will refer to it as the *shutter-speed control* in the remainder of this discussion.

OPERATING SEQUENCE ON AUTOMATIC

When operating on automatic with a standard MD or MC lens, the camera measures the light at full aperture, calculates and sets shutter speed before the lens is stopped down to make the exposure. There is no final check and readjustment of shutter speed after the lens stops down—as in XD cameras.

SAFE-LOAD SIGNAL

After loading the camera, check the Safe-Load Signal Window. When film is loaded correctly and advanced to frame 1, a red bar should appear at the left end of the window. If the bar does not appear, or appears at the far right, open the camera and double check the loading. As you expose frames, the red bar will move across the window, from left to right, indicating that film is loaded correctly and advancing correctly.

METERING SYSTEM

The camera metering system controls exposure on automatic. It does not operate on manual.

Metering range and automatic-exposure range is EV 2 to EV 17 at ASA 100 with *f*-1.4. Metering pattern is center-weighted.

SHUTTER SPEEDS

Numbered speeds are from 1 second to 1/1000 second in standard steps. You should always set the dial exactly on a marked speed, not in between.

On Manual—The camera will operate at the standard shutter speed you have selected.

On Automatic—The camera uses whatever shutter speed is needed for correct exposure whether it is a standard speed or not. This is called *stepless* operation.

Special Setting—The B setting causes the shutter to remain open as long as you hold the operating button depressed or keep the shutter open with a cable release.

VIEWFINDER DISPLAY

When the camera is set for automatic operation, the exposure meter and viewfinder display are turned on. The display is a red LED which indicates the nearest standard speed to the one that will actually be used.

All standard shutter speeds are shown from 1/1000 second down to 1/30 second. Below 1/30 there are only two more indications. One is between 1/30 and 1 second and indicates that shutter speed will be slower than 1/30. At 1 second on the scale is a red triangular under-range indicator.

OVER-RANGE AND UNDER-RANGE INDICATORS

The over-range indicator is above the shutter-speed scale. When it glows, the shutter release locks and the camera will not operate. Be sure not to hold the operating button depressed while adjusting aperture or scene illumination. If you do, the camera will operate the instant the shutter speed is within the operating range—whether you are ready or not.

XG-1 FLASH SYNCHRONIZATION		
Flash	Camera Mode	Shutter Speed
Minolta X-Type	Automatic	Flash automatically switches camera to X-sync shutter speed at 1/60 second.
Minolta X-Type	Manual	When shutter-speed is set to any numbered setting, flash automatically switches camera to X-sync speed of 1/60 second. B setting will fire flash when first curtain opens.
Other Electronic Flash	Manual	Use 1/60 to 1 second, or B.
M or MF Flash Bulbs	Manual	Use 1/15 to 1 second, or B.
FP Flash Bulbs	Manual	Use 1/15 to 1 second, or B.

XG-1 VIEWFINDER DISPLAY

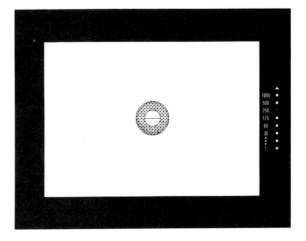

199

If the triangular under-range indicator glows opposite 1 second on the scale, it means a shutter speed of 1 second or slower will be used. This shutter speed is likely to cause reciprocity failure of the film. If you shoot with the under-range indicator glowing, the camera will make an exposure.

FOCUSING SCREEN

The focusing screen is not interchangeable. It is a conventional matte surface, rather than an Acute Matte screen. The focusing aid is a horizontal biprism surrounded by a microprism ring.

SELF-TIMER

To use the self-timer, set the Main Switch to the position labeled SELF TIMER. Advance the film and set shutter speed to any setting except B. To start the timer, depress the operating button. Delay will be approximately 10 seconds. At the beginning of the delay interval, a red light on the front of the camera will turn on and off intermittently. About 2.5 seconds before the shutter operates, the self-timer light starts blinking at a noticeably faster rate.

The amount of time delay cannot be changed. If the over-range indicator is lit, the self-timer will not operate. If shutter speed is set to B, the self-timer will not operate. After you start it, the self-timer can be canceled any time before the shutter opens by turning the Main Switch to OFF.

If the camera is on automatic and your eye is not at the viewfinder, cover the eyepiece with the Eyepiece Cap supplied with the camera. This prevents incorrect exposure due to light entering the camera through the viewing window.

EXPOSURE ADJUSTMENT

On manual, you can give more or less exposure than the camera meter suggests just by changing exposure control settings.

On automatic, to give more or less exposure for a non-average scene or any other purpose, you must override the camera. This is another use of the shutter-speed control.

The normal setting for automatic operation is to place the symbol A opposite the white index mark adjacent to the control. On either side of the white index mark are additional settings marked -1, -2 and +1, +2. These are exposure steps. To set the camera for one step more exposure than it would otherwise give, place the letter A opposite the symbol +1 instead of placing it opposite the white index mark. It is necessary to depress the Auto-Setting Release pushbutton to move A symbol away from the index mark but after that you don't need to hold the pushbutton depressed.

In other words, there are five settings for automatic operation. At the index mark, exposure is normal for an average scene. Four other settings allow you to adjust the amount of exposure from -2 to +2 exposure steps. There are half-step detents between the marked full steps. When you want normal exposure, make sure the symbol A is opposite the white index mark.

This control has the same effect as changing film speed but it cannot be used to extend the film-speed range of the camera. That is, when the film-speed dial is set to the highest number you cannot reduce exposure further by selecting -1 or -2. Similarly, when the lowest film-speed number has been selected, you cannot get further exposure by selecting +1 or +2.

FLASH TERMINAL & HOT SHOE

The camera provides X-sync only. Electronic flash can be used at the X-sync speed of 1/60 second—marked in yellow on the shutter speed control—or any slower shutter speed. Flashbulbs can also be used even though they are fired with X-sync.

The hot shoe has a center contact to fire the flash and an auxiliary contact called the Flash-Signal Input Terminal. This contact allows the camera to be set to X-sync shutter speed automatically by Minolta X-type electronic flashes such as Auto Electroflash 200X. See Chapter 11.

The hot shoe is "hot" only when a flash unit is mounted in the shoe. The flash terminal on the camera body is "hot" all the time. Two flashes can be used simultaneously, one in the hot shoe and one connected to the flash terminal.

FLASH-READY SIGNAL

When using an X-type Minolta Auto Electroflash mounted in the hot shoe, the LED indicator opposite 60 on the shutter-speed scale in the viewfinder also serves as a flash-ready indicator. It blinks on and off repeatedly when the flash is charged and ready to fire.

SHUTTER-RELEASE SOCKET

Because of the special Touch Switch capability of the shutter-button on XG cameras, the socket for a cable release must be located elsewhere. It's on the front of the camera body, below the rewind knob. The socket is primarily designed for the 50mm Remote Cord S or the 5-meter Remote Cord L, both of which have electrical pushbutton switches at their far ends. It can also be used with a conventional mechanical cable release.

MULTIPLE EXPOSURES

There is no control or factory-recommended procedure for multiple exposures. The unofficial "three-finger method" described in Chapter 8 may be satisfactory.

STOPPED-DOWN METERING

When using lenses or extension devices without a meter-coupling MC pin, full-aperture metering is not possible. Therefore stopped-down metering is necessary.

Metering equipment that has neither MC pin nor diaphragm control pin is straightforward. You

must meter stopped down but the equipment mounted on the camera is always stopped down to shooting aperture, so you get stopped-down metering automatically when needed.

An example is a mirror lens. Observe the viewfinder display to be sure the camera selects a shutter speed within the operating range. If not, select an ND filter for the mirror lens that gives a usable shutter speed.

On manual, the camera does not meter and does not control exposure. When using equipment that has neither MC pin nor diaphragm control pin, you can meter on automatic as already described and then use these or any other settings on manual, as you choose.

Metering with a lens that has a diaphragm control pin but no MC pin cannot be done correctly. Therefore you cannot use these items in the automatic mode because the camera will choose shutter speed based on an incorrect meter reading.

An example is the 35mm f-2.8 Shift CA lens which has a diaphragm control pin but no MC pin. Other examples no longer in production are Auto Bellows 1 and Auto Rokkor lenses without a stop-down button on the lens itself.

Some Auto Rokkor lenses have a stop-down button on the lens body and these are a special case, described in the following section.

When using equipment with a diaphragm control pin but no MC pin, you cannot rely on an exposure reading taken with the camera on automatic. You can use the equipment with the camera on manual but you must determine exposure settings independent of the camera.

USING OLDER LENSES

Besides MD lenses, virtually all Minolta SLR lenses can be used on aperture-priority or manual modes.

MC Lenses—Can be used on

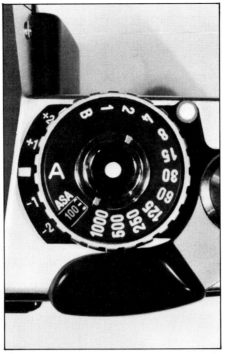

To give more or less exposure on automatic than the camera would normally use, move the symbol A opposite the number that indicates the desired amount of adjustment from +2 to -2 steps. To select manual operation, depress the pushbutton at the upper right and turn the dial to a numbered shutter speed from 1 to 1/1000 second, or B.

aperture-priority automatic or manual modes.

Auto Rokkor—Because these lenses don't have a meter-coupling pin, metering is by the stop-down method:

1. After focusing, depress the preview button on the lens to stop down the aperture.

2. Choose a suitable aperture for aperture-priority operation, or set both shutter and aperture for manual operation.

3. If on aperture-priority automatic, hold in the preview button on the lens while making the exposure. If on manual, you can release the preview button before making the exposure.

RF (Mirror) and Manual Preset Lenses—Proceed as described for Auto Rokkor lenses except that you don't have to depress the preview button on the lens.

Use only the manual mode with the 35mm f-2.8 CA Shift lens, Auto Bellows I, and Auto Rokkor lenses without a preview button.

DEAD BATTERIES

If the batteries are dead or missing, the camera will not operate on any mode or any shutter-speed setting.

BATTERY CHECK

To check batteries, turn the Main Switch to the position labeled B.C. and observe the self-timer light on the front of the camera. If the light glows steadily, batteries are OK.

CABLE RELEASES

The Shutter-Release Socket is on the camera body. It accepts two types of cable releases. Minolta Remote Cords S and L make an electrical connection to the camera and operate by an electrical pushbutton switch on the far end of the cable. To make long time exposures on B, hold the pushbutton down with your finger.

This camera will also accept a standard mechanical cable release. If you use the type that can be locked to hold the shutter open, you can make long time exposures on B without the necessity of holding the plunger in with your finger.

SPECIAL PRECAUTIONS

Clean the shutter button occasionally with a soft cloth to assure proper operation of the Touch Switch feature.

When a standard mechanical cable release is used with the camera set to B, be sure not to let any metal part of the cable release touch any metal part of the camera body while the shutter is open. If this happens, the shutter will close immediately and end the exposure.

MAJOR ACCESSORIES

Available accessory items include Minolta lenses, Auto Winder G, Minolta Auto Electroflash units, Remote Cords S and L, extension tubes and bellows units. A camera strap with spare battery holder is packaged with the camera.

SR-T CAMERAS

These are basically non-automatic mechanical cameras with a light meter built in. Everything works normally with a dead battery except the meter.

SR-T 200 AND SR-T 201

These two models are basically identical. The three differences between the SR-T 200 and the SR-T 201 are:

The SR-T 200 does not have a self-timer, it does not have a memo holder on the back cover and it does not display shutter speed in the viewfinder. Detailed specifications for each model are in the table at the beginning of this chapter.

LENSES

Either Minolta MD or MC lenses can be used. These lenses provide automatic diaphragm and full-aperture metering. Other Minolta lenses can also be used, but with fewer automatic features.

ON-OFF SWITCH

On the bottom of the camera is a three-position Battery Switch. The three settings are ON, OFF, and B.C. which is the Battery-Check setting.

OPERATING THE CAMERA

The camera uses one 1.35-volt mercury cell, EPX-625, EPX-13 or equivalent. Remove the Battery-Chamber Cover, using a coin or something similar, and insert the battery, observing the polarity indicated inside the cover.

Check the battery as described later. Load a cartridge of 35mm film in the standard way as shown in Chapter 5. Set film speed by lifting the outer rim of the Shutter-Speed Dial and turning the rim until the desired film speed appears in the window. Set the Battery Switch to ON.

Focus and compose the image. Adjust camera controls as necessary for correct exposure, observing the match-needle exposure display in the viewfinder. Depress the Shutter-Release Button to make the exposure. Advance the

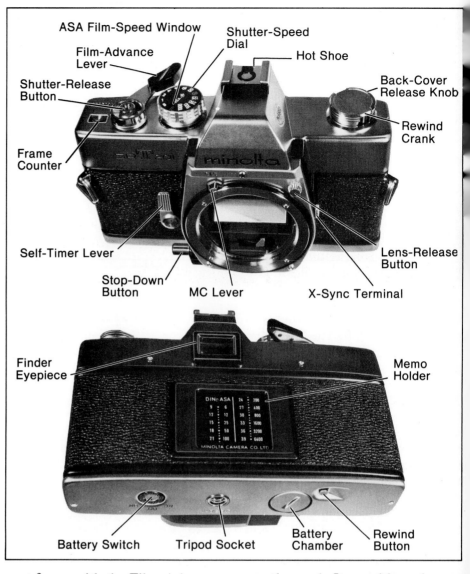

next frame with the Film-Advance Lever.

SHUTTER SPEED

Numbered speeds are from 1 second to 1/1000 second in standard steps. You should always set the dial exactly on a marked speed, not in between.

The B setting causes the shutter to remain open as long as you hold the operating button depressed with your finger or a mechanical cable release.

VIEWFINDER DISPLAY

Two moving needles are visible at the right side of the viewfinder. The plain, straight Meter Needle moves up and down according to the amount of light coming through the lens.

The Follower Needle has a circle on the end. Its position changes when you change aperture setting, shutter-speed or film speed.

When the meter needle passes through the center of the circle on the end of the follower needle, exposure is correct for an average scene.

On the SR-T 201 only, there is a shutter-speed scale along the bottom of the viewfinder. An indicator moves along the scale to show the setting of the shutter-speed dial, including the B setting.

OVER-RANGE AND UNDER-RANGE INDICATORS

On the right side of the frame are three index marks. The top and bottom marks are triangular. If the meter needle is between the two triangles, the meter is operating within its range of accuracy.

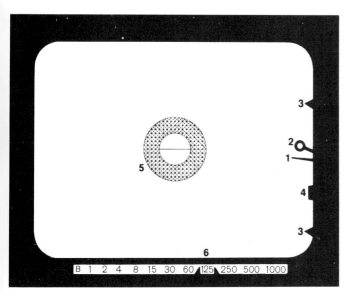

SR-T 201 and SR-T 200 FLASH SYNCHRONIZATION	
Flash	**Shutter Speed**
Electronic	1/60 to 1 second B will fire flash when first curtain opens.
M or MF Flash Bulbs	Use 1/15 to 1 second, or B.
FP Flash Bulbs	Use 1/15 to 1 second, or B.

1 Meter Needle
2 Follower Needle
3 Metering Limit
4 Battery Check Mark
5 Focusing Aids
6 Shutter-Speed Scale

Overexposure or underexposure is indicated by the position of the two needles in respect to each other.

BATTERY CHECK

The rectangular index in the viewfinder is used to check the battery. When you turn the Battery Switch to the B.C. position, the meter needle should drop down from the top and align with the index. If it does not descend that far, the battery is weak and should be replaced.

The Battery Switch *does not* return to OFF automatically after you have checked the battery. Be sure to turn the switch to OFF or to ON if you want to operate the camera.

SELF TIMER

The SR-T 201 has a self-timer. The SR-T 200 does not.

The self-timer is mechanical, operated by a lever on the front of the camera. To set the timer, turn the lever fully counterclockwise. Be sure film is advanced.

To start the timer, depress the small button on the front of the camera which is normally concealed by the self-timer lever. Self-timer delay is approximately 10 seconds.

DEPTH OF FIELD

To preview depth of field on the focusing screen of either model, push in the Stop-Down Button.

FLASH TERMINAL & HOT SHOE

These cameras provide X-sync only.

The hot shoe has a center contact to fire the flash. The shoe is "hot" only when a flash unit is mounted. The flash terminal on the camera body is "hot" all the time. Two flashes can be used simultaneously, one in the hot shoe and one connected to the flash terminal.

CABLE-RELEASE SOCKET

In the center of the Shutter-Release Button is a threaded socket to fit any conventional mechanical cable release.

MULTIPLE EXPOSURES

There is no control or factory-recommended procedure for multiple exposures. The unofficial "three-finger method" described in Chapter 8 may be satisfactory.

STOPPED-DOWN METERING

When using lenses or extension devices without a meter-coupling MC pin, full-aperture metering is not possible. Therefore stopped-down metering is necessary. This is uncomplicated because the camera never sets exposure automatically.

With any equipment without an MC pin, meter at shooting aperture without bothering to depress the Stop-Down Button on the camera. Set exposure controls and make the exposure. Examples of this equipment are non-automatic extension tubes, reflex mirror lenses and manual-preset lenses.

With any equipment that has auto-diaphragm but not an MC pin, use the Stop-Down Button on the camera to stop down the lens. Keep the button pressed in while you set exposure controls by observing the needles. Release the Stop-Down Button. Make the exposure. Examples of this equipment are the 35mm *f*-2.8 Shift CA lens and earlier Auto Rokkor lenses.

Do not depress the Stop-Down Button while metering with MD or MC lenses. The exposure reading will be incorrect.

USING OLDER LENSES

MC lenses can be used with full-aperture metering.

Auto Rokkor, reflex mirror lenses and manual-preset lenses must be used with stopped-down metering.

MAJOR ACCESSORIES

Available accessory items include Minolta lenses, Minolta Electroflash units, extension tubes and bellows.

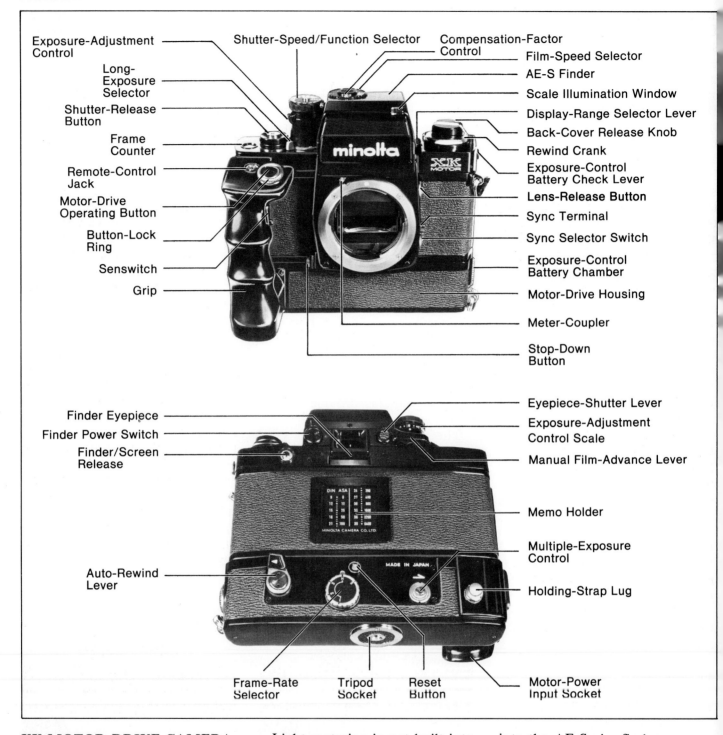

Exposure-Adjustment Control
Long-Exposure Selector
Shutter-Release Button
Frame Counter
Remote-Control Jack
Motor-Drive Operating Button
Button-Lock Ring
Senswitch
Grip

Shutter-Speed/Function Selector
Compensation-Factor Control

Film-Speed Selector
AE-S Finder
Scale Illumination Window
Display-Range Selector Lever
Back-Cover Release Knob
Rewind Crank
Exposure-Control Battery Check Lever
Lens-Release Button
Sync Terminal
Sync Selector Switch
Exposure-Control Battery Chamber
Motor-Drive Housing
Meter-Coupler
Stop-Down Button

Finder Eyepiece
Finder Power Switch
Finder/Screen Release

Eyepiece-Shutter Lever
Exposure-Adjustment Control Scale
Manual Film-Advance Lever

Memo Holder

Multiple-Exposure Control

Auto-Rewind Lever

Holding-Strap Lug

Frame-Rate Selector
Tripod Socket
Reset Button
Motor-Power Input Socket

XK MOTOR-DRIVE CAMERA

This is the top-of-the-line Minolta with capabilities, features and accessories that are not common to other Minoltas. It has a built-in motor drive, interchangeable focusing screens, interchangeable viewfinders, a 250-frame accessory film back, a variety of battery holders, remote-control devices and other accessories. Detailed specifications are in the table preceding this chapter.

Light metering is not built into the body of the camera but is available in one of the four interchangeable viewfinders. This finder, the AE-S, measures the light, operates a viewfinder exposure display and provides both aperture-priority automatic exposure and metered manual. Convenience features include motorized film advance and motorized rewind, a memo holder on the back and an eyepiece shutter built

into the AE-S viewfinder.

LENSES

Either MD or MC lenses can be used for aperture-priority automatic or metered manual operation when using the metering AE-S viewfinder.

SETTING UP THE CAMERA

To use an XK Motor camera, you must install one of the four interchangeable viewfinders. This discussion will assume that you

are using the AE-S finder.

Load Batteries—There are two sets of batteries. The camera electronics use two 1.5-volt silver-oxide S-76 or equivalent. These are called *exposure-control batteries.* If you are using the AE-S finder, these batteries supply power to the finder. Test the batteries immediately after installing and periodically thereafter by rotating the Exposure-Control Battery Checker lever clockwise while observing the adjacent lamp. If it glows steadily, these batteries are OK.

The Standard Battery Pack case attaches to the bottom of the camera and holds the motor-drive batteries. Orient the case so its electrical connector mates with the electrical connector on the bottom of the camera grip. Press these connectors together while screwing the attaching screw on the battery pack into the tripod socket on the camera.

Before or after mounting the battery pack, depress the tabs on the sides and pull the end covers off. Install five AA-size batteries in *each end* of the case, observing polarity markings inside the case. Then reinstall the covers so the white dot on each cover aligns with a white dot on the battery pack. Other battery holders can be used as described later.

Test the motor-drive batteries immediately after installation and periodically thereafter by depressing the Motor-Battery Check Button on the grip handle while observing the adjacent Motor-Battery-Check Indicator. If the needle moves to the green zone, the batteries are OK.

Load Film—Open the camera back by lifting upward on the Back-Cover Release Knob. Drop in a 35mm film cartridge, pull film across the camera and insert the leader into one of the slots in the take-up spool so a tooth on the spool fits into a sprocket hole on the film. Be sure the end of the leader does not project out of the adjacent slot on the spool—this would interfere with rewinding.

Using the camera motor or the film-advance lever, advance film one frame at a time until sprocket holes on both sides of the film engage teeth on the sprocket. Press your finger firmly on the edge of the film as shown in Chapter 5. Fold out the Manual Rewind Crank and turn it clockwise until you feel resistance. This tensions the film.

Leaving the rewind crank tipped out, close the camera back. Then advance film to frame 1 while watching the rewind crank. It should rotate during each film advance. If not, film is not loaded properly and it is not advancing.

Set film speed by depressing the Film-Speed Selector Release on the AE-S finder while turning the adjacent knurled ring to bring the correct film speed into view in the window.

OPERATING THE CAMERA

Once set up to operate with the AE-S finder, you have the choice of aperture-priority automatic exposure or metered manual and the choice of using the motor drive or not.

Camera-Body Power—At all shutter-speed settings except X and B, the focal-plane shutter is controlled electronically and requires power from the exposure-control batteries. There is no on-off switch for the shutter.

Turning the AE-S Finder On—This is done in several ways, using two controls: the Senswitch on the camera-body grip and the Power/Function Switch on the AE-S finder. The switch on the finder has three positions.

Set to Off—Viewfinder power is controlled by the Senswitch on the camera grip. When you depress and hold down the Senswitch with your finger, the meter, the viewfinder display, and the automatic-exposure system are all turned on.

Set to Plain Red Dot—With the finder power switch set to the plain red dot—not the circled red dot—the viewfinder *display* is turned on or off by the Senswitch. Everything else is on all the time.

Set to Circled Red Dot—With the finder power switch set to the *circled* red dot, everything is turned on all the time and the Senswitch doesn't do anything.

Mode Selection—To select aperture-priority automatic exposure, turn the Shutter-Speed/Function Selector knob so the word AUTO on the knob is aligned with the white dot.

AE-S DISPLAY

HIGH RANGE

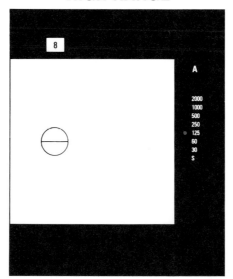

LOW RANGE

To select metered manual operation, depress the button in the center of the Shutter-Speed/ Function Selector knob and turn it to any of the numbered shutter speeds from 1/2000 to 1 second.

High and Low Range—All shutter speeds are not displayed simultaneously. The Display-Range Selector Lever on the left side of the viewfinder is used to select high or low range.

At the high-range setting, shutter speeds from 1/2000 to 1/30 second are visible as a scale of numbers. Shutter speed is indicated by red LED indicators which glow adjacent to numbers on the scale.

When set for low range, shutter speeds from 1/15 to 8 seconds are displayed as glowing LED numerals.

Overexposure and Underexposure Signals—If the low-range shutter-speed indication goes off scale at the bottom, or if the high-range shutter-speed indication goes off scale at the top, the light is beyond the automatic-exposure range of the camera.

LONG EXPOSURES

Shutter speeds from 2 to 16 seconds are made using a special Long-Exposure Selector on the camera body.

INTERCHANGEABLE FOCUSING SCREENS

The camera body accepts a variety of interchangeable focusing screens, which can be used with any of the interchangeable viewfinders.

If you are using the AE-S finder, the focusing screen in use may affect metering as shown in a table in the camera instruction booklet. Compensation is made at the ASA Film-Speed Selector dial on top of the AE-S finder. This dial has two windows. The window on the left shows the ASA film-speed setting. The window on the right shows the amount of exposure compensation.

XK MOTOR FLASH SYNCHRONIZATION			
Flash	Camera Sync Setting	Camera Mode	Shutter Speed
Electronic	X	Manual	Use X setting, 1/60 to 16 seconds, or B.
M or MF Flash Bulb	X	Manual	Use 1/30 to 16 seconds, or B.
FP Flash Bulb	FP	Manual	1/2000 to 16 seconds, X, or B.

These four interchangeable viewfinders fit the XK Motor camera. From left to right: Plain Finder, AE-S Finder, High-Magnification Finder, Waist-Level Finder.

EXPOSURE ADJUSTMENT CONTROL

On the AE-S finder, the Exposure-Adjustment Control is a button just below the Shutter-Speed/ Function Selector knob. Lift up on the button and move it to the left or right. This moves a scale of numbers, visible from the back of the camera. The numbers are exposure steps ranging from -2 to +2 with dots at intermediate half-steps.

DEPTH-OF FIELD PREVIEW

The Stop-Down Button is near the bottom of the lens mount.

FLASH TERMINAL AND HOT SHOE

An accessory hot shoe is available which fits over the Back Cover Release knob and makes electrical contact with the flash-firing circuit in the camera body. The Flash Sync Terminal, on the side of the lens mount, accepts either a threaded Minolta sync cord connector or the common push-in type.

Both flash terminal and hot shoe are controlled by the Sync Selector switch just below the flash terminal. The sync selector has two positions, X and FP, which synchronize with electronic and bulb flash as shown in the accompanying Flash Sync Table.

MOTOR DRIVE

Both the camera shutter and motor-driven film advance are controlled by the motor-drive Operating Button on the top of the handgrip. A ring surrounding the Operating Button serves as the on-off control for the motor drive and also locks the button to prevent accidental operation.

Turn the ring so the index mark aligns with the white dot and the motor drive can be operated. Turn it to the red dot and the operating button is locked.

Before using the motor, turn the Frame-Rate Selector knob on the back of the motor-drive unit to one of its four positions:

S is for single-frame operation. One frame will be exposed each time you depress the operating button. To expose the next frame, you must release the operating button and depress it again.

1, 2, and 3 are for a continuous sequence of exposures at the indicated number of frames per second.

H sets the motor to advance frames as fast as possible—about 3.5 per second with fresh batteries and a shutter speed of 1/60 or shorter.

MOTOR-DRIVE POWER SOURCES

The Standard Battery Pack fits on the bottom of the camera body. There are two alternate power

sources, either of which can be used instead of the standard battery pack.

The Separate Battery Pack is a battery case with a 1.2-meter power cord attached.

The Battery Grip attaches to the bottom of the camera using the tripod screw. It holds the motor-drive batteries and supplies power to the camera through a short power cord. It provides a convenient handle and is particularly useful for hand-holding the camera with the 250-frame film back attached.

250-FRAME FILM BACK

For some purposes, the standard cartridge that holds 36 exposures is not adequate. This special back holds 250 frames.

The Standard Battery Pack cannot be connected to the bottom of the camera with the 250-frame back in place. You can use the Battery Grip, either mounted on the camera or cord connected, or you can use the Separate Battery Pack.

MAJOR ACCESSORIES

Available accessory items include: Minolta lenses, extension tubes and bellows units, interchangeable viewfinders, interchangeable focusing screens, 250-Frame Film Back and Film Loader, Separate Battery Pack, Battery Grip, eyepiece accessories, Remote Cords S and L, Intervalometer PM.

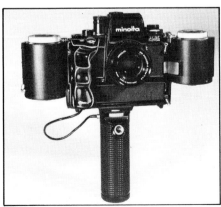

The Battery Grip not only holds the motor-drive batteries, it provides a good grip for sports and action photography using an XK Motor camera with the standard back or with the 250-Frame Film Back as shown here.

INDEX

A-8.41629850595